Smithsonian

THE ULTIMATE QUESTION
AND ANSWER BOOK

AMERICAN ART AND ARTISTS

Produced for HarperCollins by:

HYDRA PUBLISHING
129 MAIN STREET
IRVINGTON, NY 10533
WWW.HYLASPUBLISHING.COM

FIRST EDITION

Library of Congress Cataloging-in-Publication Data has been applied for.

ISBN: 978-0-06-089124-4
ISBN-10: 0-06-089124-6

07 08 09 10 QW 10 9 8 7 6 5 4 3 2 1

Smithsonian

Q&A

THE ULTIMATE QUESTION
AND ANSWER BOOK

AMERICAN ART
AND ARTISTS

Tricia Wright

Collins

An Imprint of HarperCollinsPublishers

AMERICAN ART AND ARTISTS

Contents

Alhkidokihi, Navajo sandpainting used in the rites of the Mountain Chant.

Raphaelle Peale, *Melon and Morning Glories*, 1813.

Daniel Chester French, *Spirit of Life*, 1914.

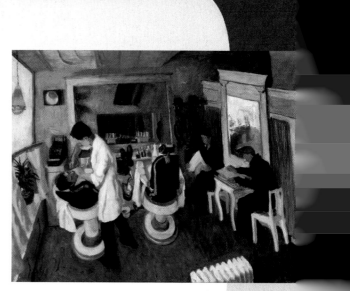

Ilya Bolotowsky, *In the Barber Shop*, c. 1934.

David Smith, *Agricola I*,
1951–52.

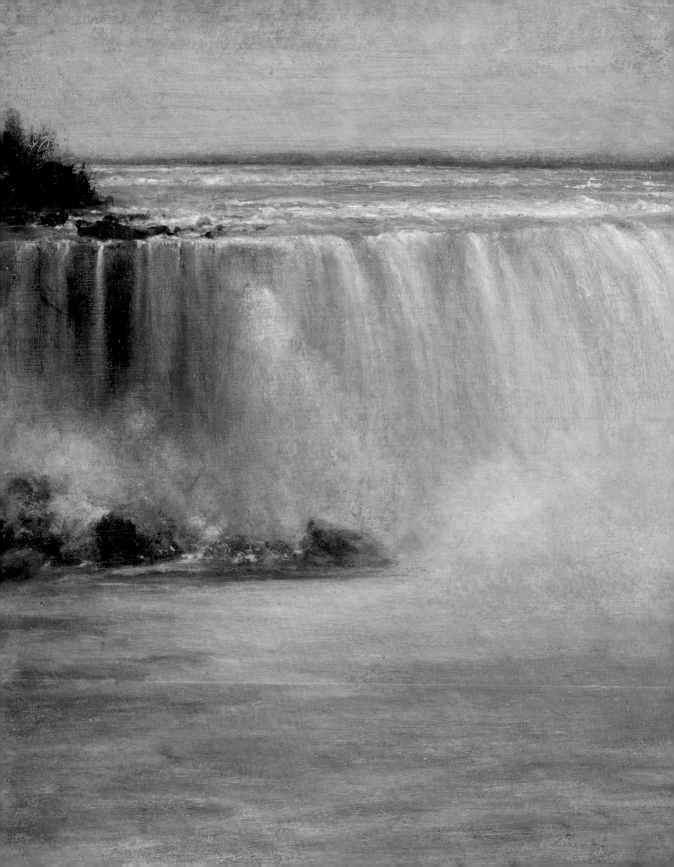

AMERICAN ART AND ARTISTS

To European settlers arriving in what they called the "New World" in the early seventeenth century, art was of little if any concern, and matters of survival took priority. The ancient legacy of art created by the Native Americans, and the wealth of European art the settlers had left behind, served little purpose for many of the early colonists. Colonial artistry at the beginning was focused largely on the making and embellishing of utilitarian objects, but as colonial society grew in strength and pride, a portrait tradition emerged, signaling the beginning of an entirely new art legacy that would eventually become the leading force in the modern art world.

Art is a great barometer for culture. It gives us invaluable insight into the appearance, behavior, values, and aspirations of human beings in society at any given time. By looking

George Inness, *Niagara Falls* (detail), 1885. Though influenced by the Hudson River School artists, Inness always followed his own impulses. He left a wide body of work, bridging more classical landscape art with the emerging Impressionist trends of the late 1800s.

Below: George W. White Jr., *Emancipation House*, 1964. White captures the combination of personal and family history and sheer whimsy that is at the heart of much folk art. He also utilizes unorthodox materials, creating a complex sculpture at odds with mainstream artistic values.

Lilly Martin Spencer, *We Both Must Fade (Mrs. Fithian)*, 1869. Spencer, who had little formal training, was one of the premier genre painters in America during the mid-1800s. She supported a family of eight children by satisfying the public's craving for sentimental, nostalgic, familiar images.

at American art, one is able to chart the course of its long and eventful history. As the country has become increasingly culturally diverse, shifts in society can be observed from increasingly diverse viewpoints. Through art we are given the opportunity to understand what the United States of America means to its citizens. It shows us how contemporary society evolves, how ideas travel, and values change. It also reveals the past goals of Americans and what they are striving for today.

America's struggle against sovereign rule and its triumphant independence from British control are well documented in American art. The journey toward artistic independence, however, was a more understated affair. European art, with its ancient

legacy and proud traditions, was the ideal to which many American artists aspired throughout the seventeenth, eighteenth, and nineteenth centuries and into the first half of the twentieth century. Early American artists were tested by their isolation from Europe, cut off from plentiful supplies of art materials and from what Europe could offer in the way of training and example. Studying in Europe became a prerequisite for artists seeking to make art that aligned with European artistic ideals.

Throughout the nineteenth and twentieth centuries, however, American artists also wrestled with the notion of creating uniquely American art, an art that embodied the nation's pioneering and independent spirit. As Thomas Eakins wrote in the early 1900s, "If America is to produce great painters, [young art students should] remain in America to peer deeper into the heart of America." After World War II, the United States began to assert a far more robust influence on the international art world. In New York, Jackson Pollock had burst onto the scene and into the public eye with his all-over abstract drip paintings. This period marked a turning point for American art, and the second half of the twentieth century saw the United States as the leading force in Western art.

It is as hard to pinpoint what American art is as it is to say what is an American. Regardless of era or style, though, certain themes persist. Chief among these is the powerful connection between Americans and the landscape. The sublime landscapes of the nineteenth century celebrated the pride and awe felt by Americans at the raw beauty of their young nation. Artists in the first half of the twentieth century, wanting to assert an authentic American voice, turned to the arid beauty of the western landscape. The Depression era and Dust Bowl landscapes of the 1930s asserted a different kind of pride, in stoic toughness and endurance in the face of disaster. In a more radical approach to the landscape, artists from the 1970s to the present day have used the land itself as raw material—turning, extracting, and shaping raw earth and

> **"Art happens—no hovel is safe from it, no prince can depend on it, the vastest intelligence cannot bring it about."**
>
> —*JAMES ABBOTT MCNEILL WHISTLER*

stone on a monumental scale to create Earth works and Land Art.

The history of American art is a monumental subject; to tackle it in a single book of modest proportions is a tall order and requires some explanation here. This book sets out to provide an overview of American art, from its early beginnings to its position of major influence in the art world today. This leads, perhaps inevitably, to the creation of a story whose plot is written with the benefit of hindsight. In reality, of course, art is a much messier affair, organic, unruly, unpredictable, and it does not always fit comfortably within orderly structures imposed upon it. The chronological format of this book connects artists, movements, and periods and helps to place art within a historical and social context. All complex organisms require different ways in which to look at and understand them. One can approach art from many angles. Since art is such a fluid thing, reflective of society and capable of showing the world in ever new and surprising ways, it is possible that one piece of art could suggest paradoxical meanings, and for these meanings all to be true. The straightforward chronological approach is a practical option for looking at early American art history, when it unfolded at a slower pace and there were relatively fewer artists to consider. The twentieth century, however, is a different story, defined by rapid growth, multiple births of different and often contradictory styles, and the impact of digital technology on how we think about art. Traveling from the second half of the twentieth century into the twenty-first, it becomes necessary to look at art as though through a fractured lens, reflecting the diversity, energy, and versatility of contemporary American art, and its influence in a global art world.

Julian Schnabel, *Portrait of Andy Warhol*, 1982. Schnabel's portrait of Warhol is painted on velvet, a fitting surface for a tribute to the velvet-jacketed Pop Art maestro.

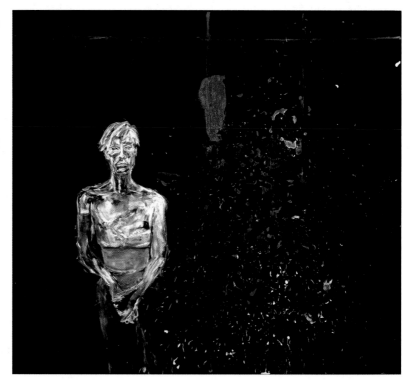

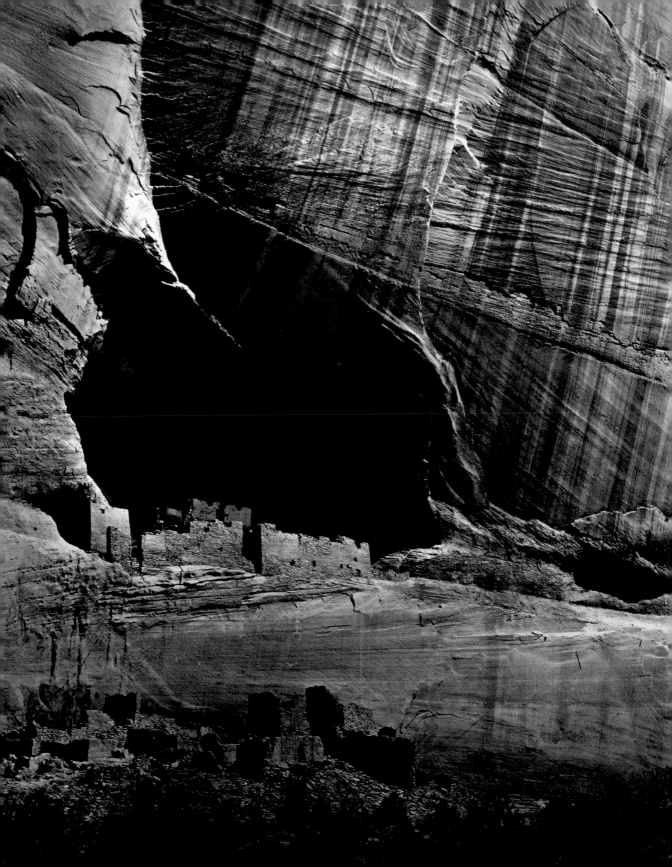

EARLY AMERICAN ART

A merican art existed long before America was colonized, and possesses a rich history of its own. Artistic expression and high levels of craftsmanship were integrated into many aspects of Native American life. The Native American population used materials found in nature—wood, grass, feathers, bone, sinew, and clay—to make simple baskets and blankets or elaborate ceremonial artifacts and monumental dwellings.

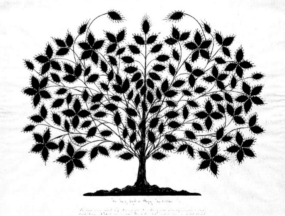

In the 1500s, the story of American art also becomes a European story, in which these earliest settlers uprooted their own traditions and transplanted them to American soil. The establishment of European colonies in the early 1600s signaled an irreversible shift in Native American life, one that was ultimately devastating. Colonial art was, like its Native American counterpart, primarily utilitarian in the beginning. By the 1700s, a wealthy merchant class had emerged in the bustling town of Boston, stimulating a demand for more elaborate art and heralding the beginning of a new art tradition in America.

Above: Hannah Cohoon, *The Tree of Light or Blazing Tree*, 1845. Cohoon, a prominent artist of the Shaker community, made this "spirit drawing."

Left: Timothy O'Sullivan, "Ruins at Canyon de Chelly in Arizona," 1873. These structures were built between the eleventh and thirteenth centuries by the ancient Pueblo people of the Anasazi culture.

Precolonial American Art

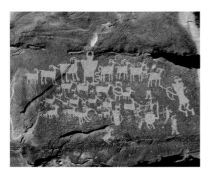

This splendid Native American petroglyph can be found carved into sandstone at Nine Mile Canyon in Utah. It is known as the *Great Hunt Panel*. Silhouetted figures of hunters can be clearly identified on the right and numerous horned beasts to the left.

Basket by Lucy Telles (Mono Lake Paiute), California, 1915. As Native American culture and tradition were supplanted by the American nation's expansion across the continent, time-honored craftsmanship such as basket making kept the traditions of Native American tribes alive.

Q: What characterized precolonial American art?

A: The art of the indigenous American peoples was deeply connected to their land. Their art was of the land itself, fashioned into pots, woven into baskets, carved and shaped into dwellings. The art made up the fabric of their lives and reflected their relationship to the land.

Q: What was the art of precolonial America?

A: Native American art boasts a rich tradition of ceramics, particularly in the Southwest, characterized by the distinctive pink clay of the arid region. There was also a sophisticated weaving tradition that grew out of the ancient practice of basket making, which can be traced back to the early "Basket Maker" culture, c. 500 CE, that existed in the Southwest region where present-day Arizona, New Mexico, Utah, and Colorado converge. Despite their sophisticated decoration and invention, these art forms served practical functions such as storage, shelter, and transportation. Pictorial art forms, however—notably the petroglyphs and pictographs found carved and painted onto rocks, and ancient and enduring traditions such as sandpaintings, were ceremonial forms of art, not intended for everyday use.

Q: How do petroglyphs and pictographs differ?

A: The main distinction between these two forms of ancient American imagery is that petroglyphs are carved directly into the rock face, and pictographs are painted onto the surface. The majority of petroglyphs and pictographs are concentrated in the Southwest United States, and though they can be found across the country, some of the best-preserved examples of pictographs are in Utah's Glen Canyon. This ancient visual expression employed a diverse range of imagery, from abstract designs to rudimentary human and animal figures. They are thought to have served a symbolic or ritualistic function and were not intended as art, at least as the term is understood today. This does not diminish their visual power or innate artistic impulses. Pictographs were more susceptible to the elements, and the best-preserved examples have been discovered under overhanging rocks and in caves. The "paints" used were produced by grinding naturally occurring mineral pigments together with a binding substance, and they were applied to the walls with hands or with brushes made from animal hairs.

Q: What is sandpainting?

A: This ancient Native American art form was practiced mainly by the Navaho and Hopi tribes. It is a ceremonial art, performed by a shaman or medicine man, in which colored sands of subtle and delicate hues made from crushed rocks are poured

onto the ground or another horizontal surface. The high degree of skill involved in making these elaborately structured paintings is especially remarkable, given their ephemeral nature. Intended to address the spirit of a sick person, the paintings are erased when the person recovers.

Q: What is Pueblo architecture?

A: The high achievement of Native American art was architectural, reaching its peak in the Anasazi culture between the eleventh and fourteenth centuries. Two distinct branches of Anasazi culture represent this achievement: the cliff dwellers and the pueblo builders. The ruins built high up into the sheer rock of Canyon de Chelly in Arizona, for instance, are remarkable not only in their technical innovation but also for their harmonious integration within the form of the canyon itself. The other great architectural phenomenon to be found are the fortified

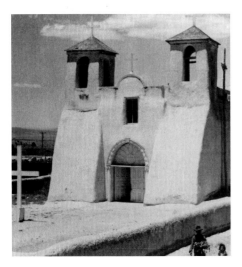

villages, or "pueblos," built on the Southwest plains. The oldest continuously inhabited town in the United States is the Acoma Pueblo in New Mexico, occupied since around 1150. The Acoma Pueblo is built on a mesa, a gigantic solid rock that provided its inhabitants a stronghold against invaders.

Q: How did Franciscan missions impact the native population?

A: Before the first Pilgrims stepped off the *Mayflower* in 1620, an earlier European presence had already made its mark in the Southwest. Indeed, a French artist was responsible for the earliest known painting of America by a European. A watercolor by French cartographer and draftsman Jacques Le Moyne, done in 1564, depicts the allegiance between the Native American chief Athore and the leader of a French Protestant colony in Florida, René de Laudonnière. By the beginning of the 1600s, under King Felipe II, the Spanish had established a Catholic presence in the Southwest. Spanish rule was missionary in nature, and by 1640 they had erected the Church of San Esteban Rey on the Acoma mesa. Spanish influence played a large part in the adobe construction of this mission church, which remains the largest of its kind in New Mexico. In addition to bringing their religion to the Native Americans, the Spanish introduced innovative tools and machinery to use in adobe construction.

The most famous example of adobe architecture is the Church of St. Francis of Assisi in Taos, New Mexico, which Georgia O'Keeffe painted in the 1930s. An adobe building is constructed of large, compressed, air-dried mud bricks covered over with a skin of mud plaster.

Art in the Colonial Era

Q: Which settlers exerted the strongest influence on art during the colonial era?

A: The arrival of small groups of settlers from England and Holland started as a trickle in the first decades of the seventeenth century, but it gathered momentum as the century progressed. The most famous of these early settlers were, of course, the "Pilgrims," who arrived in 1620 after sailing from England to Plymouth, Massachusetts, on the *Mayflower*. As with other early settlers, these English colonials were a diverse group, motivated more by economic reasons than spiritual. The word "pilgrim," with its religious connotation, more accurately applies to the Puritans who initiated a "great migration" from England beginning in 1630, in search of religious freedom. Their numbers were small at first, but by 1640 their population in America had grown to 17,800, reaching 106,000 by the century's end. Perhaps more than any other colonial group, this faction exerted enduring influence over colonial American culture and, by extension, influenced attitudes toward art.

Q: What was the impact of Native American art?

A: Native American art was centuries old and had evolved gradually over a long period of time. It served unique cultural purposes, but it was of little relevance to colonial philosophies or ambitions.

Life in the New World was extremely harsh for the first settlers. Many died on the long journey, and establishing shelter and sustenance was fraught with difficulty. Few contemporary images of Puritans exist, and their representation in American art is mostly found in imagined scenes, painted at a later date, such as this 1867 painting by George Boughton, *Pilgrims Going to Church*.

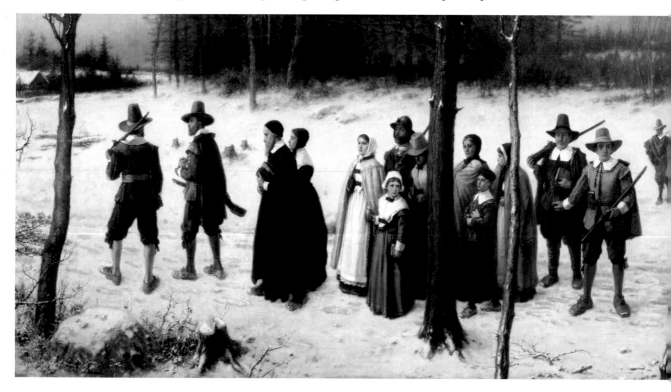

Q: What was the role of art in the New World?

A: There was little room for art of any kind in the early years of colonial America. Survival was of uppermost concern, and energies were focused solely on providing shelter, protection, and learning to adapt to a new way of life in unfamiliar terrain. Early colonial art is largely represented by architecture and utilitarian objects. The settlers had brought their tools with them on their voyage and, with an abundant supply of wood, quickly established solid English cottage-style dwellings, which later evolved into the New England or colonial-style house. Not until the 1680s did portrait painting become broadly popular among the wealthier settlers. These early portraits sought to align the sitter with religious values, supressing individuality, which was considered incompatible with one's allegiances to God and the community.

Q: What was colonial American art?

A: Artistry and fine craftsmanship could be found in many aspects of colonial life. Most notable is furniture such as the turned wood carved chairs and the "Great Chairs" of the mid-1600s and after. Despite the Puritan reputation for plainness and severity, these pieces are surprisingly decorative and became more so toward the end of the century, when they reflected English court, or Jacobean, styles in their increasingly

outward displays of wealth. A similar progression toward greater ornamentation was true of chests, drawers, and cupboards, which were important pieces of furniture in the colonial home. Trace evidences of paint on some of these kinds of furniture reveal that these were in fact considerably more colorful and less austere in their day than they might appear to modern eyes.

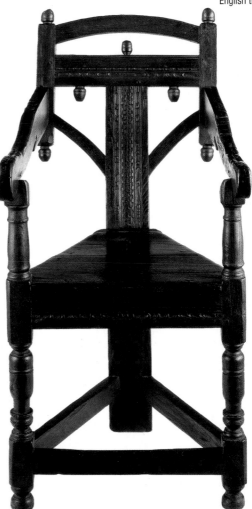

Attributed to John Elderkin, *Great Chair*, 1650–80. The Great Chair stood alone in the Puritan home, reserved for the male head of the household. While most furniture was exceptionally plain, the Great Chair was purposefully elaborate. This fine example was made in the English tradition.

Art and the Puritans and Quakers

Q: Who were the Puritans?

A: To understand the art of this period, it is helpful to understand the Puritans. They saw in the New World a potential for religious freedom and the opportunity to prove to the Old World that theirs was the true religion. Other groups chose to uproot and make a new life in America, too, and saw America as a chance to practice their faith in peace, but no group had such singularity of purpose and clarity of vision as the Puritans. They had sought to purify the Anglican Church in England, deeming it corrupted by Catholicism, and adhered more to Calvinist doctrine, which they felt was closer to the "pure" form of early Christianity. A more radical, "separatist" group (later called the Pilgrims) had moved to Holland in 1608 but twelve years later returned to England and set sail for America. A Puritan migration began in earnest nine years later.

Q: How did Puritan beliefs affect art?

A: A good example of the material manifestation of Puritan beliefs is the Old Ship Meeting House in Hingham, Massachusetts, which survives in almost its original state from the seventeenth century. That it was called a meeting house, not a church, was significant, as the Puritans distanced themselves from anything that appeared too Catholic; hence the plain foursquare design, unlike the typical cross-shaped construction of churches, and the total absence of interior decoration. There was originally no altar, and certainly no stained glass. No overtly religious paintings exist from this time, as the Puritans did not approve of them, and three art forms—drama, religious music, and erotic poetry—were banned outright.

Q: Who were the limners?

A: Portrait painters in America in the first half of the seventeenth century were self-taught and often performed other kinds of work, such as coat-of-arms painting and gravestone carving, to make a living. These artists led an itinerant existence, moving from town to town, painting portraits for wealthier families. They were called "limners" (a corruption of the English word "illuminators," which refers back to early illuminated manuscripts) and had a relatively lowly status, roughly on par with the skilled worker. Their work was often based on European engravings and showed varying degrees of skill. Most limners are now unknown by name and are

The Old Ship Meeting House in Massachusetts is so-called because of its open, wooden-beam roof construction, which from the inside resembles the hull of a ship. It is built on a symmetrical foursquare design that reflected the Puritan desire for plainness. It is the oldest wooden church in the United States.

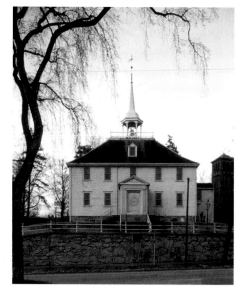

referred to simply by the family names of their subjects—hence, the Gibbs Children Limner, the Mason Children Limner, and the Beardsley Limner.

Q: Who were the Quakers?

A: The Quakers were a Christian group originating in England. Like the Puritans, the Quakers were persecuted for their religious beliefs in England. Leaving for the New World in search of religious freedom, they first arrived in America in the 1650s. They didn't fare much better after their arrival in the New World, though; they were persecuted by the Puritans. Eventually, the tension eased, as the continuing arrival of diverse religious groups to America promoted a climate of religious tolerance. The Quakers established their communities away from the Puritan strongholds in the Northeast and settled in Rhode Island and along the Delaware Valley in Pennsylvania, which was named after the Quaker leader William Penn (1644–1718). By 1750, they constituted the third largest religious group in the colonies.

Q: How did the Quakers view art?

A: The Quakers were deeply mistrustful of art, which they viewed as worldly indulgence. They believed in plainness in all aspects of life: in speech, in dress, at home, and in the meetinghouse. Any kind of ornament, whether in speech or materials, was associated with Catholicism, which the Quakers, like the Puritans, also detested. All the more surprising, then, is that one of the most ambitious and interesting artists from this period was a Quaker minister by the name of Edward Hicks.

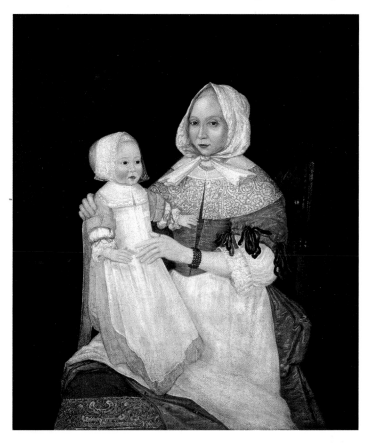

The Freake-Gibbs Limner, *Portrait of Mrs. Elizabeth Freake and Baby Mary*, c. 1671–74. This painter was one of the finest New England artists of his day.

"For we must consider that we shall be as a city upon a hill. The eyes of all people are upon us."
—*PURITAN LEADER JOHN WINTHROP*

Edward Hicks

Far right: Edward Hicks, *The Peaceable Kingdom*, c. 1834. In his *Peaceable Kingdom* paintings, Hicks gives form to the biblical text from the Book of Isaiah, 11:6. The possibility of humankind overcoming its base and destructive instincts, and living in harmony, was the motivation for these religious works.

Below: Edward Hicks, *Noah's Ark*, 1846. The depiction of the biblical story of Noah and his ark was unique among Hicks's output. Animals feature prominently in his paintings, from the wild beasts of his *Peaceable Kingdom* images to the placid livestock in his paintings of farms and homesteads. His imagination gloried in exotic animals, and prominent among the beautiful creatures entering the ark are giraffes, zebras, and camels. The commanding figure of the lion, perhaps a stand-in for Hicks, turns to the viewer in mute communication, adding weight to the image.

Q: How did Hicks's Quaker background affect his art?

A: Unlike the Puritans, who were comfortable with displays of wealth—which they viewed as signs of God's approval—the Quakers could not tolerate outward showiness. Surprisingly, one of the most interesting early American artists was Edward Hicks (1780–1849), a Quaker minister. Hicks's Quaker upbringing and his religious beliefs as a Quaker minister did not sit comfortably with his artistic leanings. He limited his output to mostly illustrating bible texts, but even that did not necessarily satisfy the qualms of his Quaker peers. He gave his paintings away as gifts, seeing them as vehicles for spreading his hopes for human society.

Q: What was *The Peaceable Kingdom*?

A: Hicks began his career as a sign painter in Bucks County, Pennsylvania, and probably would not have called himself an artist. He painted more than one hundred versions of *The Peaceable Kingdom*. In the work at right, Quaker founder William Penn can be seen discussing the Quaker peace treaty with a group of Native Americans. The biblical scene in the painting takes center stage, as a menagerie of wild and carnivorous animals, domesticated herbivores, and little children populate the foreground. The political scene being played out by the Quakers and the Native Americans is shown in the distance, taking second place to the metaphor of peace and harmony central to Hicks's beliefs.

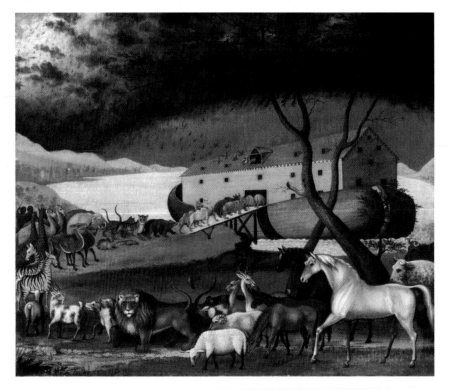

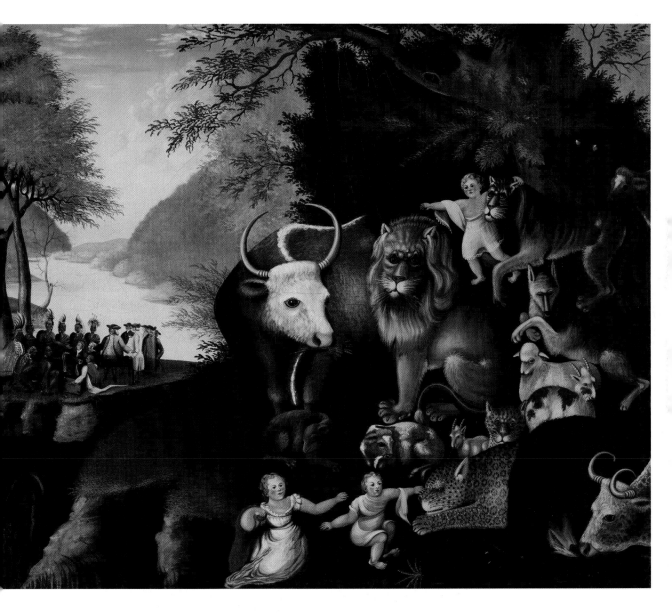

" The wolf also shall dwell with the lamb, and the leopard shall lie down with the kid; and the calf and the young lion and the fatling together; and a little child shall lead them. "

—*ISAIAH 11: 6*

Amish and Shaker Art

Q: Who were the Amish?

A: Toward the latter part of the seventeenth century, German immigrants, attracted by the Protestant character of the region, began to settle in rural areas of the state of Pennsylvania, joining what was called Penn's "holy experiment" of religious tolerance that also attracted the Quakers, Moravians, Mennonites, and other utopian groups. These German immigrants were the Pennsylvania Dutch (from the German word *Deutsch*, meaning "German"), and they brought with them a rich craft and folk art tradition. The first Amish settlers began to arrive in Pennsylvania in the 1720s and '30s.

The Amish were of Swiss and German origin, coming out of the Anabaptist movement formed during the Reformation in Europe.

Q: What is the history of the Amish quilt?

A: Not until after the Amish had settled in America did the Amish women begin to make the quilts for which they are famous. Quilt making, born out of necessity and frugality, was already practiced in America. Fabrics were expensive and in short supply, so quilts, sometimes composed of tiny scraps of cloths, were

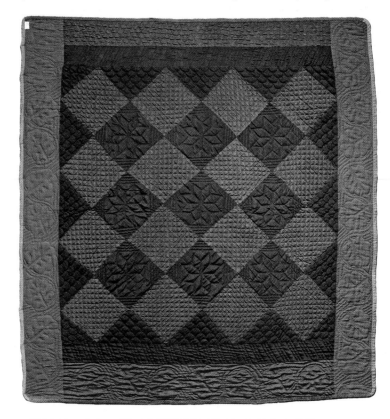

Pieced wool and cotton quilt, made by Mrs. Peachy, Allenville, Pennsylvania, early twentieth century. Amish quilts are remarkable for their vibrant colors, which are permitted in quilts but are not acceptable in clothing, and for their bold design, composed from plain, unprinted fabrics.

a way of producing beautiful and warm objects with the humblest of materials. The Amish women adopted patchwork quilt-making relatively late, but Amish quilts, particularly those made by the Lancaster Amish community, are among the finest. Amish quilts are characterized by bold simplicity and a startlingly modern minimalist aesthetic.

Q: Who were the Shakers?

A: The Shakers were a small offshoot of a radical Quaker group that originated in the north of England, the "Shaking Quakers," so called because of their animated singing, dancing, and shaking during religious services. They reached America in 1774, a band of nine believers led by "Mother" Ann Lee, a young working-class woman from the north of England. The Shakers were an extremely isolationist group who settled first in New York and Massachusetts, and after the height of their popularity, in 1840, they went into a steady decline.

Q: What is the Shaker "aesthetic"?

A: The Shaker culture is remarkable for its devotion to beauty through plainness and simplicity, and this combination later resonated strongly with the stripped-down modern aesthetic of twentieth-century America. The Shakers were highly skilled at woodworking, and their work was imbued with their religious beliefs, lending it an elusive

dignity and purity that is hard to overlook. Even the humblest household object displayed a high level of workmanship.

Q: What is Shaker art?

A: The Shaker religious experience involved intense emotional episodes that produced visions. Although decoration was frowned upon in general, these "visions" were considered gifts from God and were recorded in loving detail in small devotional or inspirational "spirit drawings." Their makers felt at liberty to embellish and decorate these works with an elaborate vocabulary of Shaker symbols: birds, hearts, candles, feathers, and trees. The tree is a common Shaker symbol for the biblical "Tree of Life" and appears frequently in such works.

Hannah Cohoon, *Tree of Life*, 1854, Hancock Shaker Village, Pittsfield, Massachusetts. This unique and sharply beautiful painting is unusual for being signed. The artist has added a written description of her vision, explaining that she has rendered the checkered leaves exactly how they came to her in her vision.

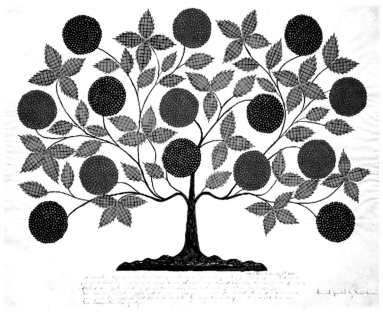

John Smibert and His Influence

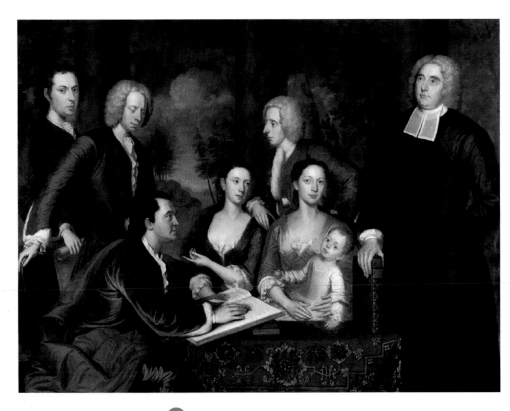

John Smibert, *The Bermuda Group*, 1729. Smibert's spatially complex painting incorporated European artistic innovations more skillfully than any work to be found in America at the time. It revealed his knowledge of Baroque pictorial concepts, and his resulting influence on American portraiture was profound.

Q: **Who was George Berkeley, and what was the Bermuda expedition?**

A: George Berkeley was the reason John Smibert arrived in America in 1729. Smibert's initial intention was not to establish himself as an artist in America, but instead to be a part of Berkeley's Bermuda expedition. Berkeley's ambition was to set up a training ground in Bermuda for Protestant missionaries and send them out across America to spread the word and fight what he perceived as the growing dangers of Jesuit influence. Berkeley's expedition was abandoned, however, and Smibert stayed behind, eventually settling in Boston in 1730. His painting *The Bermuda Group* was done in his first year in America. Commissioned by John Wainewright, one of the group, the painting depicts Berkeley on the far right and Wainewright seated on the left, presumably recording Berkeley's plan for posterity. Smibert himself looks out at us, from the far left. The remaining figures are other members of Berkeley's entourage, plus his wife and child.

Q: **Who was John Smibert?**

A: Scottish-born John Smibert (1688–1751) was the first professionally trained painter to establish a career in America, and he became a highly influential figure in the development of portrait painting. Trained by Sir Godfrey Kneller at Kneller's Great Queen Street Academy in London, he was already successfully established as a portrait painter in Scotland when he became friends with the Irish philosopher George Berkeley and joined his Bermuda expedition.

Q: Where was the center for American art in the early 1700s?

A: Smibert settled in Boston, the economic center of colonial America and the largest city in the colonies at that time. Boston was an international port, a bustling center for trade with Europe and countries around the world, and commerce was its lifeblood. A wealthy merchant class had evolved that could provide income for a portrait painter, although it was a precarious kind of income for most artists, who in the 1700s were still largely regarded as craftsmen.

Q: Why was John Smibert so influential?

A: No other artist in America had produced anything that could rival the suavity of line and complex composition of Smibert's *The Bermuda Group* before his arrival in 1729. The technical skill displayed in this groundbreaking painting was the result of his London training and his travels in Italy, where he would have studied European masterworks. American portraiture at that time expressed a more formal social dynamic and in contrast appeared somewhat stiff. After the Bermuda expedition was abandoned, Smibert lost his fee for the commissioned work and found himself with a large unwanted painting on his hands. He set up studio in Boston and exhibited the painting to great acclaim, and it had an immediate and enormous impact on the fledgling portrait tradition in the region.

Q: What is the significance of John Smibert's studio?

A: From Britain, Smibert brought quantities of engravings of European paintings and also plaster casts and copies. His studio operated as a shop, where he sold prints and artists' materials, and also as a gallery and unofficial academy, attracting younger artists eager to learn from firsthand exposure the work of a trained professional artist. One of these artists was John Singleton Copley (1738–1815); another was Robert Feke (1705–50), whose early painting *Isaac Royall and Family* clearly suggests Smibert's direct influence, although it retains a marked awkwardness in comparison to the fluid dynamics of *The Bermuda Group*.

Robert Feke, *Isaac Royall and Family*, 1741. Robert Feke made his artistic debut with this ambitious group portrait. Feke used Smibert's renowned work, *The Bermuda Group*, as his model. Although largely self-taught, Feke was an intelligent and perceptive portrait painter.

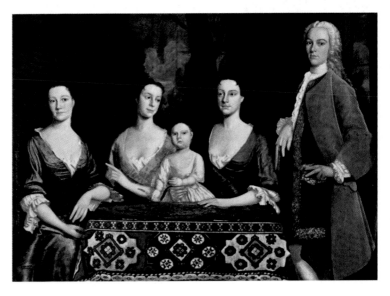

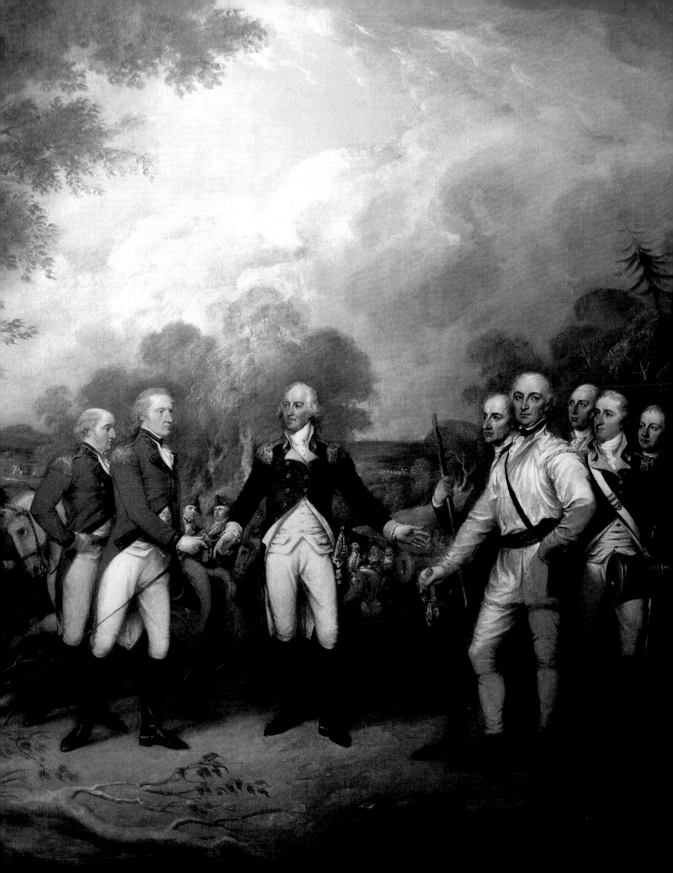

AN AMERICAN REVOLUTION IN ART

The years surrounding the War of Independence were turbulent, as the citizens of the American colonies sought to free themselves from British rule under King George III. The Revolutionary era extended over a period of roughly twenty years, from 1763 to 1783. During these years, a new republican ideology emerged, heralding a new age of politics and culture in American history. For the first time, a native-born artist rose to ascendancy on American soil and asserted uniquely American values. John Singleton Copley emerged as the new nation's foremost artist, establishing an early form of realism that would have an enduring influence over American art. In England, the expatriate artist Benjamin West became the first American artist to achieve real fame outside of America and exerted powerful influence on American art from his London studio. The establishment of the United States Constitution in 1787 and the election of the first president in 1789 marked a period of optimism and cultural growth.

Above: Charles Willson Peale, *The Exhumation of the Mastodon*, 1806. In 1801, the complete remains of a mastodon were discovered on farmland in New York State. The Philadelphia artist Charles Willson Peale adopted the project and funded the exhumation.

Left: John Trumbull, *The Surrender of Burgoyne at Saratoga, New York, October 17th, 1777* (detail), 1822.

John Singleton Copley and the Revolutionary Era

Right: John Singleton Copley, *Paul Revere*, 1768. Copley painted the now legendary Revere, then in his early thirties, at work as a silversmith. This fine portrait shows us the proud craftsman posed with a silver teapot and his engraving tools.

Below: John Singleton Copley, *Mrs. George Watson*, 1765. Mrs. Watson was the wife of a wealthy merchant. Despite her frills and bows, Copley shows us a formidable woman with a forthright gaze.

Q: Who was John Singleton Copley?

A: John Singleton Copley (1738–1815) is perhaps the greatest American artist of the eighteenth century and was the first artist to really prosper financially on American soil. His achievement is remarkable, considering his humble background as the son of working-class Irish immigrants, and the fact that he was almost entirely self-taught. Despite his inauspicious beginnings, he developed an individual and vigorous style that foreshadowed twentieth-century American realism and reflected the pragmatic nature of the merchant society in which he lived and that provided the majority of his business.

Q: How did the American Revolution affect Copley's career?

A: Copley lived and worked in Boston and witnessed the tumultuous events leading up to the War of Independence. As Boston's leading portrait painter, Copley navigated a society divided into Patriots eager for American independence and Loyalists who supported British rule. His own personal circumstances did not help matters. Though he was connected by marriage to a staunch Tory, Copley's personal affinity with the Patriots seems evident from his portraits of Samuel Adams and Paul Revere. Revere, a charismatic Patriot activist, would later become celebrated for his nighttime horseback ride, on the evening of April 18, 1775, to warn Samuel Adams and John Hancock that British troops were on the march to arrest them. Copley moved to England on the eve of the outbreak of war, alarmed by the escalating tensions that had culminated in the Boston Tea Party in 1773. His work in

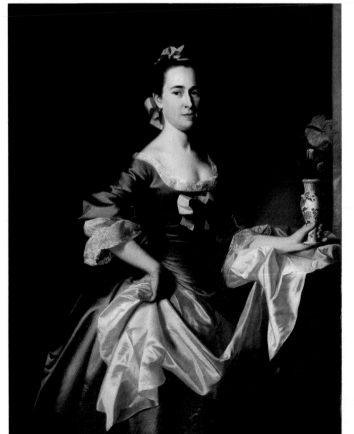

England became more ambitious, and he made his name there with *Watson and the Shark* (1778), a large, sensationalist work.

Q: How was the American Revolution commemorated in art?

A: The deeply patriotic, American-born artist John Trumbull (1756–1843) served as Washington's aide-de-camp in the army for the first two years of the War of Independence, using his drafting skills to draw maps and strategic illustrations. In 1785, probably spurred on by Thomas Jefferson and in the cause of national pride, Trumbull embarked on a series of paintings based on the Revolutionary War, completing eight large paintings of "firsthand" accounts of historical milestones, including scenes of battles, surrenders, and political events. He prided himself on the quantity of accurate portraits visible in these gatherings of notable men of the day.

Trumbull's debt to John Singleton Copley and Benjamin West is evident in his paintings' depiction of recent historical events and modern heroes in authentic, contemporary dress, though this didn't prevent him from using artistic license in other matters.

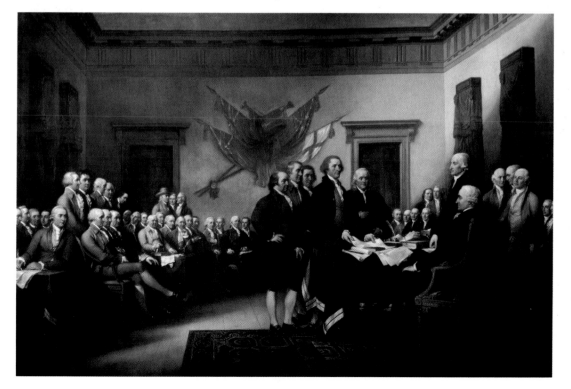

John Trumbull, *Declaration of Independence*, 1817–19. The painting features (in center, from left to right) John Adams, Roger Sherman, Thomas Jefferson (holding the document), and Benjamin Franklin standing before the desk of John Hancock (seated). Trumbull sketched the individuals and the room from life.

Benjamin West

Q: What was Benjamin West's connection with England?

A: Benjamin West (1738–1820) was born into a Quaker farmer family of ten in Pennsylvania. He was a brilliantly precocious artist and realized early on that his best chance of success lay in Europe. When he was sixteen, West received approval from his Quaker community to pursue art, and at age twenty-two he left America for Italy, settling eventually in England in 1763. There he became the first American artist to achieve real recognition outside his homeland. Originally a portrait painter when he arrived in England, West turned to history painting, which brought him his first success. During his earlier time in Italy, West had absorbed the ideas of Neoclassical artists such as Anton Raphael Mengs (1728–79). West had been in England only four years when his ambitious Neoclassical painting *Agrippina Landing at Brundisium with the Ashes of Germanicus* won King George III's approval. Upon the death of the Royal Academy's founding president, English artist Sir Joshua Reynolds (1723–92), West received the prestigious appointment as its second president, a position he held until his own death almost thirty years later.

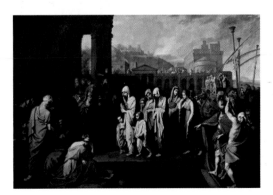

Benjamin West, *Agrippina Landing at Brundisium with the Ashes of Germanicus*, 1767. The serious, virtuous tone of this work was very much in line with Neoclassical art, which was intended to inspire noble thoughts in the viewer. This painting shows the widow of the assassinated Roman general Germanicus returning to confront his murderer.

Q: Why was Benjamin West called "the American Raphael"?

A: West earned this flattering epithet, which likened him to the great Italian Renaissance artist Raphael (Raffaello Sanzio, 1483–1520), during his first year in England, after he had exhibited a number of paintings at the Society of Artists in London. The attention he received as a result led to the important commission from the Archbishop of York to paint *Agrippina Landing at Brundisium with the Ashes of Germanicus*. Largely self-taught, West had developed his painting style from close study of works by Raphael and other Renaissance artists.

Q: Why is *The Death of General Wolfe* an important painting?

A: West's painting *The Death of General Wolfe* sealed his reputation in England as one of the most influential American artists of the eighteenth century. King George III appointed West as his history painter, initiating a friendship and long working relationship between the two. *The Death of General Wolfe* is remarkable for its departure from the conventions of history painting. The British general James Wolfe had died a slow and painful death only eleven years earlier, during the battle for Quebec, and West was adamant that the contemporary military dress and the nature of Wolfe's injuries be portrayed as realistically as possible. However, West did exercise artistic license with the cast of characters and the tone of the scene. He also asserted his American identity by tackling

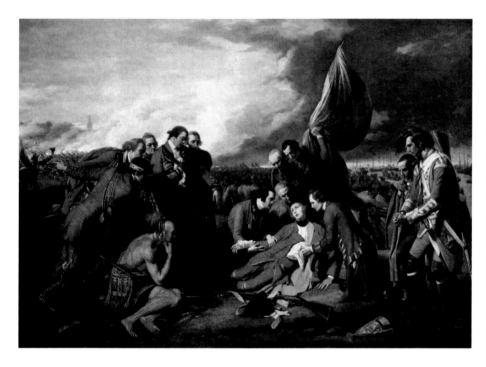

Left: Benjamin West, *The Death of General Wolfe*, 1770. By painting a modern historical scene and depicting men in contemporary military uniform, instead of the antique garb often chosen for historical themes, West revolutionized the entire history painting tradition.

Below: Benjamin West, *Penn's Treaty with the Indians*, 1771–72. Only one sketch of William Penn had been made from life, so West depended on images of prosperous eighteenth-century London Quakers as his models. The painting became an iconic representation of Quaker fairness, and Quaker artist Edward Hicks based his own paintings of Penn's treaty on this work.

New World subjects, again in defiance of convention, as exemplified by his grandiose painting *Penn's Treaty with the Indians*.

Q: What was the American School?

A: West's London studio served as a painting academy for the many younger American artists who passed through. West was happy to advise his fellow countrymen, and he exerted a powerful influence on his peers and on the course of American art. Among the many artists who benefited from West's influence (some important figures in their own right) were John Singleton Copley, Charles Willson Peale, Gilbert Stuart, and John Trumbull.

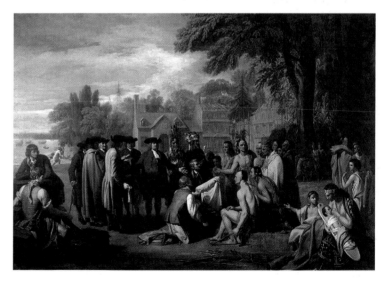

> " The same truth that guides the pen of the historian should govern the pencil of the artist. "
>
> —Benjamin West

The Early Republic and Charles Willson Peale

Q: What impact did the new American Republic have on American art?

A: The years immediately following the Revolutionary War, and newly won independence, marked a fresh beginning for America. It was a period of great optimism and belief in the future of America as a great nation. The Constitution, written in 1787, entered into American history at the Constitutional Convention in Philadelphia, which by then was the largest, wealthiest city in the country and was rapidly becoming its cultural and artistic center.

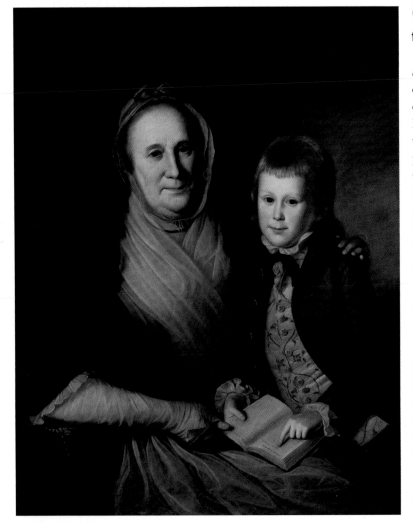

Charles Willson Peale, *Mrs. James Smith and Grandson*, 1776. Future aspirations imbue this portrait of a grandmother and her grandson, who points to the line, "To be or not to be?" from Shakespeare's *Hamlet*.

Q: Why did the center for art shift from Boston to Philadelphia?

A: Boston's economy went into a decline after the American Revolution ended and the republic was declared. It had suffered financially during the war, and Philadelphia emerged as a new political center. The Philadelphia artist Charles Willson Peale, a fervent believer in the republic, had enlisted to fight against the British in 1776. In his boundless enthusiasm for the furthering of art and knowledge, Peale personified the renewed optimism of the new republic.

Q: Who was Charles Willson Peale?

A: Charles Willson Peale was an extraordinary man, perhaps remembered as much for his contribution to the cultural life of Americans as for his achievements as an artist. He was the archetypal entrepreneur, an ambitious enthusiast with a grand vision and the insight to know that he was in the right place at the right time. Peale worked his way to the top, starting as an apprentice

to a saddler. From 1767, Peale spent two years in London, where he studied in Benjamin West's studio, then spent the rest of his life in Philadelphia. Peale's art shows his great interest in the material nature of the world, and he painted with a meticulous attention to detail.

Q: **What was the Peale family business?**

A: Art was a family concern for Peale. He fathered seventeen children and named many of them after the great artists: Rembrandt, Rubens, Titian, Raphaelle, Angelica Kaufman, Sophonisba Anguisola, and (presumably having exhausted his catalog of great artists or having a particular fondness for Titian) Titian II. Four of his sons and two of his daughters became professional artists, and other family members became artists of one sort or another. The Peale family appears to have enjoyed a mutual respect for one another's work, and continued its artistic tradition into the next generation.

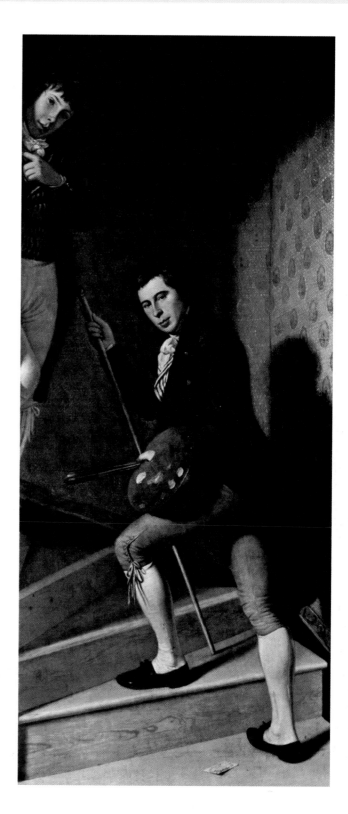

Charles Willson Peale, *The Staircase Group*, 1795. Peale's trompe l'oeil (literally meaning "tricks the eye") tour de force was reputedly so convincing that George Washington, on first seeing it, greeted the two young men, believing them to be real. *The Staircase Group* is a portrait of Peale's sons Raphaelle and Titian on a wooden staircase as they turn to face the viewer. Peale makes the artist's palette central to the painting, placing it in the hands of Raphaelle, who it can be assumed is on his way to work. In order to increase the illusion, Peale set the painting within an actual wooden doorframe and affixed a real wooden step to the bottom of the painting.

Top right: Charles Willson Peale, *The Artist in His Museum*, 1822. Peale's interests extended far beyond art. His energy and curiosity led him to the extensive study of nature and science. This self-portrait, painted near the end of his life, brings together his achievements.

Bottom left: Rembrandt Peale, *Rubens Peale with a Geranium*, 1801. Shortly before he left for Europe to further his artistic training, Rembrandt Peale made this portrait of his brother Rubens. The portrait is an affectionate and intimate portrayal of a man whose eyesight is failing. Peale has devoted an equal amount of space and attention to the geranium as to his brother, acknowledging the importance of Rubens's botanical studies. The painting gives us clues about Rubens's deteriorating vision; one hand holds on to a second pair of glasses, while the searching fingers of the other hand seem to imply a growing dependence on touch.

Q: What was America's first public museum?

A: Charles Willson Peale was responsible for opening America's first public museum in 1786. The Peale Museum was devoted to art, science, and history. It was a family-run venture, and the Peales personally preserved and cataloged the specimens. In a late self-portrait, painted at the age of eighty-one, Peale simultaneously shows off and welcomes us into his museum, filled with an eclectic mix of taxidermy, portraits of prominent Revolutionary figures (painted by Peale and his sons), fossils, and other treasures of the natural world. A wild turkey and taxidermy tools lie at his feet, and an "active" palette, resting on a table behind him, represents the arts. The star of the show, however, of which Peale, almost coyly, shows us only a glimpse, is the great mastodon skeleton, the first to be discovered in

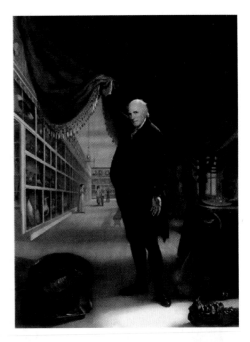

America, and which he exhumed from a New York farm in 1801.

Q: Which of Peale's children achieved success as artists?

A: Rembrandt (1778–1860) and Raphaelle Peale (1774–1825) were the most gifted of Charles Willson Peale's artistic family. Raphaelle, the eldest son, specialized in still life. His younger brother Rembrandt was a more accomplished artist. Rembrandt found success early in his career, when at age seventeen he painted a portrait of Washington. His most ambitious work was the large allegorical painting *The Court of Death* (1820), a cautionary work warning against the spiritual pitfalls of a sinful life.

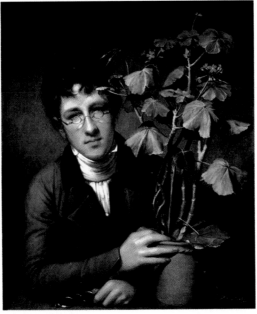

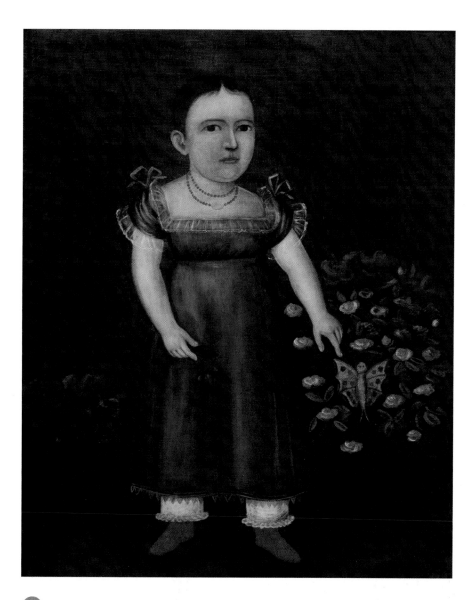

Joshua Johnston,
Portrait of Adelia Ellender,
1803–5. Johnston's
portraits are characterized
by a naive charm. His
portraits of children are
particularly memorable.

Q: Who was the first African American professional artist?

A: At some point, Charles Willson Peale's extensive household included another artist, a freed slave by the name of Joshua Johnston (1763–1832). It is thought that Johnston perhaps received some training from either Charles Willson, Rembrandt, or Polk Peale (a nephew of Charles Willson Peale). Little else is known about Johnston, beyond the fact that he established himself as a portrait painter, moving from neighborhood to neighborhood in the Baltimore area. He became one of the foremost Baltimore portraitists, and may have bought his freedom this way. He may also have been a blacksmith. Thirteen paintings survive, mainly portraits of children and small family groups.

Washington as American Icon

Charles Willson Peale, *George Washington at Princeton*, 1779. Washington personally led his men into battle at Princeton. It was an important victory against the British, who suffered high losses. Peale presents Washington as military hero, leaning on a cannon, with the British ensign at his feet.

Gilbert Stuart, *George Washington (The Athenaeum Portrait)*, 1796. Stuart's unfinished work is one of the most insightful portraits of Washington, conveying quiet assurance and a commanding presence.

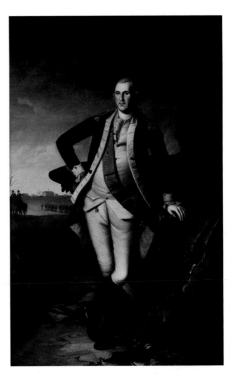

Q: Why was George Washington's image so popular?

A: After Washington's death in 1799, his image as a national hero and father of his country took on new proportions. Portraits of America's first president were in high demand, and it was not uncommon to have a likeness of Washington in the home. Portraits of Washington and scenes from his military and political life were popular subjects for a wide range of artists, before and after his death, and his face provided America with an image that represented the unity of the nation.

Q: Why is *George Washington at Princeton* a significant painting?

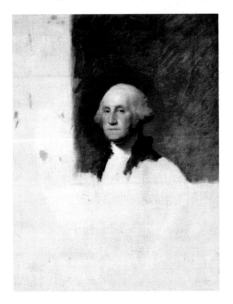

A: Charles Willson Peale's full-length portrait of Washington shows him as a man at the height of his powers, in full military gear at the Battle of Princeton in 1777. Peale made seven portraits of Washington from life and made up to sixty paintings from these, using the original seven as a model. *George Washington at Princeton* was commissioned to fill the space left by a portrait of King George III destroyed in the Revolutionary War. America needed to find a fitting image that would symbolize the break from the old hierarchy of English rule and create an icon of the new nation's chosen leader. The substitution of the English monarch with an American military hero reflects the evolution of Washington the man into Washington the heroic national symbol.

Q: Who made portraits of George Washington?

A: Gilbert Stuart created the portrait of George Washington that became the singular identifying image of Washington for the American

people, and which was the template image for Washington's portrait (in reverse) on the dollar bill. He made sixty copies alone of this painting, the "Athenaeum" portrait, painted in 1796 as Washington was about to retire from office. Stuart painted George Washington from life only three times, but from these original three versions he made over one hundred copies. Charles Willson Peale, his son Rembrandt Peale, and John Trumbull all made portraits of Washington during his lifetime, and the list of artists to paint him after his death, and into the twenty-first century, is long and impressive.

Q: What was it like to paint George Washington?

A: Stuart's full-length portrait of Washington, made the same year as the Athenaeum portrait, three years before Washington's death, provides a marked contrast to Peale's earlier depiction of Washington at a more vigorous stage in life. Stuart in fact found Washington difficult to paint from life, and this painting was a composite work, cobbled together from his own Athenaeum portrait and the figure modeled on other works. That Washington did not enjoy having his portrait painted is clear from Stuart's own words: "An apathy seemed to seize him and a vacuity spread over his countenance, most appalling to paint."

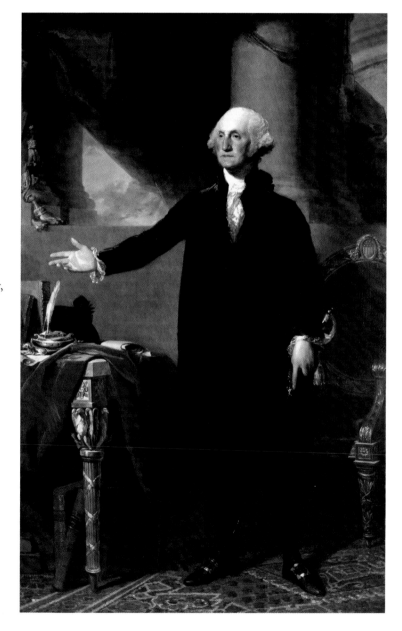

Gilbert Stuart, *George Washington (The Lansdowne Portrait)*, 1796. This life-size portrait contains symbols of democracy and authority and depicts Washington at the end of his final presidential term.

Right: Gilbert Stuart, *Martha Washington (Martha Dandridge Custis)*, 1796. *The Athenaeum Portrait* of George Washington was originally commissioned as one of a pair, with a matching portrait of Washington's wife, Martha.

Below: Gilbert Stuart, *The Skater (Portrait of William Grant)*, 1782. London's Westminster Abbey can be seen in the distance of Stuart's brilliant and unorthodox portrait. The skater's pose was partially based on a cast of the Apollo Belvedere, a famous classical Roman sculpture.

Gilbert Stuart

Q: What was Gilbert Stuart's background?

A: Gilbert Stuart (1755–1828), as his name suggests, was of Scottish descent. He was born in Saunderstown, Rhode Island, and his earliest home was a snuff mill house established by his father, the first of its kind in the United States. He lived there until age seven, when his family moved to Newport, Rhode Island. In Newport, Stuart was befriended by the Scottish artist Cosmo Alexander (1724–72). Alexander mentored Stuart and took him to Edinburgh, Scotland, sometime in 1771. After Alexander's death, Stuart returned to America, but in 1775, at the outset of the Revolutionary War, he moved to London, where he lived for twelve years. During his time there Stuart studied with his fellow American, Benjamin West, as well as Sir Joshua

Reynolds, and he also learned from the other English masters such as Thomas Gainsborough (1727–88). Stuart achieved great success in England and made his reputation with the masterly portrait *The Skater (Portrait of William Grant)* in 1782.

Q: How important was George Washington to Gilbert Stuart's career?

A: Stuart's extravagant lifestyle and bad financial habits led him into serious financial difficulties, and in order to escape his debtors, he headed for Dublin, Ireland, in 1787. Before long, though, he had amassed bad credit there, too, and was forced to flee again. This time he moved back to America, arriving home in 1793. It was at this time that Stuart painted the first of his iconic portraits of George Washington. He eventually made over one hundred copies of these three originals, supplying a growing demand for portraits of Washington and securing a lucrative income for the rest of his life.

Q: What made Stuart's portrait style distinctly American?

A: Stuart's particular achievement is his development of a portrait style that

> "In England my efforts were compared with those of Van Dyck, Titian, and other great painters—here they are compared with the works of the Almighty!"
>
> —*Gilbert Stuart*

can be described as American in character. He absorbed the refined, sophisticated nature of the English portrait style and combined it with a sharp eye for the truth and a genuine interest in the individual. Stuart was a prolific and prodigiously talented artist, painting more than a thousand portraits during his career, including many prominent figures of the Revolutionary War. He painted directly onto the canvas, without preliminary sketches, and his virtuoso technique and seemingly casual brushwork belies a powerful mastery of form. He captured the essential character of his subjects, with grace and ease, in a style that expressed the vitality and directness of the American character.

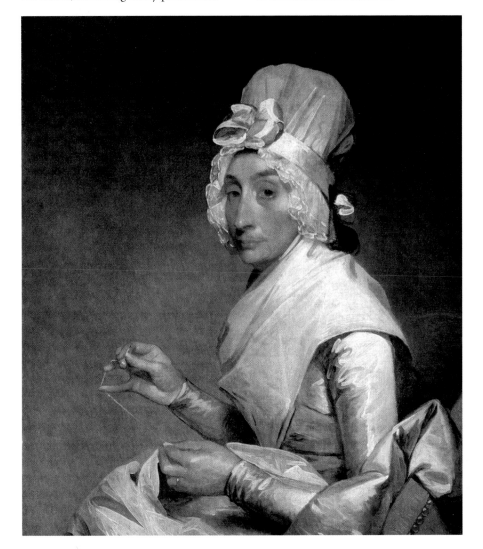

Gilbert Stuart, *Mrs. Richard Yates*, 1793–94. Stuart's mastery of his technique is exemplified in this portrait. His brilliant handling of the reflective material of the sitter's dress contrasts with the warm flesh tones of her face. It is a thoroughly believable face and full of character.

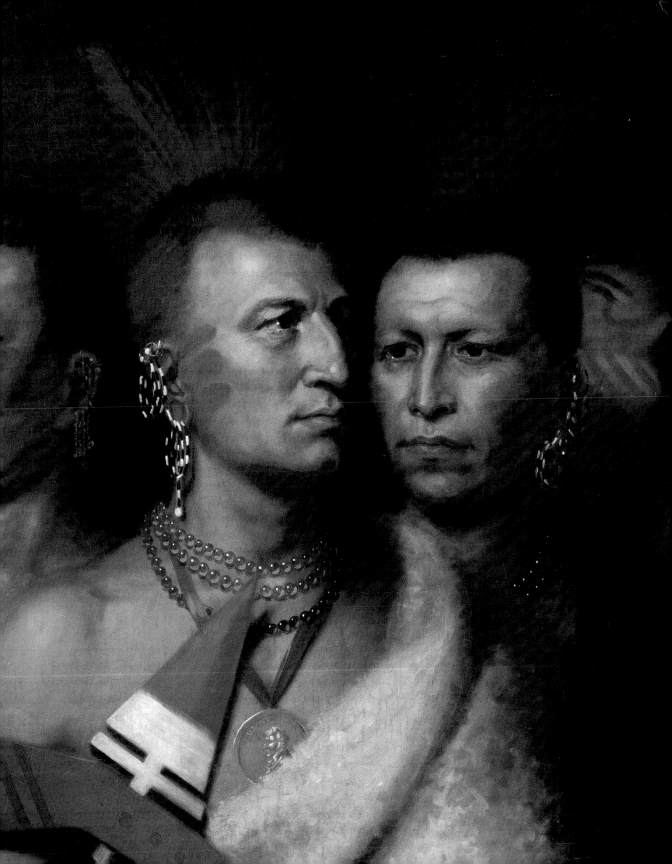

NATURE AND LANDSCAPE

At the beginning of the 1800s, the economic center of the country was in the East, and the American West was still an untamed wilderness. In 1830, to facilitate the progress of westward development, President Andrew Jackson initiated the Indian Removal Act, clearing a pathway across Indian territories and uprooting and decimating Native American tribes in the process. A number of artists went west in these early years to document the lives of the Native Americans, and these early works reflected a spirit of anthropological curiosity devoid of the sensationalism brought to the subject by artists later in the century. The early nineteenth century also saw the development of the American landscape tradition in the East, giving rise to one of the most illustrious periods in American art: the Hudson River School. The celebration of the grandeur and natural beauty of the American landscape ushered in a new Romantic expression and created a powerful symbol for the young nation that Americans could readily endorse.

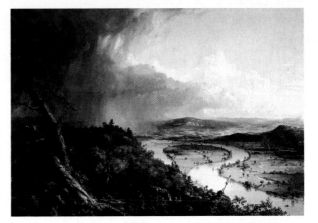

Above: Thomas Cole, *View from Mount Holyoke, Northampton, Massachusetts, after a Thunderstorm—The Oxbow*, 1836.

Left: Charles Bird King, *Young Omahaw, War Eagle, Little Missouri, and Pawnees* (detail), 1821. King created a valuable record of Native American leaders in the early 1800s.

Into the West

Q: How did George Catlin document the lives of the Native American?

A: The Philadelphia artist George Catlin (1794–1872) gave up a successful law practice in the East and traveled west to document the lives and traditions of the Native American. He had witnessed the steady disintegration of the Native American way of life, and it became his personal mission to record for posterity as much of it as he was able before it was lost forever. He created the only records in existence of some of the lesser-known tribes, and he made over 500 paintings and thousands of drawings, with written observations, of the forty-eight different tribes he encountered. Using his art to promote the cause of the Native American people, and hoping to make a profit, he organized traveling exhibitions in America and Europe. Both his mother and grandmother had been held captive by Native Americans, and their experi-ences perhaps informed Catlin's attitudes. It is also thought that, in addition to his family in the East, Catlin had another family, with a Native American woman, in the West.

Q: What was Manifest Destiny, and how did it appear in the art of the time?

A: Most white settlers of the 1800s comfortably believed it was their right to claim the West for their own. "Manifest Destiny" was held to mean that it was the settlers' God-given duty to expand across the country, bringing civilization to the wilderness. Much of the imagery during the Jacksonian era is heavily loaded with divine messages; settlers traveling west-ward in covered wagons are accompanied by personifications of divine guidance, or symbols of God's blessing. *Westward the Course of Empire Takes Its Way*, painted later, in 1861, by German-born artist Emanuel Gottlieb Leutze, commemorates these westward ambitions. Commissioned as a mural for the United States Capitol Building in Washington, Leutze's study depicts the heroic struggle of the pioneers as they fight their way across rocky terrain. At the summit, they are rewarded by a glowing sunset, indicating God's approval and the promise of success.

Q: How did art reflect changing attitudes toward Native Americans?

A: The image of the Native American during this period was influenced by

George Catlin, *Bird's-eye View of the Mandan Village, 1800 Miles above St. Louis*, 1837–39. A largely self-taught artist, Catlin created an authentic record of Native American life in the early part of the 19th century. In his many, rapidly executed paintings, he captured the behavior and traditions of a broad cross-section of Native American life.

political agendas and reflected the desires and fears of the settlers. As expansionist settlement continued westward, its movement sparked resistance among Native Americans, who in turn were increasingly depicted as murderous savages. Eventually, when the Native American population no longer constituted a threat to expansionist ambitions, a reversal occurred, in which the Native American was depicted as belonging to a bygone era, a human equivalent to the nostalgia Americans were already beginning to feel for the erosion of the virgin wilderness.

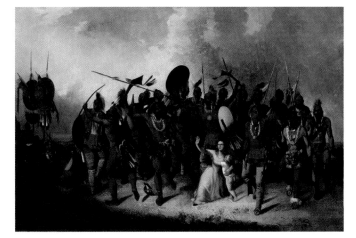

Above: John Mix Stanley (1814–72), *Osage Scalp Dance*, 1845. Paintings like this, depicting what were considered brutal rituals, fueled feelings of fear and loathing and helped to justify the subjugation of the Native American population.

Below: Emanuel Leutze, *Westward the Course of Empire Takes Its Way*, 1861.

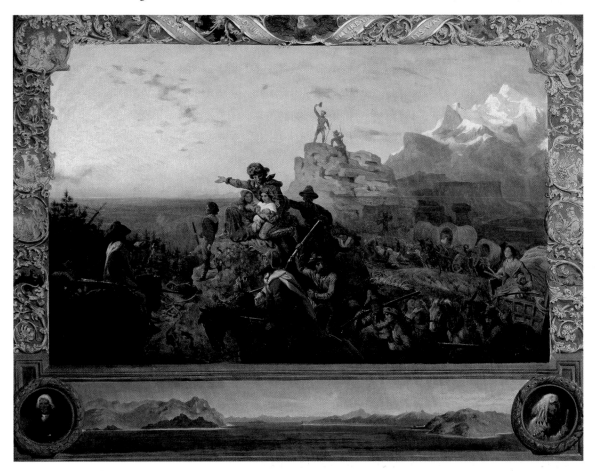

Inventing the Wild West

Q: What was the impact of progress on the West?

A: It is ironic that the West did not become fully "wild" until after the frontier was officially closed in 1890. The last decade of the nineteenth century saw the birth of the popular image of the cowboy, while the real thing, the frontier cowboy of the Old West, was fast becoming a thing of the past. The freedom of open range enjoyed by the cowboy, and mythologized by artists, was less and less a reality as the land was increasingly partitioned off and cattle fenced in by the newly introduced barbed wire.

Frederic Remington, *The Bronco Buster*, modeled 1895, cast 1910. Remington made small-scale sculptures or statuettes that were cast in bronze by the thousands and were highly popular.

Q: Who depicted the Wild West?

A: Frederic Sackrider Remington (1861–1909), whose entire career was built on depicting the Wild West, was actually a native New Yorker. Remington attended Yale University and made only occasional excursions into the western regions that provided the basis for his work. However, he was a prolific artist, and his mythologized scenes of rugged frontier life, though far removed from reality, were highly popular. Remington's first break came when his friend, future president Theodore Roosevelt, commissioned him to illustrate Roosevelt's own nonfiction work *Ranch Life and the Hunting Trail* (1896). Remington worked also as an illustrator for western magazines that were in circulation by the 1890s, and his romanticized cowboys and Indians have exerted more influence on the western genre, be it in fiction or in film, than any popular models since.

Q: How was the western myth perpetuated in art?

A: Montana artist Charles Marion Russell's (1864–1926) career coincided with the American settlement of the Great Plains and the relocation of the Native Americans to reservations. His art consistently depicted a bygone American West, representing proud Native Americans, rugged cowboys, and at times, the tense moments of contact between the two. Nostalgic in character, his art both celebrates and regrets the forces that shaped the American West. In his lifetime, Russell witnessed the upheavals resulting in the defeat and relocation of the Plains Indians. There is a poignancy in the proud demeanor of Russell's Native Americans, considering that by the time the images were painted, the fate of the Plains Indians was sealed. Largely self taught, Russell's boyhood ambitions were to be both a cowboy and a painter. Early in his career, he studied the work of his contemporary, Frederic Remington, for inspiration.

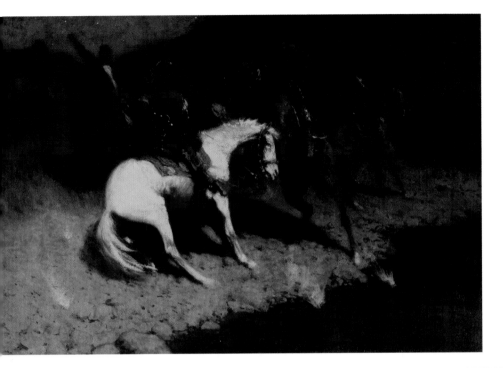

Left: Frederic Remington, *Fired On*, 1907. An eerie light illuminates this pre-dawn scene of frontier men being ambushed by an unseen enemy. The drama is encapsulated in the forms of the horses, springing back in fear from the water's edge.

Below: Charles Marion Russell, *The Medicine Man*, 1908. Russell depicted Native Americans as sovereigns of the West, using art to extract them from the grim facts of history and assert their ancient claim to the land. Though he was a cowboy himself, and often painted scenes of cowboy life, the Native American, in Russell's eyes, was the "onley [*sic*] real American."

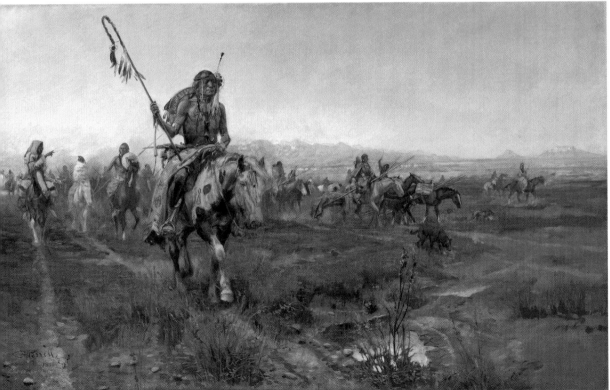

Emergence of Landscape Painting

Q: What was the Hudson River School?

A: The Hudson River School was not, in fact, a school, but a name used to describe the group of American landscape painters who produced work over a period of roughly fifty years, during the middle of the nineteenth century. These artists were not part of a coherent movement, although there was close contact between some of them. What they did share was a common enthusiasm for the grandeur of the American landscape and a belief in its spiritual potential.

Q: Who was the "father" of the Hudson River School?

A: Thomas Cole (1801–48) is considered the most influential figure and the "father" of the Hudson River School. Born in the industrial north of England, he moved to America with his family when he was seventeen years old. From the beginning, Cole was drawn to the natural beauty of the American landscape. He revisited England as an adult and spent time in Paris, where the allegorical landscapes of the French artist Claude Lorrain (1600–82) and the heightened emotion of the English Romantic artist Joseph Mallord William Turner (1755–1851) made a profound impression on him. Cole's important series *The Course of Empire*, reveals his debt to Claude Lorrain in his merging of landscape and history and in the paintings' overtly allegorical purpose.

Q: What was the Picturesque?

A: The Picturesque was, broadly speaking, a way of appreciating the landscape from a purely aesthetic point of view instead of as a source for raw materials and commerce. The Picturesque had religious associations, and the dedicated pursuit of beauty in the landscape was frequently syn-

Thomas Cole, *The Subsiding of the Waters of the Deluge*, 1829. Cole set this biblical scene in the American landscape, drawing an analogy between the receding of the Great Flood and optimism for a young nation. Noah's ark can be seen in the calm waters beyond, having survived the ravages of the deluge.

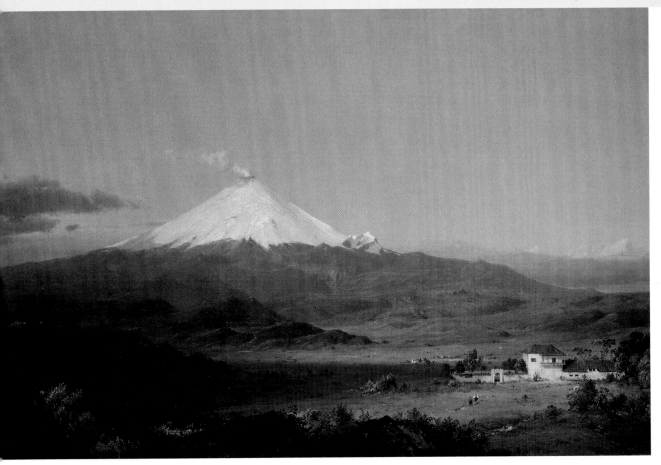

onymous with paying homage to God's creation. The wealth of awe-inspiring landscape in America lent itself naturally to such ideals, providing a fertile source for the Hudson River artists.

Q: What was the Sublime?

A: Edmund Burke's essay, "A Philosophical Enquiry into the Origin of Our Ideas of the Sublime and Beautiful," published in England in 1756, was enormously influential among artists and writers in England and across Europe. Central to Burke's theory of the Sublime is the notion of awe, the aesthetic equivalent to terror. In practice, this took the form of awe-inspiring art, aimed to induce great amounts of emotion in the viewer, and in it are contained the seeds of Romanticism. These ideas traveled to America through Cole, and continued through his successors. The artist who most strongly carried on the spirit of Cole was his pupil Frederic Edwin Church (1826–1900). Church traveled extensively in North and South America in search of great natural wonders, which he believed revealed God's presence. His ambitious paintings of spectacular landscapes—most notably *Heart of the Andes* (1859) and *Niagara* (1857) were lucrative public attractions, making him one of America's most famous and celebrated landscape artists.

Frederic Edwin Church, *Cotopaxi*, 1855. *Cotopaxi* is among the many views of the South American landscape that earned Church widespread praise and fame. Church reputedly waited an entire day for the clouds to part and reveal the peak of the smoking Ecuadorian volcano. The symbolic and destructive peak of *Cotopaxi* displays Church's belief in the divinity of nature, as well as his scientific interest in geology.

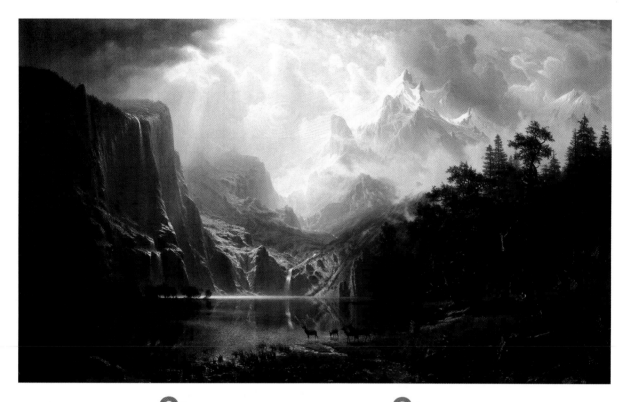

Albert Bierstadt, *Among the Sierra Nevada, California*, 1868. Bierstadt's paintings were exhibited as natural wonders in themselves. He toured Europe with this impressive scene, and it served as an advertisement, not only for his own career, but also for America to those considering emigration.

Q: What effect did the emergence of landscape painting have on the status of the artist?

A: The landscape tradition brought an elevated status to artists, essentially because of the religious connotations of the subject matter. The Hudson River School artists brought images of natural wonders to the public that were awe-inspiring, uplifting, morally refreshing—making visible, as it were, the hand of God. These artists could be seen as spiritual scouts, the aesthetic equivalent of Daniel Boone and his like. Landscape painting also became a lucrative business, and artists like Frederic Edwin Church and Albert Bierstadt became wealthy celebrities by turning the emotional experience of the American landcape into a commodity.

Q: How did Albert Bierstadt gain access to the remote Rocky Mountains?

A: In 1858, the German-born Bierstadt joined a westward-bound surveying expedition that extended into the Rocky Mountains. He made sketches *in situ*, at stop-off points along the way, that were later worked into full-size paintings. Bierstadt traveled extensively throughout the western regions. His paintings exemplify the Sublime. Typically, they are panoramas of majestic scenes, and were often painted on a huge scale. Like Church's works, Bierstadt's paintings were hugely popular with the American public, but he came to realize that the unsullied wilderness he was portraying in his paintings was fast becoming less and less of a reality. The march of progress across the territories and into

Samuel Colman (1832–1920), *Storm King on the Hudson*, 1866. Colman's luminous treatment of this Hudson River scene reveals a closer affinity to the atmospheric landscapes of the English artist J. M. W. Turner than to the epic grandeur of his compatriots.

the West was changing the face of the landscape forever, and by the time the frontier was considered closed in 1890, much of Bierstadt's work looked like pictures of a bygone era.

Q: What were America's first tourist spots?

A: The first tourist spots in America were in the Catskill region in upstate New York. The craze for the Picturesque that had taken hold in England, and which influenced the Hudson River School artists, brought many local sightseers to the Hudson Valley.

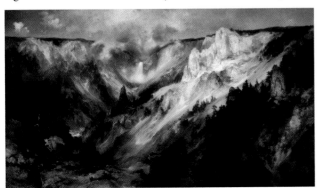

Q: Who was Thomas Moran?

A: The English-born artist Thomas Moran (1837–1926) was taught to paint by his older brother Edward, and later apprenticed in an engraving firm. As Bierstadt had done thirteen years earlier, Moran joined a westward surveying expedition. In Wyoming, he recorded the strange and beautiful features of the Yellowstone terrain in watercolor studies. Partly due to his efforts and the positive evidence of his paintings, lobbyists for the protection of the Yellowstone area from commercial interests succeeded in their mission, and Yellowstone National Park officially came into being in 1872, signed into law by President Ulysses S. Grant. *The Grand Canyon of the Yellowstone* (1872) is the result of Moran's expedition. It became the first American landscape painting to be purchased by the United States government, and was placed on view in the Capitol.

Thomas Moran, *The Grand Canyon of the Yellowstone*, 1893–1901. This later painting of the Yellowstone Canyon is more nostalgic than the original, showing a rugged wilderness barren of humanity. Moran was the first artist to record the inaccessible and beautiful terrain of the Yellowstone Canyon, popularly thought of as "the place where hell bubbled up."

John James Audubon

Q: Who was John James Audubon?

A: John James Audubon (1785–1851) was born in Haiti, the illegitimate son of a plantation-owning French sea captain and his Haitian mistress, Jean Rabine. His mother died six months after he was born, so his father took him home to Nantes, France, to be raised by his stepmother, Anne Moynet. His childhood seems to have been one of great freedom, much of it spent outdoors, drawing birds and exploring the natural world. Audubon arrived in America in 1803, at age eighteen, sent by his father to avoid conscription into Napoleon's army. He managed a family-owned estate outside Philadelphia and married his neighbor Lucy Bakewell.

"John James Audubon," photo by Mathew Brady, c. 1860.

Q: How did Audubon become a painter of birds?

A: Bankruptcy was the catalyst for Audubon's becoming an artist. He was financially successful until 1819, when his business failed and he was compelled to find a new source of income. This disaster provided an opportunity to focus on his interest in ornithology and devote himself entirely to painting birds. After bankruptcy earned him a brief spell in prison, he set off with an assistant down the Mississippi River on a bird-hunting mission. His ambition was to record all the birds of America and publish his results. He made a living during this time as a roaming portrait painter, while his wife worked as a governess.

Q: Was Audubon the first to paint the birds of America?

A: Audubon was not the first artist to achieve this distinction. From the 1720s to the 1740s, the British naturalist Mark Catesby (1683–1749) painted the wildlife of what was then Carolina, Florida, and the Bahamas. Later, Alexander Wilson (1766–1813), an ornithological artist, produced a nine-volume work called *American Ornithology* (1808–14). Audubon took ornithological art to a new level. His life-size pictures of birds are animated, enormously inventive, and have a powerful decorative element. In addition to the detailed portrayal of the physical qualities of each species, he captures their essential character, from raucous parakeets to the dignified flamingo. Unlike Wilson and other bird artists, Audubon went to great pains to show birds in their natural context. He set a size and format for his paintings, based on the largest single sheets of paper available at that time (roughly thirty by forty inches), and it

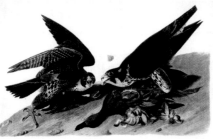

Peregrine Falcon, from *Birds of America*, published in four volumes between 1827 and 1838. Audubon was greatly skilled at capturing the essential quality of his subjects. Here, the aggressive predatory nature of the peregrine falcons is fully realized.

is remarkable how he worked within these constraints, fitting large birds, and groups of birds, within the paper's boundaries in a graceful and natural way.

Q: How did Audubon prepare his subjects?

A: In order to paint the birds, Audubon first had to catch them. He killed a great many of each species, hunting with fine shot so as to damage the plumage as little as possible. He had no compunction about the numbers of birds he killed, perhaps seeing them as an limitless resource: "I call birds few when I shoot less than one hundred per day," he once said. Using thin wire, he pinned their wings and feet, repositioning them in their characteristic attitude.

Q: What was *Birds of America*?

A: Audubon had conceived of a grand work, a complete collection of his life-size paintings of American birds, to be made into prints and bound together in multiple volumes for publication. But he could not find a publisher for his work in America, due to a combination of his prickly character—he had alienated rivals in the scientific community—and the disadvantage of his nonacademic background. So he took his work in progress to England in 1826, where it received great acclaim. Audubon was made a fellow of the Royal Society in London, where he became famous as the "American Woodsman." His published work, *Birds of America*, was issued in four volumes, from 1827 to 1838, and contained 435 species of birds. Audubon began another ambitious project in the early 1840s, this time on mammals, entitled *Viviparous Quadrupeds of North America*. He was working on it at his death in 1851, and it was completed by his sons, Victor Gifford Audubon and John Woodhouse Audubon.

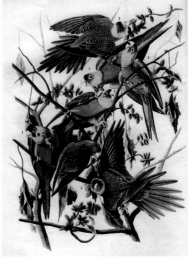

Above: *Carolina Parakeet*, from *Birds of America*. Audubon's graphic abilities were formidable, and his use of pattern in the service of accuracy and variety, such as in this impressive study of parakeets, shows the breadth of his ability.

Left: *Greater Flamingo* from *Birds of America*. Stately and weirdly beautiful, the flamingo is shown stalking toward the water's edge. Audubon has emphasized the bird's angularity, echoing the forms of its sinuous neck and long legs.

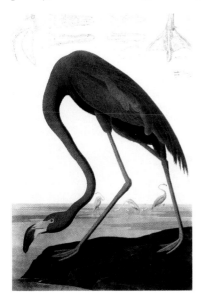

"**A true conservationist is a man who knows that the world is not given by his fathers, but borrowed from his children.**"

—JOHN JAMES AUDUBON

Marine Painting

Q: **What was the marine tradition?**

A: The mid 1800s saw a growing popularity for genre themes in America. Earlier in the century, before the romantic landscapes of the Hudson River School, there existed a modest tradition of topographical views, "portraits" of wealthy estates, and harbor views. This tradition included naval and marine painting, which had migrated to America from England. The merchant class in Boston provided a fertile market for marine paintings, which reflected the source of their wealth. Another aspect of its appeal was that its factual style satisfied the craftsman's desire for precision and authenticity. Robert Salmon (1775–1884)

Robert Salmon, *Boston Harbor from Constitution Wharf*, 1833. The clarity of Salmon's style, with its accurate attention to the details of marine life, was highly prized by the wealthy shipping merchants who bought his paintings.

certainly fulfilled these criteria. He was a latecomer to America, arriving from his native England at about the age of fifty, and he firmly transplanted the English marine painting tradition to Boston, the shipping center of the United States.

Q: **How did marine painting develop in America?**

A: Robert Salmon's American successor was Fitz Henry Lane (1804–65), who was born in a shipping and fishing area, in Gloucester, Massachusetts. Fitz Henry Lane developed a restrained and subtly expressive form of the genre. His paintings, though finely attuned to detail and

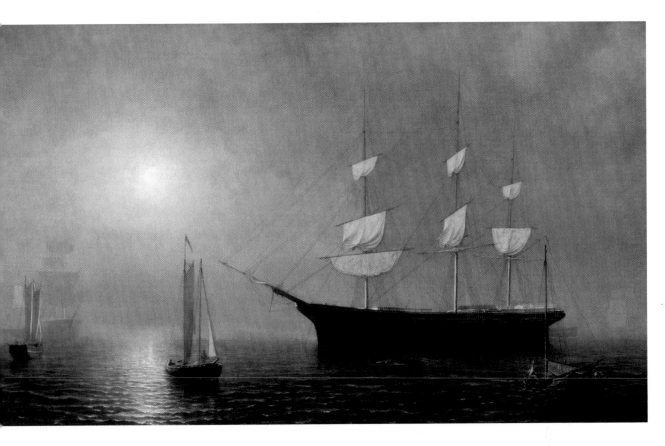

to the material realities of the shipping industry, departed from Salmon's in their interest in atmospheric light and mood. His palette was softer and subtler than his predecessor's, and the diffused light and dreamlike quality in many of his paintings, in particular his later works, prefaced the heightened atmospheric landscapes of the Luminist paintings that flourished in the second half of the century. Salmon's influence is clearly evident in Lane's late painting, *Ship Starlight*.

Q: What is Luminism?

A: Luminism is the name given to a style of work that employed light effects to convey the spiritual or the profound. The term Luminism was coined in 1954 and applied retrospectively, as art labels often are. It identifies an intensely evocative American style of landscape painting that is notable for its absence of narrative or drama but is powerful and fraught with meaning nonetheless. In Fitz Henry Lane's late work, we see an evolution toward increasing simplicity, reduction of narrative, and an even greater emphasis on mood. His last recorded paintings were of a small natural harbor in his hometown of Gloucester. It is hard to overlook the sense of desolation that imbues some of his quiet, late works, especially when one considers that the Civil War was raging for the last four years of his life.

Fitz Henry (Hugh) Lane, *Ship Starlight*, 1860. In his late paintings, such as this serenely beautiful work, Lane gave precedence to the evocation of atmosphere over the practical information that filled his early paintings. His mature works contained increasing depths of personal expression.

Still Life and Genre Painting

Q: What kind of still-life painting was popular in America in the 1800s?

A: The burgeoning merchant class that had grown up around Boston's shipping industry desired art that celebrated the material tastes of mercantile society. The still-life tradition in America, at the midpoint of the century and later, reflected America's determined enjoyment of everyday life and glorification of sensory pleasures, which persisted even through a civil war that was tearing the country apart.

Q: Who were the leading American still-life artists?

A: Severin Roesen was born around 1815 in Germany, where he worked as a porcelain painter, immersed in the Vanitas still life tradition founded in Holland. The subtle message of Vanitas art suggested the transient nature of all living things. After he emigrated to America in 1848, his influence with the Vanitas theme was significant. Roesen's magnificent *Still Life with Fruit* (1852) contains features central to the Vanitas theme of transience and mortality, but in its intemperate excess of healthy fruits

Severin Roesen (1815–71), *Still Life with Fruit*, 1852. This lush display is a celebration of harvest time. The vine leaves are bronzed, and a variety of late-season berries are scattered across the stone ledge. The glass of wine represents the fruits of labor and the pleasures of the harvest.

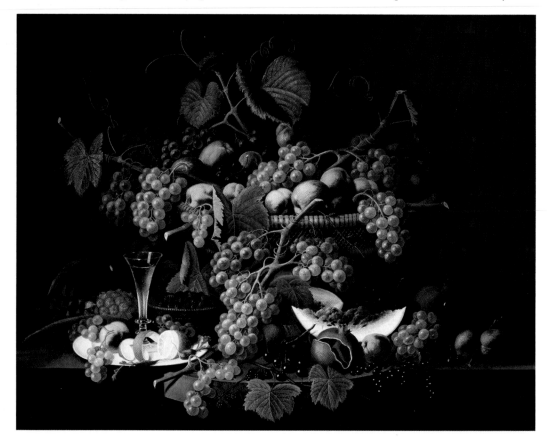

and plants, there is an assertion of luscious bounty, and an optimism that was perhaps more suited to the American character.

Luncheon Still Life (1860), by the Philadelphia artist John F. Francis (1808–86), shows the mark of a self-taught artist in its eager display of virtuoso technique, and through the clever interplay of reflective surfaces and textures. Francis began his career as an itinerant artist in the eastern Pennsylvania area, but he quickly established a successful career in Philadelphia. He tapped into the growing popularity for still lifes of bounty and abundance. Francis specialized in the luncheon still life and the dessert still life. Characterized by simple but elegant fare, these types of paintings played to the popularity of the various luxury items they displayed.

Q: What themes were popular in mid-nineteenth-century genre painting?

A: Genre painting has traditionally been associated with bourgeois taste, because of its provincial bias and close attention to material details of daily life. The heyday of genre painting was from 1830 to 1860 and generally corresponded to a flood of magazines and journals, illustrated with engravings of paintings, that started circulating in the 1840s. The attraction of genre scenes continued during the Civil War, perhaps because they offered a gentler alternative to the harsh realities of American life. The provincial nature of genre painting and its quiet celebration of everyday life is exemplified in the paintings of William Sidney Mount (1807–68), who was born into a family of artists on a farm in Long Island, New York. After an apprenticeship and brief period away from home, Mount returned to Long Island, where he devoted the rest of his life to painting anecdotal scenes of rural life. *Eel Spearing at Setauket* is a quietly affecting work; the figures appear frozen in time, and one cannot help but be drawn into the hushed suspense of the eel hunt. Mount's work also shows his love of narrative. He was influential in encouraging a movement away from lofty posturing, toward a style that was closer to expressing the reality of American life. In his day, though, Mount was criticized for limiting himself to lowly and unserious themes and ignoring more virtuous subjects. Along with George Caleb Bingham, Mount was one of America's most significant genre painters of the period.

John F. Francis, *Luncheon Still Life*, c. 1860. Though he never deviated from his successful format, the late works of this self-taught artist became more ambitious, increasing in complexity and variety as he grew in confidence and popularity.

William Sidney Mount, *Eel Spearing at Setauket*, 1845. This is one of Mount's most celebrated paintings. Its subject is a childhood memory of the man who commissioned the work. Mount used members of the man's family and his father's household as models in order to recreate the scene.

George Caleb Bingham

Q: **Who was George Caleb Bingham?**

A: George Caleb Bingham (1811–79)
is the first artist of major standing to
come out of the Midwest. He was born
in Virginia but lived in Missouri from
the age of eight. He began his career as
a portrait painter and studied for a brief
period in Philadelphia, but he produced
little of interest until the 1840s, when he
found his true subject in the everyday
life of local Missouri people. Bingham is
especially interesting for his solid devo-
tion to the area where he grew up and for
making it central to his work. There was
scant opportunity to see art of quality in
the Midwest, and Bingham made use of
available engravings, basing some of his
more complex compositions on works by
the old masters that he had seen solely in
reproduction form.

Q: **What shaped Bingham's art?**

A: Life on and around the Missouri
River is central to Bingham's art, which
drew from everyday scenes of frontier life.
He was fascinated by the rugged and unfet-
tered life of the river boatmen. However,
the boatmen and barge operators were
a dying breed, and Bingham's paintings
convey nostalgia for an aspect of American
life that by the 1870s had become obsolete.
Nostalgia is an elusive but undeniable
quality in Bingham's work; his paintings
are typically bathed in a diffused golden
light and possess a hushed atmosphere

George Caleb Bingham,
*Fur Traders Descending
the Missouri*, 1845. This
dreamy and captivating
scene of frontier life
has few precedents in
American art. Bingham
had originally called the
work "French-Trader—
Half breed Son," but the
American Art-Union gave
it the title by which it is
commonly known.

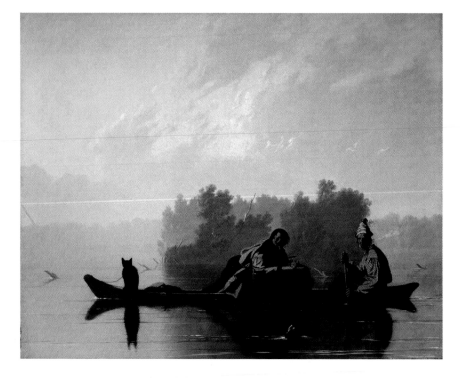

THE AMERICAN RENAISSANCE

T he years following the Civil War were a period of rapid cultural and financial growth in America. Lofty artistic ideals, laid down earlier in the century and arrested by war, peaked in the last decades of the nineteenth century and the early years of the twentieth century. Characterized by an attraction to the classics, the American Renaissance was an academic art. It was also an artistic assertion of America as a great nation, and an endorsement of an emerging class of a rich and powerful elite. Classical art provided a suitably impressive model that would endow America, a young nation, with its ancient pedigree. The first World's Fair in the United States, the Centennial International Exhibition, was held in Philadelphia in 1876, to commemorate the centennial of the Declaration of Independence. By the mid 1870s, the accumulation of great wealth among privileged groups earned the period the pejorative name "The Gilded Age," which mirrored an opulence and tendency toward ostentation in the arts.

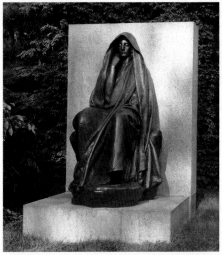

Above: Augustus Saint-Gaudens, *Adams Memorial*, 1886–91.

Left: Thomas Wilmer Dewing, *Girl with Lute* (detail), 1904–5. Finely dressed, beautiful women, engaged in artful pursuits, make up the bulk of Dewing's work and reflect the era's attraction to refinement.

Antebellum American Classicism

Q: What was America's first Classical nude?

A: The admiration for Classical art that characterized the last decades of the nineteenth century was predicted sixty years earlier in John Vanderlyn's most famous work, *Ariadne Asleep on the Island of Naxos*, probably the first idealized, Classically influenced nude presented to an American audience. Vanderlyn (1775–1852) painted this work in Paris, where he had absorbed the idealized forms and palette of the Classical school, and the work met with much success. When Vanderlyn brought his painting home to America, though, and exhibited it in several cities, the American audience, whose attitude toward art was shaped by the continuing Puritan legacy and general moral aversion to the nude, rejected it.

Q: Why was *The Greek Slave* an important work?

A: Hiram Powers (1805–52), the sculptor who won popular acceptance for the nude in American art, helped to set in motion an American tradition of the idealized nude. Unlike the sensuous abandon of Vanderlyn's *Ariadne,* however, Powers's *The Greek Slave* was celebrated for her distinctly virtuous nature, in addition to her Classical attributes. Powers was the first

John Vanderlyn, *Ariadne Asleep on the Island of Naxos*, 1814. The Greek mythological figure Ariadne was the daughter of King Minos of Crete. Her lover, Theseus, abandoned her while she slept on the island of Naxos. Dionysus discovered her and made her his wife. When she died, Dionysus threw her diadem into the sky, forming the constellation known as Corona Borealis.

American sculptor to achieve fame outside his homeland. After starting out life-modeling figures for a wax museum in Cincinnati, Powers left for Florence, Italy, in 1837, where he trained in the Neoclassical style and lived for the rest of his life. His sculpture exemplifies the Neoclassical style in its reserve and highly idealized perfection. To the American mind, *The Greek Slave* was a winning combination, in the merging of Classical beauty, derived from Greek art, and in the chastity inherent in the slave's shame at her nakedness.

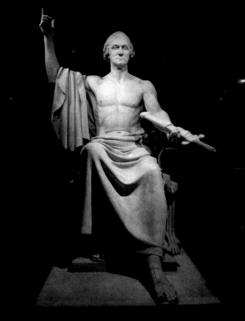

Left: Horatio Greenough, *George Washington*, 1840. Greenough's athletic, Zeus-like George Washington, sandal-footed and draped in a robe, was not compatible with American tastes. The sculptor's depiction of the Father of the Nation's naked torso provoked a controversy when it was unveiled.

Bottom left: Hiram Powers, *The Greek Slave*, modeled 1841–43. *The Greek Slave* was an instant success with the American public and sealed Powers's reputation. Many replicas and scaled-down copies of the sculpture were sold, and it attracted thousands of visitors.

Q: Why did American artists go to Europe to study?

A: By the end of the nineteenth century, America still had relatively few collections of art that could provide a model for ambitious artists. Artists went overseas in the hundreds, mainly to Italy and Paris, where they could study the real thing. A large number of American artists were concentrated in Rome and Florence. The latter became known as the "American Florentines," the foremost among them being Hiram Powers. Others included William Story (1819–95) Randolph Rogers (1825–92) and Harriet Holmer (1830–1908). Further reason to train abroad was that few homegrown American artists were entrusted with large commissions, and European artists received the lion's share of important works. Horatio Greenough (1805–52) had studied in Rome before receiving the first major public commission awarded to an American artist: a monumental statue of George Washington for the rotunda of the United States Capitol. Greenough spent nine years in Italy working on the project, and the finished sculpture (weighing 41 tons) was shipped to Washington, D.C., in 1841.

The American Renaissance

Q: What was the Genteel Tradition?

A: The American Renaissance reflected a desire to create a national art tradition that could compare to the Italian Renaissance. The rareified air and lofty ideals of the American Renaissance gave rise to the Genteel Tradition, also known as "the age of elegance," in which refinement, taste, and high culture were valued above more prosaic subject matter. This marked a departure from the prevalence of genre painting in American art; "vulgar" themes were filtered out and tidied up in favor of an idealized version of reality.

Q: What was the Classic Spirit?

A: One of the leading figures of the American Renaissance was Kenyon Cox (1856–1919), who first came to public attention for his Neoclassical-style murals that graced the White City at the Chicago World's Fair in 1893. The prevailing trend was for an idealized art based largely on the human form as an allegory for culture and learning. This resulted in an academic sterility among some artists who fell into the trap of adhering too closely to their own theories. Cox was among the more academic of these artists. He was influential in promoting what he termed "the Classic Spirit," which was central to American Renaissance art. His murals were greatly admired, but his simpler, less overtly allegorical depictions of the nude, or seminude, such as his sensuous depiction of the nymph *Echo* (1892), were considered vulgar and too close to reality to qualify as praiseworthy art.

Kenyon Cox, *Echo*, 1892. Cox painted a surprisingly natural version of Echo, who appears as a robust country girl, rather than the mournful nymph from Greek mythology, deprived of speech and cursed to echo only the last words of others.

George Caleb Bingham, *Canvassing for a Vote*, 1852. Though he actively engaged in politics himself, Bingham's affiliation here is with the voting public, who form a solid, unified triangle. The politician is placed outside this compact grouping and leans in to make his case.

that makes them appear as though lost in time. One of Bingham's most striking and representative works is *Fur Traders Descending the Missouri.*

Q: How did Bingham's political life influence his art?

A: Bingham was closely involved in Missouri politics, and a significant portion of his artistic output was devoted to this subject. Elected to the Missouri State Legislature in 1849, he was politically active for most of his later years and knew firsthand the reality of political canvassing among seasoned rural folk. *Canvassing for a Vote* shows how close to home this scene really was. Set in Arrow Rock, Missouri, Bingham's hometown, outside an inn that still exists today, the painting depicts a small gathering of local characters with various attitudes as they listen, with varying degrees of patience, to the politician excitedly promoting his argument.

" Many are always praising the by-gone time, for it is natural that the old should extol the days of their youth; the weak, the time of their strength; the sick, the season of their vigor; and the disappointed, the spring-tide of their hopes. "

—GEORGE CALEB BINGHAM

The Civil War (1861–65)

Right: Winslow Homer, *The War for the Union 1862—A Bayonet Charge*, from *Harper's Weekly*, July 12, 1862. Homer did not witness much in the way of actual battles, and his wartime reporting took the form of somewhat romanticized, fictional depictions of battle scenes.

Below: Eastman Johnson, *The Lord Is My Shepherd*, c. 1863. Johnson was an accomplished genre painter. *The Lord Is My Shepherd* is a response to the Emancipation Proclamation, which became law on New Year's Day, 1863. It is a politically ambiguous image. In the South, teaching a black person to read had been illegal. For abolitionists, reading was considered necessary for black people to gain a foothold in society.

Q: **How was the Civil War portrayed?**

A: The Civil War was unique in American history in that it was the first "recorded" war. Illustrated weekly journals had become readily available only a few years preceding the outbreak of the war, and journalists and artists employed by these journals' publishers were sent out across the country to report on the war's progress. The great American artist Winslow Homer (1836–1910) was employed in this way early in his career. He covered the war for *Harper's Weekly* magazine, started up in 1857, for a salary of thirty dollars a week plus travel expenses. Photographers were among the journalists and war artists covering the Civil War, and this new and startlingly raw medium brought the American public an unfiltered, shockingly unromanticized, "eyewitness" view of the war that was unprecedented and deeply unsettling.

Q: **What was the role of the magazine illustrator during the Civil War?**

A: The hastily drawn sketches and illustrations for weekly journals made up the majority of Civil War output. These were ephemeral objects, and most

were thrown away once processed by the publishers. A number survive, though, such as Winslow Homer's illustration for *Harper's Weekly*, *A Bayonet Charge*.

Q: How did artists respond to the Civil War?

A: Genre painting remained a popular art movement during the Civil War years. The American public wanted luscious still lifes and wistful scenes of rural American life; they did not appear to want art that depicted the horrible truths of the war. They now had access to information and visual reporting of the war as never before, and perhaps this was enough. There were war artists, and artists who were at war, but most produced work valued more for its historical interest than for its strength as art. Exceptions do exist, of course, Winslow Homer's later war paintings being the primary examples. Among the other notable artists to reckon with the events of the Civil War is the genre painter Eastman Johnson (1825–1906).

Q: Who were America's first documentary photographers?

A: The really powerful images to surface from the battlegrounds of the Civil War were the photographs taken by the first documentary photographers, Mathew Brady (1823–96) and Scottish-born Alexander Gardner (1821–82). For the first time in history, in possession of a relatively portable camera, Brady and his numerous assistants went out onto the battlefields and among the soldiers, and presented to the public back home hard evidence of the war's devastation. Brady's photographs were reproduced in the same journals and magazines that carried articles and illustrations by the war correspondents.

Alexander Gardner, "Antietam, Maryland. Confederate Dead by a Fence on the Hagerstown Road," 1862. Gardner was one of the many assistants working with Mathew Brady during the Civil War. Brady and his assistants went out onto the battlefields and documented the aftermath of armed conflict. The human degradation revealed in these photographs still has the power to shock today. Brady's photographers documented all aspects of the war, though they often rearranged the dead and staged scenes for extra dramatic effect.

broad American interest in Greek art. There had been a steady turn away from a British style through the nineteenth century, and the democratic model of ancient Greece fit in perfectly with the larger ambitions of the American Renaissance. The interest in Classical architecture had led earlier to the evolution of the Greek Revival style in American architecture and the first national architectural style.

Q: What was the connection between the Pre-Raphaelites and American Renaissance art?

A: The idealization of women is prevalent in American Renaissance art, in which they appear either dressed up as Classical or allegorical figures, or presented as ethereal, essentially decorative maiden types. This tendency was a loosely shared trait of the Pre-Raphaelite artists working in England, who also looked to the past for their inspiration and between them produced a catalog of lethargic-looking young women in various guises from poetry or medieval literature. The mid-nineteenth-century American art journal *The Crayon* praised the artistic ethics and aesthetic beauty found in the paintings of the Pre-Raphaelites. Later, Abbott Handerson Thayer and Thomas Wilmer Dewing (1851–1938) displayed an affinity with the Pre-Raphaelites, depicting dreamy, fragile women who are a far cry from the robust characters that populated the genre paintings in the first half of the nineteenth century.

Abbott Handerson Thayer, *Virgin Enthroned*, 1891. Thayer's own children, Gladys, Mary, and Gerald, modeled for this pseudo-religious work.

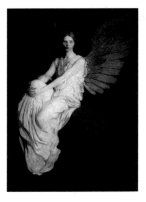

Abbot Handerson Thayer, *Stevenson Memorial*, 1903. Thayer's daughter modeled for the angel in this memorial painting. The believable wings showcase Thayer's great interest in the natural world.

Q: What was the influence of the Greek Revival style?

A: Like Kenyon Cox, Abbott Handerson Thayer (1849–1921) studied at the École des Beaux-Arts, Paris, under Jean Léon Gérome. His painting is freer and more naturalistic than Cox's, and his work was admired for its evocation of Italian Renaissance paintings. He favored Greek-style robes in his painting, which added to their wistful pseudo-Classical appearance. The bulk of Thayer's work tended to be idealized, somewhat sentimental paintings of women and children. He used his own children as models for many of his paintings, which perhaps is why his work possessed a more personalized character than is often seen in other art of this period. Thayer's paintings reflect a

John La Farge, *Athens*, 1893–94. In true American Renaissance spirit, La Farge's *Athens* is loaded with Classical attributes, featuring the goddess Athena on the left, the seminude figure of Nature at center, and the crowned personification of Athens seated on the right.

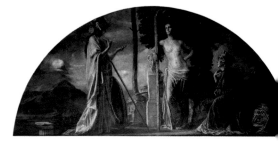

Q: Why did the American Renaissance produce so much public art?

A: If America was to compete for power and prestige with the Old World, it needed similarly impressive public works of art. One of the forms of large-scale public works to flourish during the American Renaissance period was mural painting. Mural painting in America was championed by William Morris Hunt (1824–79) and John La Farge (1835–1910). La Farge's first murals, commissioned for the Trinity Church in Boston, were influential and sparked a national trend. La Farge was influenced by the Venetian masters of the Italian Renaissance, especially in his preference for glowing color, which hints at his later forays into the art of stained glass. His mural *Athens*, for the Walker Art Building at Bowdoin College, presents us with an allegory of the symbiotic relationship between nature, art, and society.

Q: Why was Saint-Gaudens's *Shaw Memorial* important?

A: The *Shaw Memorial*, to Robert Gould Shaw and the Fifty-fourth Massachusetts Regiment, by Augustus

Augustus Saint-Gaudens, *Shaw Memorial*, 1897. In order to overcome the inherent difficulties of commemorating a group, Saint-Gaudens combined the established convention of the equestrian statue with a bas-relief frieze, using shallow space to suggest mass and depth.

Saint-Gaudens (1848–1907), is one of the highest achievements of the American Renaissance. Irish-born Saint-Gaudens was a highly gifted and prolific artist who produced a number of memorials commemorating the Civil War, and this bas-relief monument is perhaps his finest work. The *Shaw Memorial* is refreshingly free of the academic tendency to overidealize and depersonalize, and comes closest perhaps to realizing the American Renaissance desire for a national art that could bring the dignity of Classical art to a contemporary American context. The *Shaw Memorial* was unique in several ways. First in that it commemorated the entire Fifty-fourth Massachusetts Regiment and not just its colonel, and also in that the commission honored a regiment composed entirely of African American volunteer soldiers. Also noteworthy is its depiction of African Americans, who Saint-Gaudens portrayed with unprecedented naturalism and dignity, never slipping into stereotype.

Q: What was the White City?

A: The 1893 Columbian Exposition, also known as the Chicago World's Fair, celebrating the 400-year anniversary of Christopher Columbus's discovery of the New World (as it was generally perceived at the time), opened to the public in Jackson Park, Chicago. The city of Chicago had been almost destroyed by fire in 1871, and holding the fair there symbolized the city's rise from the ashes. Forty-six nations from around the world exhibited at the

Chicago fair, which was attended by up to twenty-six million visitors. The exposition was the ultimate expression of confidence and pride in America as one of the world's great nations, a premise that lies at the core of the American Renaissance. "The White City" was the name given to what was effectively America's first grand-scale theme park; two hundred buildings were erected for the fair—some permanent, some temporary plaster-covered pavilions designed to last only for the duration of the fair. Classical architecture dominated the style of these buildings, and the White City marks the peak of the American Renaissance, both in the expression of vision and in the scale of work produced. The fair provided an extraordinary opportunity for artists; Kenyon Cox's career took off because of his White City murals, and Louis Comfort Tiffany's reputation was secured with the chapel that he designed and built for the fair.

Louis Comfort Tiffany was commissioned to create his largest stained glass dome for the Preston Bradley Hall at the Chicago Cultural Center, originally the Chicago Library, built in 1897.

Katsushika Hokusai, *Courtesan*, 1796–98. Japanese art, such as this Hokusai print, combined spare elegance with decorative beauty in an abstract, nonillusionistic space, making a powerful impact on many European and American artists.

Japonism

Q: What is Japonism?

A: The term Japonism (also referred to as Japonisme, Japonaiserie, or Japanesery), entered the common lexicon in 1872, coined by the French art critic Philippe Burty to describe the pervasive influence of Japan on Western art. What originated in Paris as an interest in collecting Japanese art—initially the prints of the great Edo period ukiyo-e artists like Hokusai (1760–1849) and Utamaro (c. 1753–1806)—quickly became a craze for all things Japanese that swept across Europe from the 1850s on, and then became popular in the United States.

Q: How did Japonism influence art?

A: The influence of Japonism had a profound effect on artists in Europe, especially Edgar Degas (1834–1917), Vincent van Gogh (1853–90), Édouard Manet (1832–83), Claude Monet (1840–1926), Gustav Klimt (1862–1918), and the American expatriate artist James A. M. Whistler. These artists were inspired by the startling unfamiliarity of Japanese art, in which graphic clarity, spacial flatness, and dynamic asymmetry offered a refreshing new angle on how to see the world and how to make art. Japanese and Western traditions of art had developed in radically different directions, especially in relation to perspective and the treatment of space. The influence of Japonism that began in the second half of the nineteenth century extended well into the twentieth century and played a profound role in avant-garde developments that led eventually to modernism and abstraction.

Q: How was Japonism introduced to the American public?

A: Trade between Japan and the outside world had opened up by 1868, after Japan moved away from an earlier, strongly isolationist policy. Exposure to Japanese artifacts (and to Japanese visitors) at the Paris Exposition Universelle, in 1867, sparked widespread interest in

during his years in Paris. Whistler's art was strongly associated with Japonism, and his influence on American taste in this regard was considerable. *The Peacock Room*, originally created for the home of Frederick Leyland in England, is an intensely japonesque work. The flat, decorative design and absence of illusionistic space is a direct reference to Japanese painted screens.

James Abbott McNeill Whistler, *Harmony in Blue and Gold, The Peacock Room*, 1876–77. The Peacock Room originally decorated the walls of the London home of Whistler's patron, Frederick Leyland. The commission was fraught with disputes between Whistler and Leyland, and Whistler included symbolic references to this in the work. After Leyland's death, the entire room was purchased by Charles Lang Freer and brought to the United States. Hanging above the fireplace is Whistler's homage to the arts of the Far East, *The Princess from the Land of Porcelain (La Princesse du pays de la porcelaine)*, 1863–65.

the Japanese aesthetic. The spectacle of international expositions has its roots in Europe. Monumental world fairs took place in England in 1862 and in Paris in 1867, 1878, 1889, and 1900. America's World's Fair in Chicago, in 1893, was part of a general interest during this period for the new and the novel, and three Japanese pavilions were included among the international displays. Also en vogue in the United States were North African styles, and this was accompanied by a superficial attraction to the exotic. The American expatriate artist James Abbott McNeill Whistler was so enamored of Japanese and Oriental artifacts that he amassed an extensive collection, built up

Q: **In what aspect of American culture was Japonism most strongly felt?**

A: Japonism initially made its greatest impact on decorative arts, especially furniture and interior design. Japonism was slower to take hold in America than in Europe but eventually came to be the dominant influence on designers. It also produced a formative influence on Art Nouveau, whose sinuous, fluid forms are traceable to its Japanese origin. The Japanese influence on Art Nouveau design is clearly evident in the work of Louis Comfort Tiffany.

Artist of the Tosa School, *Flowers and Insects*, c. 1615–1868. The fine balance between abstraction and representation, between surface decoration and illusion, is exemplified in this Japanese folding screen.

James Abbott McNeill Whistler

James Abbott McNeill Whistler, *Symphony in White, No. 1: The White Girl*, 1862. The model for this painting was Whistler's mistress, a young Irish woman named Joanna Heffernan. The painting's lack of narrative baffled the public and critics alike, who were accustomed to "reading" a painting's pictorial clues. Viewers offered numerous interpretations; some speculated the "White Girl" was a bride on her wedding night, others figured she was a fallen woman.

Q: Why was Whistler such an important figure in American art?

A: James Abbott McNeill Whistler (1834–1903) is one of the big names in American art, and he would have been the first to agree. Convinced of his own genius as an artist, Whistler was also a raconteur and a dandy. Though American-born, in Lowell, Massachusetts, Whistler was an expatriate who lived abroad for most of his life. As an adult, he resided primarily in England, where he was a famous personality as well as a leading art figure. An enthusiastic member of the avant-garde, Whistler was aesthetically adventurous and an unapologetic champion of Aestheticism, or "art for art's sake." He was deeply influenced by Japanese art and brought a designer's love of elegance and style to nineteenth-century art, even adopting the Japanese convention of the pictorial symbol—in his case the butterfly motif—as a signature.

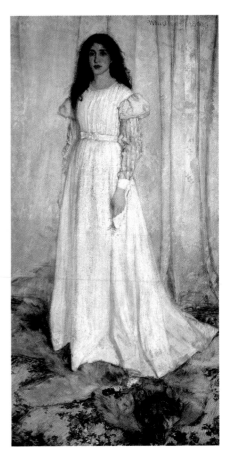

Q: What was the Salon des Refusés?

A: Whistler spent several important years in Paris after 1856. The Salon de Paris, a prestigious annual art exhibition, was organized throughout the 1860s by the Académie des Beaux-Arts and was dominated by conservative academic artists. In 1863, Napoleon III instigated the Salon des Refusés, an alternative venue for art rejected from the official Salon. The Salon des Refusés, though a controversial and derided exhibition, served to bring avant-garde art to public and critical attention. When Whistler first exhibited *The White Girl* (as it was then called) at the Salon des Refusés, it was met with derision from most critics, who objected to its lack of narrative and the girl's vacant expression. Whistler's early influence, the French realist Gustave Courbet (1819–77), is evident in the direct handling of the paint and solidity of form, but the work also contains Japanese elements, particularly the flattening of space and the emphasis of decoration over narrative. Whistler eventually rejected realism, and although he was an independent spirit

and did not adhere to any movement, he leaned toward Impressionism and the paintings of other avant-garde artists, such as the work of French proto-modernist Édouard Manet (1832–83).

Q: What was *Whistler versus Ruskin?*

A: John Ruskin, the influential English art critic and champion of the Pre-Raphaelite movement, threw down the gauntlet in 1877 with his scathing dismissal of Whistler's painting *Nocturne in Black and Gold: The Falling Rocket* (c. 1875). He accused Whistler of "flinging a pot of paint in the public's face," and Whistler consequently sued him for libel. Whistler actually won the case and was awarded the nominal recompense of one farthing in damages (an old denomination of English currency worth a quarter of a penny), but it was a hollow victory, as the legal costs of the court case financially ruined him.

Q: Why did Whistler give musical titles to his paintings?

A: When Whistler showed his 1862 painting *The White Girl* at the Salon des Refusés in Paris, the French critic Paul Mantz pronounced it "symphony in white." Whistler later renamed or added a musical reference to many of his paintings, and these titles served to support his assertion that they should be looked at as paintings and not merely as vehicles for stories, or moral and social agendas. Words such as "symphony," "harmony," "arrangement," and "nocturne" frequently arise in his paintings from the 1870s and after. These titles forge a link between painting and music, itself an extremely abstract art form, and in doing so draw attention to the formal properties of the paintings—color, tone, balance, and mood, among others. A relatively conventional 1883 portrait of the French critic Théodore Duret, for example, is called *Arrangement of Flesh Color and Black,* and there is, of course, the more famous example, Whistler's 1871 portrait of his mother, whose primary title is *Arrangement in Grey and Black No. 1.* In adopting this somewhat mannered stance, Whistler was an advocate for abstraction. He subscribed early on to the Aestheticism movement popular in England from the 1870s to the 1890s.

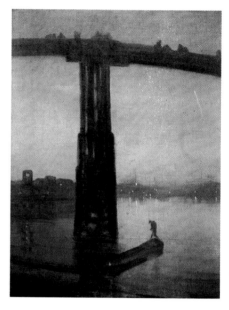

James Abbott McNeill Whistler, *Nocturne in Blue and Gold: Old Battersea Bridge,* 1872–77. The Japanese compositional device in which forms are flattened and arranged parallel to the picture plane is evident in this painting. Whistler's technique lends an exotic air to the industrial scene and solitary boatman.

" The vast majority of English folk cannot and will not consider a picture as a picture, apart from any story which it may be supposed to tell. "

—*James Abbott McNeill Whistler*

Riches of the Gilded Age

Right: John La Farge, *Peacocks and Peonies I*, 1882. This work was commissioned for the Boston home of the railroad magnate Frederick Lothrop Ames.

Below: John La Farge and Augustus Saint-Gaudens, *Apollo with Cupids*, 1880–82. The list of luxury materials employed in this decorative piece—banded African mahogany, repoussé bronze, colored marbles, mother-of-pearl, abalone shell, and ivory—conveys the opulent tastes of the Gilded Age. Artists increasingly collaborated on fine arts and crafts during this period.

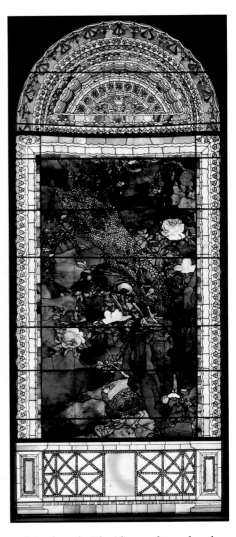

Q: Where did the expression "the Gilded Age" originate?

A: The term was originally used in a negative context, connoting a fake or superficial kind of golden age, and referred to the division between rich and poor that intensified during the period. The term comes from the book *The Gilded Age: A Tale of Today,* written by Mark Twain and Charles Dudley Warner and published in 1873. The years of the Gilded Age, roughly from the late 1860s to the early 1900s, were marred by social unrest and saw the rise of powerful and elite privileged groups.

Q: What kind of art flourished in the Gilded Age?

A: The Gilded Age, not surprisingly, saw the rise of luxury items, exquisitely crafted decorative objects that could stand up to the ostentation of the homes for which they were created. Among the wealthy, the taste for opulence and the elaborately ornate dominated the earlier years of the period, but slowly gave way to the more elegant refinement of Art Nouveau and the Arts

and Crafts style. The ideas and grand-scale ambitions of American Renaissance art stemmed from a desire to assert greatness, and this was echoed by how the American elite built and decorated their houses. *Apollo with Cupids* by John La Farge and Augustus Saint-Gaudens illustrates the symbolic function of art in the Gilded Age, which served to elevate those who either championed or bought it.

Q: Who were the leading stained-glass artists?

A: One of the most splendid art forms to flourish in the Gilded Age was stained glass. The two leading figures in this medium were John La Farge and his rival, Louis Comfort Tiffany (1838–1933). A versatile and influential artist, La Farge was also well read and well traveled. In addition to his work with stained glass, he had a successful career as a painter and had made his reputation as a mural painter. Stained glass fulfilled the desire for opulence and also the fascination for the medieval that was a feature of this period. Up until this time, stained glass was usually made by painting onto the surface of clear glass with metal oxide paints. La Farge approached stained-glass painting in a new and innovative way, layering and fusing it together. This effective blending of colors, derived largely from his understanding as a painter, led directly to the creation of opalescent glass, which he patented in 1879.

Q: Why was Louis Comfort Tiffany a sought-after designer?

A: Louis Comfort Tiffany was the leading stained-glass painter of the period, but he was also hugely successful as a designer. Like La Farge, Tiffany was initially trained

as a painter, in America and then in Paris, and he was also well traveled. He went into business as a glassmaker in 1885, and by the height of his career, in addition to stained-glass windows and lamps, his company was producing a wide range of superbly crafted household wares, interior designs, jewelry, silverware, and more. Tiffany developed a kind of handblown glassware called favrile, made with the newly invented opalescent glass, and which came to epitomize the Tiffany "look." Though La Farge had patented the invention of opalescent glass in 1879, he and Tiffany had worked on its development together in the early 1870s, and the creation of the glass was most likely a joint affair. Tiffany adopted the Art Nouveau style, and his designs show his deep affinity with the sinuous, natural forms typical of Art Nouveau.

Louis Comfort Tiffany, center-third of *Education*, 1890. This allegorical scene has a painterly depth and a sophisticated use of color that was unprecedented in the stained-glass tradition. The window's multiple layers of colored glass respond to changing light throughout the day. This center panel represents the harmony of Science and Religion, balanced by Love. Two other panels accompany the one seen here, representing Art and Music.

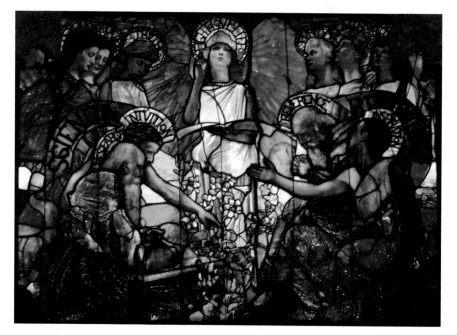

John Singer Sargent

John Singer Sargent, *Elizabeth Winthrop Chanler (Mrs. John Jay Chapman)*, 1893. Elizabeth Chanler became the head of her household while still a young girl. Sargent has painted a grave young woman, twenty-six years old at the time this portrait was commissioned, on the occasion of her brother's wedding.

John Singer Sargent, *Betty Wertheimer*, 1908. This is the kind of flattering society portrait that Sargent was often criticized for. It represents quite a different response to the sitter than his stately portrait of Elizabeth Chanler, and showcases his brilliant virtuoso technique.

Q: Who was John Singer Sargent?

A: Like Whistler, John Singer Sargent (1856–1925) was an expatriate American artist. Born in Florence, Italy, to American parents, Sargent spent his childhood in many of the cultural centers of Europe. In 1874, when Sargent was eighteen, his family settled in Paris, where he studied with the portrait artist Charles Auguste Émile Durand, known as Carolus-Duran (1838–1917). Sargent showed an extraordinary gift for portraiture, a natural facility that was, however, interpreted by some as merely facile, and critical opinion was divided in this fashion for the duration of his career.

Q: Why was the example of Diego Velázquez important?

A: Some of the best painting to come out of Paris at the end of the nineteenth century was rooted in an admiration for the great seventeenth-century Spanish painter—considered by many to be the painter's painter—Diego Velázquez. Sargent's teacher, the flamboyant and influential Carolus-Duran, held up Velázquez as a model for all his students, and Sargent took this thoroughly to heart. He was influenced by Velázquez's restrained palate, deceptive simplicity, and masterful manipulation of tone, and he applied this model to his glittering portraits. Carolus-Duran encouraged his students to paint directly onto the canvas without the safety net of preparatory drawing or underpainting. Sargent's virtuoso techniques—painting wet-in-wet (painting onto wet paint, rather than paint that has already dried) with very rapid brushstrokes and making very few changes as he went along—gloried in brevity and lightness of touch. His later works, especially his outdoor paintings, show Impressionist leanings, in manner if not in substance. Despite the formality and shallowness of some of Sargent's portraits, they can surprise with their gravity. The portrait of *Elizabeth Winthrop Chanler*, for example, shows a serious woman painted with dignity and sensitivity.

Q: Why did Sargent's painting provoke such a mixed response?

A: Sargent's flattering portraits of his rich clientele rewarded him with great

acclaim and financial success in elite
circles and in the academic art world,
but earned him the disapproval of some
critics and avant-garde artists. Some
Impressionists saw the devotion of
Sargent's considerable gifts to the pur-
suit of portraits of the rich and famous
as outmoded and empty showmanship.
They believed he wasted his talents on
pandering to the vanities of his clients,
but as Sargent himself said: "I don't dig
beneath the surface for things that don't
appear before my own eyes." He painted
a great many portraits of rich and/or
beautiful women, but the painting that
catapulted him to fame was the notori-
ous *Madame X.* When Sargent first
exhibited this portrait, at the Paris Salon
of 1884, it caused an outcry. Madame
Gautreau was an American expatriate
socialite, well known for her extramari-
tal affairs. Her deep décolletage and her
pale, lavender-powdered flesh shocked
the public. Causing further scandal,
Sargent originally painted one of the
straps as though it had slipped off her
shoulder (he later repainted it to its
current, more respectable, position).
Her haughty expression and averted
gaze also caused offense, and the ensu-
ing notoriety was part of the reason for
Sargent's departure to London. He made
a great name for himself in England
as its foremost portrait painter of the
English aristocracy.

John Singer Sargent, *Madame X
(Madame Pierre Gautreau),* 1883–84.
The cryptic title, *Madame X,* fooled
nobody in Parisian society about the
sitter's true identity. Virginie Amélie
Avegno Gautreau was a celebrated
beauty and famous socialite.

John Singer Sargent,
*Breakfast in the
Loggia,* 1910. The open
brushwork of *Breakfast
in the Loggia* showcases
Sargent's later, impres-
sionistic style. A marble
statue of Venus, symbol-
izing beauty, overlooks
the women dining in the
morning sun.

"I do not judge, I only chronicle."

—*John Singer Sargent*

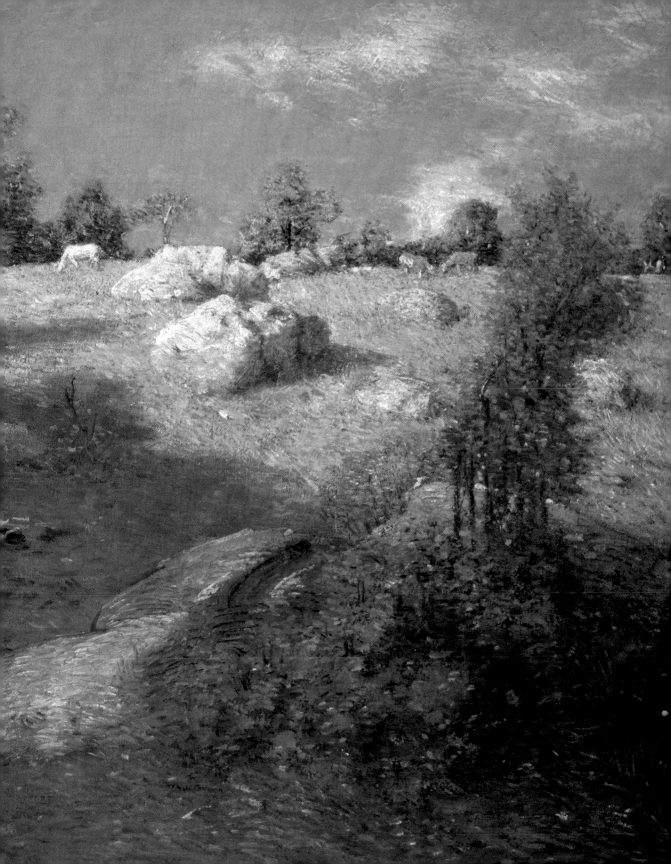

AMERICAN IMPRESSIONISM

Like many art labels, the name "Impressionism" was coined after the fact. It describes the work of a group of artists who first exhibited collectively in Paris in 1874, after rejecting the academic conventions that dominated the Paris salons, the major venues for new art. The name derives from the critic Louis Leroy's mocking definition of the work in that exhibition, which incorporated the title of the painting *Impression: Sunrise* (1872) by Claude Monet (1840–1926). The Impressionists were committed to a new style of painting that sought to recreate the atmospheric effects of light. At its core, Impressionism can be recognized by its depiction of contemporary life and everyday scenes. With a strong focus on natural light and the landscape, Impressionist painters often painted outdoors, directly from life, *en plein air* (French for "in the open air"). By the end of the 1870s, avant-garde movements eventually known collectively as Post-Impressionism began to overshadow Impressionism, but Impressionism continued to thrive in England and America.

Above: Claude Monet, *Impression: Sunrise*, 1872. Monet's modest painting of a sunrise over water gave the Impressionist movement its name, albeit pejoratively.

Left: Julian Alden Weir, *Upland Pasture* (detail), c. 1905. Inspired by the rolling Connecticut landscape, the erstwhile academic painter Julian Alden Weir produced richly impressionistic paintings.

Impressionism Travels to the United States

Q: When did Impressionism take hold in America?

A: In the spring of 1886, Paul Durand-Ruel (1831–1922), a Parisian art dealer and lifelong champion of Impressionism, brought an important exhibition of Impressionist art to America. He had struggled to promote Impressionist art for years in Paris, and his exhibitions in England during the 1870s were resounding failures. Not until his exhibition opened at the American Art Association in New York did he finally achieve critical and financial success. This exhibition provided its audience with a comprehensive view of Impressionist painting and included works by, among others, Edgar Degas (1834–1917), Édouard Manet (1832–83), Berthe Morisot (1841–95), Pierre-Auguste Renoir (1841–1919), Camille Pissarro (1830–1903), and Claude Monet. The American critics and public alike received the exhibition with enthusiasm, and soon after, the Metropolitan Museum of Art in New York purchased two major paintings by Manet for its collection.

Pierre-Auguste Renoir, *Paul Durand-Ruel*, 1910. Durand-Ruel was born into a family of French art dealers. Initially enamored of French academic artists, Durand-Ruel became a champion of Impressionism, despite his lack of success in promoting and selling the paintings. Over time, his tenacity paid off, as Impressionism became an established and lucrative style.

Q: Who were the first American Impressionists?

A: In 1883, Claude Monet, by this time the leading French Impressionist, moved from Paris to the country town of Giverny. His presence there attracted a number of artists hoping to learn from his example. Theodore Robinson (1852–96), an early American Impressionist, was one of Monet's significant visitors. Robinson was born in Vermont and, after studying art in Chicago and New York, moved to Paris, where he trained under Carolus-Duran and Jean-Léon Gérôme (1824–1904). In Giverny, Robinson and Monet became friends, and Robinson produced his finest works during his years there. Returning to America in 1892, he continued to produce Impressionist art and was active among a group of artists developing an American tradition of Impressionism.

Q: **How did Mary Cassatt contribute to American Impressionism?**

A: The American expatriate artist Mary Cassatt was influential in bringing Impressionism to the American public. Living in Paris, Cassatt encountered the art of Edgar Degas and, through Degas, became closely involved with the Impressionist artists. Cassatt actively encouraged U.S. collectors to purchase Impressionist works, and worked tirelessly to promote Impressionist art in her homeland. After Cassatt's encouragement, Louisine Havemeyer, a wealthy American art collector and friend of Cassatt, became the first American patron of Degas.

Theodore Robinson, *The Old Church at Giverny*, 1891. During his years in Giverny, Robinson increasingly turned to landscape painting. His brushwork loosened and his palette brightened, creating light-filled scenes that revealed Claude Monet's powerful influence.

Mary Cassatt

Q: What was Mary Cassatt's background?

A: Mary Cassatt (1844–1926) was born into a wealthy and cultivated family in Pennsylvania. Though her family did not approve of her pursuing art, she received her early training at the Pennsylvania Academy of the Fine Arts. Cassatt was a fiercely independent woman with strong convictions and a seemingly indomitable will. Feeling constrained by American conventions, in 1866, at the age of twenty-one, she chose the unusual course (for a gentlewoman of the time) of moving alone to Paris to study the public collections of the old masters and take command of her own artistic development. She settled permanently in Paris in 1873, where she began showing her paintings at the annual Paris salons. As she became increasingly aware of progressive trends, her palette lightened and her touch loosened. Finally, the art of Edgar Degas influenced her to fully develop her distinctive style.

Q: How was Edgar Degas important to Cassatt's development?

A: Cassatt first encountered pastels by Degas in a gallery window in Paris. The work made such a great impression on her that she wrote in a letter to a friend: "It changed my life. I saw art then as I wanted to see it." Eventually, in 1877, she met Degas, who had seen her work and was duly impressed by her skill. Degas was deeply mistrustful of women and doubted their ability to make serious art, but he recognized Cassatt's prodigious talents, befriended her, and encouraged her innovations. He invited her to show with the Impressionists, who had by this time appropriated the very name used to deride them in their first group exhibition in 1874. Degas also introduced Cassatt to Japanese art, which—coupled with Degas' examples—radically influenced her ideas about composition and

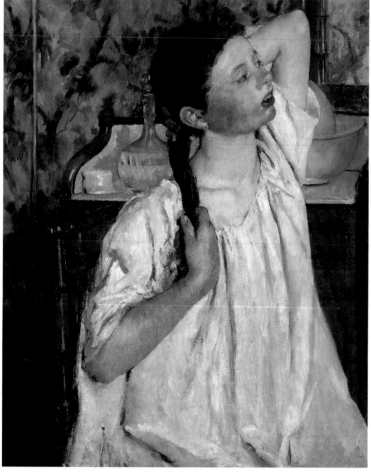

Mary Cassatt, *Girl Arranging Her Hair*, 1886. Cassatt has not sweetened this image with hints of unseen narrative, but created an image of beauty with the most ordinary materials.

how to approach her subject matter. Her work became more dynamic and less conventional, while maintaining its powerful solidity of form and quiet truthfulness. With Degas' prompting, Cassatt also took up printmaking and produced strikingly bold, simple, and graphically powerful images, usually of women and children.

Degas. Likewise, Cassatt never adopted the fragmented brushwork and broken forms characteristic of Monet's investigations into light and atmosphere, which have come to be regarded as the definitive Impressionist style. She is nonetheless considered by many to be America's greatest Impressionist artist.

Mary Cassatt, *The Caress*, 1902. *The Caress* is an image of familial intimacy, but it also contains a psychological charge. The physical intensity of the three figures pressing against one another and the moving interplay of hands is contrasted by the mother's preoccupied expression.

Q: Why did Cassatt paint women and children?

A: Mary Cassatt's own words about the sacrifices a woman artist had to make are illuminated in her almost singular devotion to depicting maternal scenes. She never married. Perhaps this was a deliberate choice, in order to preserve her life as a serious professional artist, a rare accomplishment for women at the turn of the nineteenth century. Clearly though, she was deeply attracted to the intimacy of domestic life, returning to the subject again and again. She rarely painted landscapes—a mainstay of Impressionist painting, and in this she is different from the other Impressionists, remaining closer in mood to

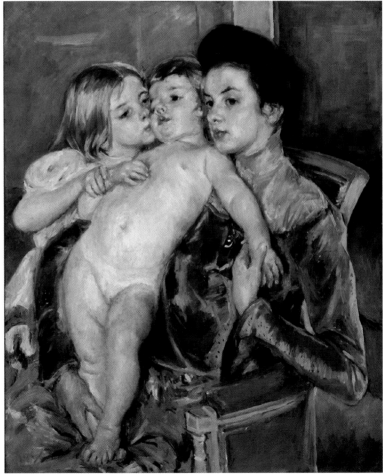

"**There's only one thing in life for a woman; it's to be a mother. A woman artist must be capable of making primary sacrifices.**"

—MARY CASSATT

Impressionism in America

Q: What is American Impressionism?

A: The American tradition of Impressionism grew in strength from its early days in the 1880s into the first decades of the 1900s through the innovations of various groups of artists who shared a similar aesthetic and often lived and worked together in artist colonies. Younger artists also absorbed Impressionism through the influence of teachers who promoted its core values: spontaneity, loose brushwork, painting out of doors, and a light color palette. Unlike French Impressionism, which, as in Monet's late works, was evolving toward abstraction, American Impressionism retained closer ties to realism.

Q: Who was William Merritt Chase?

A: William Merritt Chase (1849–1916) was born in Indiana and lived in Germany from 1872 to 1878, training with the virtuoso history painter Karl Theodor Von Piloty (1826–86). Chase later taught at the Art Students League of New York, where he proved a charismatic and influential presence. Well known for his mannered clothing and exotic tastes, Chase may have derived some of his penchant for flamboyance from his German master. A prolific artist who valued spontaneity and bravado above all, Chase championed Impressionism in the United States early in the movement, and the sparkling, diffused

William Merritt Chase, *At the Seaside*, 1892. This breezy beach scene is a particularly good example of Chase's virtuoso brushwork and his ability to capture atmospheric conditions. He has balanced the vivid blue of the sea with the two other primary colors, red and yellow, to great effect.

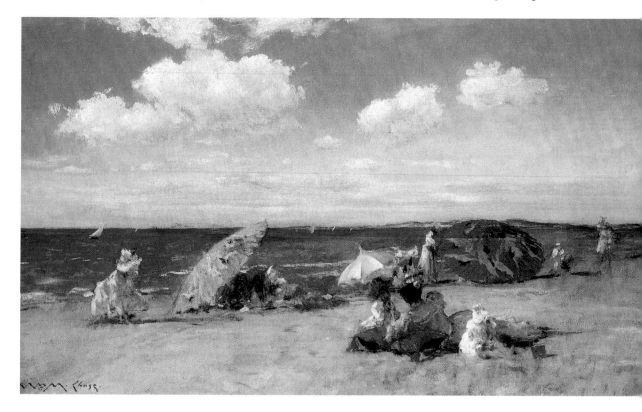

light that characterizes many of his paintings shows his adherence to the Impressionist love of light and its effects.

Q: What was Shinnecock Hills?

A: Chase built a home on Long Island, in Shinnecock Hills, New York, and spent summers there with his burgeoning family. He was an energetic and effective teacher, and in 1891 he opened a summer school in Shinnecock Hills, where he taught his students en plein air. Chase held numerous teaching posts during his career, achieving widespread influence as a teacher. He taught in Manhattan, Brooklyn, and Pennsylvania, and he opened his own Chase School of Art in New York City in 1896 (which later became the Parsons School of Design). He was fairly indiscriminate toward subject matter, and the focus of his interest was largely technique. The paintings that he made in and around Shinnecock Hills, however, are considered his best work. With his predilection for sparkling, light-filled surfaces, Chase found the perfect subject in the crystalline northern light of his Long Island retreat.

Q: What was "The Ten"?

A: "The Ten" was America's equivalent to the *Société anonyme coopérative d'artistes-peintres sculpteurs graveurs etc.*, the group of independent artists who became known as the Impressionists after their first collective

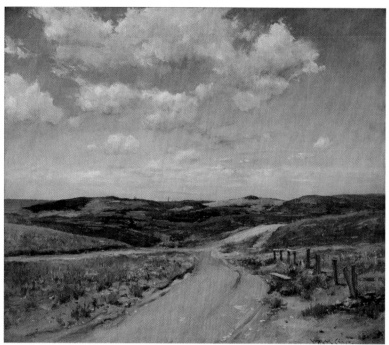

exhibition. The Ten formed for many of the same reasons as the Impressionists; they were dissatisfied with the status quo of established art societies, and they shared aesthetic beliefs and a unified approach to making art. Banded together after their collective resignations in 1898 from the Society of American Artists, Julian Alden Weir (1852–1919), John Twachtman (1853–1902), Childe Hassam (1859–1935), Thomas Wilmer Dewing (1851–1938), Robert Reid (1862–1929), Willard Metcalf (1858–1925), Frank Weston Benson (1862–1951), Edmund Charles Tarbell (1862–1938), Edward Simmons (1852–1931), and Joseph DeCamp (1858–1923) composed The Ten. After Twachtman's death in 1902, William Merritt Chase took his place.

William Merritt Chase, *Shinnecock Hills*, c. 1895. There is an undeniable air of vacation to the paintings Chase made at his country home. This painting of his familiar Long Island landscape suggests freedom, space, and solitary pleasure. The influence of French Impressionism was particularly strong in his landscape paintings.

Q: What were artist colonies?

A: From the late nineteenth to the early twentieth centuries, Impressionism thrived in American artist colonies. These were places where artists who shared aesthetic values could come together and work in a positive and mutually beneficial environment. Artists lived and/or worked in artist colonies, which tended to be located in modest, affordable towns and among beautiful landscapes that provided plenty of subject matter. There were important colonies in the states of Connecticut, New York, Massachusetts, Pennsylvania, Indiana, and California.

Q: What location was important to John Twachtman?

A: John Twachtman's Connecticut home proved central to the evolution of his work, providing a solid base for his increasingly experimental paintings. Born in Ohio, Twachtman traveled in Europe and studied art in Munich and Paris, where he developed his signature style in the mid-1880s. On his return to America in 1886, he settled on a farm in Connecticut; its features became his main subject. Twachtman's repetition of themes and his habit of returning to the same spots at different times of the day and in different seasons recalls Monet's late paintings, which were similarly rooted to his surroundings at Giverny. Among American Impressionists, Twachtman perhaps comes closest to Monet's reductive intensity in his working and reworking of few themes. He shared his affinity for the landscape with his friend Julian Alden Weir, and the artists often painted together on and around his farm and at the Cos Cob artist colony in Connecticut.

Q: Who was Julian Alden Weir?

A: Julian Alden Weir came to Impressionism late in his career. He had encountered Impressionism in its earliest days in Paris, and he was vehement in his rejection of it: "I never in my life saw more horrible things. They do not observe drawing nor form, but give you an Impression of what they call nature. It was worse than the Chamber of Horrors." His initial reaction did not safeguard him against the persuasive influence of Impressionism, however, and additionally inspired by his friendship with John Twachtman, Weir's painting loosened, gradually and inevitably, toward his mature Impressionist style.

Weir went to England during his four years in Europe, between 1873 and 1877, and came into contact with Whistler, whose work he admired. Weir's painting *The Bridge: Nocturne* (1910), also known as *Nocturne: Queensboro Bridge*, shows the strong influence of Whistler's approach to landscape in its startlingly minimal and atmospheric rendition of a cityscape at night. The title is also a direct reference to Whistler's famous use of musical titles. For an artist initially resistant to what he perceived as the undisciplined vagueness of Impressionism, Weir's *The Bridge: Nocturne* is a surprisingly abstract painting in which forms dissolve and merge into one another and almost appear to float across the surface of the canvas.

John Twachtman, *The Brook*, Greenwich, Connecticut, 1890–1900. The extremely limited palette and heavily worked surface of *The Brook* is indicative of Twachtman's habit of reworking and distilling his subject matter to its essence.

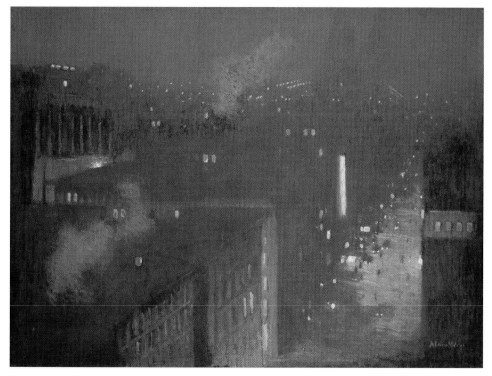

Julian Alden Weir, *The Bridge: Nocturne (Nocturne: Queensboro Bridge)*, 1910. Though he was initially repelled by Impressionism, Weir became one of America's most successful Impressionist artists. *The Bridge: Nocturne* was painted five years before Weir was elected president of the National Academy of Design.

Childe Hassam

Q: Who was Childe Hassam?

A: Childe Hassam (1859–1935) was born Frederick Childe Hassam in Dorchester, Massachusetts, a suburb of Boston (he later dropped his first name at the prompting of his friend Celia Thaxter). An independent thinker somewhat resistant to education, he was, at best, a halfhearted student. After a patchy training and an early career as a watercolor painter, he left the United States to study in Paris. Like Mary Cassatt, Hassam found inspiration there; his exposure to great art in the Parisian museums, and to Impressionism, was his artistic turning point.

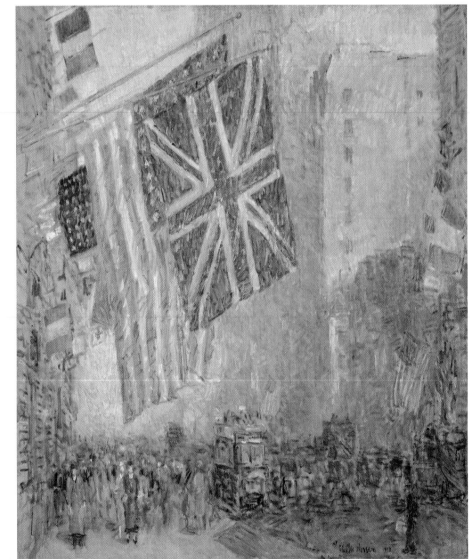

Childe Hassam, *The Union Jack, New York, April Morning*, 1918. Hassam's flag paintings show him as the patriot he truly was; the allied flags of America and Britain dominate the scene, and the people and general activity beneath the great national symbols are dissolved into anonymity. On a sensory level, the paintings also reveal his sheer visual excitement at the festivity the flags brought to the city.

After three years in Paris, he returned to the United States, where he settled in New York in 1889 and became involved with other American Impressionists. Hassam was a particularly close friend of both Julian Alden Weir and John Twachtman, and he became the leading figure of The Ten.

Q: Why did Hassam paint the city?

A: The landscape—the cityscape in particular—was Childe Hassam's abiding fascination. He returned to the urban landscape many times, clearly thrilled by the contrast of towering solidity and the ceaseless activity of the people and traffic below. He produced a series of cityscapes with a flag theme during and after World War I (1914–18), when both political campaigning and patriotism were at fever pitch.

Q: How did American Impressionism evolve?

A: Childe Hassam pushed the limits of the Impressionists' bright palette and investigation of light. His painting of his friend Celia Thaxter, in her garden in Maine, is dazzling; the woman's form is almost overexposed in the sunlight. Hassam's colors became sharper, almost overwrought in his later landscapes, mirroring the scintillating effects of light, and flattening form. The progression in his painting, especially in his later work, hints at the heightened palette and formal experimentation of Post-Impressionism.

Bottom Left: Childe Hassam, *Snowstorm, Madison Square*, c. 1890. Hassam's urban paintings show the city in a romantic and stylish light, and bear similarities to French Impressionist views of Paris.

Bottom Right: Childe Hassam, *In the Garden (Celia Thaxter in Her Garden)*, 1892. Thaxter's garden was on Appledore Island, the largest of the Isles of Shoals in Maine. The ocean can be seen in the distance, pale under the midday sun, beyond the tall flowers that frame Thaxter's sunlit figure.

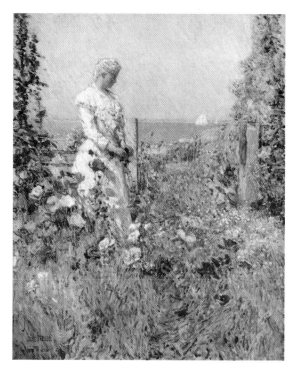

Post-Impressionism

Q: What was the impact of Post-Impressionism?

A: The English art critic Roger Fry (1866–1934) coined the term "Post-Impressionism" as the title for an exhibition he put together in London in 1910. The exhibition contained works by artists concerned with the creation of new forms, instead of the evocation of atmosphere and the imitation of nature practiced by the Impressionists. The central figure in the exhibition was the great French artist Paul Cézanne (1839–1906), who had pushed the boundaries of painting further than any other artist of the period. Post-Impressionism was not a movement as such; it referred to artists working in drastically different ways, who were connected in their desire to invent new forms and systems for painting.

Q: Who was Maurice Prendergast?

A: Maurice Brazil Prendergast (1858–1924) was born in Newfoundland, Canada. His family moved to Boston, where he spent the larger part of his upbringing. Prendergast's early art training was as an apprentice to a sign painter, and this seems to have engendered in him an abiding love for pattern and flat shapes. Despite the influence of Impressionism on his early paintings, the decorative aspect of his work situates him closer to the Post-Impressionists. In the United States, Impressionism was a more loosely applied term than it had been in France at the height of the movement, and it could include artists as wide-ranging in style as both Prendergast and John Singer Sargent. The unifying feature was loosely applied brush strokes and an emphasis on spontaneity, technique, and effect. Prendergast's tendency to flatten form, create patterns, and emphasize

Maurice Prendergast, *Park Scene*, 1915–18. During his time in Paris, Prendergast studied key Post-Impressionist artists, particularly Cézanne, who profoundly influenced his painting. This is evident in this watercolor from 1915–18, in the stylized forms of the bathing women and the shallow, compressed space.

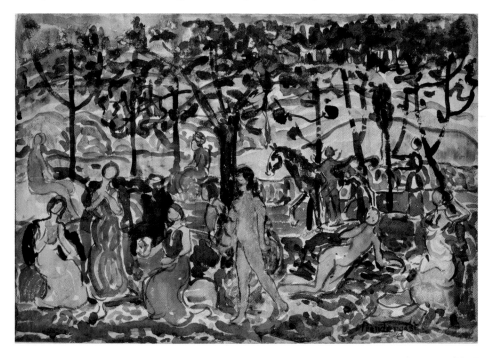

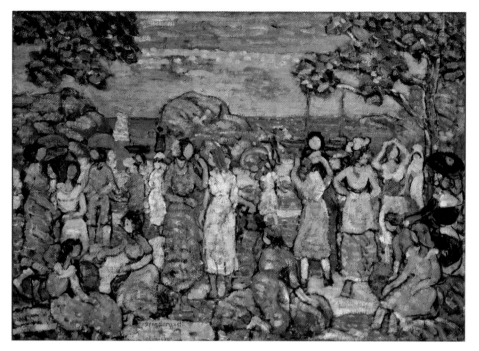

Maurice Prendergast, *Beach at Gloucester*, c. 1918–21. The suppression of spatial depth, the absence of a single focal point, and the democratic treatment of subject matter combine to bring the action up to the picture plane and emphasize surface pattern and shape.

the surface picture plane distinguishes him from the larger body of American Impressionists. In Prendergast's paintings, there is a desire to manipulate nature, to stamp it with his own identity, as a vehicle for his ideas, rather than a desire to replicate it or draw out its essence.

Q: Who were the Nabis?

A: The Nabis, Hebrew for "prophets," were a Post-Impressionist group dedicated to pattern and to the expressive use of color. They named themselves, alluding to the internal emphasis of their art and to their interest in Eastern religions. The Nabis were established in Paris, in 1892, where Maurice Prendergast first encountered their work. Prendergast was not interested in evoking the specific feel of a particular landscape, and to a greater or lesser degree he eliminated illusionistic

space from his paintings. Instead, he abstracted from the landscape, creating rhythmical elements and decorative patterns according to his own personal vision. The heavily patterned, tapestry-like surface and frieze-like compositions of Prendergast's paintings show his aesthetic allegiance to the Nabis and to two of its members in particular: the French artists Pierre Bonnard (1867–1947) and Édouard Vuillard (1868–1940). Bonnard and Vuillard had each developed a highly individual language of painting, but both artists emphasized pattern, rhythm, and formal abstraction, and their traditional subject matter—figures in interiors and garden scenes—became a vehicle for formal investigation into color and rhythm. Besides Bonnard and Vuillard, members of the Nabis were Maurice Denis (1870–1943), Ker-Xavier Roussel (1867–1944), George Lacombe (1868–1916), and Paul Ranson (1864–1909).

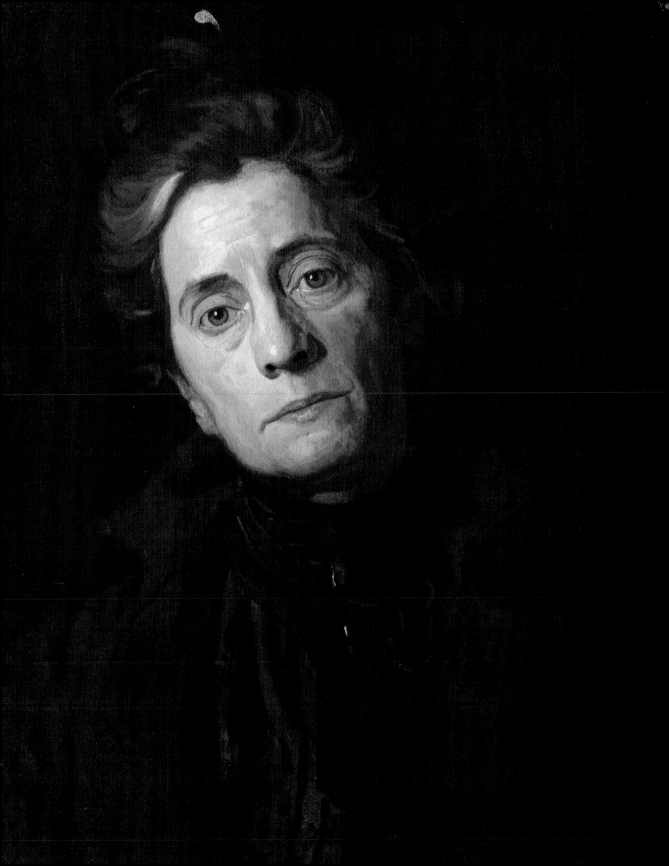

REALISM

From colonial times onward, American art had been inextricably linked to the European tradition. Artists looked to Europe as a model, and, with few exceptions, knowledge of the old masters and European practices was a prerequisite for success back home in the United States. Some of the most significant American artists—Whistler, Sargent, and Cassatt—spent their entire careers abroad, immersed in the European experience. In the late nineteenth century, American artists began to advocate new, "distinctly American" artistic values. Both Thomas Eakins and, later, Robert Henri studied in Europe, but each returned to the United States to pursue his career, making and teaching art realistic in form and subject matter that reflected what they saw as the muscular, lively, and pragmatic face of America. Realism came to stand for honest depictions of the American experience, as seen in the seemingly three-dimensional still lifes of William Michael Harnett, Winslow Homer's vivid negotiations with nature, or the Ashcan school's rugged depictions of urban life.

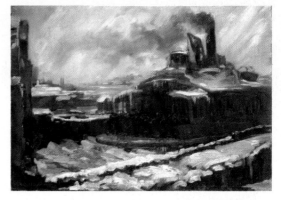

Above: John Sloan, *Ferry Slip, Winter*, 1905–6. Sloan usually painted briskly, from memory, after walking around the city to absorb subject matter.

Left: Thomas Eakins, *Mrs. Thomas Eakins* (detail), c. 1899. The austerity of this work is consistent with Eakins's late style.

Thomas Eakins— Great American Realist

Q: What were Thomas Eakins's influences?

Thomas Eakins, *The Gross Clinic*, 1875. Dr. Samuel Gross is directing an operation to remove a piece of a diseased bone from the patient's thigh. Eakins has bathed Gross's forehead in intense light, as if highlighting the caliber of Gross's scientific mind.

A: Like many artists of his day, Eakins received art training in Paris (in 1866, from Jean-Léon Gérôme). He formulated his approach to art there, and in Spain, where he was influenced by the dark and penetrating realism of the Spanish masters Jusepe de Ribera (1591–1652) and Diego Velázquez (1599–1660). On his return to the United States in 1870, however, Eakins turned his attention toward contemporary American life. In this, he shares the spirit of Cassatt and the other American Impressionists, but he held very different views about how to make artwork that distinctively represented his homeland. His work is an affirmation of the pragmatic American temperament and a celebration of scientific and technological advancements.

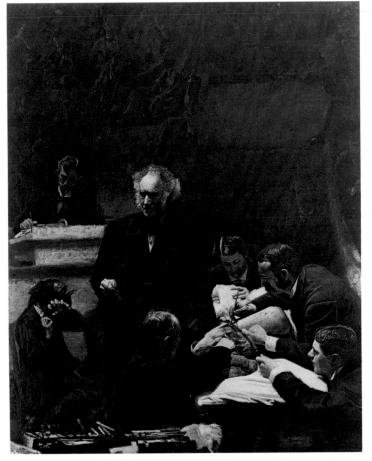

Q: Why was *The Gross Clinic* a controversial painting?

A: Eakins had a deep connection to Philadelphia. He was born there, studied at the Pennsylvania Academy of Fine Arts, taught at the Academy from 1876 onward, and was appointed its director in 1882. Fascinated by scientific developments, he painted many portraits of leading scientists, for whom he had enormous respect. In 1875, Eakins painted a portrait of Samuel Gross, one of Philadelphia's most respected physicians. *The Gross Clinic* is Eakins's most famous painting, and it polarized opinions about

what was acceptable as art. Eakins submitted the painting to the Philadelphia Centennial Exposition, but it was dismissed for being too crudely realistic and in poor taste. Eakins wanted, specifically, to show the surgeon at his work, bloody hands and all, and was severely disappointed by the jury's reaction. The painting was eventually included in the exposition, but hung in an area reserved for medical exhibits. *The Gross Clinic* is a strangely dispassionate work, despite the presence of the anguished mother shielding her eyes from the surgery. The faceless patient is reduced to anonymous flesh, forming a gruesome focal point in the crowded scene. Dr. Gross stands above the mess of mortality and human emotions, pausing for a moment to address the students amassed in the amphitheater.

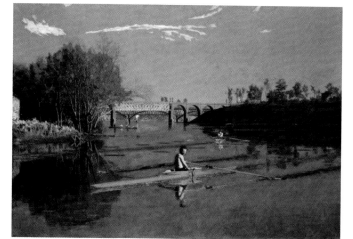

Thomas Eakins, *Max Schmitt in a Single Scull*, 1871. Eakins's commitment to science and technology extended to his art, and his preparations for this painting were detailed and thorough. Even the skinny, motionless cloud in the sky echoes Schmitt's scull, fixes it in space, and seems to ennoble it.

Q: Why is Eakins called the father of American realism?

A: Eakins brought a clear and uncompromising eye to all his subjects. His style derives from a desire to reflect reality as closely and accurately as possible. He carefully constructed each painting in his studio, from many studies, calculations, and notes based on his observations. His paintings are not dry, academic exercises, however. On the contrary, Eakins's works, especially his iconic images of rowers, are poetic distillations of contemporary American life. He was an enthusiastic rower, and he returned to the theme of rowing several times in his work. He painted his friend, the champion racer Max Schmitt, when the relatively new sport of sculling was at the height of its popularity. He painted himself into the scene also, in the background scull, shown head on, in contrast to the long diagonal of Schmitt's scull. Paintings of sleek, streamlined sculls and racers in athletic clothing reflect Eakins's interest in modern life and his aim to create a distinctly American art.

> Of course, it is well to go abroad and see the works of the old masters, but Americans must strike out for themselves, and only by doing this will we create a great and distinctly American art.
>
> —THOMAS EAKINS

The Influence of Eakins

Thomas Eakins, *Wrestlers in Eakins's Studio*, c. 1899. This photograph epitomizes the celebration of masculinity, which came to characterize the more rugged forms of realism practiced by Eakins's followers and by the later Ashcan school artists.

Q: How did Eakins's approach differ from that of the Impressionists?

A: Eakins rejected the soft neutrality of Impressionism, being more concerned with scientific investigation of fact. He had little desire to evoke a mood or a moment—he wanted to pin down the truth, as an entomologist fixes an insect in a display case (this uncompromising attention to reality meant that his portraits often did not meet with the sitter's approval). Impressionism and realism differ in both style and subject matter. Impressionism generally represented women in domestic scenes, or landscapes devoid of narrative or human form. The Impressionist aesthetic was often soft and fleeting, essentially decorative. With Eakins, American art shifted toward an assertion of physical and intellectual toughness. Eakins's iconic rowers and his portraits of scientists elevated the masculine figure and set American art on a new course.

Q: What was Eakins's impact as a teacher?

A: Eakins was highly valued as a teacher. He ingrained in his students the imperative of studying the human form directly from life, asserting: "I do not like a long study of casts. At best they are only imitations, and an imitation of imitations cannot have so much life as an imitation of nature itself." Eakins saw photography as a way to gain a greater accuracy and understanding of human anatomy. Familiar with the photographic studies of human motion by Eadweard Muybridge (1830–1904), he learned how to make his own versions. He also made photographic studies of nudes in landscapes as visual references for his more complex paintings. His students were closely involved in this process; some of them even posed naked for him, and Eakins himself appears in several of the studies. Eakins was eventually dismissed from the Pennsylvania Academy of Fine Arts because he allowed his female students to draw from the nude model. His students, however, urged him to continue his dynamic teaching at Philadelphia's Art Students League.

Q: Why is *The Ironworkers' Noontime* a key work?

A: Thomas Anshutz (1851–1912) studied under Eakins at the Pennsylvania Academy of Fine Arts, and his paintings exemplify the realist values of his teacher. *The Ironworkers' Noontime* is a powerful statement, asserting the dignity of physical labor and celebrating the strength inherent in American progress. Its message has not been refined or filtered; the painting is not an allegory of human endeavor, which the academic art of the day would have required, but instead shows the ordinary reality of labor. The palette of dark browns, grays, and umbers, contrasted with the creamy flesh of the ironworkers' naked torsos, is strongly influenced by Eakins's somber colors.

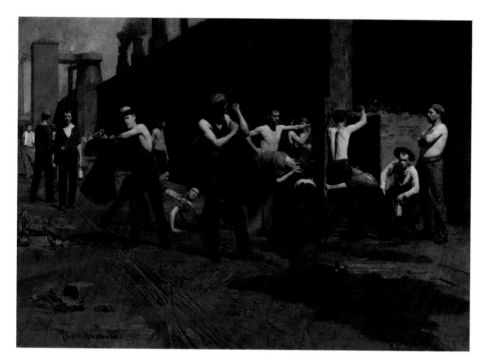

Thomas Anshutz, *The Ironworkers' Noontime*, 1880. Though the bulk of Anshutz's output was comparatively conservative, *The Ironworkers' Noontime* is a significant work, continuing Eakins's sophisticated realist vision and predicting the rugged art of the Ashcan school.

Henry Ossawa Tanner, *Mother of Henry O. Tanner*, no date. Thomas Eakins was the strongest influence on Tanner's early development, and Eakins's legacy is evident in the serious tone and dignified realism of Tanner's portrait of his mother.

Anshutz also shows his allegiance to Eakins in his depiction of male anatomy. *The Ironworkers' Noontime* was probably the peak of Anshutz's achievements as a painter, containing a directness that sets it apart from the rest of his work.

Q: What was the role of photography in realist painting?

A: Anshutz adopted Eakins's practice of making photographic studies as visual aids to painting. These studies were especially useful when working on complex paintings with grouped figures. The realists were committed to painting from direct observation, but they preferred to construct their paintings in the studio, observing photographs, rather than to paint en plein air.

Q: Who was Henry Ossawa Tanner?

A: Another of Eakins's students was Henry Ossawa Tanner (1859–1937), who has the distinction of being one of the first African Americans to achieve artistic success, albeit after he left America. After difficult early years as an artist, and believing that he would never overcome racial prejudice in America, Tanner settled permanently in France in 1891. He didn't receive critical acclaim in the United States until very late in his life. Finally, in 1927, ten years before his death, he was awarded the prestigious title of full Academician of the National Academy of Design.

The Realist Still Life

William Michael Harnett, *The Old Violin*, 1886. Harnett's brilliantly effective painting draws the viewer's eye from the envelope pinned to the door, to the sheet music curling outward, to the marks of wear and tear on the instrument, to the powdery residue of the rosin, which signifies that the violin was recently used.

Q: Who was William Michael Harnett?

A: At the end of the nineteenth century, William Michael Harnett (1848–92) was considered the leading still life painter in the United States. Born in rural southwestern Ireland to shoemaker parents who immigrated to America shortly after he was born, Harnett grew up in Philadelphia and, at seventeen, apprenticed to an engraver. He received some art training in Philadelphia and New York and from 1880 spent six years in Europe, mainly in Munich. Harnett eventually established his art career in New York, where he remained and enjoyed consistent success. Harnett had a somewhat different take on realism than Eakins. He specialized in illusionism; the nearly three-dimensional quality of his paintings made them extremely popular. In *The Old Violin*—one of his signature pieces—the palette is rich and filled with clever and highly persuasive trompe l'oeil effects.

Q: What makes William Michael Harnett's still life paintings realist?

A: Harnett's paintings are virtuoso trompe l'oeil pieces, but their ordinary subject matter situates them firmly within the realist tradition. Harnett painted the lowly materials of everyday life: old books, papers, receipts, pipes and tobacco, the accoutrements of hunting, and other, often typically masculine, objects. Though the textures and reflective surfaces are superbly rendered, calling to mind the splendors of the Dutch still life tradition, his paintings stand in sharp contrast to the conventional still lifes of flowers

and fruit. Harnett's works often imply subtle or sly narratives. Harnett produced many "batchelor" still lifes, displaying a clutter of masculine objects, before he developed his more ambitious trompe l'oeil vertical arrangements such as *The Old Violin*. As Harnett's work matured and his style refined, his paintings became paradoxically more focused on the mundane. There is a captivating discrepancy in the spare and simple subject matter rendered with such intense sophistication.

Q: How did Harnett's paintings influence John Frederick Peto?

A: Harnett's paintings were a major influence on the younger artist, John Frederick Peto (1854–1907). Like Harnett, Peto was raised in Philadelphia, and though largely self-taught, he studied for one year at the Pennsylvania Academy of Fine Arts. His career, however, was spent largely in obscurity, and he enjoyed none of Harnett's success. Peto's paintings relate specifically to a strain of Harnett's mature work—his spare, restrained pin-board arrangements. Peto's *Rack Picture for William Malcolm Bunn* is a relatively complex version of this form of still life.

John Frederick Peto, *Rack Picture for William Malcolm Bunn*, 1882. The editor of the *Philadelphia Sunday Transcript*, Bunn was a friend of Peto's.

Winslow Homer

Winslow Homer, *Snap the Whip*, 1872. Perhaps Homer's most iconic image, *Snap the Whip* details the powerful yet fragile nature of human connection, a theme Homer later explored within a more adult context in his paintings of solitary teams of outdoorsmen and fishermen at work, and in harrowing ocean images, like *The Life Line* (1884).

Q: How did nature inspire Winslow Homer?

A: Throughout his career, Winslow Homer (1836–1910) maintained a close relationship to the natural world, from his early paintings of rural idylls to his late, dark works displaying the power of the ocean. Homer was an East Coast artist, born in Boston, Massachusetts. He retained a love of the sea and the harsh northeastern climate throughout his life. He was apprenticed to a lithographer at age nineteen and spent his early career as an illustrator for *Harper's Weekly* during the Civil War. After the conflict ended, Homer developed into one of the most significant painters in America. Winslow Homer is one of America's great realists; his paintings reveal an intense commitment to the essential nature of his subjects and to the conflicted relationship between man and the natural world.

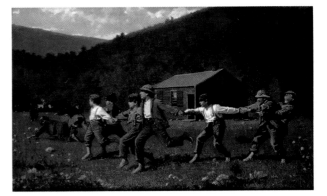

Q: What was Homer's early work?

A: Homer achieved his first success as an artist with *Snap the Whip*, an idyllic scene of robust, barefoot children playing outside a country schoolhouse. The painting is an example of the early phase of Homer's career, which is characterized by a nostalgic and timeless vision of rural American life. The seemingly carefree schoolyard game displays the underlying competition between society and solitude, an issue

Homer reckoned with throughout his career. After *Snap the Whip*, Homer rarely painted images of large, animated groups, tending toward the more solitary side of human existence.

Q: What was Homer's great subject?

A: Homer's concern for capturing exact light conditions connects him with the Impressionist movement. A commitment to realism, though, meant that he was more concerned with accuracy than evocation, and in this regard he closely relates to Thomas Eakins. His practice was to work on a certain painting at exactly the same time, and for the same duration each day, in order to ensure a truthful depiction of the light and conditions in the painting. "I work hard," he said, "every afternoon from four-thirty to four-forty, that being the limit of the light I represent, the title of my picture being *Early Evening*." From 1881, Homer lived two years in a village in Northumberland, on the bleak northeast coast of England, where he painted the

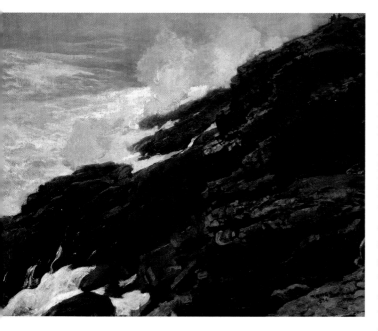

to Florida and Cuba, and was commissioned in 1884 by *The Century Magazine* to make images of Nassau in the Bahamas. Overall, he produced a superb body of watercolor paintings based on his Caribbean travels. Homer discovered watercolor painting early on in his career and valued it as highly as oil painting. His watercolor landscapes are spontaneous and vivid; he was a master of economy and color. The dazzling brightness of his watercolors beautifully captures the intense light of the tropical landscape.

Winslow Homer, *High Cliff, Coast of Maine*, 1894. Homer's last years were spent living close to the sea in Maine. The solid mass of rocks pounded by the relentless ocean suggest a tough stoicism and a respect for the power of nature.

Winslow Homer, *After the Tornado (After the Hurricane)*, 1898. Homer captures the vivid color and brilliant light of the Bahamas in this masterful watercolor. He also tells a darker story, contrasting the silent and stiff body of the young man with the frothy, roiling sea. Homer is regarded as one of the finest watercolorists in American art.

sea and the hardworking members of the fishing community. On returning to the United States, he closed his studio in New York and moved north to the state of Maine, establishing a studio in the isolated outcrop of Prouts Neck in 1883. He remained in seclusion in Maine until his death in 1910, devoting this last period to increasingly dramatic and expressionist paintings of the sea.

Q: What was Homer's connection to the Caribbean?

A: The cold and harsh Maine winters drove even the hardy Homer in search of more temperate weather. He made fishing trips with his father and brother

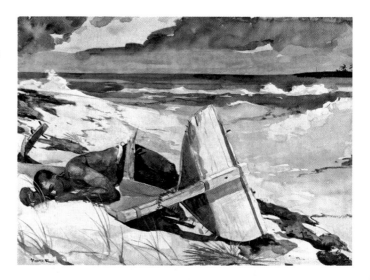

" Look at nature, work independently, and solve your own problems. "

—WINSLOW HOMER

Robert Henri and "The Eight"

Q: Who was Robert Henri?

A: Robert Henri (pronounced hen*rye*) was born Robert Henry Cozad in 1865, in Cincinnati, Ohio. In 1882, his father killed a neighbor over a land dispute, and the Cozad family escaped to Colorado, assuming new identities. Henri enrolled at the Pennsylvania Academy of Fine Arts in 1886, studying under Thomas Anshutz. In 1888, he left for Paris to continue his artistic training. He began his teaching career in 1892 in Philadelphia and began to attract the following of artists interested in pursuing a vigorous kind of realism. Henri was a charismatic and inspirational force among young artists, and he became an especially important teacher. He came to reject French Impressionism, which he felt had become, at the end of the century, a new academicism. He instead took his cue from the robust directness of the great French painter Édouard Manet.

Q: What kind of art did Henri champion?

A: Henri acquired a teaching post at the New York School of Art in 1902 and promoted a new kind of art, based on the celebration of the ordinary. He believed that art should advocate the "strenuous life"—that artists should depict ordinary people and address all aspects of their world, including its harsh realities, and not distance art from the truth in favor of beauty or aesthetic theories. Henri's philosophy led realist art to a new level and predicted the social realism of the 1930s. He encouraged his students to approach their subject matter in a direct manner, without surface polish or spontaneous open brushwork.

Q: What was "The Eight"?

A: In 1907, the National Academy of Design excluded from its annual exhibition a group of artists that Henri was closely associated with. He resigned in protest from the National Academy and organized an alternative exhibition for the excluded painters, called "The Eight." The painters formed a group of the same name, with Henri as their leader. Henri

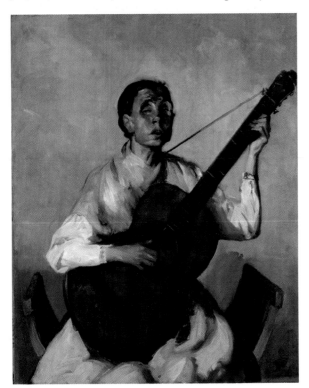

Robert Henri, *Blind Spanish Singer*, 1912. There is nothing romantic about Henri's *Blind Spanish Singer*. She is not depicted as a type, but as a distinct individual, rendered with direct, fluid, robust brushstrokes. The dynamic composition strongly evokes Manet's *The Spanish Singer* (1860).

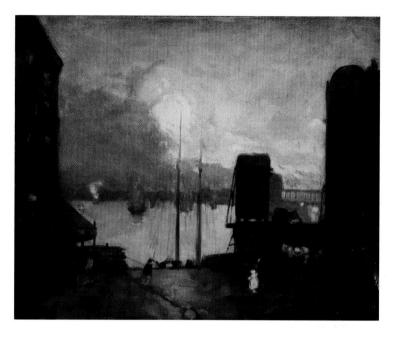

organized another exhibition along the same lines in 1910; it proved a great success, helping to pave the way for the Armory Show in 1913. The Eight were a stylistically diverse group: The younger artists John Sloan (1871–1951), Everett Shinn (1876–1953), and George Luks (c. 1866–1933) pushed the boundaries of realism, William Glackens (1870–1938) remained immersed in the Impressionist style, and Maurice Prendergast (1859–1924) had strong affinities with the Post-Impressionist movement. Despite their aesthetic differences, The Eight were united by their opposition to the conservatism of the Academy, which Henri called "a cemetery of art." The Eight also included Ernest Lawson (1873–1939), and Arthur B. Davies (1862–1928).

Q: How important was the city to The Eight?

A: The realist values championed by Henri and adopted wholeheartedly by the group's younger members came to

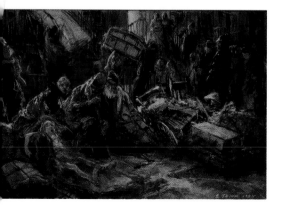

define The Eight. Later, with the addition of the young painter George Bellows, The Eight became more broadly known as the Ashcan school. The city was the central inspiration to The Eight and the Ashcan school. It symbolized life in its raw and most intense form. The poetry of Walt Whitman also spoke loudly to these artists, who, like Whitman, were enraptured by the messy spectacle and bawdy delights of city life. Glackens, Shinn, Luks, and Sloan documented the city as newspaper illustrators and cartoonists. John Sloan's depictions of the bustling crowds tended to focus on the lighter side of urban life. Though he painted the city in all its moods, he was criticized in later years for a lack of social commentary. Everett Shinn shows a more pessimistic journalistic eye in *Eviction (Lower East Side)*, a rapidly executed sketch of poor slum-dwellers being ousted from their Lower East Side apartment.

Robert Henri, *Cumulus Clouds, East River*, 1901–2. There is little picturesque or grand about this unremarkable harbor scene. Henri has, however, found beauty in the pursuit of truth, in the contrast of billowing sunlit clouds with the grime of the waterfront.

Everett Shinn, *Eviction (Lower East Side)*, 1904. Shinn was an illustrator and reporter for several magazines and newspapers in Philadelphia and New York, often turning his attention to the plight of the poor.

The Journalist's Eye

Jacob Riis (1849–1914), "Street Arabs in Sleeping Quarters" (from *How the Other Half Lives*), 1888. Although Winslow Homer's ragamuffins are poor and barefoot, they are also visibly robust and healthy, and their joyous activities—sailing boats and exploring the countryside—are darkly mirrored by Riis' sickly and abandoned "Street Arabs."

Q: Who was Jacob Riis?

A: Born in Denmark in 1849, Jacob Riis was the third child in a family of fifteen. He worked as a carpenter in Copenhagen before leaving Denmark for the United States in 1870. In New York, Riis experienced the hardship and instability of the immigrant experience. Unable to secure a regular job, he sometimes lacked a place to sleep. Riis worked at numerous menial jobs around the city before finding steady work as a reporter for the *South Brooklyn News*. In 1878, he secured employment as a police reporter for the *New York Tribune.* At the *Tribune,* Riis began his twenty-five-year campaign to bolster public awareness of the urban underclass's dire living conditions, which resulted in a popular outcry for reform. His stark and unflinching photographs of the slum dwellers of the Lower East Side are powerful records of the wretchedness of urban poverty.

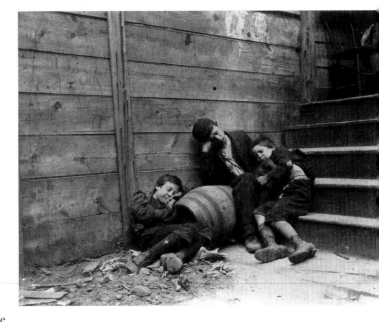

photography, photographers were suddenly able to document the nighttime world of the slums. His photographs and magic lantern shows (a forerunner of the slide projector) presented America with proof of the squalor and degradation of its citizens. His images of children in particular, contradicted the popular representation of children in the late 1800s. Riis fully employed shock value in order to provoke the strongest response from his viewers, and his tactics have often been associated with muckraking journalism.

Q: How did Riis capture the reality of New York poverty?

A: Riis was among the first photographers in America to use *blitzlichtpulver* (flashlight powder), which was invented in Germany in 1887. Using flash

Q: What was the impact of *How the Other Half Lives*?

A: Following the success of an illustrated article for *Scribner's* magazine, Riis published his first, and most famous, book of essays and photographs, *How*

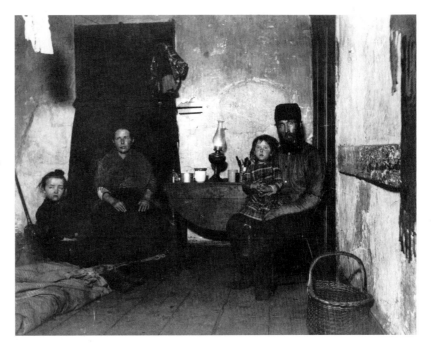

the Other Half Lives, in 1890. The book caught Theodore Roosevelt's attention (at the time, Roosevelt was the head of the New York Police Board of Commissioners) and inspired him to close some of the worst lodging houses in the city, among other reforms. In 1888, Riis had also founded an organization to address the problems of the struggling immigrant population. In 1901, the organization officially became the Jacob Riis Neighborhood Settlement House, established at 48 Henry Street. Roosevelt, who held Riis in high esteem, wrote the introduction for Riis's autobiography, The Making of an American, published in 1901. "It is difficult for me to write of Jacob Riis only from the public standpoint," Roosevelt wrote. "He was one of my truest and closest friends." Riis went on to publish numerous books attempting to bring the struggle of the poor to the broader public awareness, always placing emphasis on the plight of poor children. Among his many titles are: Children of the Poor (1892), Out of Mulberry Street (1898), The Battle with the Slum (1902), and Children of the Tenements (1903).

Jacob Riis, "Family in Poverty Gap, N.Y.C. Tenement" (from How the Other Half Lives), 1889. Riis described the wretched tenant houses as, "containing, but sheltering not, the miserable hordes that crowded beneath smouldering, water-rotted roofs or burrowed among the rats of clammy cellars."

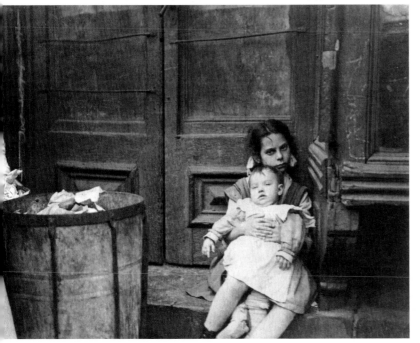

Jacob Riis, "Organized Charity—A Little Girl Minding a Baby," 1900. Often, poor children were required to care for their infant siblings while their parents worked. Riis consistently focused his lens on the trials children faced in the slums.

The Ashcan School

Q: **What was the "Ashcan school"?**

A: The Ashcan school was the continuation of certain thematic characteristics of "The Eight." The term "Ashcan school" was coined retrospectively to describe the work of artists who were committed to a rugged form of realism, whose focus was often the dirty and downtrodden elements of urban existence.

George Bellows, *Stag at Sharkey's*, 1909. Tom Sharkey's Athletic Club held a great attraction for Bellows, who had been an accomplished amateur baseball player. *Stag at Sharkey's* conveys the monumental brutality of an illegal prizefight watched by a leering, seedy crowd.

Q: **Who was George Bellows?**

A: Considered the most significant figure of the Ashcan school, precocious George Bellows (1882–1925) celebrated the violent energy of the city, and his muscular, rapidly executed paintings exude a powerful, youthful intensity. Born in Ohio, he received his early art education there, then moved to New York and studied under Robert Henri. In New York, Bellows found his style, and the paintings he made there are regarded as his best work. He made a splash in 1909 with *Stag at Sharkey's,* his impressive and brutal painting of an illegal prizefight. The same year, he was elected as the youngest member of the National Academy of Design.

Q: **What did Bellows's New York look like?**

A: *Cliff Dwellers* is the archetypal Ashcan vision of urban life. Painted in 1913, early in Bellows's career, it has all the energy, humor, and earthy realism that distinguish his best painting. The drama and bustle of city life is matched by Bellows's vigorous brushwork. In imitation of busy street life, there is no single point of focus—the viewer's eye roams across the surface, stopping at the numerous incidents that form the

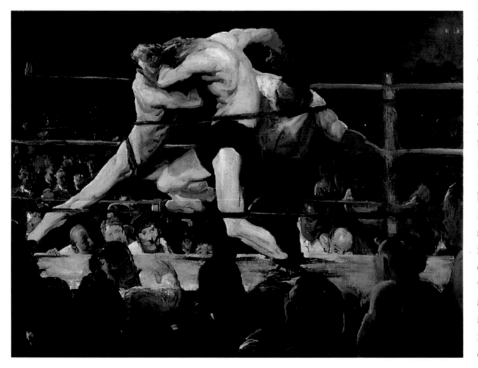

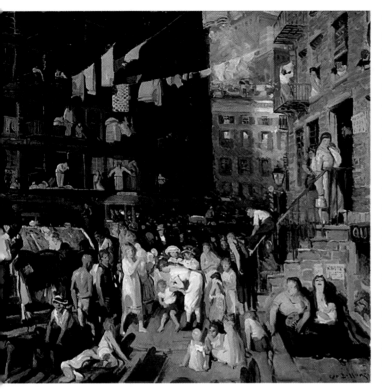

George Bellows, *Cliff Dwellers*, 1913. In this cacophonous slice of urban life, Bellows epitomized the Ashcan school's love of the unrefined. The term "Ashcan school" was coined retrospectively in the 1930s; its artists had also been given an earlier and more pejorative label—"Apostles of Ugliness."

a period when avant-garde artists had little opportunity to show their work. These were significant years in American art, incorporating the Armory Show and its influence. Stieglitz was a progressive thinker and is strongly associated with the Ashcan school, but his work represents a more reserved type of realism. An innovator with the camera, he worked hard to move photography into the mainstream of the art world. Stieglitz grew up in Manhattan, and the ever-changing face of the city remained central throughout his artistic career.

collective narrative of the city. Bellows was also involved in the organization of the Armory Show in 1913, the momentous exhibition that brought Modernism to America. Bellows's later paintings were less raw and more formally experimental and modernist, adhering to Hambridge's Theory of Dynamic Symmetry, which stated that all forms in art should be based on common geometric shapes.

Q: What was Gallery 291?

A: Gallery 291, at 291 Fifth Avenue in Manhattan, provided crucial support for avant-garde artists. The photographer Alfred Stieglitz (1864–1946) managed the gallery from 1905 to 1917,

Alfred Stieglitz, "The City of Ambition," 1910. Stieglitz has captured an image of a frenetic ferry slip in Manhattan. Steam and smoke pour out of multiple chimneys, and the older dockside buildings, dark and squat at the water's edge, are dwarfed by towering skyscrapers that embody the work's title.

American Folk Art and Outsider Art

Every culture has a folk art tradition, since folk, by definition, means "of the people." Folk art has its roots in primitive art and flourishes today in diverse, vernacular forms. Hard to define, folk art is challenging to understand in a modern context, since mainstream artists often incorporate primitive styles into their art. Folk art often serves a utilitarian purpose and is made by someone without formal art training or fine art aspirations. Much folk art is made according to family traditions and skills passed down through generations. Many folk artists are self-taught, however, and many began creating art after a lifetime spent working or raising a family. Distinct from the history of fine art movements, folk art remains a tradition dominated by craftsmanship and often tied to rural communities.

Imaginatively crafted objects such as weathervanes, decoys, toys, shop signs, and mailboxes are often considered folk art.

The term "Outsider" art originally referred to art made by mental patients and prisoners. Usually done in isolation, this work is often characterized by obsessive and visionary elements. Outsider artists are also individuals who simply operate outside the prevailing art culture, by decision or by necessity. Many Outsider artists are isolated by socioeconomic circumstances—poverty and/or a lack of education and opportunity situates them outside the mainstream. Some Outsider artists choose to avoid the conventional art market, and they create art solely for their own satisfaction.

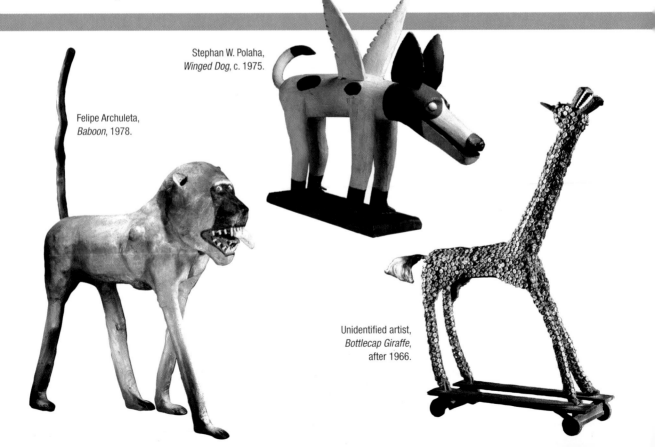

Stephan W. Polaha,
Winged Dog, c. 1975.

Felipe Archuleta,
Baboon, 1978.

Unidentified artist,
Bottlecap Giraffe,
after 1966.

Unidentified artist, *Cane with Indian, Entwined Man and Snake and Diverse Animals*, c. late 1800s.

Unidentified artist, *American Flag Whirligig*, mid-1900s.

Unidentified artist, *Guitar*, c. 1920s–1930s.

Clark Coe, Killingworth Image, *Man on a Hog*, c. 1890.

Animals

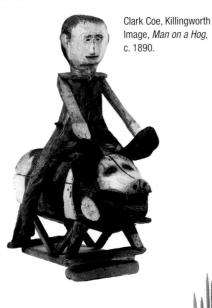

Folk art is one of America's oldest artistic traditions. The art of decoy carving predates colonial America. As a result of folk art's often utilitarian nature and folk artists' adherence to local customs and styles, a large percentage is anonymous and hard to date. Folk art has always relied on local, inexpensive materials; wood is the most commonly used material in both early and current folk art. Contemporary folk artists have also utilized modern, cheap, and abundant media, including refuse materials such as bottle caps and scrap metal.

Ulysses Davis, *Beast Going through the Grass*, c. 1984.

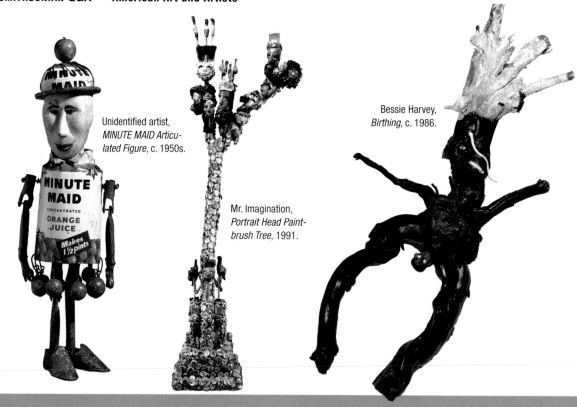

Unidentified artist,
MINUTE MAID Articulated Figure, c. 1950s.

Mr. Imagination,
Portrait Head Paintbrush Tree, 1991.

Bessie Harvey,
Birthing, c. 1986.

Religion

Religious folk art can be described as "working" art—functioning not as icons, which are considered sacred objects in themselves, but as visual sermons. Religious folk objects and paintings do not merely illustrate religious themes; they are created to inspire religious experiences. Tending to be visionary and dramatic in appearance, they often incorporate religious texts. Religious folk art reveals the ethnic diversity of the United States and contains myriad examples of vernacular symbolic language and visual conventions, descended from African, Latin American, and European traditions.

John William "Uncle Jack" Dey,
Adam and Eve Leave Eden, 1973.

Figures

Human beings have always made effigies of themselves; such objects are among the earliest surviving art forms. Folk artists produce many kinds of effigies—dolls are perhaps the most obvious examples. The crafted human figure also serves many other purposes. For some, the figure is an extension of the self, an expression and assertion of identity. For others, it is an object of fantasy, born out of loneliness and desire. The human figure is also a vehicle for humor, an integral element in folk art. Folk and Outsider artists demonstrated a remarkable ingenuity and adaptability to materials long before mainstream artists began experimenting with found objects and junk materials.

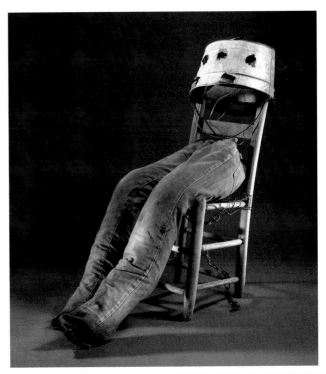

Hawkins Bolden, *Untitled*, 1987.

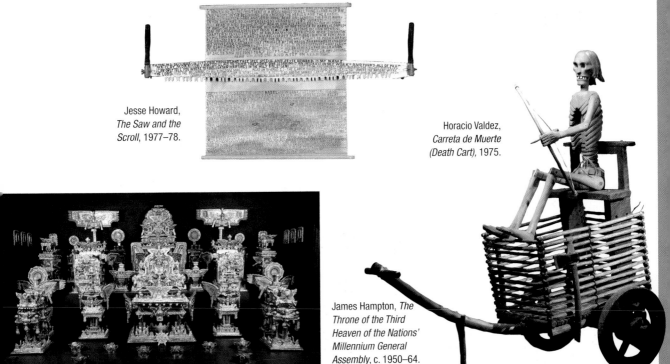

Jesse Howard,
*The Saw and the
Scroll*, 1977–78.

Horacio Valdez,
*Carreta de Muerte
(Death Cart)*, 1975.

James Hampton, *The
Throne of the Third
Heaven of the Nations'
Millennium General
Assembly*, c. 1950–64.

Landscapes

Ironically, it was mainstream artists' forays into Primitivism that inspired twentieth-century attention and admiration for folk art painting. Major artists, such as Pablo Picasso and his circle, explored Primitivism and celebrated naive art. In America, during the 1930s, unknown artists such as Grandma Moses and Horace Pippin were brought out of obscurity and placed within mainstream art. This began a fresh contextualization of folk art, which continues today.

Grandma Moses, *McDonnell Farm*, 1943.

Horace Pippin, *Old Black Joe*, 1943.

Mose Tolliver,
Self-Portrait, 1985.

Lawrence W. Ladd, *Chicago in Flames*, c. 1880.

Louise Nez,
Reservation Scene, 1992.

Howard Finster, *THE HERBERT
WADE HEMPHILL J. R.
COLLECTION FOUNDER OF
AMERICAN FOLK ART THE MAN
WHO PRESERVES THE LONE
AND FORGOTTEN. THE UN-
KNOWN COLLECTION.*, 1978.

Portraits

Folk art is predominantly represen-
tational and filled with personal
meaning. Folk art is disarmingly
direct and emotional, contrasting
the aloofness and detachment that
increasingly embodied mainstream
twentieth-century modern art. Folk
art often reveals how ethnic and social
groups feel about themselves, sometimes
in stark contrast to how they are regarded
by the predominant culture around them.
Folk art portraits often show a symbolic
figure, representing a specific culture
or universal humanity, extending
far beyond the recording of a
notable individual.

Faye Tso, *Head of Emmett*, c. 1985.

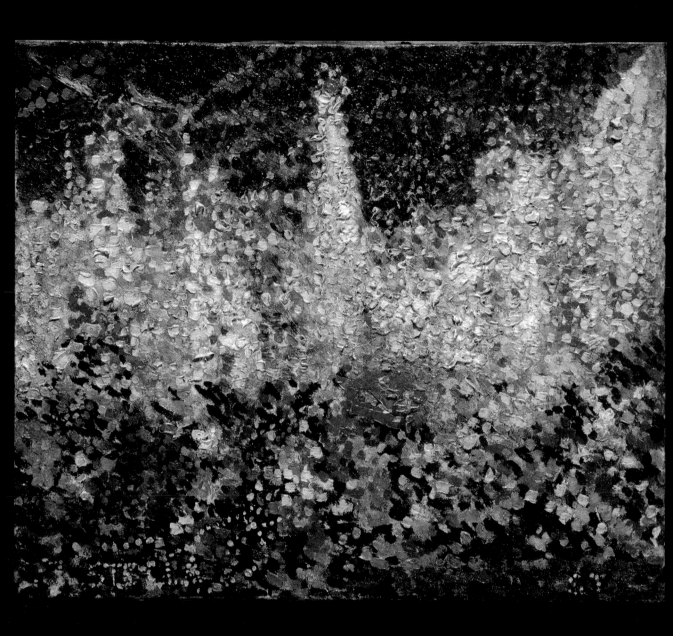

MODERNISM

Academic art still dominated the art scene in the United States at the beginning of the twentieth century. No support structure existed for avant-garde art, even in New York. The first American artists to move toward a Modernist aesthetic did so almost exclusively in Paris during the first two decades of the 1900s. Paris was the center for avant-garde developments: Fauvism, Cubism, and Futurism were in the air, and the innovations of Henri Matisse (1869–1954) and Pablo Picasso (1881–1973) were stirring the European art world. American Modernists, returning to their homeland from Paris, met with strong resistance from a market that did not recognize their work as art. Not until the Armory Show of 1913 did the public fully open its eyes to Modernism. The decades following the Armory Show saw a variety of new artistic forms, movements, and techniques. Dadaist absurdity found a home in New York, and a variety of influences—photography, folk art, and the landscape of the Southwest, among others—moved American art in diverse new directions.

Above: Max Weber, *Reclining Nude*, 1924–30. Weber was a disciple of Modernist movements in Europe early in the 1900s.

Left: Joseph Stella, *Study for Battle of Lights, Coney Island, Mardi Gras*, 1913. This Modernist frenzy is one of a variety of studies Stella made for his groundbreaking piece.

The Early Years

Q: Who were America's pioneering Modernists?

A: Alfred Henry Maurer (1868–1932) was one of the first American Modernists. After studying under William Merritt Chase at New York's National Academy, he began to receive acclaim as a realist painter. From 1897 until 1914, Maurer lived in Paris, where the heightened palette of the Fauves affected his art. At age thirty-six he converted to Modernism, remaining committed to it for the rest of his life. World War I forced Maurer to return to the United States, where his work was rejected wholesale. Maurer was financially dependent on his father, who was also an artist but deeply hostile to Modernism. Unable to tolerate an environment of continuous failure and rejection, Maurer committed suicide shortly after his father's death in 1932. The same sad trajectory shaped the short life of Patrick Henry Bruce (1881–1937). Like Maurer, he had trained with William Merritt Chase. He moved to Paris in 1904, where he developed his mature style of abstract, geometric still lives. Dogged by failure and depression, he destroyed most of his work and eventually killed himself.

John Marin (1870–1953) also belonged to the first wave of American Modernists. His years in Paris, between 1905 and 1909, brought him into contact with Cubism and Futurism, which he successfully fused with his own individual, loosely Expressionist, style. He was especially drawn to watercolor, which he exploited to great expressive effect, combining the medium's innate delicacy with strident and dynamic cubist forms. Marin's works also reveal a familiarity

Alfred Henry Maurer, *Two Sisters*, c. 1924. The motif of two girls, in varying degrees of abstraction, was a recurring theme in Maurer's work. Sometimes the figures overlap, appearing fused together; sometimes they are simply close together, as in *Two Sisters*. The simplified, stylized forms and heightened color show Maurer's allegiance to Fauvism.

with Cézanne's radically innovative watercolors. Though often approaching abstraction, Marin maintained a close connection to nature, devoting much of his art to landscapes, particularly seascapes around Maine. Marin addressed American subjects through a Modernist lens, painting the architecture of the city of New York—notably, the Brooklyn Bridge—and the local landscape with a Modernist interpretation of form.

Marsden Hartley, *Painting No. 47, Berlin*, 1914–15. In Berlin, Hartley produced a series of paintings honoring German military officers. These works contained abstract shapes referencing military insignia, regalia, and personal initials. This work commemorates Karl von Freyburg, Hartley's lover, who was killed in action in World War I.

Q: How important was Gallery 291?

A: In the earliest years of Modernism, Modernists in the United States, deprived of the progressive artistic environment of European centers, struggled to survive in a world hostile to their art. John Marin and others received consistent and valuable support from Alfred Stieglitz, then manager of Gallery 291. Stieglitz played a very important role in Marsden Hartley's development, and Hartley (1877–1943) received his first exposure to the avant-garde through the exhibitions at Gallery 291. After leaving for Europe in 1912, Hartley lived in Paris and Munich between 1913 and 1915. In Germany, he adopted a style that combined emblematic forms and symbolic abstraction, which he learned from Russian-born artist Wassily Kandinsky (1866–1944). Like Maurer, Hartley was forced to return from Germany at the outbreak of World War I, and he became one of the core American Modernists, regularly exhibiting work at Gallery 291.

Q: Who was Max Weber?

A: Weber (1881–1961) was one of the artists responsible for bringing Cubism to the United States. Born in Russia, he immigrated to America with his family at the age of ten. After studying art at Pratt Institute in Brooklyn, New York, he moved to Paris in 1905 to continue his studies, remaining there for four years. Upon his return to New York, he painted fragmented, Cubist (or as he put it, "kaleidoscopic") still lifes.

Q: What was the impact of Cubism on Max Weber?

A: Among the various strains of avant-garde developments occurring in Europe in the first two decades of the twentieth century, Cubism and the interest in Primitivism had the greatest influence on Max Weber's art. He also made paintings of women that displayed an allegiance to Picasso, Matisse, and the earlier, great proto-Modernist, Paul Cézanne.

Max Weber, *Summer*, 1909. *Summer* depicts women as primal forces of nature. Set in a pseudo-jungle environment, the women adopt languid, uninhibited poses reminiscent of Picasso's seminal painting of prostitutes in a Barcelona brothel, *Les Demoiselles d'Avignon* (1907).

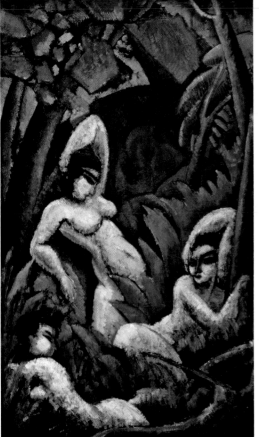

Q: How influential was Futurism?

A: Futurism was an Italian movement that found visual expression in Paris at the end of the 1910s. Futurist artists were excited by speed, and they considered modernity a state of constant flux. Combining elements of Divisionism and Cubism, they created energetic, often violently frenetic paintings. The leading Futurist artists in Paris were the Italians Gino Severini (1883–1966) and Umberto Boccioni (1882–1916). The first American artist to adopt the Futurist style, Joseph Stella (1877–1946), was also Italian born, but he had immigrated to the United States as a young man. Stella came into contact with Futurism as it emerged in Paris around 1910, and after returning to New York in 1912 he used the inspiration to produce *Battle of Lights, Coney Island Mardi Gras*, his first Modernist work. In New York, Stella became one of the avant-garde artists invited by Stieglitz to show works at Gallery 291.

Q: What was Synchromism?

A: Stanton Macdonald-Wright (1890–1973) was born and raised on the West Coast, and he studied at the Art Students League in Los Angeles before leaving for Paris in 1907. In Paris, he befriended a fellow countryman, artist Morgan Russell (1886–1953), who had moved from New York in 1908. Together, they developed a new system for art, which they named Synchromy. Their system, derived from their investigations into color and optical theory, focused on color's inherent

emotional and abstract values. They believed that color could be used as abstractly as musical notes, and by arranging colors in scales, their paintings could achieve a musical effect. However, their ideas did not fully extend to form, and their paintings achieve only partial abstraction as a result. Macdonald-Wright left Paris for England in 1914 and returned to the United States two years later.

Q: Who was the first American abstract artist?

A: Arthur Dove (1880–1946) spent only one year in Paris, but it proved to be the catalyst for releasing his latent experimental impulses. While there, Dove was closely involved with Maurer, Bruce, and Weber in the pursuit of Modernism. Dove has the distinction of being considered the first American abstract artist, based on a set of abstract paintings he made in 1910. He was also the first American artist to exhibit purely abstract paintings, at Stieglitz's invitation, at Gallery 291. Dove referred to his abstract paintings as "extractions." He wished to extract

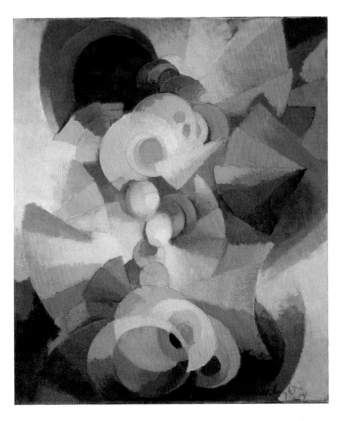

nature's essence and reveal its hidden elemental forms. He was less interested in formal exploration than in conveying the emotions evoked by nature. He lived close to the land, and his work related to nature throughout his career. Financial hardship forced him to live for several years on a houseboat on Long Island Sound, and finally as a recluse, in an abandoned post office in Centreville, New York. An innovator, Dove was comfortable working with unorthodox materials, and he produced a number of assemblage-type works in the 1920s that show an affinity with Dadaism. He also developed an organic vocabulary of forms often suggestive of the biomorphic abstractions of the Surrealist movement.

Above: Stanton Macdonald-Wright, *Conception Synchromy*, 1914. In 1919, Macdonald-Wright moved back to California and continued his experiments with color. He was an important exponent of Modernism on the West Coast.

Left: Arthur Dove, *Sun*, 1943. In this late painting, Dove created a visionary and animated image of the sun, which seems to actively communicate its radiance.

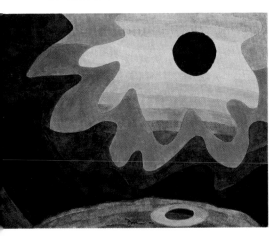

The Armory Show

Q: Why were 1910 and 1913 pivotal years for American art?

A: Before the momentous Armory Show, Robert Henri, spokesman for The Eight, had organized a historically significant exhibition. Henri had rebelled against the conservative National Academy in 1908 and created his first independent exhibition of art, which passed without much notice. The second independent exhibition he organized in 1910, though, was a popular success, showing that art could prosper independent from the Academy. Henri's efforts paved the way for the much larger, groundbreaking Armory Show three years later. The official title for the Armory Show was the International Exhibition of Modern Art. It was called the "Armory Show" because of its location at the vast 69th Regiment Armory building in Manhattan.

Arthur B. Davies, *Bathing Woman and Servant*, 1917. A small and compact drypoint etching, *Bathing Woman and Servant* shows the influence of Cubism and the impact of the Armory Show on Davies's fractured and faceted treatment of form. This was not a permanent conversion, though, and Davies returned to his former style after 1920.

Q: Why was the Armory Show so important?

A: The Armory Show was the first significant venue for Modernism in the United States, and it changed the course of American art. Realism and conservative academic art were both familiar to the American audience, and Impressionism also had become a generally acceptable style. The Armory Show showcased the avant-garde developments in full swing in Europe (mainly Paris). Examples of Fauvism, Cubism, Divisionism, Primitivism, and Symbolism were bewilderingly unfamiliar and shocking to the mainstream audience. The exhibition was huge, including 1,250 works by over three hundred artists, in eighteen separate galleries. It included American and European artists, as well as works by some earlier artists such as Francisco Goya (1746–1828).

Q: Who was responsible for organizing the Armory Show?

A: The Association of American Painters and Sculptors organized the Armory Show under the leadership of Arthur Bowen Davies (1862–1928) and Walt Kuhn (1877–1949). The show was originally conceived as a presentation of American modern art, but under Davies's influence it grew to encompass artists from across Europe. Davies possessed a sophisticated knowledge of avant-garde trends, was extremely well connected, and had eclectic tastes. Many American artists had a hand in the selection of art for the Armory Show. Robert Henri and many of the Ashcan artists helped to organize the event. Among the American artists to exhibit at the Armory Show were Maurice

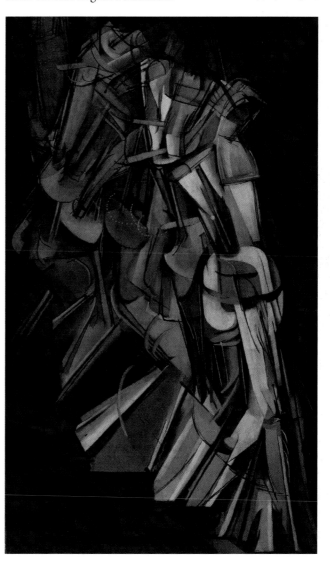

Prendergast and the American Impressionists, artists of the Ashcan school, and the American Modernists. Davies was an enthusiastic supporter of Modernism, but his own work was comparatively conservative and leaned toward a dreamy symbolism that most closely resembled the works of French artist Odilon Redon (1840–1916) and the American mystic Albert Pinkham Ryder (1847–1918).

Q: What was the most controversial work at the Armory Show?

A: There was much at the Armory Show to shock the unsuspecting American audience, but the *succès de scandale* was undoubtedly *Nude Descending a Staircase No. 2* by the young French artist Marcel Duchamp (1887–1968). The offending painting was exhibited in one of the galleries of French art that became known simply as the Cubist Room. The impact of the work, especially in the context of the Armory Show, cannot be overstated. *Nude Descending a Staircase No. 2* epitomized all that was either exhilarating or preposterous about Modernism, depending on one's point of view. Controversy became a reason in itself to see the show, and the Cubist Room earned the highest

attendance, attracting an audience eager to be amused and appalled by a work of such notoriety. However, Duchamp was by no means the only artist whose work provoked outrage and scorn; many viewers also reviled Henri Matisse, among others. Surprisingly, Picasso's paintings received little negative attention.

Left: Poster advertising the Armory Show, 1913.

Below: Marcel Duchamp, *Nude Descending a Staircase, No. 2*, 1912. Duchamp's revolutionary treatment of the human form incited both critical and public outrage.

New York Dada

Man Ray, *Self-Portrait*, 1916. *Self-Portrait* is one of Man Ray's first Dada works, as evidenced by its offbeat humor and unorthodox technique and materials (it is a photo-mechanical reproduction on plastic, laminated to plexiglass). It hints at his later experiments with photographic processes.

Q: What is Dada?

A: Dada is a French word meaning "hobby-horse." The name was chosen randomly and had no inherent meaning for the artists who adopted it. Initiated by a group of artists in Switzerland in 1916, Dada was a reaction against the carnage and meaningless destruction of World War I. The Dadaists held deeply cynical, nihilistic, and anarchic views about contemporary society. They were defiantly anti-rational—exploiting meaningless gestures, absurdity, and provocative acts as a way to subvert what they saw as a smug bourgeois complacency in the face of the mindless destruction of war. Dada did not have a unified style; it was an artistic attitude, characterized by defiance of traditions. Dadaists expressed themselves through visual arts, theater, and literature.

Q: Who created New York Dada?

A: In 1915, two years after his notorious *Nude Descending a Staircase No. 2* caused scandal at the Armory Show, Marcel Duchamp arrived in New York. His compatriot and fellow art rebel Francis Picabia (1879–1935) arrived the same year. Duchamp and Picabia teamed up with Man Ray (born Emmanuel Radnitzky; 1890–1976), a versatile artist whose work had become increasingly experimental as a direct result of the Armory Show. The three artists created a small, radically avant-garde group with a proto-Dada ethos. Their activities were centered around Gallery 291, and they were also associated with the Society of Independent Artists, founded in 1916. Duchamp and Picabia were enormously influential figures; they were both rebellious, anarchic characters who shared a Dadaist love of subversion and absurdity. It was in New York during this time that Duchamp began producing the readymades that have made him the seminal influence over modern artists. In 1917, Duchamp resigned from the Society of Independent Artists, after his famous readymade sculpture, a ceramic urinal entitled *Fountain*, was rejected by the Society. Duchamp's influence and legacy in the visual arts have been profound. His and other Dadaists' efforts constituted the beginning of anti-art, anti-aesthetics, and the supremacy of idea over form, setting a precedent that culminated in the birth of Conceptual art in the 1960s.

Q: What were the characteristics of New York Dada?

A: New York Dada art contained more humor and was generally more lighthearted than its European counterpart. New York Dada was relatively short-lived however. In 1921, Man Ray immigrated to Paris, after declaring, "Dada cannot live in New York." The Dada artists favored unconventional materials and mediums—ones not considered acceptable for art by the academic establishment. Purposefully using techniques considered crass, they showed disdain for conventional craftsmanship and traditional artistic practice. In Paris, Man Ray ventured into Surrealism and developed his distinctive and innovative Dada/Surrealist body of photographs. He also developed his photographic technique, solarization, in which color tones are reversed on a developing photograph, so dark areas appear light, and vice versa.

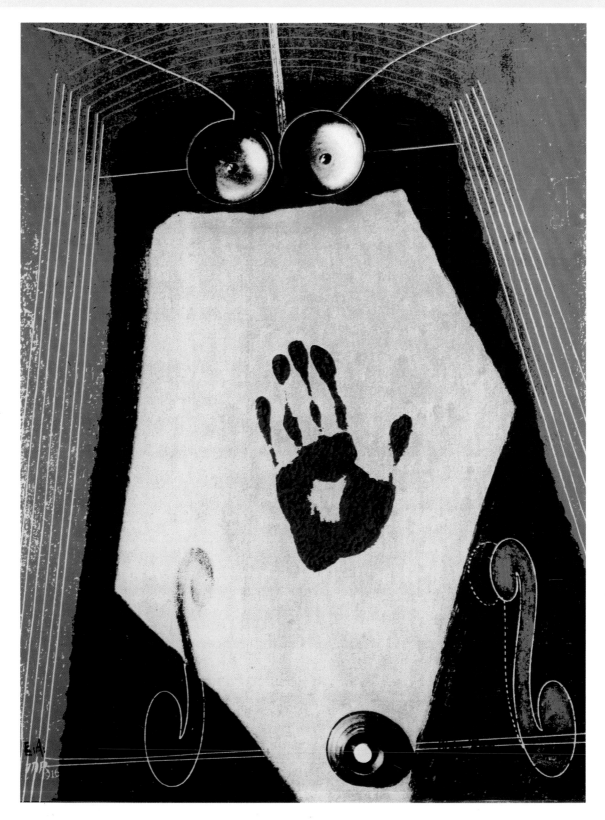

Homegrown Inspiration

Q: What uniquely American art was shown at the Armory Show?

A: Amid the excitement and the spectacle of avant-garde controversy at the Armory Show were the quiet visionary works of the elderly American painter Albert Pinkham Ryder. Ryder's small paintings were of great significance to American artists seeking a uniquely modern, American voice. The homegrown wealth of folk art was also an inspiration for sculptor Elie Nadelman, who incorporated folk elements into his own work and built the first museum of American folk art.

Albert Pinkham Ryder, *Moonlight*, 1887. Ryder's career was spent pursuing the mystical essence of the natural world. He painted mainly seascapes and religious themes, which became increasingly reductive throughout his career and are distinguished by a glowing, ethereal light.

Q: What was central to Ryder's art?

A: Ryder lived the life of a true eccentric, surrounded by flotsam and jetsam of accumulated junk in his New York apartment. As a young man, he received

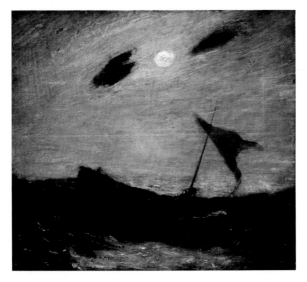

sporadic artistic training at New York's National Academy of Design, but he developed largely in isolation, and his art was the product of his unique and visionary imagination. Ryder had connections to the Society of American Artists, with whom he exhibited in 1877, but he was shy and reclusive by nature and remained generally outside artistic circles. Ryder had unusual and technically disastrous working habits; he would rework paintings over periods of years, building up thick layers of paint. He also showed a complete disregard for the drying times of paints and varnishes. He would apply paint over varnish that was still wet, and paint thinly over thick paint, which caused his paintings to darken and crack. Because of his eccentric habits, many of Ryder's paintings cannot be seen in their original state, and quite a number have deteriorated beyond recognition.

Q: Why were Albert Pinkham Ryder's visionary paintings important to the American avant-garde?

A: Ryder was invited to show ten of his paintings at the Armory Show in 1913. Since most American artists were allowed only two works at the exhibition, this was a clear indication of Ryder's high standing among America's avant-garde. His radical simplifications of form, and intensification of atmosphere, created powerfully evocative, almost abstract works that appealed to the Modernist aesthetic. Ryder's clumsy, almost primitive drawing and crude application of paint

ran counter to academic values—this endeared him to Modernists looking to the art of the Fauves for inspiration. Though firmly unaffiliated with any contemporary movement or trend, Ryder's art provided a homegrown, truly American equivalent to European Modernism.

Q: How was folk art an inspiration?

A: Polish-born sculptor Elie Nadelman (1882–1946) arrived in New York in 1914 after leading a fairly peripatetic life throughout Europe and sustaining a successful career in Paris. It was in the United States that Nadelman realized his mature style—a synthesis of classical, Modernist, and folk forms. Though not a Modernist, he remained close to his early, classically influenced style, being a true forward-thinker who saw beyond the distinctions of high and low art. He had a great admiration for American folk art—with its simplicity of form and its lack of pretension—and drew heavily from its traditions of craftsmanship. He also adopted various folk practices, such as painting his sculptures, and "jointing" his figures—constructing them from several pieces instead of carving from a solid block.

Q: Who built the first American folk art collection?

A: In 1919, Nadelman married a wealthy American woman named Viola Flannery. Together, he and his wife built a massive collection of American, European, and Russian folk art. Their collection grew until they had amassed over ten thousand artifacts. In 1926, they opened their collection to the public and established the Museum of Folk and Peasant Arts, America's first museum of folk art. Eventually, financial difficulties forced them to sell their collection to the New-York Historical Society. Nadelman's career lost momentum after his marriage, and the couple's financial stability never recovered from losses suffered during the Depression. Nadelman then became quite an obscure figure in the American art world. In 1946, suffering from poor health, he killed himself.

Above: Albert Pinkham Ryder, *Jonah*, 1885–95. *Jonah* is one of Ryder's visionary religious masterpieces, showcasing the strange glow and dynamic movement common in much of his work. Ryder reworked the image countless times—a century after he finished it, the layers of paint are still not completely hardened.

Left: Elie Nadelman, *Dancer*, c. 1918–19. Nadelman's conversion from working in bronze to carving in wood in 1917 stemmed directly from his admiration of folk art, but his wooden works proved unpopular with the public and did not sell.

Precisionism

Q: What was Precisionism?

A: Precisionism, an exclusively American movement that began in 1915, was characterized by a synthesis of objectivity and formal reduction that at times approached abstraction. Its leader, Charles Sheeler (1883–1965), chose the name Precisionism to describe his uniquely American style of painting. Precisionism was influenced to some degree by Cubism and Futurism but was especially characterized by a strong commitment to the American landscape and a celebration of industrial and technological progress in America. The two leading Precisionists were Sheeler and Charles Demuth (1883–1935).

Q: What was the role of photography in Sheeler's work?

A: Charles Sheeler was born in Philadelphia, attended the Philadelphia School of Industrial Art in 1900, and received his early art training from William Merritt Chase at the Pennsylvania Academy of Fine Arts, from 1903 to 1906. Sheeler's decision to become a professional photographer in 1912 was based on his doubts that he could support himself as an artist. Photography also played an important role in his painting, inspiring him to move toward the precise style that reached its full expression around 1920. Sheeler took clear, hard-edged photographs, mainly of architectural and engineering materials, and he transferred this focus to his supremely restrained paintings of America's industrial landscape. There are rarely living things in Sheeler's work; most of his paintings focus on the machinery of modern life. He won his first acclaim for a 1927 series of photographs he was commissioned to make of the Ford Motor Company's River Rouge plant, in Michigan.

Q: How did Charles Demuth link industry to Precisionism?

A: Sheeler's fellow Pennsylvanian Charles Demuth grew up in the town of Lancaster, then studied at the Pennsylvania Academy of Fine Arts. He occupied the same Philadelphia boarding house as the poet William Carlos Williams, and the two became lifelong friends. In 1918, Demuth paid homage to Williams's poetry in what is probably his most famous work, *The Figure 5 in Gold*. Demuth was more flamboyant and cosmopolitan than Sheeler. He had lived

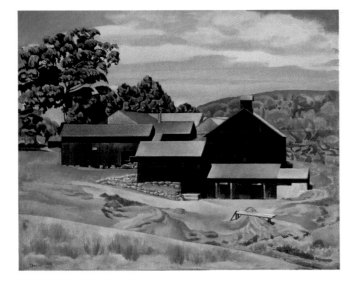

Charles Sheeler, *Connecticut Barns in Landscape*, 1934. Here, Sheeler uses his crisp and reductive style to depict a preindustrial model of American diligence—the interconnected barns of a Connecticut farm. The Precisionist treatment highlights the simple yet complex design of the barns, whose geometric certainties contrast their natural surroundings.

Q: Who was associated with Precisionism?

A: The works of Georgia O'Keeffe (1887–1986) and Ralston Crawford (1906–78) shared allegiance with the Precisionists. O'Keefe had a Precisionist interest in the towering architecture of Manhattan, though she is more accurately represented by the work she made after she left New York for New Mexico. The relationship between painting and photography that sparked Charles Sheeler's development was also a significant influence in the cleanly rendered paintings of Ralston Crawford. Born in Canada, Crawford grew up in the industrial landscape of Buffalo, New York. His work reveals his enduring attraction to the bridges, grain elevators, and shipyards of his childhood. He took up photography in the late 1930s, and his paintings became increasingly flat and radically simplified.

Charles Demuth, *Aucassin and Nicolette*, 1921. Demuth's decision to use the title *Aucassin and Nicolette* wryly acknowledges the mundanity of the factory buildings while simultaneously bestowing them with comic grandeur (Aucassin and Nicolette were two fictional lovers in a French medieval romantic comedy).

Ralston Crawford, *St. Petersburg to Tampa*, 1938. Crawford pursued a greater distillation and reduction of form than either Sheeler or Demuth—pared down to essential geometric forms, his paintings are flatter and more abstract.

in Europe and spent two years in Paris beginning in 1912. He befriended avant-garde artists and immersed himself in a Modernist environment, but his own work remained consistently representational. Cubism, however, clearly influenced the reductive and prismatic qualities of Demuth's Precisionist work. Through his friendship with Marsden Hartley, whom he met in Paris, Demuth became one of the many modern artists to exhibit at Gallery 291. Demuth was also encouraged by Marcel Duchamp to celebrate the machine age, and in his paintings, Demuth transformed the commonplace and utilitarian landmarks of industrial America—the grain silos, factory buildings, and machine plants—into heroic monuments to American progress.

Georgia O'Keeffe and Southwest Modernism

Q: When did modern artists become attracted to the American Southwest?

A: In the 1920s and 1930s, New York was the undisputed center for modern art in the United States, and the iconic image of the city itself was central to Modernism. After World War I, however, a steady trickle of artists began exploring the American landscape, in particular the arid deserts and hills of the Southwest. Many American Modernists visited New Mexico during this period, including Marsden Hartley and John Marin, but the artist that has come to represent the American Southwest, and on whom the Southwest exerted the most enduring influence, was Georgia O'Keeffe.

Q: What was O'Keeffe's background?

A: Georgia O'Keeffe was born in the aptly named town of Sun Prairie, Wisconsin. She first trained at the Art Institute of Chicago, and in 1907 she became one of the many artists to study at the Art Students League under William Merritt Chase. She later studied with Arthur Wesley Dow at Columbia University from 1914 to 1915; his teaching had a lasting impression on her. Dow's interest in Japanese art and strengths as a graphic designer imparted an awareness of the power of bold, simple graphic shapes to O'Keeffe.

Her first forays into abstraction— mostly watercolors and drawings—were a result of Dow's influence. Her early abstract works came to the attention of Alfred Stieglitz, who offered O'Keeffe her first solo show, at Gallery 291 in 1917. She moved to New York the following year, at Stieglitz's invitation, then began a relationship with Stieglitz, twenty-three years her senior. They were married in 1924. Amid Gallery 291's fertile environment of avant-garde art, O'Keeffe began to paint the large-scale, magnified portraits of flowers that brought her early success and have earned her lasting renown. From the 1920s until 1949, when she left New York permanently for New Mexico, O'Keeffe's attention was divided between flower paintings and paintings of the cityscape.

Q: Who was Mabel Dodge?

A: The turning point that initiated O'Keeffe's lifelong relationship with the Southwest was her 1929 visit to New Mexico as a guest of Mabel Dodge. Mabel Dodge Sterne Luhan (1879–1962) was, by all accounts, an unorthodox and forceful woman. A wealthy heiress, patron of the arts, and important figure in the New York art scene from around 1912 to 1916, she abandoned New York for New Mexico in 1919 and established a literary colony at Taos. She invited many important writers and artists to her ranch outside Taos, including D. H.

Lawrence and Marsden Hartley. From 1929 on, O'Keeffe spent significant portions of time in New Mexico, establishing a summer residence at Ghost Ranch in 1934. Stieglitz always stayed fiercely attached to the city, and O'Keeffe did not settle permanently in New Mexico until 1949, after Stieglitz's death in 1946 freed her from the necessity of spending part of her time in New York.

Georgia O'Keeffe, *Black Hills with Cedar*, 1941–42. O'Keeffe brought a Modernist's reductive eye to the American landscape, which distinguished her work from the more traditional art of the Southwest.

Q: What did the Southwest mean to American Modernism?

A: An important aspect of Southwest Modernism was its departure from the themes and stylistic habits of the European Modernists, who had exerted a huge influence over the development of American Modernism. Like Sheeler and the Precisionists, O'Keeffe painted subjects that were decidedly American, and she was more interested in the development of her own American artistic language than any trends Europe had to offer. "One cannot be an American by going about saying one is an American," she said. "It is necessary to feel America, like America, love America and then work." She also declared, "I think I am one of the few who gives our country any voice of its own."

Throughout her career, O'Keeffe maintained a close relationship to nature, depicting it with an innovative sense of scale and an idiosyncratic palette. She approached the landscape and rugged iconography of the desert the way the Precisionists approached America's industrial landscape—revealing and distilling its innate beauty. She brought a Modernist's reductive eye to the American landscape, which distinguished her work from the more traditional art of the Southwest.

Q: What was the Taos school?

A: Artists had settled in the town of Taos, in the north-central region of New Mexico, as early as 1898. Ernest Blumenschein (1874–1960), a founding member of the Taos Society of Artists (later known as the Taos Art Colony), helped create the American tradition of "western art." The New Mexico landscape and Taos Pueblo culture was central to western art. Mabel Dodge also attracted many artists to Taos during the 1920s and '30s, and some stayed— building a significant artistic community over time.

Ernest Blumenschein, *Picuris Mountain (Near Taos)*, c. 1940. In this quiet landscape, Blumenschein focuses on the interplay of light on the strange geology of the mountains.

THE DEPRESSION AND WORLD WAR II

American attitudes toward art from the late 1920s to the mid-1940s were influenced by two dominant events: the Great Depression (1929–c. 1939) and World War II (1939–45). A deep nostalgia for an older, pre-Depression, preindustrial America developed in the public psyche. The populace generally mistrusted and rejected European trends, and popularity grew for realistic art that promoted American values. President Franklin Roosevelt's New Deal promoted and supported art through the Federal Art Project (FAP), paying artists wages in exchange for the creation of public artworks that glorified labor and related to the concerns of the American people. Realist art dominated the scene, exemplified by the Regionalists' heartland vignettes, the critical stance of the Social Realists, and the stark slices of life of Edward Hopper. Various abstract artists—Burgoyne Diller, Alexander Calder, and Stuart Davis, among others—continued their innovations with somewhat less acclaim from the general public, and the highly original artwork of the Harlem Renaissance proudly asserted the culture and history of African Americans.

Above: William H. Johnson, *Early Morning Work*, c. 1940. Johnson used simple forms and bold colors to embody the struggles and joys of African American life.

Left: Ben Shahn, *The Riveter* (detail, mural study, Bronx Central Postal Station), 1938. Shahn made both paintings and photographs for the Works Progress Administration in the 1930s.

Norman Rockwell

Q: What was Rockwell's vision of America?

A: Norman Rockwell (1894–1978) became a household name early on in his career, and to this day he is one of America's most beloved artists. Critical opinion is divided about his work— though he is appreciated by much of the American public, he is also criticized for being overly sentimental and nostalgic. Rockwell's visions of America were often out of sync with the harsher side of American life. Though Rockwell was an established artist when the Depression swept across the country in 1929, he rarely used his art to portray the suffering of those years. Later works earned more critical appreciation for depicting more complex subjects, especially his series of illustrations addressing racism for *Look* magazine. Rockwell was undoubtedly a master of technique. He began his art training early, at age sixteen, at the Chase Art School, and then attended the National Academy of Design and the Art Students League in New York. His polished, highly detailed, narrative style remained constant throughout his career and was not overtly influenced by changing trends in the art world.

Q: How did Rockwell's art reflect popular taste?

A: Norman Rockwell's paintings were aimed at a popular audience that he understood well. In Rockwell's paintings, the United States was generally a place where wholesome, healthy, and happy citizens lived in a world filled with

Norman Rockwell, *Homecoming*, 1924. In his portrayal of a careworn man returning home to his faithful dog, Rockwell offers up uncomplicated canine devotion as a salve against the complexities and difficulties of life.

sweet sentiment and gentle humor. For forty-seven years he created illustrations for the covers of the illustrated weekly magazine the *Saturday Evening Post* and consistently provided its readers with images of the kind of America they either remembered, or wished they had. Rockwell's clever illustrations showed an America untroubled by misery, poverty, and social unrest and reflected a popular desire for escapism during troubled periods. Though his later work brought him more serious attention as an artist, he always called himself an illustrator. A prolific painter, Rockwell produced over two thousand works during his long career. His fame was partly due to the popularity and wide circulation of the *Saturday Evening Post*, and his paintings were known to most in print form only.

Q: What were the Four Freedoms?

A: Among Rockwell's most famous works are his *Four Freedoms* paintings, produced in direct response to the speech made by President Franklin D. Roosevelt in 1941. In his speech to Congress, two years after World War II had begun in Europe, Roosevelt asserted the four human freedoms essential for democracy: freedom of speech and expression, freedom of worship, freedom from want, and freedom from fear.

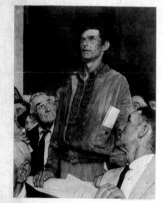
Freedom of Speech

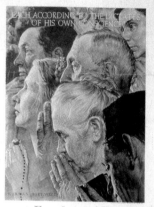
Freedom of Worship

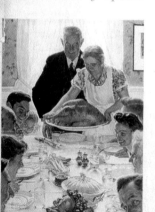
Freedom from Want

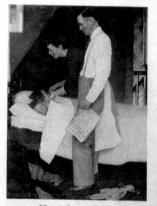
Freedom from Fear

Norman Rockwell, *Ours . . . to Fight For* (Poster depicting the Four Freedoms), 1943.

"I paint life as I would like it to be."

—NORMAN ROCKWELL

Regionalism and the American Scene

Q: What is Regionalism?

A: Regionalism encompasses a handful of American artists who became prominent in the 1930s for working in a realist style and producing images of heartland America. Chief among them were Grant Wood (1891–1942) and Thomas Hart Benton (1889–1975). The Regionalist artists rejected the European Modernist influence, worked in isolation from American avant-garde developments, and actively promoted rural values. Regionalism looked inward, turning away from the cities and the broader world beyond. Regionalist artists focused on small-town America and the great expanse of the Midwest.

Q: How did Thomas Hart Benton paint America?

A: Regionalism became nationally known in 1934, when *Time* magazine ran an article on America's regional artists, printing a self-portrait by Thomas Hart Benton on the cover. Born in Missouri, Benton studied at the Art Institute of Chicago before leaving for Paris in 1908. In Paris, he became interested in Synchromy, the abstract style created by the American artist Stanton Macdonald-Wright. Benton returned to the United States in 1913, continuing his Modernist explorations in New York until around 1920, when he had a complete change of heart and rejected Modernism outright. In 1935 Benton abandoned city life and traveled to the Midwest, finally settling once more in Missouri. He focused his art on the everyday existence of rural, working-class people, and the hardships of country living. Throughout his career Benton remained staunchly opposed to Modernism and its rarefied influence; he was a fierce proponent of realism and the democratization of art. Benton had a

Thomas Hart Benton, *Field Workers (Cotton Pickers)*, 1945. Benton's paintings contain a coiled energy that makes forms appear to writhe and twist as though resisting their immobility on the canvas. The landscape in *Field Workers (Cotton Pickers)* undulates with wavelike billows and joins the cotton pickers in a swirling rhythm that suggests an uneasy collaboration.

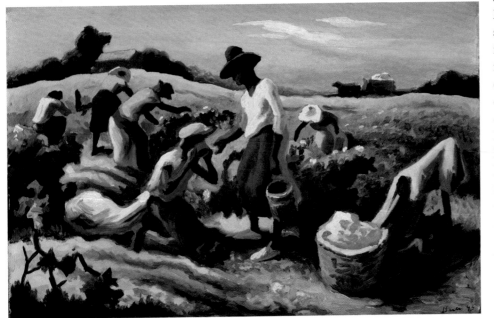

forceful personality, with strong left-wing beliefs. He produced a number of public artworks, and his raw, controversial murals for the state of Indiana brought him national attention and put him on the cover of *Time* magazine. He also made an impact as a teacher—Jackson Pollock was one of his students at the Art Students League in New York, and Benton's passionate and rebellious personality struck a chord in the young artist.

John Steuart Curry, *Ajax*, 1936–37. *Ajax* takes its name from the stalwart warrior of Greek mythology, a figure of fortitude and enormous strength, embodied here in the massive form of the prize bull. *Ajax* is also an image of rural harmony and agricultural bounty. Under temperate skies, well-fed cattle graze on rich green farmland that spreads out as far as the horizon.

Q: How did John Steuart Curry address the Dust Bowl years?

A: John Steuart Curry (1897–1946) was another important Regionalist artist. Born in Kansas, Curry followed a similar pattern to Thomas Hart Benton, educating himself at the Kansas City Art Institute and spending time in Paris before moving to New York City. Curry was not as motivated as Benton by a political agenda—he possessed a straightforward affection for rural America and an understanding of the pleasures and difficulties of those living cheek by jowl with nature. Amid the depths of the Depression, during the Dust Bowl years, drought and severe dust storms destroyed the farmland and rural economy of the Midwest, displacing as many as two and a half million Americans. Curry's *Ajax*, a portrait of a sturdy bull, was meant as a symbol of hope and a promise of renewal during uncertain times. Curry also painted murals based on American history, such as *The Tragic Prelude* (1938–40), commissioned for the second-floor corridor of the Kansas State Capitol.

Q: What was Grant Wood's America?

A: The most gifted and authentically "regional" of the Regionalist artists was Grant Wood (1891–1942). Born in Iowa, he moved to Cedar Rapids with his mother and sister when he was ten years old. Apart from Wood's art schooling in Chicago in 1913, his time in the military, and visits to Europe he made between

Grant Wood, *Young Corn*, 1931. The insistence on agrarian bounty gives this intensely stylized work an almost cartoon-like exuberance, in which growing things bulge like an overstuffed chair. *Young Corn* was painted as a tribute to a schoolteacher from Wilson School in Wood's hometown of Cedar Rapids.

1920 and 1928, Cedar Rapids remained home throughout his life. He earned his living as a public school teacher in Cedar Rapids and, from 1935 on, as a teacher at Iowa University. Wood ignored Modernism and rejected the European influence on modern American art. His subject was the American scene—the landscape of the Midwest, small town and farming life, portraits of local characters, and occasionally, images of American history. An outspoken advocate for an American voice in art, he championed Regionalism throughout his career. Wood

was a founding member of the Stone City Art Colony, established in 1932 with the intention of furthering Regionalism. In 1935, he published a pamphlet called "Revolt Against the City," declaring that urban art was filled with unhealthy, imported influences. Wood's conservatism and his outspoken rejection of Modernism eventually earned him, and some other Regionalist artists (including Thomas Hart Benton) reputations as xenophobic, reactionary figures.

Q: What is *American Gothic*?

A: Wood's experience in Europe left him completely cold to Modernism. In Paris he had been attracted to Impressionism, but a trip to Munich in 1928 converted him to the great fifteenth-century artists of the Northern Renaissance. He was deeply impressed by the wonderful exactitude of Northern Renaissance art, notable for its intense realism, fine attention to detail and texture, and smooth, uninterrupted surfaces. Two years after his visit to Munich, Wood painted *American Gothic*, his iconic image of rural American life. It won him instant acclaim. *American Gothic* reveals Wood's desire to render, with truthful accuracy and clarity, the material facts of his subject. His characters (modeled by his sister Nan and a local dentist) are wearing late nineteenth-century clothing contemporary with the Gothic Revival–style farmhouse. The title refers to the pointed, arched windows of the farmhouse and also to the Northern Renaissance pictorial convention of the formal half-portrait, which was presented straight on and up

close, with a landscape beyond. *American Gothic* is a mysterious painting; its characters' relationship is unclear—they seem psychologically isolated, yet they form a united, if physically unwelcoming, front. Wood maintained that the painting was a sincere homage to traditional American values, and not, as it is often interpreted, an ironic depiction of small-town insularity.

Q: How did Regionalism progress?

A: Andrew Wyeth (b. 1917) belongs to a younger generation of artists focusing on the American scene in a consistently representational and realist style. Less concerned with promoting or preserving a particular way of life, Wyeth's art reveals an intensely

personal relationship with his subjects. His art training was a family affair—he was taught by his father, the painter and illustrator Newell Convers Wyeth (1882–1945), and he learned the demanding skills of egg tempera painting from his brother-in-law, Peter Hurd. Wyeth won success early in his career, with his first solo exhibition in New York at age twenty. Throughout his long career, Wyeth has worked exclusively with watercolor and tempera. His work is distinctive for its technical mastery and its highly subdued palette. Wyeth divides his time between two homes, in Pennsylvania and in Maine, which make up the bulk of his subject matter.

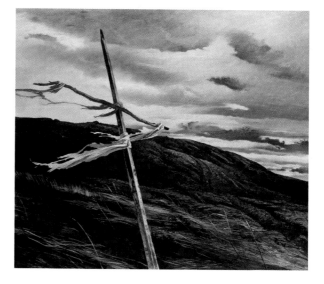

Left: Grant Wood, *American Gothic*, 1930. The farmhouse that inspired Wood's portrait was built in the 1880s in Eldon, Iowa. Reportedly Wood was impressed by its compact design and amused by its dainty gothic character, given its proximity to the rough stockyards across the street. By one account, the gothic-shaped window was a kit from the Sears, Roebuck catalog.

Below: Andrew Wyeth, *Dodges Ridge*, 1947. This bleak winter landscape displays Wyeth's typically subdued palette of earth tones and subtle grays. A broken-down stake with a crossbar and tattered remnants of fabric creates a makeshift crucifix. The painting probably commemorates the death of Wyeth's father, the illustrator N. C. Wyeth, in the winter of 1945.

Edward Hopper

Q: How was Edward Hopper unique?

A: In his commitment to American life, and desire to find a genuine American voice, Edward Hopper (1882–1967) shared certain values with the Regionalists. The association ends there though, as Hopper was an independent and truly original artist. The psychological depth of his art and his attentiveness to the internal qualities of American life distinguishes him from his contemporaries. His paintings have a profound, often melancholy presence, his distinctive use of light setting the mood for his compositions. Hopper remained aloof from progressive art trends right up until his death in May of 1967.

Q: What was Hopper's early influence?

A: Edward Hopper was a student of Robert Henri, an inspirational teacher and champion of realism. Henri's influence on Hopper's development was significant. The vivid works of the Ashcan artist John Sloan also encouraged Hopper's interest in American urban life. From 1906 to 1910, Hopper spent considerable amounts of time in Europe, mainly in Paris. Modernism held little attraction for him; he inclined more toward French realist art and the work of Edgar Degas. Hopper's experiences in Europe had a lasting influence, and back in the United States he saw America with fresh eyes. Hopper exhibited and sold his first painting at the Armory Show in 1913, but it would be years before he achieved financial success from his art. Trained early on as an illustrator, Hopper supported himself in this way until 1924, when he devoted himself solely to his art. *Eleven A.M.* was painted two years later, and the mundane scene and loosely applied brushwork reveal his interest in a straightforward realist approach.

Q: What is *Nighthawks*?

A: One of Hopper's great achievements was his ability to convey loneliness. He was able to capture the alienation of urban

Bottom left: Edward Hopper, *Eleven A.M.*, 1926. The woman's form is reminiscent of the earthy young women that populated the paintings of the Ashcan artists, such as John Sloan, but the introspection of the scene, with its strange and lonely atmosphere, is uniquely Hopper's own.

Bottom right: Edward Hopper, *Nighthawks*, 1942. The late night emptiness of the streets contrasts with the harsh glare inside the diner. The cold light serves to accentuate the isolation of the people, who seem held by lethargy as the night moves on.

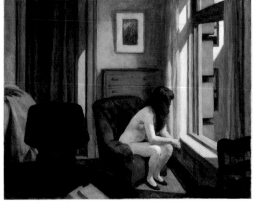

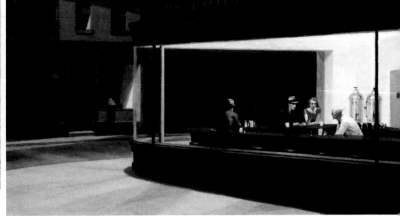

existence, as well as private internal isolation. His art does not exemplify the robust realism practiced by the Ashcan artists; his paintings are moments frozen in time—painfully evocative vignettes that have the air of film stills. *Nighthawks*, painted in 1942, is Hopper's most famous painting. *Nighthawks* is an iconic American image, like Grant Wood's *American Gothic*, but presents the viewer with a modern, urban, and decidedly stark vision of American life.

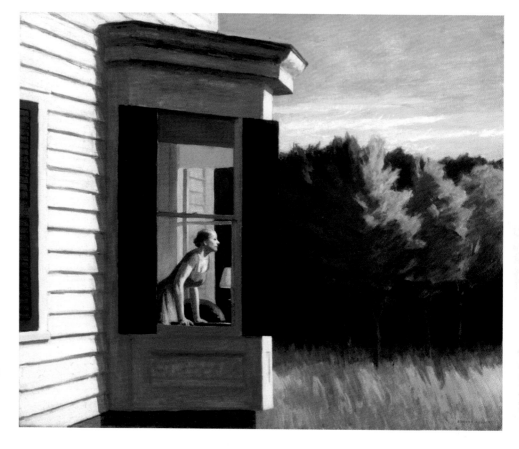

Edward Hopper, *Cape Cod Morning*, 1950. The bright morning light illuminates the white clapboards of the house, which contrast the gloomy depths of the nearby woods. The shadows hum with an optical intensity.

Q: How did Hopper create atmosphere?

A: Increasingly spare and reductive, Hopper's mature work was pared down to the barest elements. Many of his paintings convey a sense of yearning, coupled with lethargy or boredom. A sophisticated use of light and shadow is also a distinctive characteristic of his work. Hopper employed light as a tool to imbue his scenes with a powerful atmospheric charge that offsets their narrative emptiness. *Cape Cod Morning* has a sinister quality, but provides little material evidence to justify its sense of uneasiness.

" **After all, we are not French and never can be, and any attempt to be so is to deny our inheritance and to try to impose upon ourselves a character that can be nothing but a veneer upon the surface.** "

—*Edward Hopper*

The New Deal for Artists

Q: How did artists survive during the Depression years?

A: In 1933, President Franklin D. Roosevelt unveiled an unprecedented, truly remarkable economic program. The New Deal was conceived to bring financial relief to America's working poor and heal the damage the economy suffered after the crash of the stock market in October of 1929. The New Deal offered relief through meaningful labor opportunities funded by the government. It was a remarkable initiative that addressed all classes, and its Works Progress Administration (WPA) subsidized and promoted the arts, usually a low priority in a struggling economy. The visual arts branch of the WPA, the Federal Art Project (FAP), operated from 1935 to 1943. During this time, it employed 3,500 artists, for roughly twenty dollars a week. An element of the deal was that artists would provide public works of art in return for a nominal wage. The program kept artists afloat and making art during these difficult years. Numerous young artists who later rose to prominence in the 1950s were employed by the FAP: Jackson Pollock, Willem de Kooning, Lee Krasner, Mark Rothko, and Philip Guston, to name just a few.

Moses Soyer, *Artists on WPA*, 1935. Soyer's painting of busy studio activity provides an interesting record of the fertile artistic atmosphere created by the WPA.

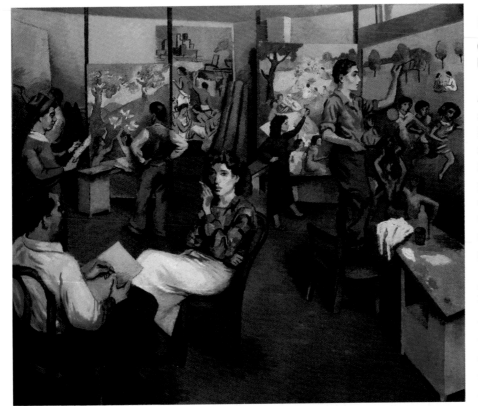

Q: What themes did the Federal Art Project encourage?

A: The FAP actively encouraged Regionalism and all forms of realist art. Social realism was promoted because of its affinity with the working class and its tendency to glorify labor. Over 1,200 murals were painted in public buildings coast to coast; popular themes were labor, solidarity, the common good, and material progress

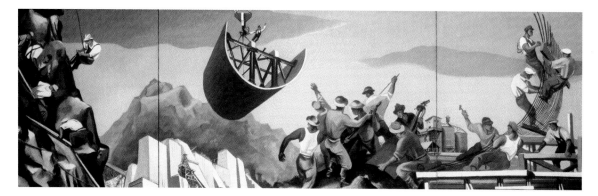

such as railroad and dam building. William Gropper's mural *Construction of the Dam*, made for the U.S. Department of the Interior, in Washington, D.C., typified the art that was encouraged by the WPA. Abstract art was not popular and was not encouraged under the Federal Art Project. There were some abstract works, however, including murals, produced in New York for the FAP. Burgoyne Diller, one of a handful of abstract muralists employed by the WPA, was an outspoken champion of abstraction during this time.

Q: Who was Berenice Abbott?

A: In 1939, Berenice Abbott (1898–1991) published a book of photographs sponsored by the FAP that documented the changing face of New York City. Abbott had fled her Ohio roots in 1918, headed for New York and then, in 1921, to Paris, where she worked as assistant to the expatriate American Dada/Surrealist photographer Man Ray, who encouraged her to take up photography. Returning to New York in 1929, Abbott saw the city anew and was struck by its constant evolution. Her book *Changing New York* remains an important record of New York City in the 1930s.

Above: William Gropper, *Construction of the Dam* (Study for mural, the Department of the Interior, Washington, D.C.), 1938. Gropper's ambitious three-paneled mural was based on the massive engineering of the Grand Coulee Dam (on the Columbia River), and the Davis Dam (on the Colorado River). Its realist style and emphasis on labor and team spirit were popular themes for government-funded works. Gropper hinted at his Communist sympathies however, in the final version, by allocating a red pocket-handkerchief to one of the workers.

Left: Berenice Abbott, "Brooklyn Bridge, Water and Dock Streets, Brooklyn," from the series Changing New York, 1936. Abbott presents the impressive Manhattan skyline from a humble viewpoint across the East River, beneath the Brooklyn Bridge. It is a dynamic work filled with a rich variety of tones and textures, a brilliant interplay of contrasts between the old and emerging architecture of New York.

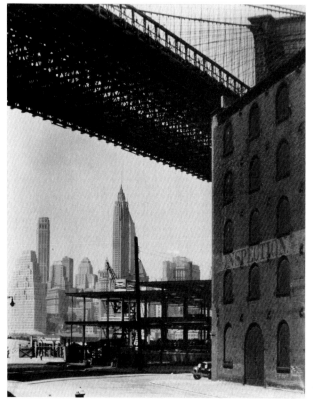

Social Realism

Q: How did Social Realism compare to Regionalism?

A: In many ways, the Social Realists were to urban life what the Regionalists were to rural America. Like Regionalism, Social Realism was representational in approach, largely ignored modern European influences, and carried an overt or implied social message. Unlike the Regionalists, the Social Realists tended to focus on contemporary American issues and were concentrated in urban centers. Through their work they spoke out against injustice and gave voice to those suffering from poverty and other hardships. Social Realism was dominated by left-wing politics and sought reforms for American society. Though Regionalism reflected the hardships of the working class, it was a more conservative and nostalgic movement.

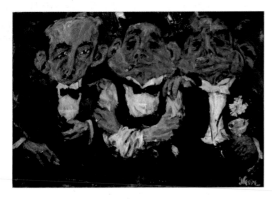

Jack Levine, *The Syndicate*, 1939. In Levine's scathing portraits of society, there is little to distinguish between powerful businessmen and rich mobsters. *The Syndicate* shows us three men who display their allegiance through their expensive habits. They fill every inch of the painting, dominating the activity around them.

Q: Who were the Social Realists?

A: Ben Shahn (1898–1969) and the younger artist Jack Levine (b. 1915) were America's leading Social Realists. Others included Philip Evergood (1901–73) and the twin brothers Moses and Raphael Soyer (1899–1974 and 1899–1987). During the 1930s, Shahn abandoned formal experimentation for a representational style that communicated his political views and social activism. He drew from journalistic photos and developed a pared-down documentary style that won him acclaim. His first works to garner wide attention were the gouache paintings of politically driven court trials, such as *The Passion of Sacco and Vanzetti* (1931–32) and *The Mooney Case* (1932).

Q: How did Jack Levine approach Social Realism?

A: Precociously gifted, Jack Levine was employed by the Federal Arts Project at the age of twenty. He won early fame in 1937 with his painting *The Feast of Pure Reason*. Levine painted in a raw, expressionist manner and greatly admired the Dutch and German old masters. He had a deeply satirical turn of mind, and his paintings often caricatured figures in positions of power, especially those who abused their power. His satirical works bear a strong resemblance to the scathing social commentary of the German artist George Grosz (1893–1959), who had arrived in New York in 1932.

Q: What influenced Social Realism in the 1930s?

A: Social Realists of the 1930s focused heavily on the plight of the working class and sought to show the devastating effect that the Depression had on the lives of ordinary people. Their approach was influenced by the earthy realism of the Ashcan school artists. Their philosophy was also strongly inspired by the Socialist politics

and art of the Mexican muralists Diego Rivera (1886–1957), José Clemente Orozco (1883–1949), and David Alfaro Siqueiros (1896–1974).

Q: What was Ben Shahn's Social Realist photography?

A: In the 1930s, Ben Shahn worked as a photographer for the Farm Security Administration. The FSA, a New Deal program, employed a large number of photographers to document the Depression. Much of the photography produced for the FSA focused on hard-hit farming communities and migrant workers in the South; some photographers also worked in urban centers. Shahn documented living conditions on the streets and in the prisons of New York, and ventured to the South to document the lives of poor rural workers. Shahn considered photography as important as painting, and he fervently focused his camera on social issues. "I am a social painter or photographer," he said. "I find difficulty in making distinctions between photography and painting. Both are pictures."

Q: How did Dorothea Lange contribute to documentary photography?

A: Dorothea Lange (1895–1965) was born in Hoboken, New Jersey. In 1918, she moved from New York to San Francisco, where she continued her career as a portrait photographer. When the Depression hit the United States, she turned her attention to the growing homeless and diplaced population. The Farm Security Administration employed her from 1935 to 1939 to bring the plight of the displaced farmers, migrant workers, and their families to national attention. Lange's compassionate and compelling response to the misery of the Depression and the Dust Bowl Years had a major influence on documentary photography, and she devoted the rest of her life to documenting social ills. Lange was the first woman to be awarded a Guggenheim Fellowship for photography. Other leading photographers who were employed by the FSA and are remembered for their Depression era work are Walker Evans (1903–75) and Gordon Parks (1912–2006).

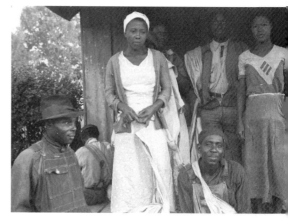

Above: Ben Shahn, "Arkansas Cotton Pickers,"1935. Shahn's Socialist background engendered in him a strong commitment to social justice. From 1935 to 1938 he was one of the many artists employed by the Farm Security Administration (FSA) to document the working and living conditions of poor people in the American South and Midwest. During these three years Shahn produced over three thousand photographs.

Left: Dorothea Lange, "Human Erosion in California (Migrant Mother)," 1936. Lange is best known for her Depression-era photographs, and "Migrant Mother" is perhaps her most famous work.

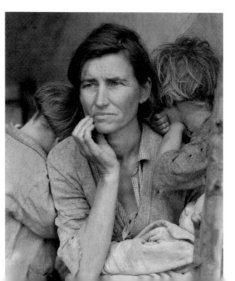

Abstraction in the 1930s

Q: What was the American Abstract Artists group?

A: American Abstract Artists formed in New York in 1936, with the express aim of raising public awareness and appreciation of abstract art. The first collective exhibition by group members was held at the Squibb Galleries in New York City in 1937. The AAA organized annual exhibitions, gave lectures, and published articles promoting abstraction. In contrast to the dominant art ethos of America during the 1930s, in which Social Realism was pervasive, American Abstract Artists promoted art without a moral, political, or social agenda, that was largely characterized by Cubist- and Constructivist-influenced geometric abstraction.

Q: What was the influence of Burgoyne Diller on 1930s' American abstraction?

A: As director for the mural division of the Federal Art Project in New York, Burgoyne Diller (1906–65) had influence over which artists were assigned to produce public works. His artistic direction ran counter to the vast majority of art produced for the FAP, and he actively promoted nonrepresentational art for the city's murals. Diller pioneered abstract art in the United States. He evolved a highly reductive, geometric abstract style, inspired by the influential Dutch artist Piet Modrian (1872–1944), Neo-Plasticism, and the minimalist abstraction of the De Stijl movement. An earlier influence was Hans Hofmann (1880–1966), who taught Diller at the Art Students League and later inspired the art of the Abstract Expressionists.

Q: What was the dominant style of 1930s' American abstraction?

A: The Russian-born abstract artist Ilya Bolotowsky (1907–81) lived through the turbulent and violent years of World War I and the Russian Revolution before fleeing to the United States. Arriving in New York in 1923, he attended the National Academy of Design and six years later became an American citizen. Bolotowsky abandoned his early representational style in favor of geometric abstraction after discovering the art of Piet Mondrian in 1933, and he adhered to geometric abstraction in his paintings and sculptures for the rest of his long career. Bolowtowsky was a founding member of the American Abstract Artists group. In 1936, he became one of the first artists (commissioned by Burgoyne Diller) to paint an abstract mural, for the Williamsburg Housing Project in Brooklyn, New York.

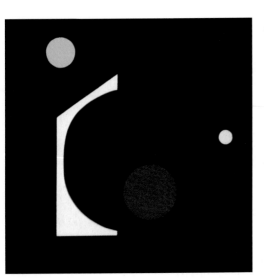

Burgoyne Diller, *Construction*, 1934. Diller's art employed geometric forms and primary colors. His paintings often expanded into three-dimensional works and sculptures that asserted a relationship to real space and foreshadowed minimalism.

elements, which Calder would later fully develop in his mobiles (a term invented by Marcel Duchamp). Calder's first abstract works were paintings, influenced by Mondrian, and he was invited to become a member of Abstraction-Création, the French prototype for American Abstract Artists. He abandoned painting, however, and produced his first mobile a year later, in 1931. In 1933 Calder returned to the United States, subsequently producing a large body of work, which despite its radical abstraction is beloved by the American public. Later, in the 1950s, Calder produced monumental outdoor immobile sculptures, known as *stabiles.*

Q: **How did Alexander Calder arrive at his "mobiles"?**

A: During a visit to Mondrian's studio in Paris in 1930, Alexander Calder (1898–1976) was converted or, in his own words, "shocked" into abstraction. An innovator in his own right, Calder is famous for creating a unique form of abstract sculpture. Calder had a deeply artistic family; his mother was a painter, and he came from two generations of sculptors on his father's side. He initially trained as a mechanical engineer; after various unfulfilling jobs, Calder changed direction and attended the Art Students League in 1923. In 1926 he moved to Paris for seven pivotal years. Calder's earliest sculptures were complex experiments with wire and other materials. They had a circus theme, and he used them to stage his own, portable, *Cirque Calder* performances. These sculptures also contained movable

Left: Ilya Bolotowsky, *Architectural Variation,* 1949. Bolotowsky's paintings show an allegiance to Mondrian's framework of the grid, though they display more diverse colors. Through the 1940s, the form, color, and space of Bolotowsky's art grew increasingly reductive, with a greater emphasis on flatness.

Below: Alexander Calder, *Zarabanda (One White Disc),* 1955. Calder's training as an engineer and his early experimentation with wire and kinetic figures provided the background for his invention of the mobile. These delicately balanced sculptures are suspended in space, their forms moving in perpetual harmony with one another.

The Harlem Renaissance

William H. Johnson, *Going to Church*, c. 1940–41. The radically simplified forms, shallow space, and restricted palette create a flat, collaged effect in Johnson's paintings. Their apparent simplicity belies their sophisticated pictorial organization and dynamic use of color.

Q: What was the Harlem Renaissance?

A: In the 1920s and 1930s, many African Americans migrated north to escape the poverty and racial intolerance endemic to the rural South. These years also saw the emergence of a powerful intellectual and artistic movement among New York's African American community. A broad outpouring of artistic expression, the Harlem Renaissance extended across the arts to include musicians, writers, dancers, painters, photographers, and sculptors. These various artists asserted the distinction and richness of African American culture with confidence and pride. Many art centers and other cultural organizations were established during the Harlem Renaissance, providing venues for emerging talent and developing artistic expression. Despite the continuing challenges of racial discrimination and economic hardship, the Harlem Renaissance created an ethos of pride in African American culture and paved the way for artists of later generations.

Q: Who was William H. Johnson?

A: William H. Johnson (1901–70) arrived at his mature style in Harlem, in the late 1930s. Marred by prejudice and financial difficulty, his career was finally cut short by family tragedy and mental illness. Johnson grew up in poverty in rural Florence, South Carolina, and moved to Harlem when he was seventeen. He studied at the National Academy of Design and then headed for Paris in 1926. Returning to New York in 1929, Johnson became acutely aware of the obstacles he faced as a black artist. He left America again, settling in Denmark, where he married and lived for nearly ten years. He returned again to New York in 1938, embracing African American themes and producing a remarkable body of work that combined a sophisticated knowledge of Modernist developments, with a pseudo-naive, or folk, style. Johnson took up a teaching post at the Harlem Community Center and was an important figure in the African American art community. After a devastating fire destroyed much of his work and possessions, and his wife died shortly after in 1944, Johnson's mental heath began to seriously decline. In 1947 he was admitted to a hospital in Long Island and, sadly, remained institutionalized for the rest of his life.

Q: **How did artists celebrate African ancestry?**

A: Lois Mailou Jones (1905–98) was one of the first African American artists to produce art that celebrated African ancestry. Early artistic disappointment due to racism had forced her to submit her paintings to art competitions anonymously, and a few times her awards were retracted when she showed up to claim them. In 1937 she was awarded a fellowship to study in Paris, where she enjoyed a more tolerant environment and produced her Modernist-influenced African tribute *Fétiches*.

acclaim for his Migration series (1940–41), and he became the first African American artist to be nationally recognized and widely acknowledged as a major American artist. He felt that he was representing himself through his Migration series. "I didn't think in terms of history in that series," he said. "It was like doing a portrait of something. If it was a portrait, it was a portrait of myself, a portrait of my family, a portrait of my peers." The Migration series constituted a collective narrative. Each small panel served as detail of a much larger story. Lawrence's paintings were a powerful, authentic record of the African American experience, and he made other series works, similarly based on African American history.

Left: Lois Mailou Jones, *Les Fétiches*, 1938. Jones traveled extensively throughout her life. Over the course of her long and productive career, she synthesized African, Carribean, European, and American styles and themes into her art.

Below: Jacob Lawrence, *Cabinet Makers*, 1946. Lawrence learned to paint using cheap materials—poster paint and brown paper—which he turned to his own advantage, developing a successful style based on an economy of means.

Q: **What was the Migration series?**

A: Jacob Lawrence (1917–2000) was one of the greatest contributors to African American art. While still a young artist, Lawrence created an ambitious series of works on the Great Migration of African Americans from the rural South to the North during the early decades of the twentieth century. Lawrence had a difficult, unsettled childhood, moving often before settling in Harlem at the age of thirteen. He trained in art at the Utopia Children's House in Harlem, and then at the Harlem Art Workshop. His first influential teacher was Charles Alston. Lawrence first achieved

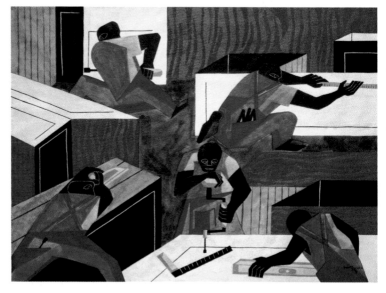

Stuart Davis

Q: What shaped Stuart Davis's artistic development?

A: Stuart Davis (1892–1964) was born in Philadelphia to artistic parents who supported him from an early age in his decision to become an artist. He studied in New York with the influential Robert Henri, and his earliest works were realist, influenced by the Ashcan school. Davis was one of the youngest American artists to take part in the controversial Armory Show of 1913. The Modernist art in the groundbreaking exhibition made an immediate and lifelong impact on the young artist. In the 1920s, Davis was particularly influenced by the work of Fernand Léger (1881–1955) and by a form of Cubism (later defined as Synthetic Cubism) being practiced by Pablo Picasso and Georges Braque (1882–1963). Synthetic Cubism incorporated collage and emblematic elements and constituted a departure from the more abstract Analytical Cubism.

Q: How was Davis a forerunner of Pop?

A: The mundane themes and literal, Cubist-inflected execution of works such as *Lucky Strike* and *Odol* (1924) prefaced the facetious solemnity of Pop Art decades before it was conceived. Ahead of his time in many ways, Davis was out of sync with dominant forces in the art world for much of his career. He worked hard to defend Modernism's validity and relevance to ordinary life, especially in the Depression years, when Regionalism and Social Realist art dominated popular tastes. Later, when Abstract Expression became the vanguard American movement, Davis was again somewhat marginalized, because his hard-edged graphic style was not in vogue.

Q: What role did music play in Davis's art?

A: Davis's art grew increasingly abstract from the late 1920s onward, though it stopped short of total, nonobjective abstraction. Davis remained constant in his belief that painting should have a solid base and rational structure, that "the elements of the medium in which the work is executed have a simple sense-perceptual relationship. The work must be well built, in other

Stuart Davis, *Lucky Strike*, 1924. *Lucky Strike*, painted in 1924, simulates a layered, collaged appearance, and objects seem to float on its surface. Davis produced a number of paintings in this way during the 1920s, most famously *Odol* (1924).

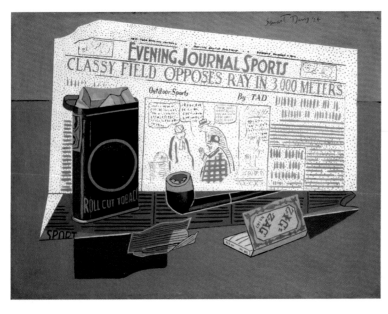

words." Music was one of the biggest influences on Davis's painting. He passionately admired jazz, which had a direct impact on his own visual language. "For a number of years," Davis said, "jazz had a tremendous influence on my thoughts about art and life." He recognized jazz as a uniquely American creation, and paralleled its complex forms and syncopated staccato beats in many of his paintings. His painting *Rapt at Rappaport's* has an overtly musical, onomatopoeic title, and Davis stressed the rhythmic function of the title by painting the actual words across the picture.

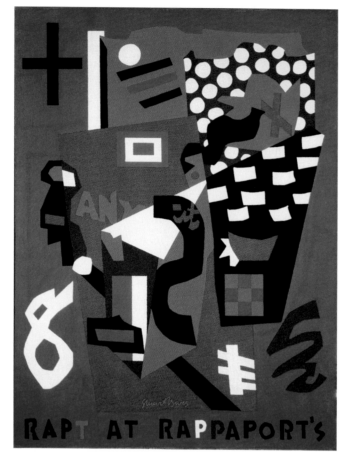

Stuart Davis, *Rapt at Rappaport's*, 1952. *Rapt at Rappaport's* was based on one of Davis's earlier Cubist-influenced paintings. The bold color contrasts and varied patterns are meant to convey the complex rhythms of jazz. The alliterative title may refer to a New York toy store.

Q: How did Davis's abstract language continue to evolve?

A: Davis developed a sophisticated form of abstraction that was rhythmical, hard-edged, and dynamic. His abstraction was clear, pragmatic, and graphic, and he had strong reservations about Abstract Expressionism (contemporary to his later career), mistrusting its emphasis on the spiritual and reliance on the subconscious. His paintings showed a prescient affinity with the language of Pop. *Memo*, from 1956, uses a clever title to describe its simplified form; it is essentially a memorandum, a message in the form of a brief note.

> " I will begin a series of paintings that shall be rigorously logical, American not French. America has had her scientists, her inventors, now she will have her artist. "
>
> —*STUART DAVIS*

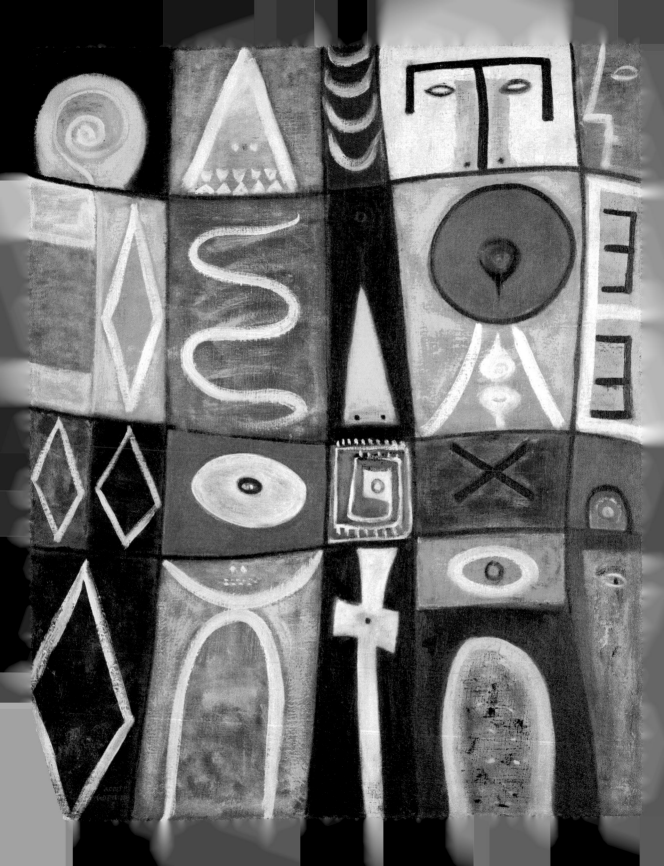

AMERICAN ART AFTER 1940

Art in the United States took a radical turn after World War II. The arrival of leading members of the European avant-garde during the war had transplanted the center of avant-garde activity wholesale to New York City. The postwar years also saw the blossoming of a new, uniquely American movement, which had begun in the early 1940s and came to be known as Abstract Expressionism. With Abstract Expressionism, the United States emerged as the new center of the art world. Several factors contributed to the development of Abstract Expressionism.

Surrealism was a considerable influence, together with a growing interest in psychoanalysis, Primitivism, and mythology. Abstract Expressionism was more of a shared ethos than an adherence to a single manifesto, and it contained a wide range of artistic styles and temperaments. From its earliest days, it was defined by an interest in the subconscious and a desire to break with conventions in pursuit of greater individual expression. There were, generally, two phases of Abstract Expressionism. While the first phase emphasized painterly gesture, this gradually gave way to the cooler, less emotional phase of Color Field painting and hard-edged abstraction.

Above: Robert Motherwell, *Monster (for Charles Ives)*, 1959. Motherwell made *Monster (for Charles Ives)* while listening to Ives's music; it pays homage to Ives's undaunted and innovative artistic spirit.

Left: Adolph Gottlieb, *Pictogenic Fragments*, 1946. Gottlieb's pictograph paintings combine mythic references with primitive and personal symbolism.

Abstract Expressionism: The Formative Years

Q: How significant was the influence of Surrealism on postwar American art?

A: Surrealist ideas profoundly influenced postwar American abstraction. A number of significant Surrealist artists were living in New York, having fled the war in Europe. American art dealer Peggy Guggenheim was a pivotal figure in New York at this time. Living in Paris before the war, she had amassed a formidable collection of Surrealist and abstract art, which she brought back to America and exhibited at Art of This Century, her Manhattan gallery established in 1942. Guggenheim's gallery provided a bridge between the art and ideas of the European émigrés and the American avant-garde. Many of the artists working at the embryonic stage of Abstract Expressionism benefited from Guggenheim's support and exhibited their work at her gallery.

William Baziotes, *Green Night*, 1957. Baziotes was one of the first of the New York School artists to embrace the Surrealist use of biomorphic forms and automtism—believed to be a conduit to pure individual expression. Although a significant figure in the New York School, he maintained a distance from the larger developments of Abstract Expressionism.

Q: What was the New York School?

A: The New York School was a self-named group of artists living in New York in the 1940s and 1950s. Its core group of artists later became known as the Abstract Expressionists, but it also included artists less associated with this genre, such as William Baziotes (1912–63) and Adolph Gottlieb (1903–74). Many of the New York School artists had worked for the Federal Art Project in the 1930s, developing relationships and artistic alliances during those years.

Q: How did Native American art influence the New York School?

A: Like many American artists in the postwar years, Adolph Gottlieb felt a strong attraction to Native American and other "primitive" art forms; these represented direct, authentic expression of the individual, detached from fine-art conventions and formal constraints, that corresponded to the prevailing influence of Surrealism and automatism. Two landmark exhibitions—of Surrealism and of prehistoric art at the Museum of Modern Art in 1936 and 1937, respectively—had also brought so-called primitive art and art of the subconscious to wide attention.

Q: What was the influence of Primitivism?

A: In the late 1930s and early 1940s, the Museum of Modern Art held major retrospectives of the work of Pablo Picasso and Joan Miró (1893–1983). These exhibitions, representing two vital spheres of influence, had a powerful effect on artists of the New York School. Picasso's experiments with Primitivism

ful works. An artistic chameleon, Gorky made several major transformations in his art before he arrived at his late, great abstract paintings of the 1940s.

Left: Arshile Gorky, *Soft Night*, 1947. Unique among Gorky's vibrant abstract paintings of the 1940s, *Soft Night* is notable for its use of rich mysterious grays.

Q: What shaped de Kooning's development during the 1940s?

A: Willem de Kooning (1904–97) immigrated illegally to America from Holland in 1926, arriving penniless and without connections. He fell under the charismatic influence of John Graham (1886–1961), a Russian émigré artist who possessed an almost cultlike following among New York's avant-garde. He also became a close friend of Arshile Gorky, and in the 1930s they shared a studio. Gorky's formal power and the pathos of his portraits absorbed and reformulated Classicism as translated by Picasso; this as well as the biomorphic forms and innovative palette of his late abstractions were early and enduring influences on de Kooning's development as an artist. De Kooning progressed toward greater and greater abstraction throughout the 1940s, arriving at his mature style with his famous Women series in the early 1950s. Like Gorky's, de Kooning's abstractions always maintained a close connection to natural forms and the human figure.

had inspired Cubism and led, as fellow Cubist Georges Braque (1882–1963) put it, to "the materialization of the new space." Investigation of a "new space" is a central tenet of the experimental art produced in New York during the formative years of Abstract Expressionism.

Q: Who was Arshile Gorky?

A: The Armenian artist Arshile Gorky (born Vosdanik Manoog Adoian, 1904–48) had perhaps the most important influence on the New York School's progression toward Abstract Expressionism. Gorky arrived in America at the age of sixteen with a legacy of persecution and tragedy behind him, which he evoked frequently in his paintings. The classically inspired portraits of his family, made in the late 1930s, such as his memorable work *The Artist and His Mother* (c. 1926–36) are among his most power-

Abstract Expressionism:
The First Generation

Clyfford Still, *1946-H (Indian Red and Black)*, 1946. The raw, heavily impastoed surfaces of Still's paintings situate them in the early phase of Abstract Expressionism, but his later work belonged more to Color Field painting.

Q: **What is Abstract Expressionism?**

A: Abstract Expressionism began with the artists of the New York School in the 1940s, and it flourished in the 1950s. The term Abstract Expressionism was originally used to describe European artists such as Wassily Kandinsky (1866–1944), who combined abstraction with animated and expressionist brushwork; the critic Robert Coates, in his *New Yorker* review of 1946, first used the term in the United States. The core group of the first wave of Abstract Expressionists included Jackson Pollock (1912–56), Arshile Gorky, Willem de Kooning, Hans Hofmann (1880–1966), Lee Krasner, Robert Motherwell (1915–91), Clyfford Still (1904–80), Franz Kline (1910–62), Adolph Gottlieb, and William Baziotes. Abstract Expressionism resists a singular definition, because it represents a shared approach rather than a stylistic affiliation. For this reason, many of its artists preferred to be known by their chosen collective of the New York School. By the end of the 1940s, the dominance of Surrealist theories gave way to the emergence of distinct individual styles, and the biomorphic forms and symbolic imagery of Surrealism were abandoned in favor of increasing abstraction, with an emphasis on introspection and the self. This first phase of Abstract Expressionism was notable for its shift toward monumental scale, and energetic, often violently gestural brushwork. Clyfford Still was one of the first artists to produce the very large-scale works that have come to exemplify this aspect of Abstract Expressionism. He remained somewhat aloof from the New York School and lived outside the New York art scene for most of his career.

Q: **What was the significance of surface in Abstract Expressionist painting?**

A: The clotted, thickly layered surface of Hans Hofmann's late work *Fermented Soil* (1965) embodies the assertion of the picture plane and the emphasis on materiality or "objectness" central to critical understanding of Abstract Expressionism. Two influential art critics, Clement Greenberg and Harold Rosenberg, promoted and helped to define Abstract Expressionism, though they stressed different aspects of it. Greenberg believed fervently in the dissolution of illusionary space and the emphatic assertion of flatness as the logical conclusion to Modernism's initial break with conventional pictorial space. He viewed Hofmann as a key figure in this, writing, "It is thanks in part to Hofmann that the 'new' American painting in general is distinguished by a new liveness of surface." Hofmann's greatest contribution, however, was as a progressive teacher. Among his students were Lee Krasner

(1908–84), who played a significant, if conflicted role in the early years of Abstract Expressionism, Robert Motherwell and other New York School artists, and Louise Nevelson (1900–88).

Q: What is Action Painting?

A: The critic Harold Rosenberg first coined the term "Action Painting" in 1952, in his essay "The American Action Painters." Rosenberg articulated an aspect of painting being practiced by Pollock, de Kooning, and others outside the New York School. In his criticism, Rosenberg relocated meaning beyond the material limitations of the canvas and placed equal emphasis on the action of painting. Rosenberg greatly influenced how art was perceived, and his opinions resurfaced later in the antiform stance of the Conceptual and Performance artists of the 1960s and 1970s. The label Action Painting also served to distance the practice from any one group of artists—largely those of the New York School—and provide a more inclusive definition for a wide range of art that shared the characteristic. Franz Kline became an action painter as a result of an epiphany he had, around 1948, after witnessing his small drawings greatly enlarged by a projector. The revelation immediately and radically transformed his painting, and he took the spontaneity and calligraphic energy of his modest brush drawings and recreated them on a large scale, using very large brushes. Moreover, in his transformation to a grand scale, Kline retained a radically simple palette and his paintings were usually black on white. The resulting works actively convey the gestural energy with which they were made, possessing both spontaneity and sculptural massiveness.

Q: What is Gestural Abstraction?

A: The terms Gestural Abstraction and Action Painting are largely interchangeable, but they have subtly different connotations. Action Painting contains Gestural Abstraction, but generally in the "all-over" style, which Jackson Pollock began utilizing at the end of the 1940s. The "all-over" style involved the artist standing at a distance from the painted surface—hence the practice of dribbling, splashing, and pouring paint—while paradoxically asserting the physical presence of the artist in the process. Gestural Abstraction, on the other hand, reflects a greater intimacy of brushwork and direct handling of paint, as exemplified by de Kooning's paintings. De Kooning maintained, "[E]ven abstract shapes must have a likeness," and he asserted the figurative subject matter of his paintings even as they became increasingly abstract. He struggled financially for many years, achieving some success and the respect of his peers for his abstract paintings. Finally, his notorious Women series, first exhibited in 1953, won him fame.

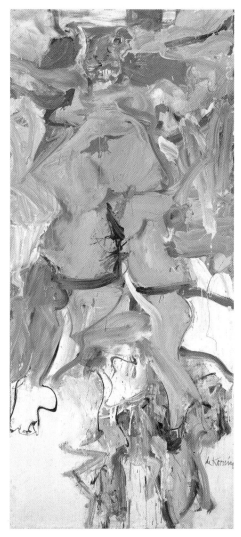

Willem de Kooning, *Woman, Sag Harbor*, 1964. The aggressive nature of de Kooning's Women series shocked the public, and the overtly figurative aspect of the paintings unsettled his contemporaries, who were by then immersed in an atmosphere of increasingly spare and nonobjective abstraction.

Jackson Pollock

Q: Who was Jackson Pollock?

A: Jackson Pollock (1912–56) represents a watershed in American art. Like his pivotal European Modernist predecessors, who broke with the past to create new pictorial languages, Pollock was responsible for a whole new way of evaluating and understanding art. Pollock's all-over drip paintings destroyed all notions of subject matter, motif, and illusion. His abstract paintings set a new course for art on an international scale and influenced generations of artists. As with other Abstract Expressionists, Pollock's development was shaped by a combination of Surrealist automatism, Primitivism, mythology, psychoanalysis, and the influence of Picasso and Miró; but Pollock took the myth of the self, of the untrammeled expression of unconscious imagery, further than any other. His formidable drive and energy seem fueled by a need to find a universal language that could adequately express the intensity of his experience. Pollock's childhood was defined by constant upheaval and financial hardship, in the care of what appears to have been a cold, domineering mother and a defeated father. The adult Pollock, a difficult and rebellious character, suffered from depression, alcoholism, and violent, unresolved feelings toward women. In 1947 Pollock abandoned all forms of imagery, totemic symbols, and compositional structure and began to produce his all-over drip paintings. With the drip paintings, Pollock no longer needed images or symbolic forms to speak for him—instead, the physical evidence of his gesture served as an undeniable expression of his own experience. He worked in this way until 1954, when his output almost dried up. He always struggled to keep his alcoholism under control, and self-destructive behavior led to his death in a car crash in 1956.

Q: What shaped Jackson Pollock's paintings of the 1940s?

A: Jackson Pollock's paintings of the 1940s contain totemic elements and are filled with primitive symbols and mythological allusions. His deep interest in Native American shamanism and Navajo sandpainting led to his later, groundbreaking drip paintings. The monumental aspect of the rock paintings and carvings of the Native Americans and other ancient cultures was also a contributing factor, influencing the scale of the art that would come later.

Q: What was the impact of *Life* magazine's article about Pollock?

A: By the time Pollock had made his breakthrough with his all-over drip paintings, Peggy Guggenheim had closed her gallery and moved back to Europe. Another New York dealer, Betty Parsons, became the first to exhibit Pollock's drip paintings. Clement Greenberg also championed Pollock, who began to attract attention from the press, though most was hostile and derisive. The attention culminated in a 1949 full-color *Life*

magazine article, with photographs of Pollock and his paintings, carrying the provocative heading: "Jackson Pollock. Is he the greatest living painter in the United States?" The article was hyperbolic and somewhat mocking in tone, and the public largely dismissed it. However, it reflected a growing interest in modern art and was part of an increase in articles about contemporary art.

Q: How did Jackson Pollock "break the ice"?

A: It was Willem de Kooning who said that Pollock "broke the ice." Pollock transformed painting in several ways. With his all-over drip paintings from 1947, he eliminated visible references to subject matter altogether and created subjective, abstract paintings with no motif or focal point. He also dispensed with the paintbrush—at least as it was used in the traditional sense—and began to apply very liquid paint to his canvas from a distance, without actually touching the surface. He generally dribbled paint onto the surface with a stick or another implement, and experimented with a variety of ways in which to deliver the paint onto the surface. Pollock was not the first to employ dripping or pouring—automatism was derived from Surrealist practice—but Pollock's dripping was less about chance than about the expression of his own self. He moved his canvases off the walls and onto the floor, working on them directly from above, dripping and pouring with rhythmic and controlled motions, and echoing the Navajo sandpainters he admired. The move from wall to floor meant that he also eliminated a fixed-point perspective—once the canvas was on the floor, he was able to move around it and work on it (literally, in the case of very large canvases) from all directions. The all-over aspect of his paintings suggested the infinite, since they were contained only by their borders, not composed in direct reference to the edges of the canvas. Pollock described an interviewer "who wrote that my pictures didn't have any beginning or any end. He didn't mean it as a compliment, but it was. It was a fine compliment."

Jackson Pollock, *Number 25, 1950*. Pollock's all-over application of paint and elimination of fixed-point perspective brought an ambiguity of scale to his painting. This encaustic painting measures approximately ten inches by thirty-eight inches but could have functioned equally well on the grand scale he favored during this period.

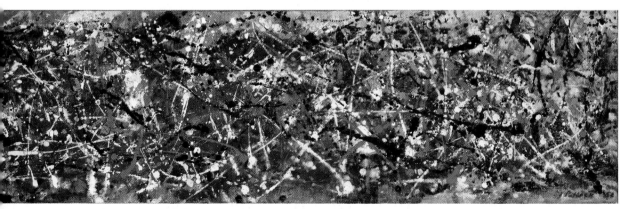

Robert Motherwell and David Smith

Q: Who was Robert Motherwell?

A: Robert Motherwell (1915–91) was one of the most versatile of the Abstract Expressionists. Unlike Pollock or de Kooning, who struggled to overcome financial hardship in order to maintain an artistic life, Motherwell came from a wealthy background, and his family supported him financially. Motherwell had already earned his bachelor's degree and was studying for a doctorate in philosophy at Harvard when he switched to art history at Columbia, before finally abandoning academic life to become a practicing artist. He was well traveled and well read. His sophistication and self-awareness had a direct bearing on his art, and his ideas and processes were set apart from the other Abstract Expressionists, though his work was equally inspired by Surrealism, Picasso, Miró, and Matisse. Motherwell was one of the few Abstract Expressionists to embrace the Surrealists' practice of collage, which he made uniquely his own, achieving a remarkable degree of fluidity and spontaneity. He was a close friend of the sculptor David Smith (1906–65), whose work was similarly influenced by Surrealism.

Q: What kind of Abstract Expressionist was Robert Motherwell?

A: Motherwell, who met Surrealist artists living in New York in the early 1940s, was impressed with automatism as a way to greater self-expression. Adopting a more analytical approach than that of other Abstract Expressionists, he maintained a careful balance between direct emotional expression and self-conscious formalism. Motherwell lectured and published essays throughout his career, and his broad and sophisticated interests are reflected in the themes his work addressed. He explored analogies between form in painting and the forms in avant-garde writing and music, making works that referenced modern seminal figures such as James Joyce, T. S. Eliot, and Charles Ives.

Q: What was Elegy to the Spanish Republic?

A: One of Motherwell's most impressive and enduring projects was Elegy to the Spanish Republic, a series of paintings that he began in 1949 and returned to

Robert Motherwell, *Elegy to the Spanish Republic #129*, 1974. Motherwell's heavy use of black references the artistic lineage of Spanish black that traveled from the great paintings of the Spanish master Diego Velázquez to the works of Édouard Manet, and later Henri Matisse. Motherwell's elegies were the first of several intensive series that he produced during his long and exceptional career.

many times, spanning a period of forty years. Although he never visited Spain, he was deeply affected by the Falangists' execution of the Spanish poet Frederico García Lorca during the Spanish Civil War (1936–39). Motherwell said his elegies were meant to be "a visual equivalent . . . to the feeling of García Lorca's 'Lament for Ignacio Sánchez Mejías,'" Lorca's own elegiac poem to a bullfighter gored to death by a bull. The abstract forms in these paintings evoke the bull and the matador.

Q: What was the impact of Surrealism on David Smith's sculpture?

A: Surrealism influenced David Smith early in his career and became a lasting presence in his work. Smith applied Surrealist notions of spontaneity and chance to sculpture, and was able to do so partly because he adopted the technique of welding, a practice that was, at that time in the United States, associated only with construction. Smith's first encounter with welded sculpture was through reproductions of work by Pablo Picasso and Julio González (1876–1942) in a book by John Graham. Smith's early sculptures contained biomorphic and dream forms inspired by Surrealism, as well as totemic elements, all of which appear in Abstract Expressionist painting. Smith began his career as a painter, and his sculptures maintained close references to the picture plane. His pieces are notable for their frontal orientation, appearing as if drawn across an empty canvas. It was his habit to lay pieces out on a flat surface and weld them directly into place. In 1950, Motherwell and Smith began a friendship that would last until Smith's untimely death in 1965. Also around 1950, Smith's sculptures increased dramatically in scale, and he entered into an intensely prolific period that continued until his death. Smith began to work in series form around 1951.

Q: How was David Smith an innovator?

A: Smith began his geometric Cubi series in 1961, working on it until his death four years later. Possessing a sense of urgency and a desire to make up for lost time in his work, he produced twenty-eight major sculptures in his late period. The Cubi series is considered Smith's greatest achievement, in which he brought to sculpture an unprecedented synthesis of spontaneity and permanence. His sculptures retained a sense of hand drawing, and they were humanized by his use of humble material, scrap metals, and the everyman technique of welding. Despite an obvious abstract, geometric form, a Cubi sculpture has the human form at its core. Smith used stainless steel for the Cubi series, which he burnished with swirling, painterly gestures. The sculptures were conceived for outdoor locations, where their highly reflective surface was enlivened and activated by natural light.

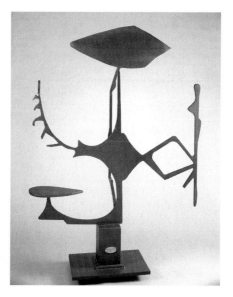

David Smith, *Agricola I*, 1951–52. One of Smith's working methods was to lay pieces of metal out on a flat surface and weld them directly in place. *Agricola I* (Latin for farmer) is a series work, and its title refers to the incorporation of farming tools and equipment.

Color Field Painting

Q: What is Color Field painting?

A: Color Field painting is the name given to the second, moderated phase of Abstract Expressionism. Emerging in the 1950s, it differed from the first manifestation of Abstract Expressionism in several important ways. Less emphasis was placed on heavily built-up surfaces and painterly gesture, with the focus on simplicity and austerity. Visible references to nature and figurative imagery were rejected in favor of abstract evocation, and Color Field painters tended to plan paintings in advance rather than arrive at a finished image through the process of painting. As its name suggests, Color Field painting is characterized by large areas of often intense, monochrome color, thinly or smoothly applied. In Color Field painting, the presence of the artist is more discreet, and the simplicity, openness, and large scale of the compositions invite the viewer into the abstract space. The pioneering Color Field painters were Mark Rothko, Barnett Newman (1905–70), and Ad Reinhardt (1913–67). Color Field painting encompassed a range of styles, from the subtle, evocative modulations of Rothko's rectangular compositions, to the razor-sharp, starkly reductive canvases of Barnett Newman.

Q: What was the Subjects of the Artists school?

A: Mark Rothko bridges two aspects of Abstract Expressionism. He sought to express universal truths in his art, which is characteristic of early Abstract Expressionist painting, but his paintings' chromatic simplicity and gestural restraint are defining aspects of Color Field painting. In 1948, Rothko cofounded the short-lived Subjects of the Artists, a school of art whose mission was the promotion of abstraction with meaningful content (as opposed to pure, nonobjective abstraction). The school was founded with Clyfford Still, William Baziotes, Robert Motherwell, and Barnett Newman. The idea of "less is more," or as Rothko phrased it, "the simple expression of the complex thought," is central to Color Field painting. Rothko evolved a format that satisfied his desire for a simplicity of means and a grandeur of expression. He developed his formula—the horizontally divided rectangle—at the end of the 1940s, and he worked within it until his death in 1970. Rothko imbued the static and simple rectangle with a versatility of touch, chromatic sophistication, and a breadth of expression that belies its simple structure. His paintings are able to convey, simultaneously, the spiritual and the sensual; a sense of tragedy accompanied by poignant beauty.

Q: What was the significance of scale to the Color Field painters?

A: Size was a key expressive vehicle in Color Field painting. It automatically suggested the sublime, the universal, the infinite. It also drew the viewer into the painted space, since the larger the

canvas, the less aware the viewer was of its intrusive edges. Rothko acknowledged this counterintuitive dynamic, saying, "The reason for my painting large canvases is that I want to be intimate and human." In sheer scale, however, none of the Color Field painters compared to Barnett Newman. His canvases reached gargantuan dimensions, and were, in direct proportion, radically minimal. Newman is famous for his "Zip," the thin, sharp vertical line that dissected his canvases from the late 1940s on, remaining central to his work. Newman considered abstraction the only way to evoke the sublime in painting; he had monumental and heroic ambitions for his art and believed abstract art provided a key to universal and metaphysical secrets. His penchant for philosophical, religious, and cosmic titles reveals his unshakable confidence in the power of his art to convey profound truths. A case in point is his huge painting of 1950–51, *Vir Heroicus Sublimis*—Latin for "man, heroic and sublime"—measuring approximately eight by eighteen feet. Newman eliminated painterly gesture, and his art anticipated the formal austerity of Minimalism, but his emphasis on his paintings' spiritual role and meaning associated him with the Color Field painters.

extraneous elements, and his paintings are so closely toned and so compositionally quiet that at first sight they appear to be monochromes. Reinhardt's art, unlike that of the other Color Field painters and Abstract Expressionists, did not grow out of a figurative background, and his primary influences were not Surrealism and Picasso. Instead, Reinhardt's interest was with the Russian Suprematist Kasimir Malevich (1878–1935) and the abstract paintings of Piet Mondrian (1872–1944). Reinhardt's work was abstract from the start. He exhibited with the Color Field painters, and the austerity and chromatic simplicity of his work connects him with the group, though he did not share their grandiose ambitions. He believed that "the laying bare of oneself . . . is obscene." As a staunch formalist, he wanted no meanings or interpretations attached to his paintings.

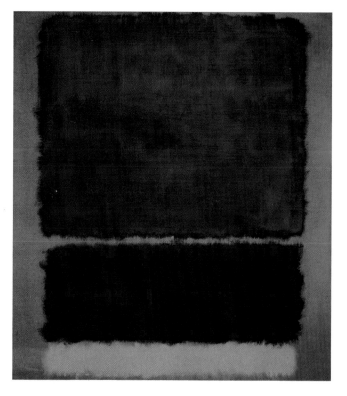

Mark Rothko, *Blue, Orange, Red*, 1961. Rothko had large ambitions for his paintings, saying, "I am interested only in expressing basic human emotions: tragedy, ecstasy, doom, and so on."

Q: What did Ad Reinhardt mean by "art is art. Everything else is everything else"?

A: Ad Reinhardt's painting can be more easily described by what it isn't rather than what it is. He believed in emptying out of all unnecessary and

Abstract Expressionism: The Second Generation

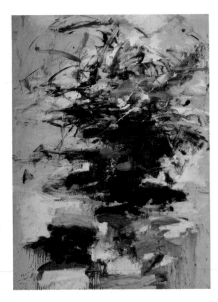

Joan Mitchell, *Marlin*, 1960. With a title like *Marlin*, references to the sea in this luscious painting are unavoidable. Mitchell maintained a close connection to nature in her work, but such allusive titles can also be misleading, diverting attention from the painting's formal qualities and internal logic.

Q: What was the origin of second-generation Abstract Expressionism?

A: The second generation of Abstract Expressionists was as diverse a group of individuals as the first generation. The second consisted of younger abstract painters, influenced and inspired largely by the paintings of Jackson Pollock, Willem de Kooning, and Franz Kline. The second generation expanded upon the ideas of the first and initiated innovations in Abstract Expressionist painting that questioned conventional attitudes to surface.

Q: How did the second generation of Abstract Expressionists differ from the first?

A: The second generation of Abstract Expressionists was represented on the East Coast by, among others, Joan Mitchell (1925–92), Lee Krasner, Philip Guston (1913–80), Milton Resnick (1917–2004), Elaine de Kooning (1918–89), Grace Hartigan (b. 1922), and Helen Frankenthaler (b. 1928). On the West Coast, the second generation included Sam Francis (1923–94), Richard Diebenkorn (1922–93), and artists of the Bay Area Figurative School. The first generation of Abstract Expressionists had

been overwhelmingly male, promoting a rugged, macho approach to painting. Abstract Expressionism was raw, theatrical, often huge-scale, and defined by an existential struggle imagined in heroic terms and discussed in frequently overblown language. Women had been excluded from this first phase, and artists like Lee Krasner, who had contributed to Abstract Expressionism's early evolution, were largely ignored. In an important shift, the second generation of Abstract Expressionists included female artists. The 1950s saw a general increase of women in the arts, and some artists who had been overshadowed by their more successful husbands such as Lee Krasner, who was married to Jackson Pollock, and Elaine de Kooning, began to receive more serious attention. Generally more inclusive than the first, the second generation of Abstract Expressionists admitted a greater range of expression and pictorial language. An increased lyricism and sensuous use of color dominated the paintings of the second generation, accompanying a revival of figurative painting that benefited from the groundbreaking formal innovations achieved by first-generation artists.

Q: What is "Abstract Impressionism"?

A: This term was invented by Elaine de Kooning to describe the lyrical abstractions produced in the 1950s by Philip Guston, Sam Francis, and Joan Mitchell. The label was also an attempt to distinguish their

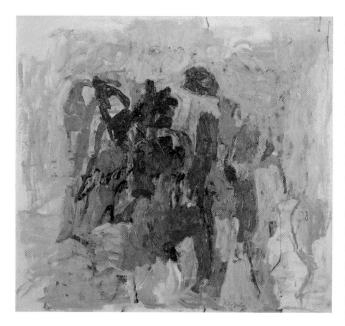

unique approach within the broader category of Abstract Expressionism. Their paintings were so-called because their brushstrokes and all-over application of roughly uniform size patches of paint recalled the atmospheric brushstrokes of Impressionist painting. As with the Impressionists, nature was popular subject matter among these artists. In 1955, Claude Monet's large-scale late work *Water Lilies* (c. 1920) was purchased and put on display by the Museum of Modern Art in New York City. It inspired a reevaluation of Monet's work among vanguard New York artists, who were attracted to the abstract quality of his late paintings.

Q: What is Figurative Expressionism?

A: Figurative painting was radical-ized after Abstract Expressionism. The movement's bold, energetic brushwork and unapologetic transparency of tech-nique provided a new model for figurative

artists and led to a new vigor in figura-tive painting. Grace Hartigan was an early exponent of figurative painting in New York. It was especially popular on the West Coast; Richard Diebenkorn and the artists of the Bay Area Figurative School were exploring an energetic figurative approach, which had evolved out of Abstract Expressionism and abstraction in general. Diebenkorn's paintings of the 1950s, such as *Berkeley No. 22*, show the far-reaching impact of Abstract Expressionism. In the 1960s, Diebenkorn developed his signa-ture series of paintings, called Ocean Park, which are cooler and more abstract.

Philip Guston, *Oasis*, 1957. The abstract paintings of Guston's early career display his distinctive, sophisticated use of color. His paintings of this period were composed of even-sized brush strokes, forming hazy, crosshatched veils or clusters spreading outward from the center of the canvas.

Richard Diebenkorn, *Berkeley No. 22*, 1954. There is intense energy in Diebenkorn's painting of the California landscape. It hovers on the verge of abstraction, but it is recognizably a landscape, rendered with fluid, gestural brushwork and a subtle, light-filled palette.

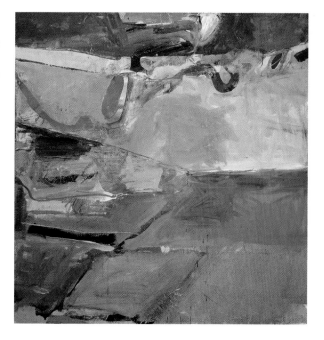

Stain Painting

Helen Frankenthaler, *Small's Paradise*, 1964. This large (100 x 93 5/8 inches), chromatically intense work was made using fast-drying acrylic paint. Acrylics can be used in diluted form, still retain depth of hue, and dry to a matte finish. These qualities were perfectly suited to Frankenthaler's needs, since they quickly soaked into the raw canvas. Named after a New York City juke joint, *Small's Paradise* exudes the visual pleasure of gaudy entertainment.

Q: What is Stain Painting?

A: Helen Frankenthaler (b. 1928) pioneered "staining," one of the most significant developments in second-generation Abstract Expressionism and a major influence on Color Field artists. Within the broad parameters of Abstract Expressionism, Frankenthaler's innovations led abstract painting in an entirely new direction, forcing yet another reevaluation of pictorial convention. Influenced by Jackson Pollock's practice of painting directly onto raw canvas, she took the immediacy a step further by "staining" the canvas. She thinned paint to a fast-flowing, inky consistency, poured it directly onto the canvas, manipulated it, and pushed it into the raw fabric with sponges so that the canvas soaked up the color. Pollock's all-over drip paintings had asserted the "objectness" of painting and eliminated allusions to known forms; Frankenthaler took this a crucial step further by closing the gap between canvas and painted surface, eliminating an illusionistic depth of space. The paint and canvas were no longer two separate layers, but one inseparable object.

Q: What was the pivotal work in Stain Painting?

A: Frankenthaler's breakthrough work was *Mountains and Sea*, a large piece (ten by seven feet) painted in 1952. Influenced by the arabesque forms of de Kooning and Arshile Gorky as well as the late paintings of Claude Monet, Frankenthaler developed a highly sensuous, chromatically intense abstract language that is notable for its lush beauty.

Q: Who were the "Stainers"?

A: *Mountains and Sea* made an intense impact on Morris Louis (1912–62) and Kenneth Noland (b. 1924), close friends of Frankenthaler. Both artists visited her studio shortly after *Mountains and Sea* was completed, and both consequently adopted staining in their own painting. Louis abandoned the use of brushes altogether and developed a successful, highly individual style, based on pouring. His paintings did not contain any kind of gestural mark; his forms were dictated by a skillful manipulation of varying consistencies of paint and a harnessing of gravitational pull. Louis produced numerous series of often large-scale canvases, with Magna acrylic paints (the first artist's acrylic paints, developed in 1947). These ranged from veil-like waterfalls, in which the colors acted like watercolor washes, to spare and diffused stripes of unmodulated, intense color. Louis was an important influence on Color Field painting during the 1950s.

Kenneth Noland, *Beginning*, 1958. Noland painted a series of studies of bull's-eyes in the late fifties.

Q: Who were the Washington Color painters?

A: The "stainers" fell within the category of Post-Painterly Abstraction, a term coined by the art critic Clement Greenberg to define the movement he saw as the rightful legacy of Abstract Expressionism. Greenberg's enormous influence and outspoken pronouncements about good and bad art played a decisive role in the evolution of second-generation Abstract Expressionism. He was a passionate devotee of Color Field painting and the nonobjective, "pure" chromatic abstractions that were especially manifest in Morris Louis and Kenneth Noland's paintings. Louis and Noland lived outside the New York hub of avant-garde activity. Based in Washington, D.C., they were leading figures among a group of Color Field artists who became known as the Washington Color painters. Louis and Noland both used Magna acrylic paints, which enabled them to achieve chromatic intensity with very thin washes of paint. Noland's paintings from the late 1950s took on a circular, minimal form, which focused attention toward the center of the canvas, denying the edge and making the forms seem to float in space. He experimented with color combinations, as influential German-American artist and teacher Josef Albers (1888–1976) had done, from 1949 onward, in his Homage to the Square series. Noland adopted other forms later, including chevron- and diamond-shaped works, all painted in a hard-edged style.

Morris Louis, *Beta Upsilon*, 1960. Louis strove for maximum optical effect with this large canvas, measuring over twenty feet long. He challenges the viewer by limiting the painting's activity to the very edges. His mysterious titles, such as *Beta Upsilon, Alpha-phi*, and *Dalet Zayin*, are simply numbers from Greek and Hebrew alphabets.

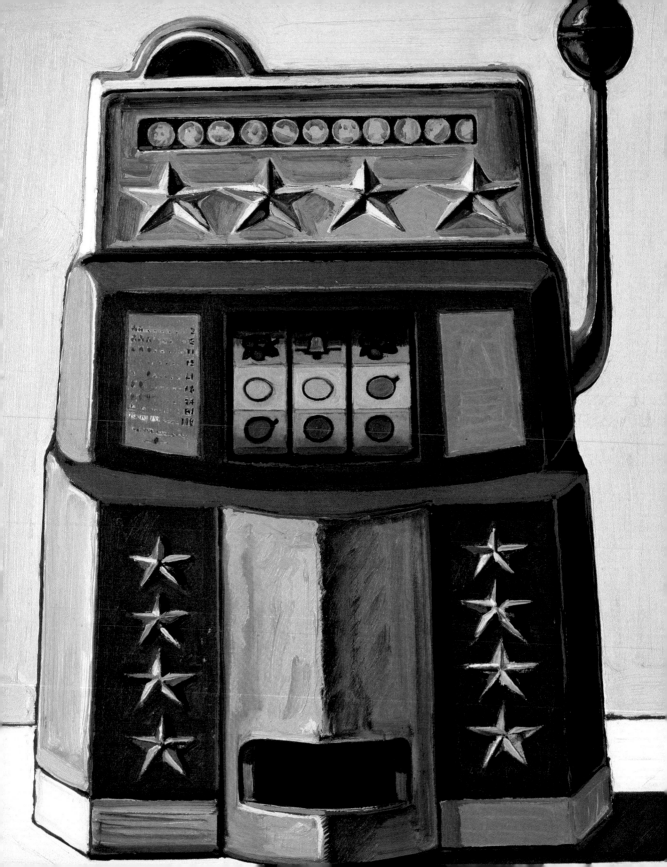

POST-ABSTRACTION

The revitalization of painting initiated by the Abstract Expressionists in New York City in the 1940s and 1950s extended across the nation. A figurative painting revival continued throughout the 1950s and set the scene for the 1960s' emergence of Pop Art, which contained a strongly figurative component from its outset. Figurative painters and Pop artists rebelled against the dominance of abstraction and the aesthetic rigidity in the opinions of the powerful critic Clement Greenberg. The 1950s and 1960s ushered in a reevaluation of what constituted "serious" art; artists began to challenge the distinctions between high and low art, defiantly employing non-art materials in their work. The 1960s gave rise to multiple forms of expression with loosely shared or overlapping concerns. The diverse forms and social and artistic concerns emerging in American art multiplied in the following decade, leading to the Pluralism of the 1970s.

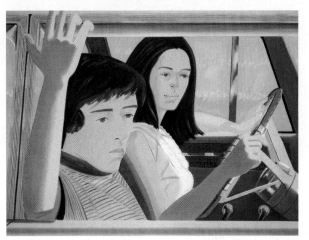

Above: Alex Katz, *Ada and Vincent in the Car*, 1972. Katz was one of a new group of figurative painters who emerged in the 1960s.

Left: Wayne Thiebaud, *Jackpot Machine* (detail), 1962. *Jackpot Machine* is Thiebaud's wry comment on the fickle nature of success in a commercially driven culture. It was painted around the time that he first won long-awaited critical acclaim for his paintings.

A New Figurative Expression

Q: How did new figurative painting develop on the East Coast?

A: After Abstract Expressionism, attitudes about how to approach the empty space of the canvas were irrevocably changed. Larry Rivers (born Yitzoch Loiza Grossberg, 1923–2002), a student of Hans Hofmann and William Baziotes, was interested in figurative painting from early in his career. An exhibition at the Museum of Modern Art in 1948 exposed him to the delicate balance of abstraction and figuration in the quietly radical paintings of French artist Pierre Bonnard (1867–1947). Rivers painted ironic figurative compositions that referenced social and art history with a comic seriousness that foreshadowed Pop's cynical stance. He treated his canvases with a casual disregard for conventional narrative or pictorial space. Rivers's complex paintings possess an all-over "field" of activity that recalls Pollock's abstractions. Disparate elements appear almost casually arranged, rendered in sketchy brushwork, without a focal point. Rivers's work contained an intelligence and irreverence that typifies art of later decades. In his own day, Rivers was criticized for being too rebellious and too restless as an artist, for changing styles too often, which is perhaps why his paintings resist categorization.

Larry Rivers, *The Athlete's Dream*, 1956. Human forms emerge and dissolve into abstraction, their incompleteness signifying rather than describing the subjects depicted.

Q: What was the status of realism in an abstract ethos?

A: Another approach to figurative painting in the 1950s and 1960s was a deadpan, sharp-focused, "hard" realism that had precedence in the emotionally restrained works of Edward Hopper. Some New York artists adopted this stance in outright rebellion against what had become a stiflingly prescriptive atmosphere. Abstraction was considered the only acceptable form of serious or progressive art, and figurative painting had become passé. Both Alfred Leslie (b. 1927) and Philip Pearlstein (b. 1924) began as Abstract Expressionist painters but abandoned the approach for figurative painting around 1960.

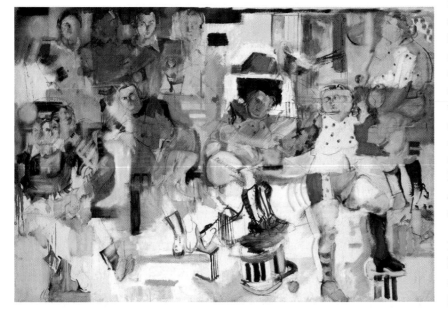

Pearlstein's paintings, though having little stylistically in common with Rivers's, also contain an "all-over-ness" in their uniform handling of forms and their striking indifference to the psychological potential of their subject matter.

Q: What was New Realism?

A: Philip Pearlstein, Fairfield Porter (1907–75), Alex Katz (b. 1927), and Neil Welliver (1929–2005) were among the artists practicing the "New Realism" of the 1950s. New Realism sought to apply abstract values to looking realistically at the physical world. Katz developed a deadpan, emotionless figurative style that became increasingly sophisticated, cool, and detached over the following decades, associating him with Pop Art.

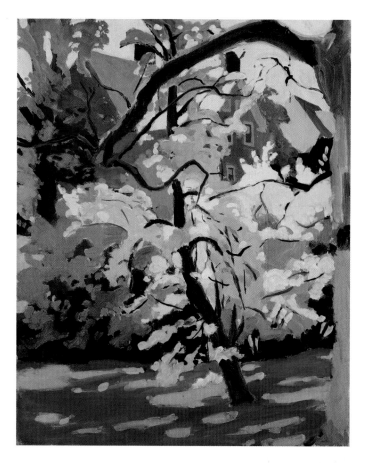

Welliver revived the artist's relationship with the landscape. Porter's restrained and elegant style came out of his understated approach to painting from life, and an admiration that he shared with Larry Rivers for the Nabis artists Pierre Bonnard and Édouard Vuillard (1868–1940). Porter relied on intelligent investigation of his chosen subject matter—mostly domestic interiors and landscapes— to produce deceptively quiet Modernist works.

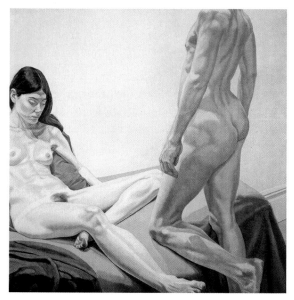

Fairfield Porter, *Forsythia and Pear in Bloom*, 1968. Porter distanced himself from the frenetic New York art world and pursued his own investigations into light and form at his homes on Long Island and Maine.

Philip Pearlstein, *Male and Female Nudes with Red and Purple Drape*, 1968. Pearlstein invites the viewer to look beyond the traditional subject matter of the nude. Sensuous elements and individual personalities have been suppressed, and forms are equalized under harsh artificial lighting.

Q: What was the Bay Area Figurative School?

A: A new, strong tradition of figurative painting emerged on the West Coast in the early 1950s, at the California School of Fine Arts in San Francisco. David Park (1911–60), Elmer Bischoff (1916–91), and younger artist Richard Diebenkorn, who had all moved from Abstract to Figurative Expressionism, led the movement. The vigorous new trend was known as the Bay Area School, and it was heavily influenced by the energetic brushwork and formal innovations of the New York School. The Bay Area artists applied the thick paint, heavily impastoed surfaces, and bold colors of Abstract Expressionism to semi-abstract or radically simplified figurative subjects. In an era in which abstraction was widely considered the only true modern approach, this was a radical choice. The modestly proportioned scale of the paintings of the Bay Area School also differed from the contemporary trends.

Elmer Bischoff, *Woman on Sofa*, 1959. Bischoff and the painters of the Bay Area School asserted the validity of figurative painting, defying dominant critical thinking, which leaned heavily toward abstraction. These artists were criticized in some quarters for being reactionary and anachronistic.

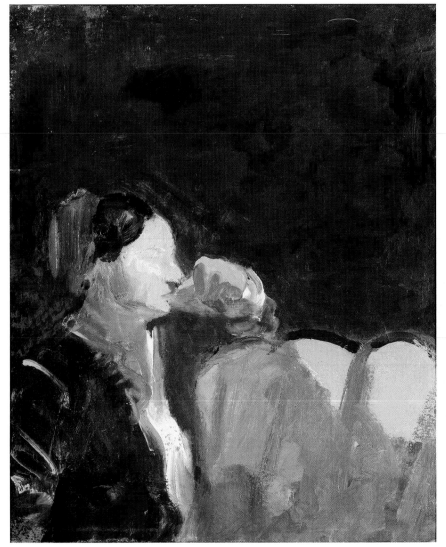

Q: What was the Monster Roster?

A: A vital scene had matured in 1950s' Chicago. Socially and politically engaged artists, whose work shared affinities with German Expressionism, had fallen under the influence of the French Art Brut proponent Jean Dubuffet (1901–85). A major exhibition of Dubuffet's paintings at Chicago's Art Club in 1951, followed by his highly influential lecture and artistic call

to arms, "Anticultural Positions," made a significant impact on certain Chicago artists. This group became known as the Monster Roster, after the Chicago Bears football team—the "Monsters of Midway"—because of the distorted or misshapen ways in which they depicted the human figure. The work of Leon Golub (1922–2004) was informed by his sociopolitical convictions from the beginning. Married to political activist and artist Nancy Spero, Golub dealt in his paintings with such themes as the Vietnam War, racial and sexual injustice, and political corruption.

Q: **What shaped Alice Neel's painting?**

A: Alice Neel (1900–84) painted throughout the 1930s, 1940s, 1950s, and 1960s but was largely ignored until the renewed interest in figurative painting

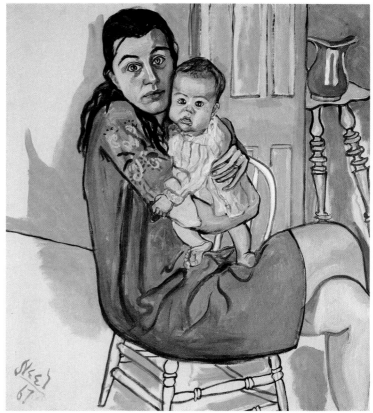

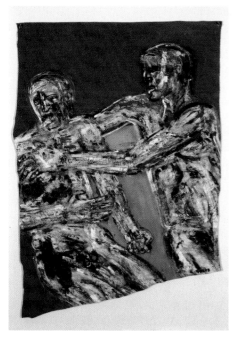

brought her critical attention toward the end of the 1960s. She also went on to achieve iconic standing among feminist artists in the 1970s. Neel arrived at her distinctive style early, and she remained faithful to it regardless of the ways that art had evolved during the successive decades. Her adult life was shaped by tragedy and sorrow. Her first child died just before the age of one, and Neel experienced a severe mental collapse, attempting suicide in 1930. The turmoil and loss in her personal life is reflected in her empathetic approach to portraiture. She referred to herself as a "collector of souls," and her paintings convey a poignant vulnerability and pervasive anxiety.

Above: Alice Neel, *Mother and Child (Nancy and Olivia)*, 1967. In a subtle reversal of the mother/child dynamic, Neel portrays the mother clutching her baby fearfully, as though the child were a living talisman. However, they form a compact unit and are more solidly real than their insubstantial surroundings.

Left: Leon Golub, *Napalm V*, 1969. *Napalm V* belonged to a series of paintings on the Vietnam War. Golub's textured, sinuous surfaces are both repulsive and persuasive indictments of human cruelty and weakness.

Assemblage or "Junk" Sculpture

Q: What is Assemblage art?

A: French artist Jean Dubuffet coined the term "Assemblage" art in 1953. He created this label to draw a distinction between flat, paper-based collage and three-dimensional constructions. Assemblage art is truly three-dimensional, incorporating found materials as well as hand-wrought imagery. Joseph Cornell (1903–72) was one of the great Assemblage artists. A quiet, religious man, Cornell lived and worked in relative isolation, supporting his mother and brother at their home in Queens, New York. His art was deeply influenced by the Surrealists, and irrational juxtaposition of objects is central to his artistic language. However, Cornell rejected the Surrealists' preoccupation with the body and carnal desire—the emphasis of his art is nostalgia, longing, and the evocation of childhood. As he expressed it, he wanted to create Surrealism's "white magic," not its darker version.

Joseph Cornell, *Medici Princess*, c. 1952. Cornell's assemblages mostly took the form of glass-fronted, carefully constructed boxes—enclosed and protected microcosmic worlds, which operated to his own interior logic and represented a magical, fantastical alternative to the domestic banality of his life.

Q: Who was Louise Nevelson?

A: Louise Nevelson (1899–1988) developed a style of Assemblage sculpture in the 1950s that is immediately identifiable. The elegance of her sculptures belies the fact that they are composed almost exclusively from junk materials—mostly scrap wood, discarded parts, and broken household objects. Toward the end of the 1960s, she did occasionally use other materials, such as aluminum, steel, and Lucite. Nevelson was born in Russia and lived there until the age of five. She was the daughter of a timber merchant and handled wood from an early age; her love of the material is fully evident in her work. She stacked and

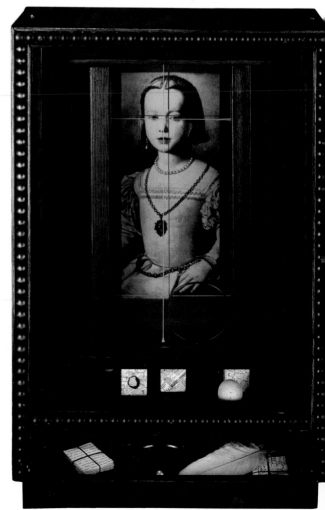

layered disparate and unrelated objects into sculptural walls of forms and unified them into one coherent visual statement by painting them with a monochrome color. Her sculptures are suggestive of both intimate domestic spaces and grand-scale architecture.

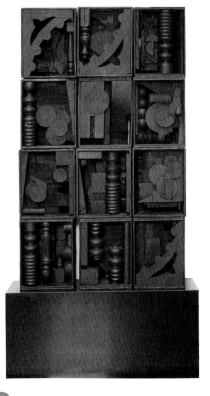

Louise Nevelson, *Black Wall*, 1964. Nevelson's sculptures are frontal objects; they make strong reference to the picture plane and, in their articulation of light and shadow, are a testimony to the influence of Hans Hofmann, with whom Nevelson studied early in her career.

Q: What is "Junk Art"?

A: Junk Art refers to art made mainly from discarded metal and other kinds of solid scrap material. It was distinguished from Assemblage because it necessitated welding, a precedent set in the United States in the 1950s by the sculptor David Smith. The term "Junk Art" was coined by the critic Lawrence Alloway, in reference to Robert Rauschenberg's "combines," but it expanded outward to include art made from a variety of scrap materials. John Chamberlain (b. 1927) made sculptures from crushed car parts, rearranged and welded together, with often startlingly beautiful results. Other Junk artists, some of whom incorporated industrial materials and produced work on an enormous scale, were Mark Di Suvero (b. 1933), Richard Stankiewicz (1923–83), and Robert Mallary (1917–97).

Q: What is "Funk Art"?

A: Essentially a West Coast manifestation of Assemblage and collage art, Funk Art was closely connected to the San Francisco Beat culture of the 1950s and early 1960s. Beat poets and Funk artists placed great value on found and cheap materials—the fabric of the streets—and thus shared an affinity with Pop Art's mission to celebrate the commonplace and debunk the distinctions between high and low art. Funk artists included Ed Kienholz (1927–94), Jess Collins (1923–2004), Wally Hedrick (1928–2003), Wallace Berman (1926–76), and Bruce Connor (b. 1933). Funk Art differed from Junk Art, which, often large-scale and heavy-duty, required welding and industrial techniques. Artists like Bruce Connor valued spontaneity and incorporated ephemeral and less stable materials in their works.

Below left: Bruce Conner, *Chigadera/Ratbastard*, 1962. This mysterious object, humorous and sinister in equal measure, is composed of a variety of cast-off materials, including a scarf, jewelry, and Mexican artifacts.

Robert Rauschenberg

Q: What shaped Robert Rauschenberg's development?

A: As much as the Abstract Expressionists looked inward, Robert Rauschenberg (b. 1925) looked outward. As the Abstract Expressionists explored the internal in search of universal truths, Rauschenberg celebrated the external, reveling in the flux and chaos of the world at large. Rauschenberg represented an alternative vision at a time when Abstract Expressionism reigned supreme. Despite his wayward and rebellious nature, his early exposure to Josef Albers's teaching at Black Mountain College in 1948 rubbed off on him. Rauschenberg embodied Albers's values in his early abstract paintings, and shared his mistrust of both the Abstract Expressionists' introspection and their self-congratulatory notions of the inherent authenticity of their art. Rauschenberg also befriended the experimental composer John Cage, who also taught at Black Mountain. Rauschenberg was influenced by Cage's explorations into chance forms and random structure, and by his belief that art should be open and attentive to the world, without attempting to impose order on it. Marcel Duchamp, the seminal figure and original "bad boy" of modern art, was also a pervasive influence on this ethos, and the legacy of his readymades was a persistent factor in avant-garde thinking throughout the 1950s and beyond.

Robert Rauschenberg, *Monogram*, 1955–59. Rauschenberg preferred to call his assemblages "combine paintings," asserting his convictions that a painting was more than mere paint on canvas and that all materials were equally relevant. "There is no reason not to consider the world as one gigantic painting," Rauschenberg once said.

Q: What were the combine paintings?

A: Assemblage art tended to be antiestablishment. Irreverent, debunking, and with a level of humor not conceivable in the high-minded paintings of the Abstract Expressionists, it also shared close affinities with the Dadaists' irreverent attitudes toward high art and their provocative use of "non-art" materials. In 1961 the curator William Seitz organized a breakthrough international exhibition of Assemblage art. In the Museum of Modern Art in New York, he brought together the famous artists Marcel Duchamp, Georges Braque, and Pablo Picasso, among others. Seitz also included young American artist Robert Rauschenberg. Rauschenberg had begun to produce his "combines" in the early 1950s and continued to create these extraordinary hybrid works until 1962. His subject matter, impetus, and materials were gathered from the real world; his incorporation of life's messy,

undisciplined detritus into and onto his art paved the way for the Pop artists of the 1960s. Rauschenberg has remained a consistent influence on modern artists.

Q: What was the significance of Rauschenberg's relationship with the artist Jasper Johns?

A: After Rauschenberg met Jasper Johns (b. 1930) in 1954, the two artists embarked on a mutually inspirational relationship and love affair, lasting for a number of years. Rauschenberg had an intensely collaborative nature and was regularly involved with various kinds of performing artists. Rauschenberg and Johns were temperamentally quite different. Johns was more intellectual, while Rauschenberg possessed phenomenal energy; but they both shared a desire to close the gap between art and reality, and their relationship sparked a fertile crossover of ideas. Rauschenberg and Johns came to prominence at the same time and were a powerhouse force in the art world by the late 1950s. They initiated the practice of appropriation, which became a central tenet of Pop and has been a key ingredient in modern art for the last forty years. Rauschenberg's combine painting *Reservoir* was painted as his relationship with Johns deteriorated.

Q: How did Rauschenberg adopt printmaking techniques?

A: Rauschenberg incorporated images from the media in addition to his found

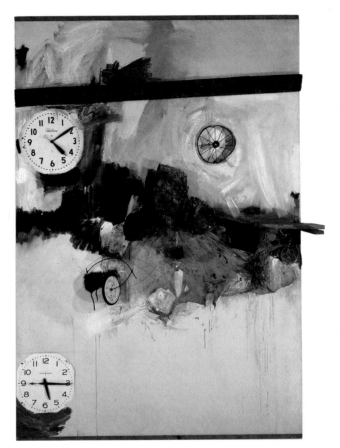

materials, prefacing Pop Art's fascination with advertising. His restless nature kept him constantly absorbing new ideas and adopting new practices. Andy Warhol (born 1928 as Andrew Warhola) introduced Rauschenberg to the technique of silkscreen printing, which Rauschenberg began to utilize around 1962. His silkscreen works reflected the media's visual bombardment of images, echoing the increasingly fast pace and multiplicity of modern life. Silkscreen printing proved to be a highly successful vehicle for creating multiple juxtapositions rapidly and two-dimensionally; Rauschenberg pushed the technical boundaries of the technique further than it had gone before.

Robert Rauschenberg, *Reservoir*, 1961. Rauschenberg set the clock on the upper left to the time he began the painting, and the lower left clock to the time he finished; the clocks continued to run, so the length of time that the painting represents is unknown.

Combines, Collage, and Appropriation

Right: Jasper Johns, *Untitled*, 1954. This piece, once owned by the performance artist Rachel Rosenthal, contains a cast of her face, boxed in odd juxtaposition to a textural upper section. Though the labels in different languages in the upper portion are suggestive of travel and the scope of the imagination, the work remains strangely oppressive.

Below: Jasper Johns, *Three Flags*, 1958. *Three Flags* is composed of three separate canvases and projects five inches from the wall, giving it an indisputable objectlike stature. Its layers of paint are lush, painterly, and precisely controlled.

Q: **What was the importance of signs to Jasper Johns?**

A: Jasper Johns singled out known images and symbols for inclusion in his work, precisely because they were already understood, needed no explanation, and invited no additional interpretation. His most famous of these "known objects" is his series of paintings of the American flag, the first of which he made in 1955. As a supreme cultural icon, it needs no introduction. John's paintings of the American flag were not politically motivated; he appropriated the image, treated it as a readymade abstract design and, impossibly, made it his own. He worked in the demanding medium of encaustic (wax) painting. His flag paintings are emotionally blank and utterly flat, yet their surfaces are full of texture and character,

sensitively applied. He successfully closed the gap between image and object in his flag paintings and took the same approach with other commonly known signs, such as targets, numbers, letters, and the map of the United States. Johns experimented with nuance of surface, structure, and contextual shifts, as the Abstract Expressionists and Color Field painters had done, but free from the weight of implied personal meaning or symbolism. Johns wielded enormous influential on the philosophy behind Pop Art.

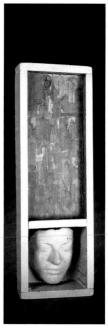

Q: **Why did Jasper Johns destroy his work in 1954?**

A: Jasper Johns's enigmatic, untitled work of 1954 is one of the few surviving pieces from this period, since he destroyed much of his work in an attempt to get rid of all evidence of derivative influence from

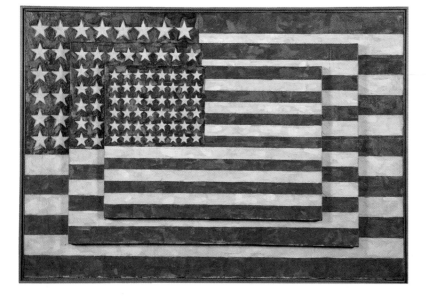

other artists. His art after 1954—the year in which he began his relationship with Robert Rauschenberg—represents a new beginning. The emotionally blank, veiled quality evident in Johns's early work remained a constant element of his art. He began making plaster casts of body parts around 1953 and incorporated them into his paintings and assemblages.

Q: How did Romare Bearden make use of collage?

A: Romare Bearden (1911–88) belonged to the Abstract Expressionist generation; like many of that generation, he had worked for the Federal Art Project in the 1930s. The conceptual groundwork for Bearden's pictorial approach was the biting social satire of the German artist George Grosz (1893–1959), who taught Bearden at the Art Students League in New York in the late 1930s. Not until the 1960s, when Bearden turned to collage,

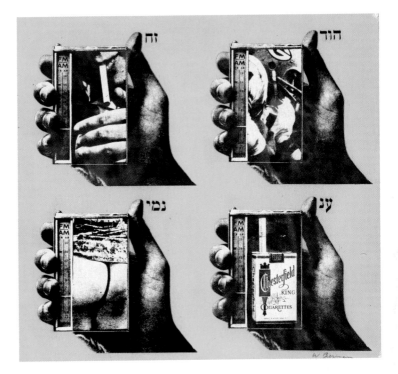

did he give full rein to this latent, satirical expression. Spurred on by civil rights activism and a desire to present the true African American experience in America, Bearden developed a potent formula of collage and photomontage that made him a leading African American artist of his generation.

Q: What distinguishes 1960s' collage?

A: Wallace Berman was a West Coast artist, loosely associated with the Funk artists and part of the Beat culture of the 1960s. His collages often employed the serial image format that made strong references to technology and mass production, a format popularized by Andy Warhol.

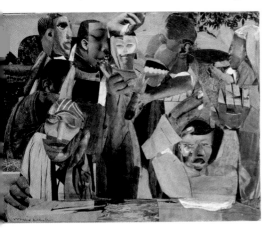

Above: Wallace Berman, *Untitled (Four Hands with Radios),* c. 1965. Berman is best known for his verifax collages. A versatile artist and independent thinker with a natural ability to move freely between the worlds of visual art, music, and poetry, he was one of the most influential figures of the Beat generation on the West Coast.

Left: Romare Bearden, *The Prevalence of Ritual: Baptism,* 1964. Bearden first achieved success in his fifties, after turning to collage. The use of photo-montage enabled him to assert specific aspects of African American culture in an immediate way, while drawing from the universal language of art.

American Pop Art

Q: What is Pop Art?

A: The Pop Art movement celebrated the transience and flux of contemporary life. It promoted mass culture, the "popular" experience, and was strongly characterized by irony and irreverence. The evolution of Pop Art in the United States began around the end of the 1950s, quickly came to prominence in the 1960s, and continued into the 1970s. Robert Rauschenberg and Jasper Johns played a significant part in bridging the gap between the earnest monumentalism of Abstract Expressionism and the irreverent "disposability" of Pop. Pop Art ushered in new ways of looking as well as a visual language with far-reaching implications, underscoring post-modern attitudes to making art in later decades.

Q: "Just what is it that makes today's homes so different, so appealing?"

A: Pop Art first began in England, where the English critic Lawrence Alloway coined the name "Pop." Richard Hamilton (b. 1922) pioneered British Pop, and his work *Just what is it that makes today's homes so different, so appealing?* was the mascot image for the groundbreaking This Is Tomorrow exhibition in London in 1956. Hamilton's modest-scale photomontage, with its slyly provocative title, was an ironic depiction of suburban happiness, with all the "mod cons" and beautiful, well-built people, as seen through the lens of commercial advertising. It depicts a slinky, leisurely, topless woman reclining on a couch, and a musclebound, half-naked body builder holding a giant lollipop on which the word POP is written in block letters.

Q: How did Pop Art develop in America?

A: British and American Pop Art differed in significant ways. From its very beginnings, British Pop was motivated by an interest in the relationship between hand-wrought art and commercial mass-produced imagery, while American Pop initially grew out of a reaction against Abstract Expressionism. Jasper Johns and Robert Rauschenberg initiated the move away from emotive personal expression toward a cool, emotionally neutral impersonality in the 1950s. This progression was continued by figures like Jim Dine (b. 1935), who incorporated ordinary objects into his works, letting them speak for themselves. However, Dine still emphasized the sensual nature of paint and nuanced surface, allowing a restrained expression that distinguished his work from the more radically impersonal, machine-made appearance of other Pop artists' work.

Q: What were happenings and environments?

A: The end of the 1950s saw the introduction of happenings—live, theatrical, avant-garde art "events." Happenings had their roots in Abstract Expressionist

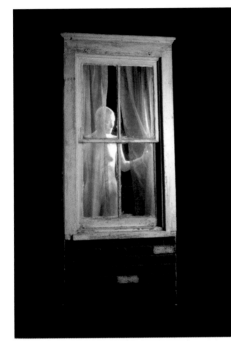

action painting, but the focus shifted even further, dispensing with the end product of the painting and focusing entirely on the "action." Happenings were pure process, unharnessed from the object and played out in real space, not on a canvas. Behind this radical, conceptual approach was the influence of John Cage, Dada, and Assemblage art practices. The artist who staged the first happening in 1959, and paved the way for performance art, was Allan Kaprow (1927–2006), one of Cage's student at Black Mountain College. Other key Pop artists involved in happenings were Jim Dine, Claes Oldenburg (b. 1929), and George Segal (1924–2000). Closely related to happenings were environments—artistic spaces that viewers could fully enter. The life-size scale of George Segal's environments were, in a sense, the logical extension of the large-scale Abstract Expressionist "field," in that the viewer could literally enter the space of the art and not merely experience an evocation of it. Happenings and environments were in many ways the grim cousins of Pop Art's lighter side.

Q: What was soft sculpture?

A: Claes Oldenburg's involvement in happenings drew him away from painting and into the sculptural work for which he is famous. In 1961, he created The Store, an actual shop in which he made and sold plaster replicas of household objects, clothes, and food. This led to his sculptures of ephemeral subjects, such as food, as well as sculptures of ordinary domestic objects, made out of fabric and vinyl. Oldenburg monumentalized the ordinary by recreating it on a giant scale, injecting humor and provocative playfulness into his nonetheless powerful sculptures.

George Segal, *The Curtain*, 1974. Segal's art doesn't look much like Pop Art as it has come to be understood, but in its literal realism, it shares the general ethos of the period—a systematic dissolution of the barriers between art and non-art objects.

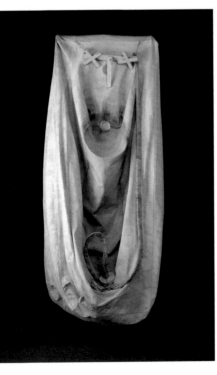

Claes Oldenburg, *Soft Bathtub (Model)–Ghost Version*, 1966. By detaching ordinary objects from their functional association, Oldenburg released their latent expressive forms. Much of his work has an erotic or fleshlike quality. He typically made three versions of his sculptures: a "hard" version, of variable materials; a "soft" version, made of vinyl; and a "ghost" version, made of raw canvas.

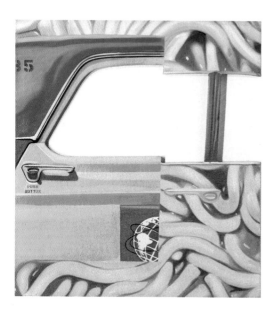

James Rosenquist, *The Friction Disappears*, 1965. The bland surface, sweet colors, and dislocated imagery derived from advertising and mass media reflect the bombardment of information and the mood of rapid cultural change that defined the 1960s.

Roy Lichtenstein, *Sweet Dreams, Baby!*, from the portfolio, *11 Pop Artists*, Volume III, 1965. Printmaking made up a significant part of Lichtenstein's work, and comic books and advertisements formed the basis for much of his paintings.

Q: How did Pop relate to commercial art?

A: Richard Hamilton had worked in advertising as a young man, Andy Warhol was a successful commercial artist, and James Rosenquist (b. 1933) had firsthand experience as a billboard painter. These artists recognized that the rapid growth of mass media and advertising during the 1950s and 1960s was a fundamental and defining aspect of their contemporary world. Pop artists were attracted to the strategies and imagery used in commercial art, and a crossover between the traditionally opposed worlds of fine and commercial art was inevitable. Rosenquist's experience in adapting images to billboard size, and his understanding of the power of the sign, is central to his art. He developed a style in debt to Rauschenberg's screen prints, which he made distinctly his own. Rosenquist produced very large canvases; his 1965 masterpiece *F-III* measures a cool ten by eighty-six feet, effectively bringing the billboard off the streets and highways and into the gallery space.

Q: Is there a Pop style?

A: The Pop Art movement as a whole was broad, with a variety of styles. By its very nature, as a mirror of popular culture, it evolved constantly, reflecting popular trends and mirroring the fast pace of the media and of advertising. The paintings of Roy Lichtenstein (1923–97) turned tradition on its head by imitating the machine-copied, mass-produced, cheap reproductions in comic books, cartoons, and advertisements. Lichtenstein's paintings and prints are self-consciously ironic, full of deadpan humor. In imitating the machine-made image, he eliminated all trace of the artist's presence and reduced the image to its bare essentials of form, design, and color. With the image removed from its original context, the process of transformation carries the work's meaning, not the image itself, which performs the role of signifier.

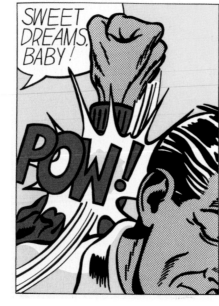

Q: What was the Great American Nude?

A: In 1960, Tom Wesselman (1931–2004) began his Great American Nude series of paintings, which epitomized the impersonality of

Pop. Wesselman's nude women embodied the anonymity of advertising and mass-produced goods. Wesselman eliminated identity and stressed sexual attributes, mirroring the baldly manipulative strategies used in advertising.

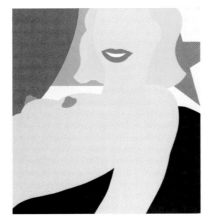

Q: How did Wayne Thiebaud's Pop differ from East Coast Pop?

A: The West Coast extension of Abstract Expressionism—the Bay Area School—strongly influenced Wayne Thiebaud's relationship to paint. Thiebaud (b. 1920) had already arrived at his signature style before Pop Art came to prominence. Though his subject matter has all the characteristics of Pop Art, he did not abandon lush painterly surface, and his painting falls between Figurative Expressionism and Pop's cool, deadpan depiction of consumer goods. Thiebaud's first affiliation was always to painting—as he expressed it, "Painting is more important than art."

Q: What characterized L.A. Pop?

A: If Pop belonged anywhere, it belonged in Los Angeles, a city built on artifice and deeply attached to the appearance of things. The landscape of signs making up Los Angeles deeply underscored the work of Ed Ruscha (b. 1937) and other Los Angeles artists such as Latvian-born Vija Celmins (b. 1939) and the British expatriate Pop artist David Hockney (b. 1937). Like Jasper Johns and Andy Warhol, Ruscha took famous cultural landmarks, such as the famous facade of letters perched on the hills above Hollywood, and presented them as empty icons. The dubious reliability of signs and the relationship between visual and verbal languages have made up a large part of Ruscha's work. His witty subversions of text and image have had far-reaching influence on post-modern attitudes. A deadpan dry wit pervades Ruscha's work, especially in his painting *The Los Angeles County Museum on Fire*, in which the museum, depicted as an architect's model, burns, isolated from the considerations of community and landscape.

Tom Wesselmann, *Study for "First Illuminated Nude,"* 1965. Art critic Lucy Lippard considered Wesselmann one of the five "hard-core" Pop artists, alongside Warhol, Lichtenstein, Rosenquist, and Oldenburg.

Ed Ruscha, *The Los Angeles County Museum on Fire*, 1965–68. Ruscha made this work in the same year the museum opened to the public, and it reflected the general disappointment within the art community with both the building and its program.

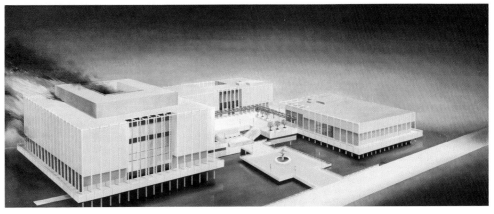

Andy Warhol

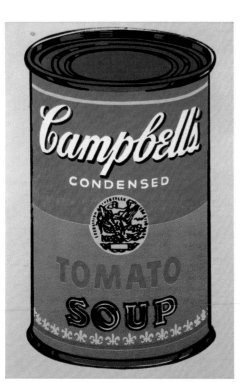

Andy Warhol, *Campbell's Soup*, 1965. Warhol's successful blend of commercial and fine-art values marked the birth of a new attitude toward the meaning of an artist in a society dominated by mass media and popular trends. Warhol's actions have been an enduring model for artists navigating the often-treacherous world of modern art and commerce.

Q: Who was Andy Warhol?

A: The elusive Andy Warhol (1928–87) was the defining artist of Pop. He began life as the son of the Warholas, Slovakian Catholic immigrants who immigrated to Pittsburgh, where his father worked as a coal miner. Warhol's early artistic leanings and training as a graphic designer led him to the fashion business, where he worked as a commercial artist in the 1950s. This experience shaped his tastes and provided him with firsthand knowledge of the dynamics of presentation and marketing, which would become central to his approach to making art. Warhol infused his art with the design and marketing strategies of the commercial world. He lived by these tenets, too, marketing his own image, as though he was himself another exciting new product. Warhol was the ultimate self-promoting artist; the brazen desire for money and fame that constituted both his motivation and his raw material was antithetical to the idealism of Abstract Expressionism and to traditional notions of what being an artist meant.

Q: What was the appeal of mass culture?

A: Warhol found the democratizing sameness of mass culture deeply attractive. He was fascinated that "you can be watching TV and see Coca-Cola, and you can know that the president drinks Coke, Liz Taylor drinks Coke, and just think, you can drink Coke, too. A Coke is a Coke and no amount of money can get you a better Coke than the one the bum on the corner is drinking. All the cokes are the same and all the Cokes are good." The legacy of Warhol's working-class background speaks through these words. Warhol's art subverted every value held dear to Abstract Expressionism. He denied the value of originality, made his images look as though they were machine made, produced work to an assembly-line model, emphasized banality through meaningless repetition, and employed a host of assistants in his studio, which he purposefully named the Factory.

Q: What was the significance of fame to Warhol?

A: Warhol was equally fascinated by the modern phenomenon of media fame, another form of mass production, in which a person's identity is simultaneously elevated to secular icon and reduced to the banality of a consumer product. Warhol was also deeply attracted to the cultural currency that fame brought. In his art, he reproduced famous products, famous

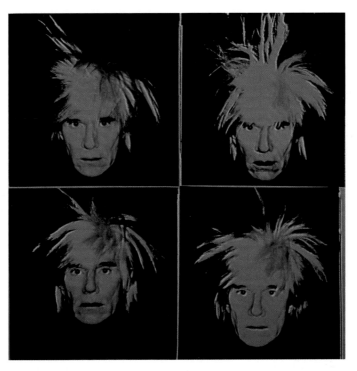

Andy Warhol, *Self-Portrait*, 1986. Warhol applied the neutralizing device of repetition to his own self-portrait, made in the year before his death. Harshly lit and emptied of expression, four skull-like versions of his aging face appear to float in an empty space, evoking ghastly trophies and the blankness of death masks.

people, and courted fame himself. He moved, perhaps inevitably, into the media of filmmaking and directed several underground films in the 1960s. Warhol was unapologetic about his businesslike approach to art. "Being good in business is the most fascinating kind of art," he once said. His focus on popular and glamorous subjects that already held the public's interest closed the gap between high and low art, making art more accessible to average Americans. He brought a voyeuristic eye to his popular subjects— Marilyn Monroe, Mao Tse-tung, Elizabeth Taylor, Elvis Presley, and Jackie Kennedy, among others—reducing them to disembodied signs and mirroring the emotional detachment of photojournalism.

Q: Why did Warhol employ repetition?

A: In 1962, Warhol applied the desensitizing effect of the serial image to emotive or distressing images, which he took from press photographs. These included the race riots in Alabama, suicide victims, and bloody car wrecks. The use of repetition robbed the images of their emotional impact, dehumanizing them and recreating the psychological detachment induced by the mass media's bombardment of sensational imagery. He applied this approach to the singularly loaded image of the electric chair, for example— deflating its power and reducing the image to the role of a decorative pattern that nonetheless leaves the viewer with a disturbing sense that he or she is being shown something as it really is, while being asked to suspend emotion and enjoy the image's compelling presentation.

"If you want to know all about Andy Warhol, just look at the surface of my paintings and films and me, and there I am. There's nothing behind it.
—*ANDY WARHOL*

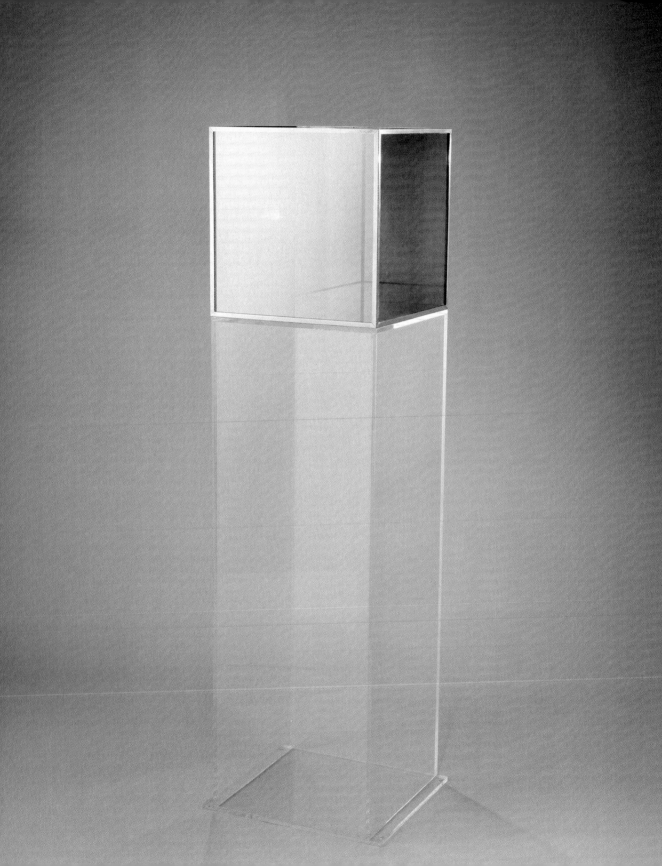

MINIMALISM AND ITS INFLUENCE

Minimalism and Pop Art were both born out of a reaction against the high emotionalism of Abstract Expressionism. On the surface, they seemed to have nothing in common. However, Minimalism shared some of Pop's attitudes to authorship and materials, as well as its attraction to the impersonality of machine-made, serially produced objects. In Minimalism's hands, these interests materialized in very different forms. Minimalism is broadly identifiable for its radically reductive form, mostly geometric in nature, and is notable for its high sculptural content. Unlike Pop Art, which Andy Warhol said "was about liking things," and celebrated popular culture, Minimalism was reactionary in nature; it could be rigid and at times authoritarian. Ironically, though it stood in direct opposition to the Abstract Expressionists, Minimalism was a similarly all-male domain at first, valuing rugged physicality and tending toward the monumental. Minimalism extended beyond the literal application to form, however, and had a wide expression and far-reaching influence. Minimalist and post-Minimalist ideas were eventually incorporated into a variety of art forms. The 1960s and 1970s saw a move away from traditional materials and toward increasingly conceptual attitudes regarding making and understanding art.

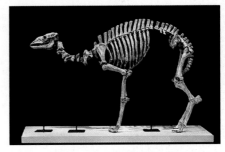

Above: Nancy Graves, *Pleistocene Skeleton*, 1970. Inspired by eighteenth-century anatomical models, Graves's fabricated fossils are constructed with steel, wax, and marble dust and then painted.

Left: Larry Bell, *Untitled*, 1964. Bell employed combinations of clear glass and glass coated with reflective materials—such as bismuth, chromium, and rhodium (all of which are used in this piece)—to create subtle and compelling variations on transparency.

Minimalism

Q: What were the first Minimalist works?

A: The paintings of Frank Stella (b. 1936) were the first self-consciously Minimalist works. Stella had been impressed by the literalness, or "object-ness," of Jasper Johns's paintings of flags and targets, and the extreme reduction in Ad Reinhardt's abstract color fields. He set out to make paintings that possessed no external references, which functioned purely as painted objects, could be immediately understood as such, and not seen as symbols for other ideas. Stella is famous for declaring about his art, "What you see is what you see." His paintings were a significant influence on the development of Minimalist sculpture.

Frank Stella, *Arundel Castle*, 1959. Stella's first excursions into Minimalism resulted in chromatically restricted canvases; he employed repetitious pinstripes, in formations designed to accentuate the flatness of the canvas, creating a simple structure that can be fully grasped at first glance.

Q: Why is Minimalism most strongly represented in sculpture?

A: The concreteness of sculpture—its undeniable reality as an object—greatly appealed to Minimalist artists because it avoided the tendency toward illusion that painting epitomized. The sculptural object operates in three-dimensional space, not in an illusory, two-dimensional space. One of the leading Minimalist artists was Donald Judd (1928–94). In 1961, to escape the restrictions of the canvas, Judd abandoned painting for sculpture. He adopted hard-edged, geometric forms and smooth, impersonal materials that resisted any allusions to nature and therefore avoided being understood as anything other than the material reality of the object. Eventually, as he achieved greater financial success, Judd had his sculptures machine made (echoing Warhol's production line at the Factory), eliminating all traces of the artist's hand in the work. Judd produced the ultimate Minimalist object, the metal cube, and continued to explore the possibilities of creating art through such reductive means, endlessly employing the stacked form and open cube.

Q: Why was the "impersonal" integral to Minimalist art?

A: The use of prefabricated materials became central to Minimalist sculpture. They satisfied the Minimalist's desires to suppress evidence of personal expression and illusion, and to maintain truth to the materials. Prefabricated materials were ready-made components and were thus impervious to interpretation. They lent themselves well to repetition, an important aspect of Minimalism, since it emphasized the impersonal. Carl Andre (b. 1935) moved from carving wooden, totemlike sculptures, influenced by Constantin Brancusi (1876–1957), to working exclusively with prefabricated materials in the mid-1960s. He caused a stir with his *Equivalents* series, in which he arranged a shallow pile of bricks in grid formation directly onto the floor. In these sculptures, the specific placement of the materials in a certain space was crucial to the effect of the work. The relationship of an object to its surrounding was an important aspect of Minimalist sculpture.

Donald Judd, *Untitled*, 1969. Judd's aggressively impersonal sculptures often contain a surprising delicacy and nuance of surface, employing semireflective coatings and making use of reflected light.

Carl Andre, *Magnesium-Zinc Plain*, 1969. Andre emphasized space over object by placing his sculptures directly on the gallery floor. His use of ordinary prefabricated materials created the feel of an ordinary space and invited the viewer to enter that space by walking onto the sculpture.

Dan Flavin, *"monument" for V. Tatlin*, 1967. Flavin's *"monument"* belongs to his largest series of works, made in honor of the Russian pioneer of Constructivism, Vladimir Tatlin (1885–1953). Tatlin believed in the value of the utilitarian object, moved freely between painting, architecture, and design, and was an early proponent of mass production.

Q: What were Minimalist materials?

A: Dan Flavin (1933–96) represented a less prosaic form of Minimalism. He exclusively used fluorescent tubing, arranged in often-playful configurations and, in later years, incorporating lush color. He managed to achieve both the anonymity of the machine-made object and aesthetic warmth from the atmospheric effects of fluorescent illumination. Early in his career, he began experimenting with artificial light. He first produced his "Icons"—wall-mounted illuminated boxes—in the early 1960s, eventually abandoning the supports and working exclusively with fluorescent lights. Flavin's use of artificial light activated the space around it in a nontactile way; his work was significant for detaching the "action" of the sculpture from its physical form.

Q: How was Minimalism perceived?

A: The "less is more" principle couldn't apply more to the art of Larry Bell (b. 1939). Minimalism prompted a hostile response from the public, as well as many art critics, who saw such literal emptiness as facetious. Bell has taken emptiness to its extreme in his quietly provocative work *Untitled* (1964), turning the traditional sculptor's plinth into an integral part of the piece, which revolves around ideas of openness and transparency. Bell's play on solidity and transparency, and his work's delicate relationship to the space it occupies, show affinities with Flavin's incorporeal sculpture.

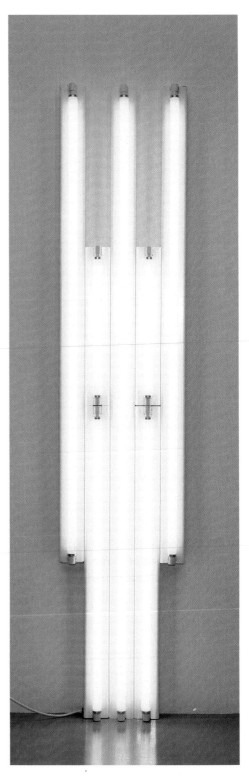

Agnes Martin, *Play*, 1966. Martin's paintings are austere, extremely spare, and reductive, employing minute varieties of repetitive geometric forms arranged in gridlike patterns.

Q: When is a Minimalist not a Minimalist?

A: Agnes Martin (1912–2004) was among the very few women associated with the early years of Minimalism. She lived in New York, in the heyday of Abstract Expressionism, where she was part of a circle that included Ellsworth Kelly. Martin evolved her mature style in the early 1960s. Leaving New York for good in 1967, she settled permanently in New Mexico, where she lived a spartan life devoted to painting. Her work would appear to belong to Minimalism, but the intricately created surfaces depart from the kind of high Minimalism ex-emplified by Donald Judd and other early Minimalists. Her art has very little to do with the absolute certainties of Donald Judd's metal cubes or Carl Andre's grids of prefabricated building materials. Martin's works are very hand-wrought, with each line carefully and deliberately drawn by hand, using a short ruler and a pencil. The wavering evidence of her human touch, though deeply restrained and "minimal," is nonetheless central to her creations. She preferred to see her work in terms of Abstract Expressionism. Her paintings are meditative, their intent to induce a contemplative state in which "untroubled" existence subsumes the ego, the noisy mind, and the awareness of self.

Post-Minimalism

Q: What characterized post-Minimalist painting?

A: Later in the 1960s, Minimalism expanded to include other artists who employed radically simplified forms or monochromatic palettes but did not necessarily adhere to the uncompromisingly inexpressive manifestations of early Minimalism. From the late 1950s onward, Ellsworth Kelly (b. 1923) had created hard-edged, elegant, abstract paintings of sparse beauty and intense color. Unlike the Minimalists, however, Kelly took his forms from the natural world, from observations of chance interactions of shapes around him, and distilled them into abstract forms. He also produced shaped canvases, which, as Frank Stella had set out to do,

emphasized the material reality of a painting—the fact that whatever its source or inspiration, it remains first and foremost a painted object. Kelly eliminated evidence of brushwork, so that his paintings are rendered in smooth, unmodulated, solid colors. His art intensely celebrates the pleasure of color and form.

Q: How did Minimalism influence pictorial space?

A: Robert Mangold (b. 1937) also made paintings on unorthodoxly shaped canvases or supports, employing curves, crosses, and asymmetrical shapes that challenged conventional expectations of what composed a painting. Mangold's

Ellsworth Kelly, *Red White*, 1961. During the 1950s, Kelly gave his paintings evocative or poetic titles that often referred to places. He abandoned the practice from the 1960s onward, opting instead for straightforward, descriptive titles such as *Yellow Panel, Blue Green Curve,* or *Red Blue Green.*

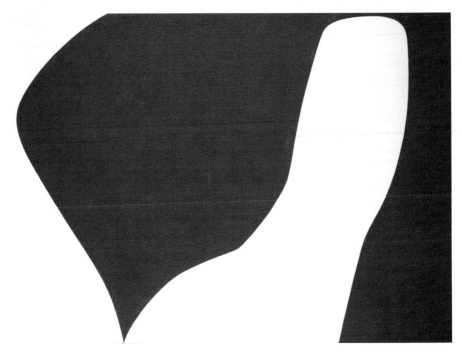

paintings contain an element of uncertainty, of incompleteness. Interested in the balance of shapes and colors, his paintings revolve around the tensions set up by unequal properties. He often makes references to structural and architectural forms. In *Four Color Frame Painting*, made later, in 1984, he merged the idea of the frame with the work itself, leaving the central area, which normally constitutes the work, empty. The painter Jo Baer (b. 1929) explored paintings' structural qualities. She asserted, through flat surfaces and minimal color, that paintings were not illusions, but three-dimensional objects.

Q: **How did Minimalism continue to develop?**

A: Brice Marden's (b. 1938) ultra-quiet, intensely beautiful paintings from the mid-1960s onward represented a new direction for painting, at a time when subtlety did not hold much currency in the visual arts. In their combination of flat, minimal color, empty design, and powerfully evocative, sensuous surfaces, Marden's paintings strongly convey what distinguishes post-Minimalism. Marden achieved his sensuous minimalism through remarkably sophisticated and

subtle use of color and masterly handling of encaustic (wax) paints, a notoriously difficult medium, which he had admired in Jasper Johns's tactile paintings.

Q: **How did attitudes toward scale change in this period?**

A: Minimalist sculpture had become increasingly monumental, and its large, anonymous forms had been embraced by the corporate world. There was a distinct and conscious shrinking in terms of the scale of post-Minimalist art. Most of the post-Minimalist painters worked on a relatively modest scale; the artist Richard Tuttle (b. 1941) epitomized this counter-aesthetic in his intimate and unassuming works. Tuttle made colored objects out of irregularly shaped dyed pieces of canvas. He abandoned wooden canvas stretchers, sewed the edges of the fabric, pinned the works directly to the wall, or simply laid them on the floor.

Richard Tuttle, *Tan Octagon*, 1967. Tuttle avoided working within a narrow range of materials, and his art resists categorization. He preferred simple materials and produced small-scale, intimate pieces that merge the properties of sculpture, painting, and drawing.

Cy Twombly

Q: What was Twombly's background?

A: The art of Cy Twombly (b. 1928) resists direct association with any specific movement. His early work contained Abstract Expressionist influences, particularly the black-and-white action paintings of Franz Kline. Twombly developed his distinctive style early, in the 1950s. Over the course of his long career, he continues to evolve a personal language that resists affiliation with trends in painting, and has had significant influence on younger artists. Twombly trained at the Art Students League in New York from 1950 to 1951. He also studied at the progressive, experimental Black Mountain College from 1951 to 1952, where he came under the influence of John Cage and his experimental, conceptually based compositional practice.

At Black Mountain College, Twombly also met Robert Motherwell and became close friends with Robert Rauschenberg. Twombly's painting contains an expressive vitality and gestural energy that maintains associations with Abstract Expressionism. There is also an all-over component in some of his paintings that bears affinities with Pollock, but Twombly's art has an ironic, knowing, intellectual bent, at odds with Abstract Expressionism, that was developed independently, at a distance from the dominant influences of the day.

Q: How did travel inform Twombly's development?

A: In 1952, funded by a grant from the Virginia Museum of Fine Arts, Twombly

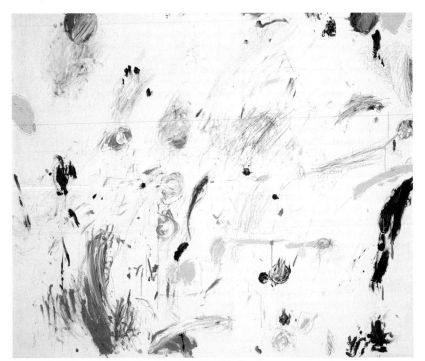

Cy Twombly, *August Notes from Rome (Ferragosto)*, August 1961. Twombly looked to antiquity for inspiration and took ancient history, mythology, poetry, and other literary works as his main subject matter. He avoided the trends of his generation, which saw Pop Art and Minimalism turn their backs on tradition.

traveled to North Africa, Spain, Italy, and France. The experience left an indelible impression on him. He lived in New York from 1955 to 1959, where he was active in a vital circle of artists including Robert Rauschenberg and Jasper Johns. Twombly left America for good in 1959, settling in Rome. Twombly's paintings are poetic and elusive, creating an unresolved atmosphere that hovers at the edge of disclosure but thwarts the viewer's attempts to read the work in a systematic fashion. Twombly explores the boundaries between painting and drawing, recognizable and abstract forms, and communication and sheer obfuscation.

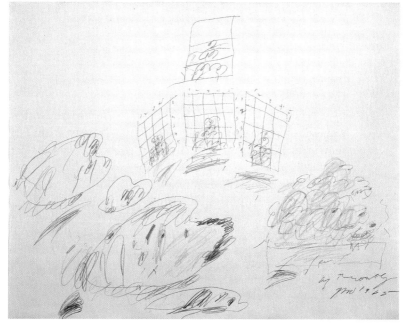

Cy Twombly, *Untitled*, November 1965. The presence of semirecognizable forms and diagrammatic drawing in Twombly's art lures the viewer into attempting to find meaning. The artworks' refusal to be read thwarts this impulse, challenging the ways in which paintings should be approached.

Q: What is the meaning of Twombly's mark making?

A: The seemingly random scribbles and casual indifference to form in Twombly's works strongly evoke John Cage's experiments with chance music of the 1950s. A word often used to describe Twombly's mark making is "cryptic." Twombly was, in fact, a cryptologist during his stint in the Army in 1953. He was one of the first American artists to incorporate graffiti-like writing in his paintings. His scribbles and half-formed marks suggest illegible handwriting or doodles, as well as the automatic writing practiced by the Surrealists. Often these illegible scribbles coalesce and reveal whole words and quotations from classical literature—beautiful, poetic phrases delivered in crude graffiti scribble, accentuating the shock of recognition. Twombly returned repeatedly to the same quality of marks in his paintings, which served as syntax for a personal language. Twombly's abstract forms hint at lost or archaic languages, in which the original meaning has been obscured over time.

" My line is childlike, but not childish. It is very difficult to fake: To get that quality you need to project yourself into the child's line. It has to be felt. "

—CY TWOMBLY

Eccentric Abstraction and Anti-Form

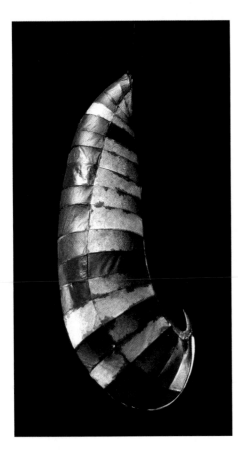

Lee Bontecou, *Cocoon I*, c.1960–69. Bontecou makes organic forms from industrial materials, creating biomorphic mechanistic hybrids that both celebrate nature and contain an element of threat. The destructive nature of humankind toward itself and the planet underscores her work, and even the gently curved form of *Cocoon I* has sinister undertones.

Q: **What is Eccentric Abstraction?**

A: The intense formalism of Minimalist sculpture provoked a countermovement, as constraining systems invariably do. In the early 1960s, a number of artists, some of whom had turned to sculpture from a painting background, were making highly personal and tactile work that presented the visual opposite of Minimalism's sleek geometry. These artists revitalized metaphor and produced visceral, psychologically loaded works, contrasting the detachment of Minimalism, and engaging the viewer on an emotional level. Eccentric Abstraction, a 1966 exhibition in New York curated by the young critic Lucy Lippard, brought together younger and older artists experimenting with organic forms and materials. Among the many artists directly and indirectly associated with Eccentric Abstraction are Eva Hesse (1936–70), Lee Bontecou (b. 1931), Keith Sonnier (b. 1941), Lynda Benglis (b. 1941), Nancy Graves (1940–95), Lucas Samaras (b. 1936), and Louise Bourgeois (b. 1911). This type of art is notable for embracing unorthodox materials, such as fur, foam, latex, wax, fiberglass, and neon. Unlike Minimalism, Eccentric Abstraction represented a higher proportion of women artists.

Q: **What shapes Louise Bourgeois's approach to art?**

A: Louise Bourgeois was using diverse and unorthodox materials, working in a broad variety of styles, and producing sculptural objects of heightened psychological content decades before her inclusion in the exhibition Eccentric Abstraction. She was born in France in 1911 and moved to New York in 1938, where she has remained for the course of her extremely long and productive career. There are strong Surrealist elements in Bourgeois's works. She traveled her own path, however, steadfastly pursuing her personal vision, with impressive unconcern for external trends. Bourgeois's art is based almost entirely on traumatic childhood memories, and much of her work is disturbing—even menacing—in expression.

Q: **How did Eva Hesse subvert Minimalism?**

A: Eva Hesse made sculptures that departed from the Minimalists' detached, impersonal stance while maintaining the autonomy of the object and the central

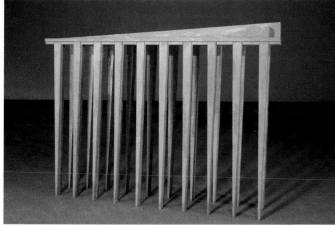

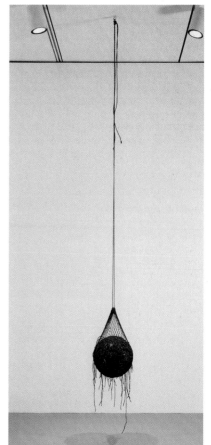

importance of materials. Imbued with potent psychological presence, her sculptures were neither figurative nor illusionistic. Hesse saw a sublimated kind of expression in the simple repetition of Minimalist sculpture, particularly in the serial works of Carl Andre. She constructed psychologically loaded works, employing paradox and open contradiction as metaphors for the uncertainty of life. As with Louise Bourgeois, the impetus of Hesse's work was traumatic early childhood experiences. Sadly, Hesse's life and great potential were cut short by a brain tumor while she was still in her thirties.

Q: What is "Anti-Form"?

A: In the mid-1960s, Robert Morris (b. 1931), a Minimalist sculptor, began to experiment with ways in which process could share the meaning of the finished work. In 1968 he published an essay in *Artforum* magazine entitled "Anti Form." Anti-Form embraced the Minimalist commitment to materials but shifted the focus away from the exclusivity of the art object. Instead, Morris stressed the process involved in the making of the object and the importance of the space inhabited by the object. Anti-Form shared its radical approach to materials with Eccentric Abstraction. Anti-Form sculpture employed flexible, nonrigid materials and embraced the unpredictable forces of chance and gravity. It rejected the rigidity of Minimalist materials and reconnected to the painterly forms celebrated by the Abstract Expressionists. Bruce Nauman (b. 1941) and Richard Serra (b. 1939) were among the artists exploring Anti-Form. Serra's process piece *Splashing* (1968) was made by throwing molten lead against a wall; the action of throwing was encapsulated in the lead's cooled state. Serra emphasized the process by using a verb to title the work. American art's focus on process at the end of the sixties led to an unprecedented diversity of styles and approaches, as art expanded outward into the realm of performance and into public space and the landscape.

Land Art

Q: What is "Land Art"?

A: Land Art, or Earth Art, emerged in the late 1960s and flourished in the 1970s. Pop Art and Minimalism, the two dominant movements of the period, were overwhelmingly apolitical and generally ignored the political upheavals of the 1960s. By the end of the decade, however, the mood had begun to shift, and artists were developing new strategies for art that could relate directly to the environment. Land Art was an extension of the Minimalist concern with literalness and truth to materials, and it also shared the post-Minimalist emphasis on process. Land Art took work out of the galleries, into the wide-open spaces of the American landscape, and rejected the increasing commodification of art. Land Art closed the gap between art and the object, the two existing inextricably and functioning simultaneously.

Robert Smithson, *Spiral Jetty*, 1970. Smithson bulldozed tons of rock, earth, and salt and raised a fifteen-foot-wide spiral that coiled over 1,500 feet out into the water. The uncontrollable nature of the project connects it to Process art. Exposure to the elements brought unpredictability to the earthworks. *Spiral Jetty* disappeared for a number of years, submerged beneath rising water levels, but has since reappeared.

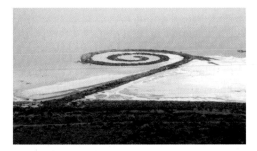

Q: What are non-sites?

A: The early sculptures of Robert Smithson (1938–73) were minimalist in nature. He began during the late sixties making art that interacted directly with the land, and first developed the concept of the "non-site" in 1967. Smithson would select an outdoor site and then alter it by digging, removing, or rearranging the raw material. The actual workplace was the site; the non-site was the presentation of the site in gallery, which consisted of photographs and maps of the site exhibited among materials taken from the site during its alteration. Non-sites elaborated on the Minimalist concern with the unification of idea and object, in which the viewer was asked to consider how location, space, subject, and object all interact to create a single artwork. Smithson's non-sites led him toward making site-specific Land Art, and his most famous single piece is *Spiral Jetty*, built on the Great Salt Lake in Utah.

Q: What is *The Lightning Field*?

A: Walter De Maria (b. 1935) created two well-known Land Art pieces, both of which use earth as material, yet assert the dematerialization of art. De Maria's *Earth Room* took shape in 1968, when he covered the floor space of the Heiner Friedrich Gallery in Munich with three feet of soil. He eventually created a permanent *Earth Room* in 1977, filling a 3,600-square-foot loft space in New York with 140 tons of black soil. His other celebrated work is *The Lightning Field*, created in 1977 in the high desert of southwestern New Mexico. De Maria planted four hundred stainless steel rods into the ground over a one-mile by one-kilometer space, according to a preconceived grid. When a storm passes

through, the steel rods attract bolts of lightning. By setting this work in a remote landscape and harnessing the terrifying power of nature, De Maria asserted the sublime qualities of the American landscape, and exemplified the metaphysical power of art divorced from commerce.

Q: What was the "Light and Space" movement?

A: Artists Robert Irwin (b. 1928) and James Turrell (b. 1943) formed the Light and Space movement in the late 1960s. Turrell's art acts entirely on one's experience of light and space; it is, as he put it, "perceptual work." Turrell cuts holes in ceilings and gaps in walls so natural light can be experienced in an intensely concentrated way. He then contrasts the shaped natural light with artificial interior lights. The materials used are secondary, generally consisting of containers or supports for the intangible elements of light and space. Turrell's art confuses the senses and transforms spaces: Air appears solid, and light seems to dematerialize solid forms. From 1974 onward Turrell has been working on a monumental artwork called *Roden Crater*. After having tunneled through the base of an extinct volcano in Arizona's Painted Desert, he is transforming the mouth of the volcano into an immense, open space for viewing the sky.

Q: What kind of Land Art is made by Christo and Jeanne-Claude?

A: Christo (Christo Javacheff; b. 1935) and his wife and collaborator Jeanne-Claude de Guillebon (b. 1935) make ephemeral Land Art—installed for a short amount of time, then removed, returning the site to its original state. Their work does not focus entirely on the landscape or primarily on remote sites, but on a diverse assortment of objects and locations. Using synthetic fabric, they have wrapped a mile of coastline in Australia, the Pont Neuf Bridge in Paris, the Reichstag in Berlin, and 178 individual trees in Switzerland, among other places. The effect is similar to the way a heavy snowfall transforms a familiar environment—politically or socially iconic sites are disarmed and reduced to their sculptural qualities, and the innate beauty of natural forms is defined and accentuated. Christo and Jeanne-Claude desire to engage the public and challenge conventional ways of seeing, rather than preserve the integrity of art. Each project requires protracted negotiations with officials and legal representatives. The works of art are entirely self-funded and subvert commercial values because they are temporary, not driven by profit, and cost nothing to see.

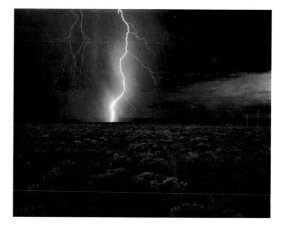

Walter De Maria, *The Lightning Field*, 1971–77.

Christo and Jeanne-Claude, *Running Fence, Project for Sonoma and Marin Counties*, 1975. Christo became a U.S. citizen in 1973, the same year he began the process leading to *Running Fence* in California. *Running Fence* spanned nearly twenty-five miles, crossed two counties, and cost $3.2 million to create.

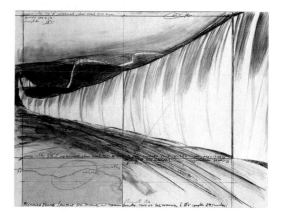

Conceptual Art

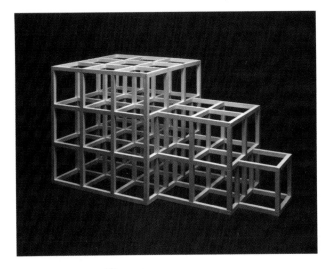

Sol Lewitt, *Maquette, for One, Two, Three*, 1979. Despite championing Conceptual art, LeWitt did not abandon the art object altogether. He continues to make three-dimensional structures and maquettes, whose forms are dictated by preconceived mathematical systems.

Q: What is Conceptual art?

A: Conceptual art was among the most challenging art forms to emerge at the end of the 1960s. Conceptual thinking was a driving force for much art in the late 1960s, and it came to dominate the 1970s. Conceptual art asserted the intellectual aspect of art and de-emphasized the physical presence of the art object. The roots of Conceptual art lie in the readymades of Marcel Duchamp, who was the first artist to ask the viewer to accept that his art was art, just because he said it was. Conceptual art eventually took this attitude to its furthest conclusion, making the art object and formal considerations redundant. Conceptual art's preference of the idea over the art object led to an increasingly theoretical environment, in which definitions of art and critical investigations dominated art thinking. Inevitably, the subordination of the art object in favor of theoretical positions led to an increasing use of text in art, influencing the emergence of text-based and Performance art.

Q: Who is Sol LeWitt?

A: Sol LeWitt's (b. 1928) sculptures of the early to mid-1960s were Minimalist in appearance and based on logical, mathematically informed systems. He referred to his sculptures as "structures," since their geometric form was dictated by mathematical information, rather than formal values. The information that shaped his structures eventually took precedence over the art object, and LeWitt became one of the earliest exponents of Conceptual art. In 1967, LeWitt published an influential essay in *Artforum* magazine, entitled "Paragraphs on Conceptual Art," in which he outlined the primacy of information over the art object. He wrote, "When an artist uses a conceptual form of art, it means that all of the planning and decisions are made beforehand and the execution is a perfunctory affair." LeWitt's dismissal of the craft involved in making art was exemplified in the wall drawings he produced after 1968. The wall drawings constituted a set of instructions to be carried out by assistants according to his measurements and plan.

Q: How did documentary photography influence Conceptual art?

A: The large scale of many Earth Art works meant that they were never realized

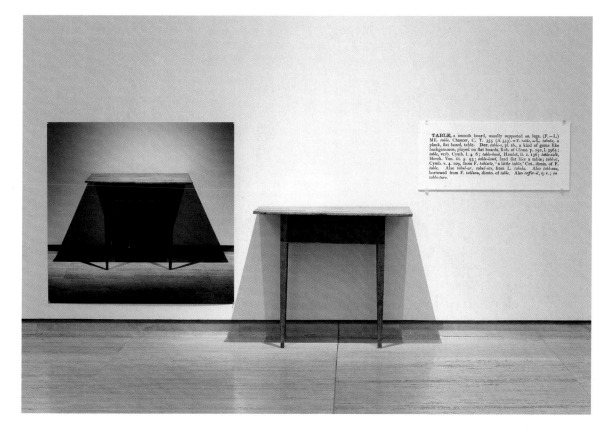

TABLE, a smooth board, usually supported on legs. (F.—L.) ME. *table*, Chaucer, C. T. 355 (A 353).—F. *table*.—L. *tabula*, a plank, flat board, table. Der. *table-s*, pl. sb., a kind of game like backgammon, played on flat boards, Rob. of Glouc. p. 192, l. 3965; *table*, verb. Cymb. i. 4. 6; *table-book*, Hamlet, ii. 2. 136; *table-talk*, Merch. Ven. iii. 5. 93; *table-land*, land flat like a table; *tabl-et*, Cymb. v. 4. 109, from F. *tablette*, 'a little table,' Cot., dimin. of F. *table*. Also *tabul-ar*, *tabul-ate*, from L. *tabula*. Also *tabl-eau*, borrowed from F. *tableau*, dimin. of *table*. Also *tuffer-el*, q. v.; *en tablature*.

and existed only in the planning stage. Many completed works were purposefully located in remote areas and are only known to most people through photographs, maps, and documentary evidence. Walter De Maria's *Lightning Field*, for example, requires a pilgrim's dedication in order to reach it, and experiencing the full effect of the work depends entirely on chance. Thus, most people have experienced this piece solely through photographs. Over time, the documents originally intended as substitutes for experience, or as components in more complex works, such as in Robert Smithson's non-sites, were viewed as autonomous works in their own right. The theoretical fervor of the late 1960s and 1970s meant that visual art focused increasingly on

definitions of language as a way of understanding art. The investigation of language established by Conceptual art has had far-reaching influence.

Q: What is text-based Conceptual art?

A: Text-based art completely broke the connection with formalist art and represented the complete "dematerialization of the art object," as described by the art critic Lucy Lippard. It operated in the space between theory, criticism, and philosophy. The late 1960s and 1970s was a period dominated by art theory and criticism. Critic Donald Kuspit stated that "the critic is artist," and magazines, books, and other kinds of publications were regarded as venues for art.

Joseph Kosuth, *One and three tables*, 1965. Kosuth creates Conceptual works that combined the object with image and text, raising questions about reality and the location of meaning. *One and three tables* presents three versions of a table and asks the viewer to consider which is the truest.

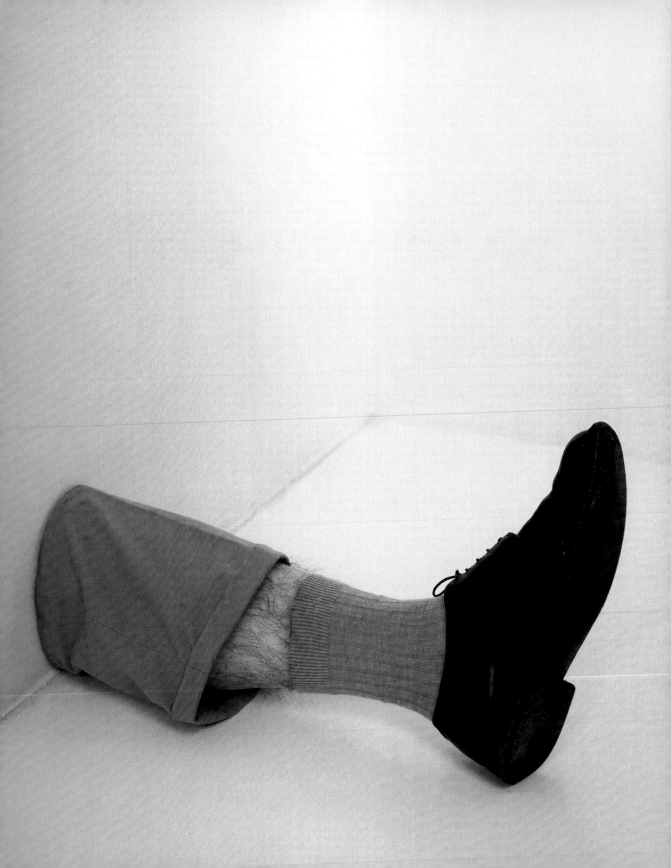

THE BODY REVISITED

The 1970s saw a sharp increase in politically informed art, which contrasted sharply with the largely apolitical movements of Pop Art and Minimalism that dominated the 1960s. The seventies was the decade of pluralism—a time when art fractured into many diverse strands without a dominant movement or philosophy. There were distinct trends—though with a growing interest in Conceptual and Performance-based art, many deemed painting anachronistic. Feminist art also played a significant role during this period, refocusing American perception of the body and posing questions of identity that have permeated much of modern art since. The seventies also witnessed an assertion of African American and Latino influence through activist art movements and the establishment of alternative museums. The 1980s saw a renewed enthusiasm for painting, heavily imbued with postmodern values. Fed by pluralism, Postmodernism examined the relationship between language and meaning, challenging perceptions of truth and authorship, and it continues to underscore art in the digital era.

Left: Robert Gober (b.1954), *Untitled*, 1990. Gober's sculptures address physical and psychological states through concoctions of commonplace objects and body parts.

The Impact of Feminism

Q: What was the impact of the women's movement on art?

A: Beginning in the United States in the late 1960s, the women's movement played a central role in the art of the 1970s. The challenges facing female artists at the end of the 1960s mirrored the societal struggles of contemporary American women. Asserting equality in a patriarchal environment, and doing so on their own terms, inevitably raised questions about the status and identities available to women in both art and life. The women's movement asserted the value of traditionally female artistic practices, which had been relegated to a lower tier, and viewed as "mere" decoration in an aesthetic hierarchy dominated by formalist values. Female art historians and curators sought to revise the contemporary and historical underrepresentation of women in the arts. Feminism challenged the ways in which women are represented in society and sought to reclaim the female image from predominately male definitions. The body became a key symbol, a politicized assertion of both equality and otherness. It was invoked both politically and artistically, and utilized to full effect in Performance art. The deconstructive aim of feminism is also central to Postmodernism. The movement has had a lasting influence over both male and female artists of all styles.

Q: How did the Feminist Art Program originate?

A: In 1969, Judy Chicago (b. 1939) launched the Feminist Art Program at California State University, Fresno. In 1972, Chicago and the program's codirector, Miriam Schapiro (b. 1923), organized a women-only exhibition, called *Womanhouse,* inside an old mansion in Hollywood. Each of the seventeen rooms was assigned to a different artist; each artist transformed her domestic space into a single piece, installation, or performance. The first day of the exhibition was reserved for a female-only audience. *Womanhouse* both challenged and parodied stereotypes about women, refuting the notion that domesticity and art were incompatible. The Feminist Art Program founded by Schapiro and Chicago in 1971 marked the beginning of similar art and women's studies programs in universities across the country.

Miriam Schapiro with Sherry Brody, *Dollhouse,* 1972. *Dollhouse* was one of the installations within the groundbreaking collaborative project *Womanhouse*, in 1972. At the time, Sherry Brody was Miriam Schapiro's student. Schapiro's use of patterned textiles in this piece marked a turning point in her art, and she was one of the founders the Pattern and Decoration movement in the mid-1970s.

Q: Who were the most prominent feminist artists?

A: Theory and criticism underscored the art of the late sixties and seventies. Particularly influential among feminist artists were the European, French-based theorists Julia Kristeva, Luce Irigaray, and Hélène Cixous. An important and widely influential feminist work was *Post-Partum Document* (1973–79) by Mary Kelly (b. 1941). *Post-Partum Document* was a conceptual, text-based analysis of her son's development from birth to the point at which society imposed mother-child separation. Kelly documented the first four years of her son's life, coolly examining and deconstructing stereotypes about motherhood, individuality, and identity.

One of the most famous and enduring feminist works is Judy Chicago's *The Dinner Party*, 1974–79. Chicago's ambitious work caused controversy when first exhibited at the San Francisco Museum of Art in 1979. Conceived as homage to thirty-nine women from ancient to modern history, it is intended to elevate the women to a historical plateau normally reserved for men. It takes the form of a three-sided Last Supper—each side represents a different historical age. There are thirteen place settings per side, and each setting bears a woman's name and a ceramic dish containing visual or sculptural references to the vagina.

Q: To what extent was art activist in the seventies?

A: The seventies in the United States was an era of political activism. Against the backdrop of the Vietnam War, the women's movement, and the gay rights movement, artists protested against racial and sexual inequalities in both art and society. Numerous groups were formed in the late 1960s and early 1970s whose provocative tactics brought the issues of the day to wide public attention. These groups set a precedent for art activism that continued into the 1980s, with the notable arrival of the Guerrilla Girls in 1984. Nancy Spero (b. 1926) is a feminist artist whose work addresses the two archetypal battlegrounds of war and sex. She belonged to a growing culture of politically active artists in the early 1970s (which also included her husband, Leon Golub). Spero drew her inspiration from antiquity, referencing iconic images of mythological women and ancient religions and exposing the social constructs that both promoted and perpetuated female stereotypes.

Judy Chicago, *The Dinner Party*, 1974–79. Although conceived by Chicago, *The Dinner Party* is a collective work (often a feature of feminist art) including individual contributions by various artists. In addition to the individual women honored at the table, the tiled triangular floor bears additional names of culturally and historically significant women.

Performance and Video Art

Ana Mendieta, *Anima (Alma/Soul)*, 1976/ printed 1977. Mendieta used the silhouette of her own naked body as a living symbol for women, producing a series of works that documented the repeated display of her silhouette in various natural environments.

Q: What is Performance art?

A: The term Performance art was coined in the late 1960s as a collective name for the many forms of conceptually driven art that placed emphasis on the dialogue between artist, idea, and viewer.

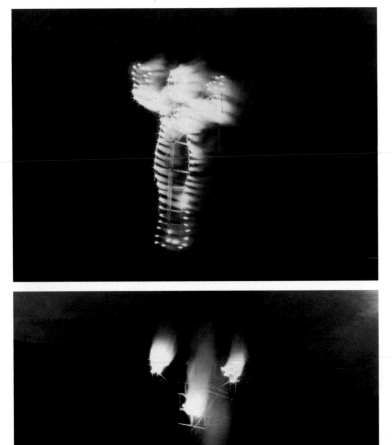

Performance art covers an extremely wide range of practices. Its ideas relate to central aspects of Land and Process art and extend into dance, activism, video, and theatrical work. Performance art is distinct, however, for its use of the body as a medium. Much Performance art made by women in the early seventies addressed questions of image and identity, actively challenging prevailing perceptions of the female body. In reclaiming their body for themselves, Performance artists parodied or reenacted social constructs and symbolically dismantled them. The Cuban-born artist Ana Mendieta (1948–85) directly addressed these issues, focusing often on violence toward women, in highly charged visceral performances in which she reenacted this abuse.

Q: What is the significance of the viewer in Performance art?

A: Performance art places a great emphasis on the relationship between the artist and the viewer, something it shares with Conceptual art. However, the psychological intensity inherent in the physicality of Performance art elicits new and unique responses in the viewer. The Performance art of the early seventies was provocative, humorous, visceral, and frequently disturbing. Artists like Carolee Schneemann (b. 1939), Chris Burden (b. 1946), and Vito Acconci (b. 1940) employed shocking and even dangerous means, heightening the audience's emotional investment and achieving a complete unity of artist and

artwork. In 1972, Vito Acconci created his well-known Performance piece *Seedbed* at the Sonnabend Gallery in New York. He constructed a low, raised platform in the gallery and masturbated, unseen but audible to gallery visitors who walked above him.

Q: How did Performance artists cross boundaries?

A: The pluralism of the 1970s caused boundaries between different forms of art to become increasingly blurred, stimulating collaborative projects between visual artists, musicians, composers, and choreographers. Laurie Anderson (b. 1947) produced large-scale, multimedia Performance pieces that merged theater, music, and video presentation, successfully bridging the gap between avant-garde art and popular entertainment. Her piece *O Superman* (1981) crossed over into mainstream media, reaching number two in the pop music charts in the UK, and led to a recording contract with Warner Brothers Records.

Q: Who were the pioneers of video art?

A: The person credited as the first practitioner of video art was the South Korean–born artist Nam June Paik (1932–2006). Early in his career, he was involved in the loosely defined movement Fluxus (influenced, like much avant-garde thinking of the period, by the experimental composer John Cage), and he created art that combined music, electronics, and performance. In 1965,

Sony released the first portable video/audio camera, the Portapak. The first video art piece created with this new and versatile electronic tool was Paik's *Videotape Study No. 3* (1967–69). It soon attracted other artists already making Performance and/or multimedia art, including Peter Campus (b. 1937), Dennis Oppenheim (b. 1938), and John Baldessari (b. 1931). Bruce Nauman (b. 1941) worked in a wide variety of conceptually based mediums, and his video works have exerted a major influence on American avant-garde art. The use of video gained momentum throughout the 1970s and continued into the 1980s, 1990s, and beyond, in works by—among others—Paul McCarthy (b. 1945), Mike Kelley (b. 1954), Bill Viola (b. 1951), and Diana Thater (b. 1962). Video art reached new heights of scale and complexity in the video/film hybrids exemplified by Matthew Barney's (b. 1967) full-length *Cremaster* series (1994–2002).

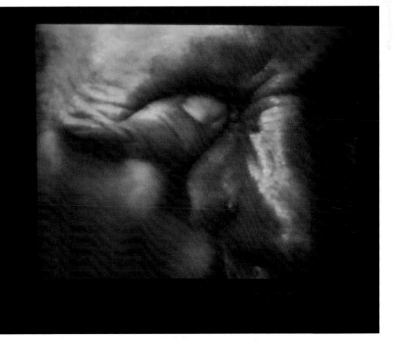

Bruce Nauman, "Poke in the Eye 3/8/94" Edit, 1994. Nauman's art explored the boundaries of bodily experience, language, and communication.

Photorealism and the Modern Photograph

Right: Robert Cottingham, *Flagg Bros*, 1975. Cottingham's paintings reveal a fascination with signs, from movie marquees and barber shops to advertisements and crosswalk lights. His art is imbued with nostalgia for a disappearing world, conveying faded promise and lackluster optimism.

Q: Why did Photorealism emerge?

A: The non-object–centered art practices of the late 1960s and the 1970s—Process, Performance, Conceptual, and Environmental art—relied on photography to document their time-based and/or ephemeral nature and to provide a visual reference to remote and inaccessible site-specific works. The increasing importance of the photographic document stimulated interest in photography, and a form of painting emerged that was influenced by the matter-of-fact literalness of the documentary photograph. Among the painters to adopt an intense Photorealist style were Ralph Goings (b. 1928), Audrey Flack (b. 1931), Robert Bechtle (b. 1932), Richard Estes (b. 1932), Robert Cottingham (b. 1935), and William Beckman (b. 1942).

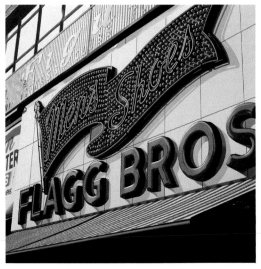

Q: What was the relationship between painting and photography in the 1970s?

A: In the politically charged atmosphere of the period, representational painting suffered from its association with the patriarchal art historical tradition, and artists sought new and untried mediums that could better reflect the changing times. Representational art of the 1970s thus required an added self-awareness to compete with conceptually based avant-garde art. Photorealists coolly used preexisting images, readymades in the form of photographs, postcards, color brochures, and so on, to bring a conceptual component to painting.

Their systematic approach to creating the image, in which the image was broken down into impersonal cells of visual information, allied the practice with aspects of Minimalism. Chuck Close (b. 1940), for example, created enormous, hyper-realistic portraits directly from snapshots of friends. These paintings were executed according to a strict system: A grid was imposed over the photograph, and Close painted one small section at a time according to the grid.

Q: What is Super Realist sculpture?

A: Pop Art, notably the life-size sculptures of George Segal, influenced the Super Realist sculpture of the 1970s. Super

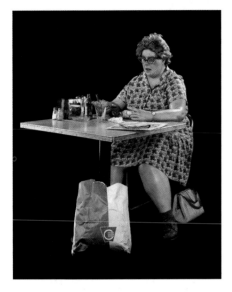

Realist sculpture was a small, uniquely American movement, whose two leading figures were John DeAndrea (b. 1941) and Duane Hanson (1925–96). Like Segal, these artists made casts from life, but used materials such as polyester resin, which more accurately enabled the realistic colors and textures the artists sought. On the surface, Super Realist sculpture ran counter to dominant art trends, but it also dealt with perceptions of reality and shared the period's pervasive interest in bodily presence. Hanson's work in particular had a political component that raised questions about American contemporary culture.

Q: What was the New Topography?

A: One of the developments in photography in the 1970s was the reevaluation of color photography. At the time, black-and-white photography was still considered the serious, legitimate version of the medium, and color photography was associated with the amateur snapshot and the advertisement. William Eggleston (b. 1939) single-handedly elevated the status of color photography with his 1976 exhibition at the Museum of Modern Art, which was the first single-artist exhibition of color photography at MoMA. His richly colored photographs of radically mundane and seemingly random subject matter were both celebrated and denounced as bland snapshots. Eggleston developed his early techniques in relative isolation from other contemporary photographers, and his work centered on life in the South. Artists like Robert Adams (b. 1937) and Stephen Shore (b. 1947) turned their cameras onto ordinary American life and the changing landscape in a way that mirrored the cool detachment of the documentary photograph. A 1975 exhibition in New York, entitled New Topographics: Photographs of a Man-Altered Landscape, presented an alternative vision of the American landscape without the emphasis on natural beauty that characterized earlier American photography and landscape painting.

Duane Hanson, *Woman Eating*, 1971. Made from polyester resin and fiberglass, and dressed in real clothes, Hanson's sculptures blur the boundaries between realistic and real, true and fake. His sculptures are poignant partly because they are so weirdly convincing and operate on a tragicomic level.

Robert Adams, "New Housing, Longmont, Colorado," 1973. New Topographical works, like Adams's unromantic presentation of a housing development under construction, share a worldly wise, deadpan quality, calmly reflecting the conflicted relationship between the American people and the landscape.

Philip Guston

Q: What was the course of Guston's career?

A: Philip Guston's career follows a fascinating arc. He radically shifted his style midway through his artistic life and seemingly rejected all his previous positions on painting, which polarized critical opinions about his work. His earliest paintings were figurative, and he had produced murals for the Federal Art Project in the 1930s. By the beginning of the 1950s, Guston had moved completely into nonobjective abstraction, and throughout the 1950s and first half of the 1960s, he produced paintings of great lyrical beauty. A leading figure in the second generation of Abstract Expressionism, he explored sensuous, atmospheric abstraction, which earned the name Abstract Impressionism because of its superficial resemblance to Impressionist painting. Then, in 1969, at the height of his successful career, Guston's painting underwent a complete and radical transformation. He abandoned abstraction altogether for a return to a defiantly nonlyrical, representational style, peopled with crude cartoonlike figures. Despite the almost perverse crudeness of his new paintings, however, Guston's sophisticated use of color meant that his paintings remained unfailingly beautiful throughout his career.

Philip Guston, *Painter III*, 1960. Guston's characteristic all-over application of paint in regular crosshatched brush marks, which had won him acclaim in the 1950s, began to disintegrate, simplify, and coalesce into areas suggestive of solid matter. Increasingly in his work, clunky, elusive forms appeared like half-submerged debris.

Q: What compelled Guston to change direction in his art?

A: The disparity between the rarefied aestheticism of Guston's abstract art and his strong personal feelings about the turbulent time he lived in left him increasingly frustrated. The transformation in his painting was motivated by an overwhelming need to connect two realities—the reality of painting and the reality of his own position in the world, which "pure" abstraction could not directly address. Guston realized that he wanted to tell stories, and spent two difficult years struggling to find a way forward, seesawing between representational and nonrepresentational work, which he described as "two equally powerful impulses at loggerheads." Guston's paintings of the 1960s show a gradual transformation from the nonobjective "purity" of abstraction to more narrative imagery.

Q: What was the critical response to Guston's return to figuration?

A: Guston's rejection of abstraction provoked scorn and outrage among his peers and from art critics, who felt betrayed and bewildered, in particular by the cartoonlike qualities of his new paintings. Critical condemnation of the 1970 exhibition debuting his new style, at the Marlborough Gallery in New York, nearly destroyed his

career, and he also lost the support of many friends. Guston, in turn, felt betrayed by the lack of appreciation and understanding of his new work. Two years later, he ended his relationship with the Marlborough Gallery and returned to teaching. He continued to paint in the same vein until his death, and withdrew somewhat from the Manhattan art world to work in the relative isolation of his home and studio in the village of Woodstock in upstate New York.

Q: What drove Guston's imagery?

A: Guston loved cartoons and comics as a boy, and he retained his deep attraction to cartoon drawing and animation throughout his life. Both his earliest and his late figurative paintings drew from his admiration for early Italian Renaissance artists, especially Piero della Francesca (c. 1420–92), for whom Guston held a lifelong admiration. He was also deeply interested in the Dutch master Rembrandt van Rijn (1606–69) and the darkly satirical art of the German artists Max Beckmann (1884–1950) and George Grosz (1893–1959). The white hooded figures that appear in Guston's late works represent his own, cloaked self-portrait as well as evoking the Ku Klux Klan. They hark back to his childhood, when he would retreat into a cupboard (lit by a naked bulb) to draw, safely hidden from his visiting relatives.

Guston had depicted real Klansmen in his political murals of the early 1930s, but they return in his late paintings rather as grotesque, clownish symbols for violence, stripped of real menace, and with a broader significance than their prototypes. The regular appearance of shoes was Guston's indirect reference to victims of the Holocaust and came to symbolize mortality and the degradation of all human life. His paintings include the flotsam and jetsam of objects that made up his working life: the light bulb that lit his night studio, bottles, food, cigarettes, brushes, books, and the act of looking itself, represented by his own head and his huge, transfixed eye.

Philip Guston, *Ancient Wall*, 1976. Here, heavy, hobnailed work-shoes dangle from redundant legs. Some even take on a horseshoe shape, connoting hard labor and creating an image of work and exhaustion.

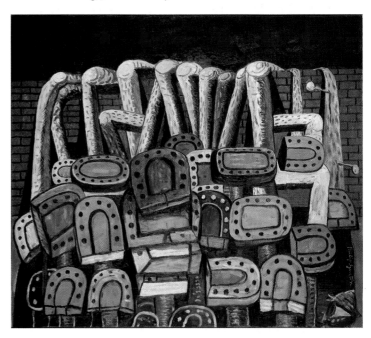

66 **I am a night painter, so when I come into the studio the next morning the delirium is over. I come into the studio very fearfully, I creep in to see what happened the night before. And the feeling is one of, 'My God, did *I* do *that*?'** 99

—*PHILIP GUSTON*

A New Spirit in Painting

Q: How was painting revitalized in the 1970s and 1980s?

A: The challenge for American painters in 1970s was how to compete with newer, more radical art forms, especially in addressing social or political concerns, using an age-old traditional medium, which (in strictly formalist terms) seemed to have gone as far as it could. Faced with the growing marginalization of painting and exclusion from the critical arena, artists reexamined the possibilities of painting. Philip Guston was among the few artists of an older generation to explore the uneasy territory between the opposing camps of "pure" abstraction and "impure" figuration. Cy Twombly (b. 1928) was another innovator; both artists were enormously influential in reenergizing painting for a younger generation. Toward the end of the 1970s, artists began to reassert the value of demotic language, narrative, and a wide variety of visual forms, which from the 1960s onward had been systematically rejected in favor of greater and greater conceptualism. American painting entered a period of renewed energy in the late 1970s, partly driven by defiance and encouraged by an international reassertion of painting in general. The wide variety of contemporary styles attested to the strength of this renewal, from the precise figuration of Robert Longo (b. 1953) to the "bad" painting of artists like Neil Jenney (b. 1945), to the cartoonlike exuberance of the painting/sculpture hybrids of Elizabeth Murray (b. 1940).

Q: What was "New Image Painting"?

A: A 1978 exhibition at New York's Whitney Museum of Art brought together young artists who were exploring painting in a variety of ways. These artists shared an interest in surface and image, while simultaneously stressing abstract qualities. They walked the line between abstraction and nonabstraction, favoring neither approach. In some cases, this duality simulated the effect of an optical puzzle (such as the silhouetted illusion of two profiles surrounding a Greek vase), forcing the mind to shift rapidly back and forth between two realities. This fluid, dialectical position underscored New Image Painting. Artists adopted paradox to isolate the structural components of a painting, allowing the viewer to see them both separately and as parts of a coherent work. Jennifer Bartlett (b. 1941) created elaborate multipaneled works that explored the innumerable possibilities that exist between representation and abstraction. Susan Rothenberg (b. 1945) combined the historically contradictory

Elizabeth Murray, *In the Dark*, 1987. Elizabeth Murray's exuberant, unconventionally shaped paintings transcend the boundaries between painting and sculpture. Her works often begin from an autobiographical starting point. Their cheerily cartoonlike forms belie the intensely personal subject matter at their core.

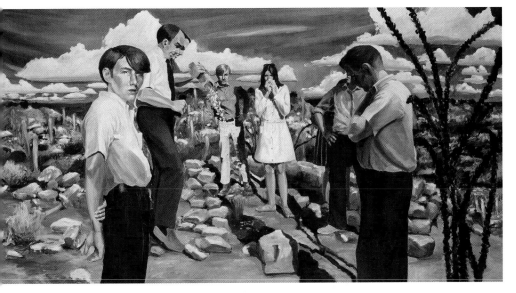

Eric Fischl, *The Funeral: A Band of Men (2 Women) Abandonment!*, 1980. Fischl's work relates more closely to the American realist tradition, and the quiet psychological tension of Edward Hopper, than to the rawness of Neo-Expressionism.

approaches of painting an expressive surface, with abstract color, Minimalist composition, and mute imagery reduced to outline shape.

Q: How important were developments in Europe at this time?

A: Art in Europe underwent a revolution in figurative painting in the 1970s. Neo-Expressionism began in Germany and Italy but became an international trend in the 1980s. Neo-Expressionism was figurative, raw, and messy. It emphasized human vulnerability through uncertain, clumsy, often crude painting, which mirrored the raw emotionalism of the self-taught artist. The self-conscious crudeness of much of the work influenced by Neo-Expressionism earned the label "bad painting." Julian Schnabel (b. 1951) was perhaps the closest American exponent of Neo-Expressionism, but its influence on American figurative painting in general was considerable.

Q: What was the "New Spirit in Painting"?

A: In 1981, London's Royal Academy hosted a major exhibition intended to showcase the state of international contemporary painting. The New Spirit in Painting had a significant impact on painting of the time. The exhibition was predominantly figurative and heavily represented Neo-Expressionism and related submovements. It included some abstract artists and also significant artists whose work did not fit comfortably into categories. Among the American artists invited to take part in this exhibition were Julian Schnabel, David Salle (b. 1952), and Eric Fischl (b. 1948). Fischl's painting shared certain qualities characterizing much of the new figurative painting, notably the stylistic awkwardness of his forms and the uncertain handling.

New York in the Eighties

Q: What happened to American art in the 1980s?

A: The American art world, firmly centered in New York, underwent a boom in the 1980s. Art prices were hiked up, and artists' careers were carefully orchestrated by media hype and manipulation of the art market by powerful dealers and auction houses. Overnight sensations arose, such as Jean-Michel Basquiat (1960–88). An obscure downtown artist at the beginning of the 1980s, Basquiat was catapulted to art world superstardom in the course of only a few short years.

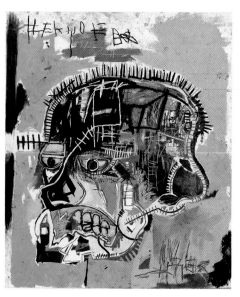

Jean-Michel Basquiat, *Untitled*, 1981. Basquiat's earliest graffiti works were collaborations with his friend Al Diaz, but Basquiat soon abandoned outdoor graffiti art for the more portable vehicle of painting.

Q: What is graffiti art?

A: Graffiti art began in poor New York boroughs in the 1970s and reached its height in the 1980s. Graffiti artists drew from the graphic art of underground comics and cartoons and used subway cars and walls as surfaces on which to paint (usually with spray paint and markers). Graffiti art employed a combination of images and text, notably in the invention of the "tag"—the pseudo-identity each of these artists adopted and made an integral part of their work. One of the earliest graffiti artists was TAKIS 183, and others included Crash, Dondi, Futura 2000, Lady Pink, Lee, Phase 2, Rammellzee, Revolt, Seen, and Zephyr. It was a short-lived "movement" and, with two notable exceptions (Basquiat and Keith Haring), remained largely outside the mainstream art world. Basquiat came from a middle-class background. He dropped out of high school a year before graduation and spent a couple of years on the streets, heavily involved in New York's downtown art and street scene. Basquiat's career took off after his work attracted the attention of a SoHo (a neighborhood in lower Manhattan) art dealer in 1981. By 1984 he had been represented by some of New York's most powerful dealers and also had gallery representation in Europe. The combination of Basquiat's formidable productivity, the massive publicity and hype endemic to the decade, and the close friendship he developed with arch-publicist Andy Warhol, made him an art world superstar. By the time he was twenty-four, he was on the front cover of *Time* magazine. Three years later he was dead from a drug overdose, and mainstream graffiti art faded from prominence.

Q: What was the downtown art scene?

A: In contrast to the heady commercialism of SoHo, an alternative downtown scene emerged in Manhattan's Lower East Side, centered in and around the East Village. Small galleries and artists' collectives opened up, and nightclubs also served as alternative venues for artists who either felt marginalized by the big SoHo galleries or rejected commercialism outright. The

downtown scene was politically activist and community based, and artists employed grass-roots methods, such as flyers, posters, and graffiti, to get their message to a larger audience. The downtown street culture was a vital but dangerous environment, fueled by drug use, with a harsh, brash aesthetic, influenced by punk culture. This lifestyle ultimately took its toll on the artists and the community. Photographers like Robert Mapplethorpe (1946–89) portrayed the dark glamour of New York's subculture in his glossy images of garage band musicians and beautiful transsexuals, while the photographs of Nan Goldin (b. 1953) reveal a more intimate view of human vulnerability and the personal fallout integral to the downtown scene.

Q: Who was Keith Haring?

A: Keith Haring (1958–90) grew up in Pennsylvania, outside New York graffiti culture. He moved to New York City in 1978 and became an active part of New York's downtown art community in the 1980s. His earliest work was a form of graffiti art; he began (illegally) making chalk drawings on the empty spaces prepared for advertisements in New York subway stations. His work consistently retained a signature combination of cartoonlike simplicity and humor, with serious, activist content. Haring tackled AIDS awareness and other social issues in his art, employing a street language of graffiti with a shrewd Pop sensibility, making his art accessible and immensely popular. In the early 1980s the downtown art community suffered

high losses to AIDS, which was a newly discovered and widely misunderstood disease. In 1989, one year after Haring was diagnosed with AIDS, the Keith Haring Foundation was established to assist children with AIDS-related problems. Haring died from the disease in the following year.

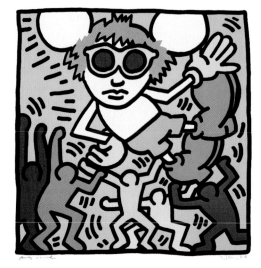

Above: Keith Haring, *Untitled, from the portfolio Andy Mouse*, 1986. Haring paid tribute to Andy Warhol with his Andy Mouse series. He merged Warhol and the famous Disney cartoon idol, implying that Warhol had become a Pop idol in his own right.

Q: What was the impact of AIDS on eighties art?

A: By the mid-1980s, the scale of the AIDS epidemic was becoming fully apparent. Many of these artists lost friends or lovers to AIDS and contracted the disease themselves. AIDS entered the common lexicon as a metaphor for loss and death, underscoring much of the art of the period.

Felix Gonzales-Torres, *"Untitled" (For Jeff)*, 1992. Gonzales-Torres (1957–1996), whose partner died from AIDS, made art that expressed, directly or indirectly, the experience of personal loss, and he also made public art to raise awareness of the disease.

Postmodernism

Q: What is Postmodernism?

A: Modernism sought universal truths and held notions of essential form and meaning. Postmodernism, on the other hand, denies the possibility of fixed meaning and examines the nature of language, how it is used and how it influences the way we interpret art. Postmodernism asserts that meaning is conditional, since language and culture are constantly changing and evolving. It also challenges ideas about authorship and the originality of expression. The name was coined in the 1970s, but its roots can be traced back to the cool irony of Duchamp's readymades, and to Pop Art's referencing of advertising, mass media, and attentiveness to the language of signs. Postmodernism was the central thrust of the art of the 1980s and 1990s, underlying the pervasive ironic detachment that characterizes much of the period's art, and inspiring artists to subvert and appropriate imagery. Postmodernist art of the 1980s and 1990s was often regarded as cynical and willfully subversive—however, it reveals artists' attentiveness to popular culture and to the fractured nature of the visual information of the mass media at the end of the twentieth century.

Q: What is "appropriation"?

A: Appropriation is a kind of visual sampling, in which visual material is isolated from its original context and historical significance and combined in often surprising ways. The separation of an image from its original point of reference and its juxtaposition with other dislocated materials thwarts single, fixed meaning, denies narrative, and emphasizes ambiguity and multiple readings. It mirrors the fractured, multifarious nature of visual information that began with the rapid growth of advertising and mass consumerism in the sixties, and which reached unprecedented levels with the rise in digital technology and the Internet in the 1990s. Artists began to "borrow" images and incorporate them directly in their own works from the end of the 1970s onward.

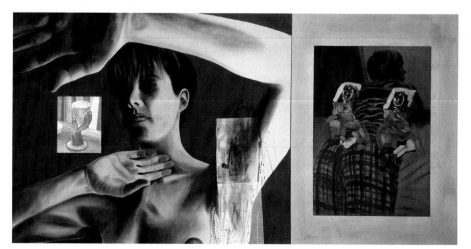

David Salle, *Pastel*, 1986. David Salle's provocative subversion of pictorial language and his paintings' denial of meaning shocked his audience, and his wholesale appropriation of images landed him in court for copyright infringement in 1984.

Q: How did photographers appropriate images?

A: The appropriation or manipulation of preexisting images strips them of their original meaning, draws attention to the process of looking and interpretation, and therefore diverts "meaning" elsewhere, altering the function of the image. The appropriated image becomes a sign for itself, and acts as a cultural marker. Once the appropriated image has been represented as a sign, it shifts the viewer's attention to the culture that produced the image in the first place. This is particularly true for the appropriation of photographic images. It raised thorny questions about authorship and originality that harked back to Marcel Duchamp and his readymades. Sherrie Levine (b. 1947) also garnered attention in the 1980s for her appropriation of famous works of art. The subversive nature of appropriation is exemplified in Levine's sleek sculpture *Fountain* (1991), which is a bronze duplicate of Duchamp's infamous 1917 readymade of the same name. With her casual recycling of Duchamp's idea, Levine elaborates on Duchamp's artistic joke.

Q: How did art and consumerism intersect?

A: Jeff Koons (b. 1955) took everyday consumer items such as vacuum cleaners and basketballs and remade them into art objects. They were not presented as readymades as such, because Koons's process involved transforming these objects in some way. By recasting banal objects in unlikely materials, or reproducing them on a dramatically different scale, Koons invited the viewer to assess them for their aesthetic value. The intersection of kitsch and art is at the core of Koons's work. By choosing banal popular objects, such as a heart-shaped balloon or a plush puppy, he subverts questions of taste, challenging our aesthetic criteria for art while also drawing on the efficiency of kitsch to deliver a clear message.

Above: Jeff Koons, *Michael Jackson and Bubbles*, 1988. The ultimate in kitsch, Koons's life-size ceramic sculpture of pop icon Michael Jackson and his pet chimpanzee "Bubbles" challenged notions of high and low art, as well as widely held ideas about good and bad taste. It belonged to a series called Banality, which explored themes of celebrity, image, and pop culture values.

Left: Richard Prince, "Cowboy," from *Cowboys and Girlfriends*, 1992. In 1977, Richard Prince (b. 1949) created a stir when he began rephotographing other peoples' photographs and exhibiting them as his own work.

Culture, Image, and Identity

Cindy Sherman, "Untitled # 121," 1983. By creating fictitious female protagonists, Sherman explores the transformative nature of women's roles in society.

Far right: Kara Walker, *The Means to an End … A Shadow Drama in Five Acts*, 1995. Walker (b. 1969) adopted the traditional device of the cut-out silhouette, creating large-scale narrative cycles that combine fairy tales with historical references as a way to reexamine racial stereotypes.

Q: How have artists addressed questions of identity and image?

A: Gender and racial identity were two of the major themes addressed by American art at the onset of the 1990s. In order to assert an alternative position, artists exploited the very strategies used in advertising and mass media, which generally promote clichéd and stereotypical attitudes. The multicultural nature of the United States, and the decentralizing, inclusive nature of the Internet in the 1990s were reflected in the growing diversity in art, echoing the pluralism of the 1970s. Ethnic groups across America had grown in number and in confidence, and racial identity became a major theme, especially among African American and Latino artists. Artists of diverse ethnicities shared a desire to make art that challenged stereotypes and asserted and celebrated their own cultural identity.

Q: How does Cindy Sherman use the body to represent culture?

A: Using herself as model, Cindy Sherman (b. 1954) created fictional personas that parodied stereotypes of women in popular culture. From 1977 to 1980, still early in her career, she made a series of black-and-white photographs called *Complete Untitled Film Stills*. This acclaimed and influential body of work drew from clichéd images of women, as presented in film, television, and popular magazines. Sherman created a series of invisible narratives, stills from films that did not exist, mirroring the artificial construct that lies behind stereotypes. For these stills, Sherman created elaborate and authentic-looking fake sets, among which she embodied a variety of popular screen types from 1950s-era film and television. She has continued this practice, using herself as model, in sometimes grotesque guises, and turned her attention to history and social dysfunction, creating large, glossy, color photographs that at times cross over into horror and decay. Questions of authenticity and the line between real and fake underscore Postmodernist art. Sherman's art addresses the power of advertising and the mass media in constructing identity and examines the conflict between appearance and identity.

Q: Why did artists adopt the tools of advertising?

A: Jenny Holzer (b. 1950) challenged accepted wisdom and commercially motivated slogans by creating her own slyly confrontational "truisms," such as: "STARVATION IS NATURE'S WAY" or "ABUSE OF POWER COMES AS NO

SURPRISE" (exhibited in Times Square in 1982). She first developed her truisms in 1977. She uses text exclusively, in public places usually dominated by commercial interests. In her early career, she distributed flyers and buttons on the streets; she has since moved on to large-scale electronic LED installations that evoke public message systems and flashing advertisement billboards.

As the art director for *Mademoiselle* and other magazines, Barbara Kruger (b. 1945) had firsthand experience in mass media and advertising. She developed her signature style in the 1980s, combining bold advertising design and slogans with found images, parodying advertising's language in order to draw attention to its ubiquitous influence on society.

Q: How did African American artists address racial identity in the 1990s?

A: In the 1990s, significant numbers of African American artists emerged into the public eye. The decade is also notable for the number of large-scale exhibitions that focused on issues of racial identity and image. Race relations were at the fore of political and artistic debate during this time, particularly on the West Coast, where videotaped police brutality and the ensuing 1992 race riots in Los Angeles seared America's longstanding racial conflicts into the public consciousness. African American artists such as David Hammons (b. 1943) and Kerry James Marshall (b. 1955), among others, directly addressed racial identity in their work. Female African American artists such as Carrie Mae Weems (b. 1953) and Lorna Simpson (b. 1960) addressed the complex and thorny issues of both race and gender identity, in photography and/or mixed-media works.

Above: Barbara Kruger, *Untitled (And)*, from the *Untitled Portfolio*, 1985. Kruger's work often examines the sexual stereotyping integral to mass marketing, and she exhibits her work on billboards usually reserved for commercial advertising.

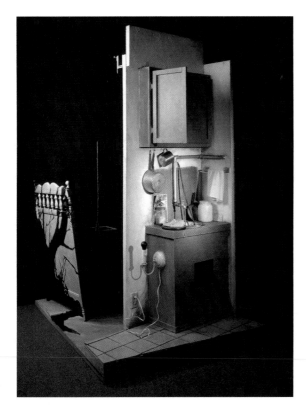

Above: María Brito, *El Patio de Mi Casa (The Patio of My House)*, 1990. Brito's mixed media installations serve as expressions of personal experiences. They center on her own identity—as a woman, a mother, and a wife—and on her feelings of cultural dislocation as a Cuban exile.

Right: María Castagliola, *A Matter of Trust*, 1994. *A Matter of Trust* is a restrained but powerful statement about the importance of community and the value of loyalty.

Q: How have Latino artists addressed identity?

A: María Brito (b. 1947), an installation artist, painter, and sculptor, is a leading figure of the Miami generation of Cuban-born artists based in Florida. Brito's works revolve around personal history, recalling memories and the loss of home and family. The trauma of early separation and the rupture in personal narrative created by immigration, or exile, is a recurring motif. In *El Patio de Mi Casa (The Patio of My House)*, which takes its name from a nursery rhyme from Brito's childhood, this rift is made explicit in the wide crack in the floor. The cradle evokes early childhood, darkened and nightmarish, overcast with ominous shadows. The other side of the piece recreates a humble kitchen, a universal symbol for nurture, traditionally the warm center of the family, with strong associations of home and security.

Q: What is Latino art?

A: The Chicano movement on the West Coast, which was initiated in the late 1960s to defend and promote the rights of Mexican Americans, inspired an assertion of Latino culture and a rapid growth of contemporary Latino art. Latino art had been relatively marginal throughout the twentieth century, but the spirit of multiculturalism in the 1990s along with a general enthusiasm for diversity afforded greater attention to less mainstream sections of American culture. The vital and varied world of contemporary Latino art contains a diversity of styles, materials, and mediums and is imbued with the shared cultural themes of memory, identity, loss, and family history.

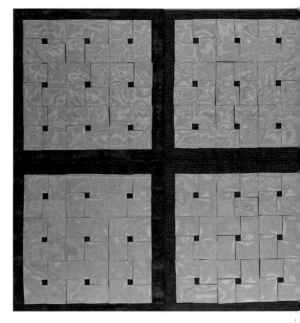

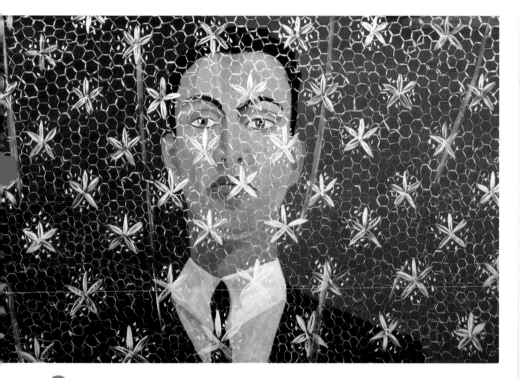

Q: What is the importance of shared history?

A: María Castagliola (b. 1946) arrived in America from Cuba in 1961 at the age of fifteen. Her work is abstract and, paradoxically, extremely personal. She combines the traditional form of the quilt, and its associations of home and comfort, with the unlikely materials of paper and fiberglass. Each patchwork square contains a letter carrying a deeply personal secret from family members and friends of the artist. The letters are stitched into the quilt and permanently sealed off from the world, giving the piece an elusive private quality and asserting the autonomy of difference. Castagliola has ensured that these secrets will stay safely concealed within the piece by sandwiching the quilt between two layers of fiberglass, preserving it like a historical artifact in a museum, or a time capsule, and transforming the secrets into unknowable historical documents.

Q: How have artists portrayed biculturalism?

A: The Mexican-born artist Roberto Gil de Montes (b. 1950) has returned to the theme of screens and veils repeatedly in his paintings, visual metaphors for the challenge of bicultural identity and the invisible barriers that exist between cultures.

María Martínez-Cañas (b. 1960) was born in Cuba, but her family was soon uprooted by the ongoing Cuban Revolution. She grew up in Puerto Rico and came to America as a young woman to study. Growing up listening to stories about her lost homeland fueled her fascination with Cuban history and culture and her own forgotten past.

Above: María Martínez-Cañas, *Totem Negro XVI*, 1992. Martínez-Cañas combines fragmented, collaged images that reference aspects of Cuba, which reflect her own fractured relationship to her heritage.

Above left: Roberto Gil de Montes, *Screen*, 1996.

American Art in a Global Era

Q: What was the impact of digital technology on art?

A: The diversity of American art at the beginning of the twenty-first century is too great to focus on a particular artist or approach, and distance is needed in order to identify trends that may in time be seen as part of a larger movement. The 1990s were characterized by an inclusiveness that admitted all manner of materials, subjects, and approaches to art. A defining feature of the decade, however, was the rapid growth of digital technology and the birth of the Internet. Digital technology plays an integral role in artistic practice for a growing number of contemporary artists, many of whom have either adopted technology as a tool, or embraced it as a primary medium. The birth of the Internet provided instant access to a wide range of information and facilitated international cultural exchange on a hitherto unknown scale. The multicultural, democratizing aspect of the Internet also provides a platform for individuals to present their ideas to a global audience. On the other hand, artists face the challenge of making work that can retain its meaning against the Internet's tendency to dilute or homogenize aspects of popular culture, style, and language. The period saw the emergence of a diverse range of media art, which made primary use of computer-based technology, such as digital and Internet art. The Internet has brought about significant changes in attitudes to making, finding, and distributing art. It has contributed to the decentralization of art, which for America has meant that New York is no longer the unquestionable center for avant-garde activity, but is instead one of many vital art centers across the globe.

Q: How have artists worked with technology?

A: Video installation and film reached new levels of expertise during the 1990s and were produced to an increasingly ambitious scale, complexity, and technical sophistication. They were afforded greater critical attention and positioned at the forefront of contemporary art. One of the most innovative and influential artists to have consistently explored the relationship between art and technology was the Korean-born artist Nam June Paik. A groundbreaking artist, Paik was the

Nam June Paik, *Electronic Superhighway: Continental U.S., Alaska, Hawaii*, 1995. Paik created this electronic map of the United States midway through the 1990s. Its title references the physical superhighways that cover the country, and the flickering images from television screens provide a constant visual stream, a virtual road trip reflecting the multiplicity of contemporary American culture.

earliest pioneer of video art; he embraced a range of cutting-edge technology throughout his career, until his death in 2006. Paik first coined the phrase "electronic superhighway" in the early 1970s, showing a prescient understanding of the global potential of electronic media and technology. He used the phrase to reference television, video, and film, but it was later used to describe the digital phenomenon now widely known as the Internet.

Paik understood the power of electronic media and its potential to disseminate ideas. He saw how it could extend far beyond the boundaries of the gallery or museum, bypass notions of high and low art, and reach out to a contemporary audiences on a grand scale. Paik's own bicultural identity, his interdisciplinary approach to art, and his ease with popular culture embodied qualities that lie at the heart of twenty-first-century art.

Further Reading

Books

Landau, Ellen G. *Jackson Pollock*. London: Thames & Hudson, 1989.

Pleynet, Marcelin. *Motherwell*. Paris: Daniel Papierski, 1989.

Edited by Waldman, Diane. *Ellsworth Kelly: A Retrospective*. London: Tate Gallery Publishing, 1996.

Storr, Robert. *Philip Guston*. New York: Abbeville Press, 1986.

Edited by Britt, David. *Modern Art, Impressionism to Post-Modernism*. London: Thames & Hudson, 1992.

Phillips, Lisa. *The American Century, Art and Culture 1950-2000*. New York: Whitney Museum of American Art, 1999.

Lucie-Smith, Edward. *Visual Arts in the 20th Century*. London: Laurence King Publishing, 1996.

Mendelowitz, Daniel M. *A History of American Art*. New York: Holt, Rinehart and Winston Inc., 1970.

Hughes, Robert. *American Visions, The Epic History of Art in America*. New York: Alfred A. Knopf Inc., 1997.

Wheeler, Daniel. *Art Since Mid-Century, 1945 to the Present*. New York: The Vendome Press, 1991.

Fineberg, Jonathan. *Art Since 1940, Strategies of Being*. London: Laurence King Publishing, 1995.

Honnef, Klaus. *Contemporary Art*. Cologne: Benedikt Taschen Verlag, 1990.

Elderfield, John. *Frankenthaler*. New York: Harry N. Abrams, Inc., 1989.

Jennings, Kate F. *Winslow Homer*. N.p.: Magna Books, 1990.

Goodrich, Lloyd. *Edward Hopper*. New York: Harry N. Abrams, Inc., 1993.

Dorment, Richard & Margaret F. Macdonald. *James McNeill Whistler*. London: Tate Gallery Publications, 1994.

Maresco, Frank & Roger Ricco. *American Vernacular, New Discoveries in Folk, Self-Taught, and Outsider Sculpture*. Boston: A Bullfinch Press Book, Little Brown & Co., 2002.

Bowman, Russell, Kenneth L. Ames, and Jeffrey R. Hayes. *Common Ground—Uncommon Vision: The Michael and Julie Hall Collection of American Folk Art*. Milwaukee: Milwaukee Art Museum, 1993.

Websites

Smithsonian American Art Museum www.americanart.si.edu

Hirshhorn Museum and Sculpture Garden www.hirshhorn.si.edu

Free and Sackler Galleries www.asia.si.edu

Archives of American Art www.aaa.si.edu

Richmond Hill Historical Society www.richmondhillhistory.org

National Audubon Society www.audubon.org

Walker Art Center, Minneapolis www.walkerart.org

Phillips Collection, New York www.phillipscollection.org

Metropolitan Museum of Art, New York www.metmuseum.org

The Museum of Modern Art, New York www.moma.org

Los Angeles County Museum of Art www.lacma.org

San Francisco Museum of Modern Art www.sfmoma.org

Museum of Fine Arts, Boston www.mfa.org

Tate Modern www.tate.org

Artcyclopedia www.artcyclopedia.com

At the Smithsonian

There is no shortage of places to view art at the Smithsonian. The 170-year-old former Patent Office Building, which houses the Smithsonian American Art Museum and National Portrait Gallery, was sumptuously restored and reopened in 2006 with new galleries, amenities, and facilities, as well as 57,000 more square feet of public space. Several blocks south, on the National Mall, sits the donut-shaped Hirshhorn Museum and Sculpture Garden, America's national museum of modern and contemporary art. A short walk away, abutting the Smithsonian Castle, are the Freer and Sackler Galleries, which house a rich collection of Asian art, including American works inspired by the art of the Near and Far East. Last, but not least, on the corner of Pennsylvania Avenue and 17th Street, one can find the Renwick Gallery of the Smithsonian American Art Museum, which collects, studies, exhibits, and preserves American decorative arts and crafts from the nineteenth to twenty-first centuries.

The Smithsonian American Art Museum (SAAM) was founded in 1929, as the first federal art collection. It is devoted exclusively to American artwork. Representing more than 7,000 artists, its collection covers colonial portraits, nineteenth-century landscapes, American impressionism, twentieth-century realism and abstraction, New Deal projects, sculpture, prints and drawings, photography, contemporary crafts and decorative arts, African American art, Latino art, and folk art. The SAAM was one of the first general museums to collect and display folk art. Its collections of African American and Latino art are also particularly rich and diverse. The bulk of the artwork in this volume hails from the Smithsonian American Art Museum.

The Hirshhorn Museum and Sculpture Garden opened in 1974, utilizing the innovative modern art collection of Joseph H. Hirshhorn. It collects and displays international contemporary art, aiming to reflect the moods and trends of the day. Its unique circular structure earned it a label as the "biggest piece of abstract art in town," from the architecture critic Benjamin Forgey.

All in all, the Smithsonian owns perhaps the largest and most diverse collection of American art within a radius of only a few miles. Admission is free at all museums of the Smithsonian Institution; normal operating hours are 10 a.m. to 5:30 p.m. daily. The Smithsonian Museum of American Art is open from 11:30 a.m. to 7 p.m. daily. E-mail info@si.edu or phone (202) 633-1000.

Above: The Hirshhorn Museum and Sculpture Garden.

Bottom left: James Turrell, *Milk Run*, 1996. *Milk Run* is in the collection of the Hirshhorn Museum.

Bottom right: Mary T. Smith, *Black and Red Male Figure with Upraised Arms*, c. 1980s. The SAAM is committed to collecting and displaying the works of American folk artists.

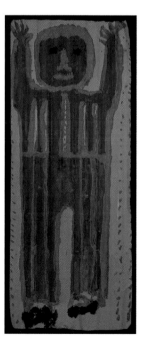

Index

Acknowledgments & Picture Credits

Many thanks to the editor, Marcel Brousseau, for all his hard work, and to everyone at Hylas who worked on this project. A special thank you goes to Grace and Finn, for tolerating my long hours at the computer with sweetness and understanding.

The author and publisher also offer thanks to those closely involved in the creation of this volume: consultant Guy Jordan; Ellen Nanney, Senior Brand Manager, Katie Mann and Carolyn Gleason, with Smithsonian Business Ventures; Collins Reference executive editor Donna Sanzone, editor Lisa Hacken, and editorial assistant Stephanie Meyers; Hydra Publishing president Sean Moore, publishing director Karen Prince, editorial director Aaron Murray, art director Brian MacMullen, designers Erika Lubowicki, Eunho Lee, Ken "Hollywood" Crossland, Gus Yoo, Anthony Antfarmer and La Tricia Watford; copyeditor extraordinaire Suzanne Lander, editors Lisa Purcell, Ward Calhoun, Mike Smith, Rachael Lanicci, Gail Greiner, and Kristin Maffei, picture researcher Ben Dewalt, proofreader Glenn Novak, and indexer Stuart A. P. Murray; Joan Mathys, of MJM Picture and Film Research, Cristin O'Keeffe Aptowicz of the Artist Rights Society, and Kim Tishler of the Visual Arts and Galleries Association.

PICTURE CREDITS

The following abbreviations are used: SAAM—Smithsonian American Art Museum; HMSG—Hirshhorn Museum and Sculpture Garden; NPG/SI—National Portrait Gallery, Smithsonian Institution; LoC—Library of Congress; ARS—Artists Rights Society (ARS), New York; VAGA—Licensed by VAGA, New York, NY

(t=top; b=bottom; l=left; r=right; c=center)

Introduction

IIIl Wikimedia **III**r Nam June Paik, *Video Flag*, 1985–96. 70 video monitors, 4 laser disc players, computer, timers, electrical devices, wood and metal housing on rubber wheels. 94 3/8 x 139 3/4 x 47 3/4 in. (239.6 x 354.8 x 119.9 cm). Holenia Purchase Fund in Memory of Joseph H. Hirshhorn, 1996/ HMSG **IV**t LoC/ With permission from Northwestern University Library **IV**c *Melons and Morning Glories*, 1813, Raphaelle Peale. Oil on canvas, 20 3/4 x 25 3/4 in. (52.6 x 65.4 cm.). Gift of Paul Mellon/ SAAM **IV**b *Spirit of Life*, 1914, Daniel Chester French. Bronze, 51 x 28 x 30 in. (129.5 x 71.1 x 76.2 cm). Museum purchase through the Luisita L. and Franz H. Denghausen Endowment/ SAAM **IV–V**background Ellsworth Kelly, *Red White*, 1961. Oil on canvas. 62 3/4 x 85 1/4 in. (159.5 x 216.6 cm). Gift of Joseph H. Hirshhorn, 1972/HMSG **V**t Ilya Bolotowsky, *In the Barber Shop*, c. 1934. Oil on canvas, 23 7/8 x 30 1/8 in. (60.6 x 76.5 cm). Transfer from the U.S. Department of Labor. SAAM/ Art © Estate of Ilya Bolotowsky/ VAGA **V**b David Smith, *Agricola I*, 1951–52. Painted steel, 73 1/2 x 55 1/4 x 24 5/8 in. (186.5 x 140.3 x 62.5 cm.) incl. base h: 1 in. (2.5 cm.). Gift of Joseph H. Hirshhorn, 1966. HMSG/ Art © Estate of David Smith/ VAGA **VI–1**background *Niagara Falls*, 1885, George Inness. Oil on wood, 15 7/8 x 24 in. (40.2 x 60.9 cm.). Gift of John Gellatly/ SAAM **1**b *Emancipation House*, 1964, George W. White, Jr. Mixed media: wood, cloth, and oil, 19 1/2 x 23 1/4 x 18 1/2 in. (49.5 x 59.2 x 47.0 cm.). Museum purchase/ SAAM **2** *We Both Must Fade (Mrs. Fithian)*, 1869, Lilly Martin Spencer. Oil on canvas, 72 x 53 3/4 in. (182.9 x 136.5 cm.). Museum purchase/ SAAM **3** Julian Schnabel, *Portrait of Andy Warhol*, 1982. Oil on velvet, 107 3/4 x 120 1/8 in. (274.0 x 305.0 cm.). Joseph H. Hirshhorn

Purchase Fund and Regents Collections Acquisition Program with matching funds from the Jerome L. Green, Sydney and Frances Lewis and Leonard C. Yaseen Purchase Fund, 1994/ HMSG

Chapter 1: Early American Art

4 LoC **5**background Wikimedia **5**r Hancock Shaker Village, Pittsfield, Massachusetts **6**tl Photo by Geron Marcom, www.petroglyphs.us **6**bl Photo by Ernest Amoroso, © Smithsonian Institution/ National Museum of the American Indian **7** LoC **8** Collection of The New-York Historical Society, on permanent loan from the New York Public Library, accession number S-117 **9** Courtesy, Chipstone Foundation; photo, Gavin Ashworth **10** G.E. Kidder Smith, Courtesy of Kidder Smith Collection, Rotch Visual Collections, M.I.T **11** Worcester Art Museum, Worcester, Massachusetts, Gift of Mr. and Mrs. Albert W. Rice **12** Philadelphia Museum of Art: Bequest of Lisa Norris Elkins, 1950 **13** Hicks, Edward (American, 1780–1849) *Peaceable Kingdom*, c. 1834, canvas, .762 x .902 (30 X 35 1/2) National Gallery of Art, Washington, Gift of Edgar William and Bernice Chrysler Garbisch **14** Smithsonian Photographic Services/ Division of Textiles, National Museum of American History/ Smithsonian Institution [78-5217] **15** Hancock Shaker Village, Pittsfield, Massachusetts **16** Wikimedia **17** Wikimedia

Chapter 2: An American Revolution in Art

18 Architect of the Capitol **19**r Wikimedia **20**bl Copley, John Singleton, *Mrs. George Watson*, 1765. Oil on canvas, 49 7/8 x 40in (126.7 x 101.6cm) Partial gift of Henderson Inches, Jr., in honor of his parents, Mr. and Mrs. Inches, and museum purchase made possible in part by Mr. and Mrs. R. Crosby Kemper through the Crosby Kemper Foundation; the American Art Forum; and the Luisita L. and Franz H. Denghausen Endowment/ SAAM **20**tr Wikimedia **21** Architect of the Capitol **22** Wikimedia **23**t Wikimedia **23**b Wikimedia **24** Peale, Charles Willson, *Mrs. James Smith and Grandson*, 1776. Oil on canvas, 36 3/8 x 29 1/4 in (92.4 x 74.3 cm.). Gift of Mr. and Mrs. Wilson Levering Smith, Jr. and museum purchase/ SAAM **25** Wikimedia **26**tr Public Domain **26**bl Wikimedia **27** Johnson, Joshua, *Portrait of Adelia Ellender*, 1803–5. Oil on canvas, 26 1/4 x 21 1/8 in. (66.7 x 53.7 cm.). Gift of Mr. and Mrs. Norman Robbins/ SAAM **28**bl NPG/SI; owned jointly with Museum of Fine Arts, Boston **28**tr U.S. Senate Collection **29** NPG/SI; acquired as a gift to the nation through the generosity of the Donald W. Reynolds Foundation **30**l Wikimedia **30**t NPG/SI; owned jointly with Museum of Fine Arts, Boston **31** Wikimedia

Chapter 3: Nature and Landscape

32 King, Charles Bird, *Young Omahaw, War Eagle, Little Missouri, and Pawnees*, 1821. Oil on canvas, 36 1/8 x 28 in. (91.8 x 71.1 cm). Gift of Miss Helen Barlow/ SAAM **33**r Wikimedia **34** Catlin, George, *Bird's Eye View of the Mandan Village, 1800 Miles above St. Louis*, 1837–39. Oil on canvas, 24 1/8 x 29 in. (61.2 x 73.6 cm). Gift of Mrs. Joseph Harrison, Jr./ SAAM **35**t *Osage Scalp Dance*, 1845, John Mix Stanley. Oil on canvas, 40 3/4 x 60 1/2 in. (103.5 x 153.6 cm). Gift of the Misses Henry/ SAAM **35**b *Westward the Course of Empire Takes Its Way* (mural study, U.S. Capitol), 1861, Emanuel Gottlieb Leutze. Oil on canvas, 33 1/4 x 43 3/8 in. (84.5 x 110.1 cm.). Bequest of Sara Carr Upton/ SAAM **36** *The Bronco Buster*, modeled 1895, cast 1910, Frederic Remington. Founder: Roman Bronze Works. Bronze, 23 1/4 x 20 1/4 x 11 1/2 in. (59.1 x 51.4 x 29.2 cm). Gift of Jean and William M. (Oz) Osborne in memory of Donald S. Vogel and in honor of Cheryl and Kevin Vogel/ SAAM **37**t *Fired On*, 1907, Frederic Remington. Oil on canvas, 27 1/8 x 40 in. (68.8 x 101.6 cm.) Gift of William T. Evans/ SAAM **37**b Charles M. Russell, *The Medicine Man*, 1908, oil on canvas, 1961.171, Amon Carter Museum, Fort Worth, Texas **38** *The Subsiding of the Waters of the Deluge*, 1829, Thomas Cole. Oil on canvas, 35 3/4 x 47 3/4 in. (90.8 x 121.4 cm). Gift of Mrs. Katie Dean in memory of Minnibel S. and James Wallace Dean and museum purchase through the Smithsonian Institution Collections Acquisition Program/ SAAM **39** *Cotopaxi*, 1855, Frederic Edwin Church. Oil on canvas, 28 x 42 in. (71.1 x 106.8 cm). Gift of Mrs. Frank R. McCoy/ SAAM **40** *Among the Sierra Nevada, California*, 1868, Albert Bierstadt. Oil on canvas, overall: 72 x 120 1/8 in. (183 x 305 cm), frame: 96 1/4 x 144 3/8 x 7 1/4 in. Bequest of Helen Huntington Hull, granddaughter of William Brown Dinsmore, who acquired the painting in 1873 for "The Locusts," the family estate in Dutchess County, New York/ SAAM **41**t *Storm King on the Hudson*, 1866, Samuel Colman. Oil on canvas, 32 1/8 x 59 7/8 in. (81.6 x 152.0 cm.). Gift of John Gellatly/ SAAM **41**b *The Grand Canyon of the Yellowstone*, 1893–1901, Thomas Moran. Oil on canvas, 96 1/2 x 168 3/8 in. (245.1 x 427.8 cm.), Frame: 188 x 116 1/4 in. Gift of George D. Pratt/ SAAM **42**t LoC **42**b Public Domain **43**t Public Domain **43**b Public Domain **44** U.S. Naval Academy Art Collection, #1922.002.63 **45** Fitz Hugh (Fitz Henry) Lane, *Ship Starlight*, 1860. Oil on canvas, 30" x 50." Collection of the Butler Institute of American Art, Youngstown, Ohio **46** *Still Life with Fruit*, 1852, Severin Roesen. Oil on canvas, 34 x 43 7/8 in. (86.5 x 111.5 cm.). Gift of Maria Alice Murphy in memory of her brother Colonel Edward J. Murphy, Jr. and museum purchase through the Director's Discretionary Fund/ SAAM **47**t *Luncheon Still Life*, c. 1860, John F. Francis. Oil on canvas, 25 3/8 x 30 3/8 in. (64.6 x 77.2 cm.) Museum purchase/ SAAM **47**b Wikimedia **48** Public Domain **49** George Caleb Bingham, American (1811–79). *Canvassing for a Vote*, 1852. Oil on Canvas, 25-1/4," x 30-1/2" (64.14 x 77.47 cm). The Nelson-Atkins Museum of Art, Kansas City, Missouri. Purchase: Nelson Trust, 54-9. Photograph by Jamison Miller. **50**t *The War for the Union 1862—A Bayonet Charge*, from *Harper's Weekly*, July 12, 1862, 1862, Winslow Homer. Wood engraving on paper image: 13 3/4 x 20 3/4 in. (34.9 x 52.7 cm.). The Ray Austrian Collection, Gift of Beatrice L. Austrian, Caryl A. Austrian and James A. Austrian/ SAAM **50**b *The Lord Is My Shepherd*, c. 1863, Eastman Johnson. Oil on wood, 16 5/8 x 13 1/8 in. (42.3 x 33.2 cm.) Gift of Mrs. Francis P. Garvan/ SAAM **51** LoC

Chapter 4: The American Renaissance

52 *Girl with Lute*, 1904–5, Thomas Wilmer Dewing. Oil on wood panel, H: 60.8 cm, W: 45.0 cm, United States Gift of Charles Lang Freer/ Freer and Sackler Galleries **53**r Photograph by Gordon Sweet. Courtesy of the Department of the Interior, National Park Service, Saint-Gaudens National Historic Site, Cornish, NH **54** *Greek Slave*, modeled 1841–43, Hiram Powers. Plaster, 13 3/4 x 7 x 10 3/4 in. (35.0 x 17.7 x 27.4 cm). Museum purchase in memory of Ralph Cross Johnson/ SAAM **55**r *George Washington*, 1840, Horatio Greenough. Marble, 136 x 102 x 82 1/2 in. (345.4 x 259.1 x 209.6 cm). Transfer from the U.S. Capitol/ SAAM **56** *Echo*, 1892, Kenyon Cox. Oil on canvas, 35 3/4 x 29 3/4 in. (90.8 x 75.7 cm.). Gift of Mrs. Ambrose Lansing/ SAAM **57**t *Virgin Enthroned*, 1891, Abbott Handerson Thayer. Oil on canvas, 72 1/2 x 52 1/2 in. (184.3 x 133.2 cm) Gift of John Gellatly/ SAAM **57**br *Stevenson Memorial*, 1903, Abbott Handerson Thayer. Oil on canvas, 81 5/8 x 60 1/8 in. (207.2 x 152.6 cm.). Gift of John Gellatly/ SAAM **58**t Bowdoin College Museum of Art, Brunswick, Maine, Gift of the Misses Harriet Sarah and Mary Sophia Walker **58**b Courtesy of the Department of the Interior,

National Park Service, Saint-Gaudens National Historic Site, Cornish, NH. **59** Photo courtesy of Gillian Troup **60** *Courtesan*, 1796–98, Katsushika Hokusai. Edo period Hanging scroll; ink and color on paper W: 39.7 cm, Japan. Gift of Charles Lang Freer/ Freer and Sackler Galleries **61**t *Harmony in Blue and Gold: The Peacock Room*, 1876–77, James McNeill Whistler. Oil paint and gold leaf on canvas, leather, and wood, H: 421.6 W: 613.4 D: 1026.2 cm, United States. Gift of Charles Lang Freer/ Freer and Sackler Galleries **61**bl *Flowers and Insects*, c. 1615–1868, Artist of the Tosa school, Edo period, Pair of six-panel folding screens; ink, color and gold on paper H: 155.0 W: 361.1 cm, Japan. Gift of Charles Lang Freer/ Freer and Sackler Galleries **62** Wikimedia **63** Wikimedia **64**l *Apollo with Cupids*, 1880–82, Designer: John La Farge Modeler: Augustus Saint-Gaudens. Banded African mahogany, repoussé bronze, colored marbles, mother-of-pearl, abalone shell, and ivory 27 3/4 x 63 1/2 in. (70.5 x 161.3 cm.). Gift of James Maroney and museum purchase/ SAAM **64**tr *Peacocks and Peonies I*, 1882, John La Farge. Stained glass window frame: 112 x 51 1/4 x 6 1/2 in. (284.5 x 130.3 x 16.5 cm.). Gift of Henry A. La Farge/ SAAM **65** Wikimedia **66**tl *Elizabeth Winthrop Chanler (Mrs. John Jay Chapman)*, 1893, John Singer Sargent. Oil on canvas, 49 3/8 x 40 1/2 in. (125.4 x 102.9 cm.). Gift of Chanler A. Chapman/ SAAM **66**b *Betty Wertheimer*, 1908, John Singer Sargent. Oil on canvas, 50 1/2 x 39 3/8 in. (128.3 x 100.0 cm.). Gift of John Gellatly/ SAAM **67**t Wikimedia **67**b *Breakfast in the Loggia*, 1910, John Singer Sargent. Painting; oil on canvas H: 51.5 W: 71.0 cm., United States. Gift of Charles Lang Freer/ Freer and Sackler Galleries

Chapter 5: American Impressionism

68 *Upland Pasture*, c. 1905, J. Alden Weir. Oil on canvas, 39 7/8 x 50 1/4 in. (101.2 x 127.6 cm.). Gift of William T. Evans/ SAAM **69**r Wikimedia **70** Wikimedia **71** *Old Church at Giverny*, 1891, Theodore Robinson. Oil on canvas, 18 x 22 1/8 in. (45.8 x 56.1 cm.). Gift of William T. Evans/ SAAM **72**l Wikimedia **73** *The Caress*, 1902, Mary Cassatt. Oil on canvas, 32 7/8 x 27 3/8 in. (83.4 x 69.4 cm.). Gift of William T. Evans/ SAAM **74** Wikimedia **75** *Shinnecock Hills*, c. 1895, William Merritt Chase. Oil on canvas, 34 1/8 x 39 1/2 in. (86.6 x 100.4 cm.). Gift of William T. Evans/ SAAM **77**t *The Brook, Greenwich, Connecticut*, c. 1890–1900, John Henry Twachtman. Oil on canvas, 25 1/8 x 34 7/8 in. (63.7 x 88.5 cm.). Gift of John Gellatly/ SAAM **77**b Julian Alden Weir, *The Bridge: Nocturne (Nocturne: Queensboro Bridge)*, 1910. Oil on canvas mounted on wood. 29 x 39 1/2 in. (73.6 x 100.4 cm.). Gift of Joseph H. Hirshhorn, 1966/ HMSG **78** Childe Hassam, *The Union Jack, New York, April Morning*, 1918. Oil on canvas, 36 x 30 1/8 in. (91.3 x 76.5 cm.). Gift of Joseph H. Hirshhorn, 1966/ HMSG **79**l Wikimedia **79**r *In the Garden (Celia Thaxter in Her Garden)*, 1892, Childe Hassam, Oil on canvas, 22 1/4 x 18 in. (56.5 x 45.7 cm.). Gift of John Gellatly/ SAAM **80** *Park Scene*, c. 1915–18, Maurice Prendergast. Watercolor on paper sheet: 15 x 22 1/8 in. (38.1 x 56.2 cm.). Gift of Mrs. Charles Prendergast/ SAAM **81** Maurice Prendergast, *Beach at Gloucester*, c. 1918–21. Oil on canvas, 30 5/8 x 43 1/8 in. (77.9 x 109.3 cm.) Gift of the Joseph H. Hirshhorn Foundation, 1966/ HMSG

Chapter 6: Realism

82 *Mrs. Thomas Eakins*, c. 1899. Oil on canvas. 20 1/8 x 16 1/8 in. (51 x 40.8 cm). Gift of Joseph H. Hirshhorn, 1966/ HMSG **83** John Sloan, *Ferry Slip, Winter*, 1905–6. Oil on canvas. 21 5/8 x 31 3/4 in. (55.1 x 80.5 cm.). Gift of Joseph H. Hirshhorn, 1966/ HMSG **84** Public Domain **85** Public Domain **86** Thomas Eakins, *Wrestlers in Eakins's Studio*, c. 1899. Platinum print on paper, 3 5/8 x 6 in. (9.0 x 15.2 cm.). Gift of Joseph H. Hirshhorn, 1966/ HMSG **87**t Thomas Pollock Anshutz, (1851–1912) *The Ironworkers' Noontime*, 1880, oil on canvas, 17 x 23 (43.2 x 60.6 cm.). Fine Arts Museums of San Francisco, Gift of Mr. and Mrs. John D. Rockefeller 3RD, 1979.7.4 **87**b *Mother of Henry O. Tanner*, n.d., Henry Ossawa Tanner. Oil on plywood, 13 x 9 1/4 in. (33.0 x 23.5 cm.). Gift of Dr. Nicholas Zervas/ SAAM **88** Harnett, William Michael (American, 1848–92), *The Old Violin*, 1886, oil on canvas, .965 x .610 (38 x 24); framed: 1.197 x .841 x.051 (47 1/8 x 33 1/8 x 2). Image © 2006, Board of Trustees, National Gallery of Art, Washington. Gift of Mr. And Mrs. Richard Mellon Scaife in honor of Paul Mellon **89** *Rack Picture for William Malcolm Bunn*, 1882, John F. Peto. Oil on canvas 24 x 20 in. (61.0 x 50.8 cm.). Gift of Nathaly Baum in memory of Harry Baum/ SAAM **90** Winslow Homer, *Snap the Whip*, 1872. Oil on canvas, 22" x 36." Collection of the Butler Institute of American Art, Youngstown, Ohio **91**t *High Cliff, Coast of Maine*, 1894, Winslow Homer. Oil on canvas, 30 1/4 x 38 1/4 in. (76.8 x 97.2 cm.). Museum Gift of William T. Evans/ SAAM **91**b Wikimedia **91**b *Blind Spanish Singer*, 1912, Robert Henri. Oil on canvas, 41 x 33 1/8 in. (104.0 x 84.0 cm.). Gift of Mr. J.H. Smith/ SAAM **93**bl *Eviction (Lower East Side)*, 1904, Everett Shinn. Gouache on paper mounted on paperboard sheet: 8 3/8 x 13 1/8 in. (21.3 x 33.3 cm.). Bequest of Henry Ward Ranger through the National Academy of Design/ SAAM **93**tr *Cumulus Clouds, East River*, 1901–2, Robert Henri. Oil on canvas, 25 3/4 x 32 in. (65.4 x 81.3 cm.). Gift of Mrs. Daniel Fraad in memory of her husband/ SAAM **94** LoC **95**t LoC **95**b LoC **96** George Bellows (American, 1882–1925). *Stag at Sharkey's*, 1909. Oil on canvas; 110 x 140.5 x 8.5 cm. Copyright The Cleveland Museum of Art, Hinman B. Hurlbut Collection, 1133.1922 **97**t Wikimedia **97**b LoC

Ready Reference

98l *Baboon*, 1978, Felipe Archuleta. Carved and painted cottonwood and pine, 69 1/4 x 41 3/4 x 16 in. (175.9 x 106.0 x 40.6 cm.). Gift of Herbert Waide Hemphill, Jr. and museum purchase made possible by Ralph Cross Johnson/ SAAM **98**c *Winged Dog*, c. 1975, Stephan W. Polaha. Painted wood, metal, and glass, 17 7/8 x 22 x 10 1/2 in. (45.4 x 55.9 x 26.7 cm.). Gift of Chuck and Jan Rosenak and museum purchase through the Luisita L. and Franz H. Denghausen Endowment/ SAAM **98**r *Bottlecap Giraffe*, completed after 1966, Unidentified Artist. Carved and painted wood, bottlecaps, rubber, glass, animal hair and fur, and sheet metal, 72 1/2 x 54 x 17 1/2 in. (184.2 x 137.2 x 44.5 cm.) Gift of Herbert Waide Hemphill, Jr. and museum purchase made possible by Ralph Cross Johnson/ SAAM **99**tl *Guitar*, c. 1920s–30s, Unidentified Artist. Painted wood and plywood, brass chrome, iron, lead, celluloid, metal wire, and photograph, 34 3/4 x 10 7/8 x 4 1/4 in. (88.3 x 27.6 x 10.8 cm.). Gift of Herbert Waide Hemphill, Jr. and museum purchase made possible by Ralph Cross Johnson/ SAAM **99**tc *Cane with Indian, Entwined Man and Snake and Diverse Animals*, c. late 19th century, Unidentified Artist. Carved, painted, and varnished hickory and pecan with metal, 37 x 4 x 1 1/2 in. (94.0 x 10.2 x 3.7 cm.). Gift of Herbert Waide Hemphill, Jr. and museum purchase made possible by Ralph Cross Johnson/ SAAM **99**tr *American Flag Whirligig*, mid-20th century, Unidentified Artist. Painted iron and carved and painted wood, 28 1/4 x 38 1/2 x 28 1/4 in. (71.8 x 97.8 x 71.8 cm.). Gift of Herbert Waide Hemphill, Jr. and museum purchase made possible by Ralph Cross Johnson/ SAAM **99**bl *Killingworth Image, Man on a Hog*, c. 1890, Clark Coe. Mixed media: carved, assembled, and painted wood, tinned iron, iron nails, textile remnants, hair. Man: 30 1/4 x 20 x 14 3/8 in. (76.7 x 50.8 x 36.5 cm.) hog: 20 7/8 x 38 in. Gift

of Herbert Waide Hemphill, Jr. and museum purchase made possible by Ralph Cross Johnson/ SAAM **99br** *Beast Going Through the Grass,* c. 1984–1985, Ulysses Davis. Carved and painted wood with rhinestones, 35 1/8 x 9 5/8 x 6 3/4 in. (89.2 x 24.4 x 17.1 cm.). Museum purchase made possible by Ralph Cross Johnson/ SAAM **100tl** *"MINUTE MAID" Articulated Figure,* c. 1950s. Unidentified Artist. "Minute Maid" orange juice can, carved and painted wood, and turned iron, 10 1/2 x 3 1/2 x 2 3/4 in. (26.7 x 9.0 x 7.0 cm.). Gift of Herbert Waide Hemphill, Jr. and museum purchase made possible by Ralph Cross Johnson/ SAAM **100tc** *Portrait Head Paintbrush Tree,* 1991, Mr. Imagination. Mixed media: bottlecaps, paintbrushes, and paint on wood, 65 1/8 x 22 3/4 x 18 3/4 in. (165.4 x 57.8 x 47.6 cm.). Museum Purchase/ SAAM **100tr** *Birthing,* c. 1986, Bessie Harvey. Painted wood, beads, rhinestones, sequins, glitter and nail, 9 1/2 x 35 3/4 x 17 7/8 in. (24.2 x 90.8 x 45.4 cm.). Museum purchase and gift of Estelle E. Friedman/ SAAM **100b** *Adam and Eve Leave Eden,* 1973, John William ("Uncle Jack") Dey. Model airplane enamel on fiberboard, 23 1/8 x 47 in. (58.7 x 119.4 cm.). Gift of Herbert Waide Hemphill, Jr. and museum purchase made possible by Ralph Cross Johnson/ SAAM **101t** *Untitled,* 1987, Hawkins Bolden. Galvanized iron, cotton, wood, wire, straw, 38 x 17 1/2 x 44 in. (96.5 x 44.5 x 111.8 cm.). Gift of William Arnett/ SAAM **101bl** *The Throne of the Third Heaven of the Nations' Millennium General Assembly,* c. 1950–64, James Hampton. Gold and silver aluminum foil, Kraft paper, and plastic over wood furniture, paperboard, and glass, 180 pieces in overall configuration: 10 1/2 x 27 x 14 1/2 ft. Gift of anonymous donors/ SAAM **101bc** *The Saw and the Scroll,* 1977–78, Jesse Howard. Acrylic and crayon on canvas and wood; acrylic on metal and wood, overall: 39 3/4 x 71 x 1 1/2 in. (101.0 x 180.3 x 3.8 cm.). Gift of Chuck and Jan Rosenak and museum purchase through the Luisita L. and Franz H. Denghausen Endowment/ SAAM **101br** *Carreta de Muerte (Death Cart),* 1975, Horacio Valdez. Painted cottonwood, hair, and leather, Overall: 55 1/2 x 51 7/8 x 32 3/4 in. (141.0 x 131.8 x 83.2 cm) Gift of Chuck and Jan Rosenak and museum purchase through the Luisita L. and Franz H. Denghausen Endowment/ SAAM **102t** *Moses, Grandma, McDonnell Farm,* 1943. Oil on hardboard, 24 x 30 in.; 60.96 x 76.2 cm. Acquired 1944, The Philips Collection, Washington, DC **102b** *Old Black Joe,* 1943, Horace Pippin. Oil on canvas, 24 x 30 in. (61.0 x 76.1 cm.). Museum purchase through the Luisita L. and Franz H. Denghausen Endowment/ SAAM **102bc** *Self-Portrait,* 1985, Mose Tolliver. Oil on fiberboard with human hair, 24 1/2 x 16 7/8 in. (62.2 x 42.9 cm.). Gift of Herbert Waide Hemphill, Jr. and museum purchase made possible by Ralph Cross Johnson/ SAAM **103tl** *Chicago in Flames,* c. 1880, Lawrence W. Ladd. Watercolor and pencil on paper sheet: 18 x 29 1/8 in. (45.7 x 74.1 cm.). Gift of Bates and Isabel Lowry/ SAAM **103tr** *Reservation Scene,* 1992, Louise Nez. Commercial yarn, 41 1/8 x 41 3/4 in. (104.6 x 106.1 cm.). Gift of Chuck and Jan Rosenak and museum purchase made possible by Ralph Cross Johnson/ SAAM **103bl** *THE HERBERT WADE HEMPHILL J.R. COLLECTION FOUNDER OF AMERICAN FOLK ART THE MAN WHO PRESERVES THE LONE AND FORGOTTEN. THE UNKNOWN COLLECTION,* 1978, Howard Finster. Enamel on plywood frame: 79 1/2 x 50 in. (201.9 x 126.9 cm.). Gift of Herbert Waide Hemphill, Jr. and museum purchase made possible by Ralph Cross Johnson/ SAAM **103br** *Head of Emmett,* c. 1985, Faye Tso. Fired clay with piñon pitch, 10 3/8 x 7 1/4 in. (26.4 x 18.4 cm.) diam. Gift of Chuck and Jan Rosenak and museum purchase made possible by Ralph Cross Johnson/ SAAM

Chapter 7: Modernism

104 Joseph Stella, *Study for "Battle Of Lights, Coney Island, Mardi Gras,"* 1913. Oil on canvas. 9 15/16 x 12 in. (25.3 x 30.5 cm.). Gift of Joseph H. Hirshhorn, 1966/ HMFG **105r** *Reclining Nude,* 1924–30, Max Weber. Woodcut on paper, 1 7/8 x 4 1/4 in. (4.8 x 10.6 cm.). Museum purchase/ SAAM **106** Alfred Henry Maurer, *Two Sisters,* c. 1924. Oil on canvas mounted on fiberboard, 30 x 19 7/8 in. (76.0 x 50.2 cm.). Gift of Joseph H. Hirshhorn, 1966/ HMSG **107** Marsden Hartley, *Painting No. 47, Berlin,* 1914–15. Oil on canvas. 39 1/2 x 31 5/8 in. (100.1 x 81.3 cm.). Gift of Joseph H. Hirshhorn, 1972/ HMSG **108** *Summer,* 1909, Max Weber. Oil on canvas, 40 1/4 x 23 7/8 in. (102.2 x 60.6 cm.). Museum purchase through the Luisita L. and Franz H. Denghausen Endowment/ SAAM **109t** *Sun,* 1943, Arthur Dove. Wax emulsion on canvas, 24 x 32 in. (61.0 x 81.4 cm.). Bequest of Suzanne M. Smith/ SAAM **109tr** *Stanton Macdonald-Wright, Conception Synchromy,* 1914. Oil on canvas, 36 x 30 1/8 in. (91.3 x 76.5 cm.). Gift of Joseph H. Hirshhorn, 1966/ HMSG **110** *Bathing Woman and Servant,* 1917, Arthur B. Davies. Drypoint on paper image: 6 1/8 x 3 1/2 in. (15.6 x 8.9 cm.). Museum purchase/ SAAM **111tl** Wikimedia **111br** Philadelphia Museum of Art: The Louise and Walter Arensberg Collection, 1950 **113** Man Ray, *Self-Portrait,* 1916. Photomechanical reproduction on plastic, laminated to plexiglass. sheet: 20 5/8 x 15 1/4 in. (52.4 x 38.4 cm.) image: 20 1/16 x 14 5/8 in. (51.0 x 37.1 cm.). The Joseph H. Hirshhorn Bequest, 1981/ HMSG/ © 2006 Man Ray Trust/ ARS/ ADAGP, Paris **114** *Moonlight,* 1887, Albert Pinkham Ryder. Oil on mahogany panel, cradled 15 7/8 x 17 3/4 in. (40.4 x 45.0 cm.). Gift of William T. Evans/ SAAM **115tr** *Jonah,* c. 1885–95, Albert Pinkham Ryder. Oil on canvas mounted on fiberboard 27 1/4 x 34 3/8 in. (69.2 x 87.3 cm.). Gift of John Gellatly/ SAAM **115bl** *Dancer,* c. 1918–19, Elie Nadelman. Painted cherry wood and gesso, 28 1/4 x 14 1/2 x 5 1/8 in. (71.8 x 36.8 x 13 cm.). Promised and partial gift of Linda Lichtenberg Kaplan/ SAAM **116** *Connecticut Barns in Landscape,* 1934, Charles Sheeler. Oil on canvas, 23 1/8 x 29 1/8 in. (58.7 x 74 cm.). Transfer from the General Services Administration/ SAAM **117tl** Wikimedia **117br** Ralston Crawford, *St. Petersburg to Tampa,* 1938. Oil on canvas, 30 1/4 x 36 1/4 in. (76.8 x 92 cm.). Gift of Joseph H. Hirshhorn, 1960/ HMSG **119t** Georgia O'Keeffe, *Black Hills with Cedar,* 1941–42. Oil on canvas, 16 x 30 in. (40.6 x 76.0 cm.). The Joseph H. Hirshhorn Bequest, 1981/ HMSG/ © 2006 Georgia O'Keeffe Museum/ ARS **119b** *Picuris Mountain (Near Taos),* c. 1940, Ernest L. Blumenschein. Oil on canvas, 10 1/4 x 25 3/8 in. (26.1 x 64.4 cm.). Gift of Arvin Gottlieb/ SAAM

Chapter 8: The Depression and World War II

120 Ben Shahn, *The Riveter* (mural study, Bronx, New York central postal station), 1938. 33" x 14 3/4" (83.8 x 37.5 cm.), tempera on paperboard. Transfer from the General Services Administration. SAAM/ Art © Estate of Ben Shahn/ VAGA **121r** *Early Morning Work,* c. 1940, William H. Johnson. Oil on burlap, 38 1/2 x 45 5/8 in. (97.8 x 115.9 cm.). Gift of the Harmon Foundation/ SAAM **122** *Homecoming,* 1924, Norman Rockwell. Oil on canvas, 22 3/4 x 18 5/8 in. (57.8 x 47.4 cm.). Gift of Mr. and Mrs. Bernard M. Hollander/ SAAM/ Work by Norman Rockwell, Printed by permission of the Norman Rockwell Family Agency, © 2007 the Norman Rockwell Family Entities **123** LoC/ Work by Norman Rockwell, Printed by permission of the Norman Rockwell Family Agency, © 2007 the Norman Rockwell Family Entities **124** Thomas Hart Benton, *Field Workers (Cotton Pickers),* 1945. 8 3/4" x 13 1/2" (22.2 x 34.3 cm), oil on canvas. Gift of Joseph H. Hirshhorn, 1966. HMSG/ Art © Thomas Hart Benton and Rita P. Benton Testamentary Trusts/UMB Bank Trustee/ VAGA **125** *Ajax,* 1936–37, John Steuart Curry. Oil on canvas, 36 x 48 1/4 in. (91.4 x 122.6 cm.). Gift of Peter and Paula Lunder/ SAAM **126** Grant Wood,

American, 1891–1942, *Young Corn,* 1931. Oil on masonite panel, 24 x 29 7/8 inches, Memorial to Linnie Schloeman, Wilson School, Copyright, Cedar Rapids Community School District/ Art © Estate of Grant Wood/ VAGA **127t** Grant Wood, American, 1891–1942, *American Gothic,* 1930. Oil on beaver board, 30 11/16 x 25 11/16 in. (78 x 65.3 cm) unframed, Friends of American Art Collection, 1930.934 Photograph by Bob Hashimoto. Reproduction, the Art Institute of Chicago/ American Gothic, 1930 by Grant Wood, All rights reserved by the Estate of Nan Wood Graham/ VAGA **127b** *Dodges Ridge,* 1947, Andrew Wyeth. Egg tempera on fiberboard, 41 1/8 x 48 1/8 in. (104.5 x 122.3 cm.). Gift of S.C. Johnson & Son, Inc. / SAAM **128l** Edward Hopper, *Eleven A.M.,* 1926. Oil on canvas. 28 1/8 x 36 1/8 in. (71.3 x 91.6 cm.). Gift of the Joseph H. Hirshhorn Foundation, 1966/ HMSG **128r** Edward Hopper, American, 1882–1967, *Nighthawks,* 1942, oil on canvas, 84.1 x 152.4 cm, Friends of American Art Collection 1942.51 Photograph by Robert Hashimoto. Reproduction, the Art Institute of Chicago **129** *Cape Cod Morning,* 1950, Edward Hopper. Oil on canvas, 34 1/8 x 40 1/4 in. (86.7 x 102.3 cm.). Gift of the Sara Roby Foundation/ SAAM **130** Moses Sawyer, *Artists on WPA,* 1935. Oil on canvas, 36 1/8" x 42 1/8" (91.7 x 107 cm.). Gift of Mr. and Mrs. Moses Sawyer. SAAM/ Art © Estate of Moses Soyer/ VAGA **131t** *Construction of the Dam* (study for mural, the Department of the Interior, Washington, D.C.), 1938, William Gropper. Oil on canvas, overall: 27 1/4 x 87 1/4 in. (69.2 x 221.7 cm). Transfer from the U.S. Department of the Interior, National Park Service/ SAAM **131b** *Brooklyn Bridge, Water and Dock Streets, Brooklyn,* 1936, Berenice Abbott. Gelatin silver print mounted on paperboard sheet: 18 x 14 3/8 in. (45.7 x 36.6 cm.) Transfer from the Evander Childs High School, Bronx, New York through the General Services Administration/ SAAM **132** Jack Levine, *The Syndicate,* 1939. Oil on canvas, 30 1/8" x 45 1/8" (76.5 x 114.5 cm.). Gift of the Joseph H. Hirshhorn Foundation, 1966/ HMSG/ Art © Jack Levine/ VAGA **133t** LoC **133b** LoC **134** Burgoyne Diller, *Construction,* 1934. Painted wood and fiberboard, 24" x 24" x 1" (61.1 x 61 x 2.4 cm.). Gift of Joseph H. Hirshhorn Foundation, 1966/ HMSG/ Art © Estate of Burgoyne Diller/ VAGA / Est. Represented by the Michael Rosenfeld Gallery **135t** Ilya Bolotowsky, *Architectural Variation,* 1949. Oil on canvas, 20 x 30 in. (50.8 x 76.2 cm.). Gift of Patricia and Phillip Frost. SAAM/ Art © Estate of Ilya Bolotowsky/ VAGA **135b** Alexander Calder, *Zarabanda (One White Disc),* 1955. Painted sheet metal, metal rods and wire, flat: 42 x 65 3/8in. (106.6 x 166.1 cm.), hanging: 33 x 89 1/2 x 21 1/2in. (83.8 x 227.3 x 54.6 cm.). Gift of Joseph H. Hirshhorn, 1972/HMSG/ © 2006 Estate of Alexander Calder/ ARS **136** *Going to Church,* c. 1940–41, William H. Johnson. Oil on burlap, 38 1/8 x 45 3/8 in. (96.8 x 115.4 cm.). Gift of the Harmon Foundation/ SAAM **137t** *Les Fétiches,* 1938, Lois Mailou Jones. Oil on linen, 21 x 25 1/2 in. (53.3 x 64.7 cm.). Museum purchase made possible by Mrs. Norvin H. Green, Dr. R. Harlan, and Francis Musgrave/ SAAM **137b** Jacob Lawrence, *Cabinet Makers,* 1946. Gouache with pencil underdrawing on paper, sheet: 22 x 30 3/16 in. (55.9 x 76.6 cm.), image: 21 3/4 x 30 in. (55.2 x 76.1 cm.). Gift of Joseph H. Hirshhorn, 1966/ HMSG/ © 2006 The Jacob and Gwendolyn Lawrence Foundation, Seattle/ ARS **138** Stuart Davis, *Lucky Strike,* 1924. Oil on canvas, 33 1/8 x 18 in. (45.6 x 60.9 cm.). Museum Purchase, 1974. SAAM/ Art © Estate of Stuart Davis/ VAGA **139** Stuart Davis, *Rapt at Rappaport's,* OCTOBER, 1952. Oil on canvas, 52 x 40 in. (131.8 x 101.4 cm.). Gift of the Joseph H. Hirshhorn Foundation, 1966. HMSG/ Art © Estate of Stuart Davis/ VAGA

Chapter 9: American Art after 1940

140 Adolph Gottlieb, *Pictogenic Fragments,* 1946. Oil on canvas, 36 1/8 x 30 1/8 in. (91.7 x 76.4 cm.). Gift of Joseph H. Hirshhorn, 1966/ HMSG/ Art © Adolph and Esther Gottlieb Foundation/ VAGA **141** Robert Motherwell, *Monster (for Charles Ives),* 1959. Oil on canvas, 78 1/4 x 118 1/4 in. (198.8 x 300.4 cm.). Gift of S.C. Johnson & Son, Inc. SAAM/ Art © Dedalus Foundation, Inc./ VAGA **142** William Baziotes, *Green Night,* 1957. Oil on canvas. 36 1/8 x 48 1/8 in. (91.7 x 122.2 cm.). Gift of the Joseph H. Hirshhorn Foundation, 1966/ HMSG **143** Arshile Gorky, *Soft Night,* 1947. Oil, india ink, and conte crayon on canvas. 38 1/8 x 50 1/8 in. (96.7 x 127.1 cm.). The Joseph H. Hirshhorn Bequest, 1981/ HMSG/ © 2006 ARS **144** *1946-H (Indian Red and Black),* 1946, Clyfford Still. Oil on canvas 78 1/4 x 68 3/8 in. (198.8 x 173.7 cm.). Museum purchase from the Vincent Melzac Collection through the Smithsonian Institution Collections Acquisition Program/ SAAM **145** Willem de Kooning, *Woman, Sag Harbor,* 1964. Oil and charcoal on wood. 80 x 36 in. (203.1 x 91.2 cm.). Gift of Joseph H. Hirshhorn, 1966/ HMSG/ © 2006 The Willem de Kooning Foundation/ ARS **147** Jackson Pollock, *Number 25, 1950,* 1950. Encaustic on canvas, 10 x 37 7/8 in. (25.0 x 96.2 cm.). Gift of the Joseph H. Hirshhorn Foundation, 1966/ HMSG/ © 2006 The Pollock-Krasner Foundation/ ARS **148** Robert Motherwell, *Elegy To The Spanish Republic #129,* 1974. Acrylic and charcoal on canvas, 96 x 120 in. (244.0 x 304.9 cm.). Museum Purchase and Partial Gift of Joseph H. Hirshhorn, by Exchange, 1981/ HMSG/ Art © Dedalus Foundation, Inc./ VAGA **149** David Smith, *Agricola I,* 1951–52. Painted steel, 73 1/2 x 55 1/4 x 24 5/8 in. (186.5 x 140.3 x 62.5 cm.) incl. base h: 1 in. (2.5 cm.). Gift of Joseph H. Hirshhorn, 1966/ HMSG/ Art © Estate of David Smith/ VAGA **151** Mark Rothko, *Blue, Orange, Red,* 1961. Oil on canvas. 90 1/4 x 81 1/16 in. (229.2 x 205.9 cm.). Gift of the Joseph H. Hirshhorn Foundation, 1966 HMSG/ © 1998 Kate Rothko Prizel & Christopher Rothko/ ARS **152** *Marlin,* 1960, Joan Mitchell. Oil on canvas, 95 x 71 in. (241.3 x 180.3 cm.). Gift of S.C. Johnson & Son, Inc./ SAAM **153tl** Philip Guston, *Oasis,* 1957. Oil on canvas. 61 1/2 x 68 in. (156.2 x 172.7 cm.). Gift of the Joseph H. Hirshhorn Foundation, 1966/ HMSG **153br** Richard Diebenkorn, *Berkeley No. 22,* 1954. Oil on canvas. 59 x 57 in. (149.8 x 144.8 cm.). Regents Collections Acquisition Program, 1986/ HMSG **154** *Small's Paradise,* 1964, Helen Frankenthaler. Acrylic on canvas, 100 x 93 5/8 in. (254.0 x 237.7 cm.). Gift of George L. Erion/ SAAM **155t** Kenneth Noland, *Beginning,* 1958. Magna on canvas, 90 x 95 7/8 in. (228.5 x 243.5 cm.). Gift of the Joseph H. Hirshhorn Foundation, 1966/ HMSG/ Art © Kenneth Noland/ VAGA **155b** *Beta Upsilon,* 1960, Morris Louis. Acrylic on canvas, 102 1/2 inches x 243 1/2 inches (260.4x618.5 cm). Museum purchase from the Vincent Melzac Collection through the Smithsonian Institution Collections Acquisition Program/ SAAM

Chapter 10: Post-Abstraction

156 Wayne Thiebaud, *Jackpot Machine,* 1962. Oil on canvas, 38 x 26 7/8 in. (96.5 x 68.3 cm.). Museum purchase made possible by the American Art Forum and gift of an anonymous donor/ SAAM/ Art © Wayne Thiebaud/ VAGA **157** Alex Katz, *Ada and Vincent in the Car,* 1972. Oil on canvas, 72 x 96 1/4 in. (182.8 x 244.0 cm.). The Joseph H. Hirshhorn Bequest, 1981/ HMSG/ Art © Alex Katz/ VAGA **158** Larry Rivers, *The Athlete's Dream,* 1956. Oil on canvas, 82 1/8 x 118 7/8 in. (208.7 x 301.8 cm.). Gift of S.C. Johnson & Son, Inc. SAAM/ Art © Estate of Larry Rivers/ VAGA **159bl** Philip Pearlstein, *Male And Female Nudes With Red And Purple Drape,* 1968. Oil on canvas. 75 1/4 x 75 1/2 in. (191.2 x 191.8 cm.). Gift of Joseph H. Hirshhorn, 1972/ HMSG **159tr** *Forsythia and Pear in Bloom,* 1968, Fairfield Porter. Oil on canvas, 36 1/8 x 29 in. (91.7 x 73.6 cm.). Gift of the Woodward Foundation/

SAAM **160** Elmer Bischoff, *Woman On Sofa*, JANUARY 1959. Oil on canvas. 30 7/8 x 25 3/4 in. (78.5 x 65.5 cm.). Gift of Joseph H. Hirshhorn, 1966/ HMSG **161**t Alice Neel, *NANCY AND OLIVIA*, 1967. © Estate of Alice Neel. Courtesy Robert Miller Gallery, New York **161**b *Napalm V*, 1969, Leon Golub. Acrylic on canvas, 59 x 41 in. (149.9 x 104.1 cm.). Bequest of Edith S. and Arthur J. Levin/ SAAM **162** Joseph Cornell, *Medici Princess*, c. 1952. Painted wood, photomechanical reproductions, painted & colored glass, painted paper, string, cork, metal rings, plastic balls, and a feather, in glass-faced, painted wood box, 17 5/8 x 12 1/4 x 4 3/4 in. (44.5 x 31.1 x 12.1 cm.). Museum Purchase, 1979/ HMSG/ Art © The Joseph and Robert Cornell Memorial Foundation/ VAGA **163**bl *Chigadera/ Ratbastard*, 1962, Bruce Conner. Assemblage, 33 1/2 x 13 1/4 x 5 in. (85.1 x 33.7 x 12.7 cm.). Bequest of Edith S. and Arthur J. Levin/ SAAM **163**r Louise Nevelson, *Black Wall*, 1964. Painted wood construction. 64 3/4 x 39 1/2 x 10 1/8 in. Gift of Joseph H. Hirshhorn, 1966/ HMSG/ © 2006 Estate of Louise Nevelson/ ARS **164** Robert Rauschenberg, *Monogram*, 1955–59. Moderna Museet, Stockholm/ Art © Robert Rauschenberg/ VAGA **165** Robert Rauschenberg, *Reservoir*, 1961. Oil, wood, graphite, fabric, metal, and rubber on canvas, 85 1/2 x 62 1/2 x 15 1/2 in. (217.2 x 158.7 x 39.4 cm.). Gift of S.C. Johnson & Son, Inc./ SAAM/ Art © Robert Rauschenberg/ VAGA **166**bl Jasper Johns b. 1930, *Three Flags*, 1958. Encaustic on canvas, Overall: 30 7/8 x 45 1/2 x 5in. (78.4 x 115.6 x 12.7cm.). Framed: 32 x 46 3/4 x 5in. (81.3 x 118.7 x 12.7cm.). Whitney Museum of American Art, New York; 50th Anniversary Gift of the Gilman Foundation, Inc., The Lauder Foundation, A. Alfred Taubman, Laura-Lee Whittier Woods, and purchase 80.32/ Art © Jasper Johns/ VAGA **166**r Jasper Johns, *Untitled*, 1954. Painted, painted plaster cast, photomechanical reproductions on canvas, glass, and nails, 26 1/4 x 8 7/8 x 4 3/8 in. (66.6 x 22.5 x 11.1 cm.). Regents Collections Acquisition Program, with Matching Funds from the Thomas M. Evans, Jerome L. Greene, Joseph H. Hirshhorn, and Sydney and Frances Lewis Purchase Fund, 1987. HMSG/ Art © Jasper Johns/ VAGA **167**bl Romare Bearden, *The Prevalence Of Ritual: Baptism*, 1964. Photomechanical reproductions, paint and graphite on board, 9 1/8 x 12 in. (23.2 x 30.5 cm.). Gift of Joseph H. Hirshhorn, 1966/ HMSG/ Art © Romare Bearden Foundation/ VAGA **167**tr Wallace Berman, *Untitled (Four Hands with Radios)*, c. 1965. Verifax collage and synthetic polymer with prestype on paperboard. 12 1/2 x 13 1/2 in. (31.7 x 34.2 cm.). Gift of Charles Cowles, 1982/ HMSG **169**t George Segal, *The Curtain*, 1974. Mixed media: plaster, glass and painted wood, 84 1/2 x 39 1/4 x 35 1/2 in. (214.6 x 99.7 x 90.2 cm.). Museum purchase. SAAM/ Art © The George and Helen Segal Foundation/ VAGA **169**b Claes Oldenburg, *Soft Bathtub (Model)—Ghost Version*, 1966. Acrylic and pencil on foam-filled canvas with wood cord and plaster. 94 3/4 x 35 3/8 x 35 3/8 in. (240.7 x 89.8 x 89.8 cm.). Joseph H. Hirshhorn Purchase Fund, 1998/ HMSG **170**tl James Rosenquist, *The Friction Disappears*, 1965. Oil on canvas, 48 1/2 x 14 in. (122.2 x 112.4 cm.) irregular. Gift of Container Corporation of America SAAM/ Art © James Rosenquist/ VAGA **170**br *Sweet Dreams, Baby!*, from the portfolio, *11 Pop Artists, Volume III*, 1965, Roy Lichtenstein. Publisher: Original Editions color serigraph on paper, image: 35 3/4 x 25 5/8 in. (90.7 x 65.0 cm.). Gift of Philip Morris Incorporated/ © Estate of Roy Lichtenstein/ SAAM **171**t Tom Wesselmann, *Study for "First Illuminated Nude*," 1965. Acrylic on canvas with pencil underdrawing, 46 x 43 in. (116.8 x 109.2 cm.). Gift of Joseph H. Hirshhorn, 1966/ HMSG/ Art © Estate of Tom Wesselmann/ VAGA **171**b Ed Ruscha, *The Los Angeles County Museum on Fire*, 1965–68. Oil on canvas. 53 1/2 x 133 1/2 in. (135.9 x 339.1 cm.) Gift of Joseph H. Hirshhorn, 1972/ HMSG **172** Andy Warhol (American 1928–87), *Campbell's Soup*, 1965. Acrylic on Canvas, 36 x 24 in. Milwaukee Art Museum, Gift of Mrs. Harry Lynde Bradley, M1977.156/ © 2006 Andy Warhol Foundation/ ARS, NY/ TM Licensed by Campbell's Soup Co. All rights reserved **173** Andy Warhol, *Self-Portrait*, 1986. Synthetic polymer and silkscreen ink on linen. 80 x 80 1/4 in. (203.0 x 203.4 cm.). Partial Gift of the Andy Warhol Foundation for the Visual Arts and Partial Purchase, Smithsonian Collections Acquisition Program and Joseph H. Hirshhorn Bequest Fund, 1995/ HMSG/ © 2006 Andy Warhol Foundation for the Visual Arts/ ARS

Chapter 11: Minimalism and its Influence
174 Larry Bell, *Untitled*, 1964. Glass, bismuth, chromium, gold, and rhodium on gold-plated brass. 54 1/4 x 16 3/8 x 14 1/4 in. (137.9 x 41.5 x 36.4 cm.). The Joseph H. Hirshhorn Bequest, 1981/ HMSG **175** Nancy Graves, *Pleistocene Skeleton*, 1970. Steel, wax, marble dust and acrylic, 84 x 120 x 36 in. (213.4 x 304.8 x 91.4 cm). Museum purchase through the Luisita L. and Franz H. Denghausen Endowment. SAAM/ Art © Nancy Graves Foundation/ VAGA **176** Frank Stella, *Arundel Castle*, 1959. Enamel on canvas. 121 3/8 x 73 1/8 in. (308.1 x 186.1 cm.) Gift of Joseph H. Hirshhorn, 1972/ HMSG/ © 2006 Frank Stella/ ARS **177**t Donald Judd, *Untitled*, 1969. Brass and colored fluorescent plexiglass on steel brackets, ten pieces, each 6 1/8 x 24 x 27 in. (15.5 x 60.9 x 68.6 cm.) with 6 in. between (15.2 cm.) overall: 116 1/2 x 24 x 27 in. Gift of Joseph H. Hirshhorn, 1972/ Art © Judd Foundation/ VAGA **177**b Carl Andre, *Magnesium-Zinc Plain*, 1969. Magnesium and zinc, 3/8 x 72 x 72 in. (1 x 182.9 x 182.9 cm.). Collection Museum of Contemporary Art San Diego, Museum purchase with matching funds from the National Endowment for the Arts, 1974.4.1-36, Photographed by Philipp Scholz Rittermann/ Art © Carl Andre/ VAGA **178** Dan Flavin, *"monument" for V. Tatlin*, 1967. Cool white fluorescent lights. 96 1/8 x 19 3/4 x 5 in. (244.2 x 50.2 x 12.7 cm.) The Joseph H. Hirshhorn Bequest Fund, 1995/ HMSG **179** Agnes Martin, *Play*, 1966. Acrylic on canvas. 72 1/8 x 72 in. (183.0 x 182.9 cm.). Gift of Joseph H. Hirshhorn, 1974/ HMSG/ © Agnes Martin/ ARS **180** Ellsworth Kelly, *Red White*, 1961. Oil on canvas. 62 3/4 x 85 1/4 in. (159.5 x 216.6 cm.). Gift of Joseph H. Hirshhorn, 1972/ HMSG **181** Richard Tuttle, *Tan Octagon*, 1967. Dyed canvas. diameter: 54 3/4 in. (139.0 cm.). Joseph H. Hirshhorn Purchase Fund, 1991/ HMSG **182** Cy Twombly, *Untitled*, November 1965. Crayon and pencil on paper. 26 1/2 x 33 15/16 in. (67.3 x 86.2 cm.). The Joseph H. Hirshhorn Bequest, 1981/ HMSG **183** Cy Twombly, *August Notes From Rome (Ferragosto)*, August 1961. Oil, oil crayon and pencil on canvas, 64 3/4 x 78 7/8 in. (164.5 x 200.3 cm.). Gift of Joseph H. Hirshhorn, 1966/ HMSG **184** *Cocoon I*, c. 1960–69, Lee Bontecou. Mixed media: fabric, wood, copper wire, shellac and ink, 9 7/8 x 3 3/4 x 4 1/8 in. (25.1 x 9.6 x 10.5 cm.). Gift of the Woodward Foundation/ SAAM **185**tl Louise Bourgeois, *THE BLIND LEADING THE BLIND*, 1947–49, Wood, painted pink, 70 3/8 x 96 7/8 x 17 3/8"; 178.7 x 246 x 44.1 cm. Regents Collections Acquisition Program with Matching Funds from the Jerome L. Greene, Agnes Gund, Sydney and Frances Lewis, and Leonard C. Yaseen Purchase Fund, 1989. Collection Hirshhorn Museum & Sculpture Garden, Washington D.C. Art © Louise Bourgeois/ VAGA **185**br Eva Hesse, *Vertiginous Detour*, 1966. Acrylic and polyurethane on rope, net, and papier mache. Diameter of ball: 16 1/2 in. (41.9 cm.); length of rope: 154 in. approx. (391.0 cm.). Joseph H. Hirshhorn Purchase Fund, 1988/ HMSG **186** Photograph by Soren Harward/ Wikimedia **187**t Walter De Maria, *The Lightning Field*, 1977. Quemado, New Mexico. Collection Dia Art Foundation. Photo: John Cliett. © Dia Art Foundation. **187**b Christo, *Running Fence*, Project for Sonoma and Marin Counties, 1975 Crayon, pencil, colored paper, cloth, and glue on paper. 22 x 28 in. (55.9 x 71.1 cm.). Gift of Jacqueline and Myron Blank,

Des Moines, Iowa, 1996/ HMSG **188** *Maquette for One, Two, Three*, 1979, Sol LeWitt. Assembled and painted balsa wood, 11 5/8 x 22 3/4 x 11 5/8 in. (29.4 x 57.9 x 29.5 cm.). Transfer from the General Services Administration, Art-in-Architecture Program. © 2006 Sol LeWitt/ ARS/ SAAM **189** Joseph Kosuth, *One and three tables*, 1965. Wooden table, gelatin silver photograph, and pjotodtat mounted on foamcore, 120.0 x 310.0 x 58.0cm installed. Mervyn Horton Bequest Fund, 1999, Collection: Art Gallery of New South Wales/ © 2006 Joseph Kosuth/ ARS/ Photograph: Mimi Sterling

Chapter 12: The Body Revisited
190 Robert Gober, *Untitled*, 1990. Wax, cotton, wood, leather shoe, and human hair. 10 3/4 x 20 1/2 x 5 5/8 in. (27.2 x 52.0 x 14.2 cm.). Joseph H. Hirshhorn Purchase Fund, 1990/ HMSG **192** *Dollhouse*, 1972, Miriam Schapiro and Sherry Brody. Wood and mixed media overall: 79 3/4 x 82 x 8 1/2 in. (202.6 x 208.3 x 21.6 cm.). Museum purchase through the Gene Davis Memorial Fund/ SAAM **193** *Through the Flower/* © 2006 Judy Chicago/ ARS **194** *Anima (Alma/Soul)*, 1976/ printed 1977, Ana Mendieta. Color photograph mounted on paperboard. Sheet, image and mount: 13 1/2 x 20 in. (34.3 x 50.8 cm.). Museum purchase through the Smithsonian Latino Initiatives Pool and the Smithsonian Institution Collections Acquisition Program/ SAAM **195** Nauman, Bruce, *Poke in the Eye/Nose/Ear 3/8/94 Edit*, 1994. Video projector, videodisc player, videodisc (color, silent), 52 minutes. Collection Walker Art Center, Minneapolis, T.B. Walker Acquisition Fund, 1994/ © Bruce Nauman/ ARS **196** Robert Cottingham, *Flagg Bros*, 1975. Oil on canvas. 78 x 78 in. (198.0 x 198.1 cm.). Museum Purchase, 1976/ HMSG **197**t Duane Hanson, *Woman Eating*, 1971. Polyester resin, fiberglass, polychromed in oil paint with clothes, table, chair and accessories, overall: 50 x 30 x 55 in. (127.0 x 76.2 x 139.7 cm.). Museum purchase through the Luisita L. and Franz H. Denghausen Endowment. SAAM/Art © Estate of Duane Hanson/ VAGA **197**b *New Housing, Longmont, Colorado*, 1973, Robert Adams. Gelatin silver print on paper mounted on paperboard sheet: 6 x 7 5/8 in. (15.1 x 19.3 cm.). Transfer from the National Endowment for the Arts/ SAAM **198** *Painter III*, 1960, Philip Guston. Oil on canvas, 60 5/8 x 68 in. (154.1 x 172.8 cm.). Gift of S.C. Johnson & Son, Inc./ SAAM **199**b Philip Guston, *Ancient Wall*, 1976. Oil on linen. 80 x 93 5/8 in. (203.2 x 237.7 cm.). Regents Collections Acquisition Program, 1987/ HMSG **200** Elizabeth Murray, *In The Dark*, 1987. Oil on canvas. 115 1/8 x 142 3/8 x 24 5/8 in. (292.9 x 361.7 x 62.5 cm.). Museum Purchase, 1988/ HMSG **201** Eric Fischl, *The Funeral: A Band of Men (2 Women) Abandonment!*, 1980. Oil on canvas. 55 1/8 x 103 1/8 in. (139.8 x 261.8 cm.). Regents Collections Acquisition Fund, with matching funds from the Jerome L. Greene, Sydney and Frances Lewis, and Leonard C. Yaseen Purchase Fund, and the Joseph H. Hirshhorn Purchase Fund, 1990/ HMSG **202** Basquiat, Jean-Michel, *Untitled*, 1981. Acrylic and mixed media on canvas, 81 x 69 1/4 inches, The Eli and Edythe L. Broad Collection, Los Angeles. Photograph by Douglas M. Parker Studio, Los Angeles/ © 2006 The Estate of Jean-Michel Basquiat/ AGAGP, Paris/ ARS **203**t © The Estate of Keith Haring **203**b Felix Gonzalez-Torres, *"Untitled" (For Jeff)*, 1992. Photomechanical reproduction on paper and certificate of authenticity. variable: 8 x 10 in., 8 x 10 in., 8 1/2 x 11 in. (20.4 x 25.4 cm., 20.4 x 25.4 cm., 21.1 x 28.0 cm.) Gift of the Peter Norton Family Foundation, 1995/ HMSG **204** David Salle (American), *Pastel*, 1986. Oil and acrylic on canvas, 84" x 162". Portland Art Museum, Oregon. Museum Purchase: Robert Hale Ellis Jr. Fund for the Blanche Elouise Day Ellis and Robert Hale Ellis Memorial Collection/ Art © David Salle/ VAGA **205**t Associated Press/ The Broad Art Foundation **205**b Prince, Richard, *Cowboys and Girlfriends*, 1992. Ektacolor print, 20" x24". Collection Walker Art Center, Minneapolis, T.B. Walker Acquisition Fund, 2000 **206** Cindy Sherman, *Untitled #121*, 1983. C-print. sheet: 40 x 27 1/2 in. (101.6 x 69.8 cm) image: 35 3/16 x 21 1/4 in. (89.2 x 54.0 cm.). Gift of Dr. William H. Goldiner, 1998/ HMSG **207**t *Untitled (And)*, from the *Untitled Portfolio*, 1985, Barbara Kruger. Publisher: Peter Blum Edition Photo-offset lithograph and serigraph on paper sheet: 20 1/2 x 20 1/2 in. (52.0 x 52.0 cm.). Museum purchase/ SAAM **207**b Walker, Kara, *The Means to an End … A Shadow Drama in Five Acts*, 1995. Etching, aquatint on paper, 34-3/4" x 115-5/8." Collection Walker Art Center, Minneapolis, T.B. Walker Acquisition Fund, 1996 **208**tl *El Patio de Mi Casa*, 1990, Maria Brito. Acrylic on wood and mixed media overall: 95 1/2 x 68 1/4 x 65 in. (242.6 x 173.4 x 165.1 cm.). Museum purchase through the Smithsonian Institution Collections Acquisition Program/ SAAM **208**br *A Matter of Trust*, 1994, Maria Castagliola. Paper on fiberglass screen with cotton thread, 72 x 72 x 1/8 in. (183.0 x 183.0 x .3 cm.). Gift of the artist/ SAAM **209**l *Screen*, 1996, Roberto Gil de Montes. Oil on canvas, 72 x 108 in. (182.9 x 274.3 cm.). Museum purchase through the Luisita L. and Franz H. Denghausen Endowment/ SAAM **209**r *Totem Negro XVI*, 1992, María Martínez-Cañas. Gelatin silver print on paper mounted on paperboard sheet and image: 53 1/2 x 9 3/8 in. (135.9 x 23.8 cm.). Museum purchase through the Smithsonian Institution Collections Acquisition Program/ SAAM **210–211** *Electronic Superhighway: Continental U.S., Alaska, Hawaii*, 1995, Nam June Paik. 49-channel closed circuit video installation, neon, steel and electronic components, approx. 15 x 40 x 4 ft. Gift of the artist/ SAAM

At the Smithsonian
213tr Smithsonian Photographic Services **213**br *Black and Red Male Figure with Upraised Arms*, 1980s, Mary T. Smith. Acrylic on metal, 65 1/4 x 26 3/4 in. (165.7 x 67.9 cm.). Gift of Chuck and Jan Rosenak and museum purchase through the Luisita L. and Franz H. Denghausen Endowment/ SAAM **213**bl James Turrell, *Milk Run*, 1996. Light projection of fluorescent tubes and colored gel., dimensions variable Joseph H. Hirshhorn Bequest Fund, 1998/ HMSG

Cover
Front cover (clockwise from top): Charles Sheeler, *Classic Landscape*, Collection of Barney A. Ebsworth, Image © 2006 Board of Trustees, National Gallery of Art, Washington, 1931, oil on canvas, 63.5 x 81.9 cm (25 x 32 1/4 in.); Nam June Paik, *Video Flag*, 1985–96. 70 video monitors, 4 laser disc players, computer, timers, electrical devices, wood and metal housing on rubber wheels. 94 3/8 x 139 3/4 x 47 3/4 in. (239.6 x 354.8 x 119.9 cm.). Holenia Purchase Fund in Memory of Joseph H. Hirshhorn, 1996/ HMSG; Wikimedia **Back cover**: David Smith, *Cubi XII*, April 7, 1963. Stainless steel, 109 5/8 x 49 1/4 x 32 1/4 in. (278.5 x 125.1 x 81.9 cm.) incl. base h: 2 7/8 in. (7.2 cm.). Gift of the Joseph H. Hirshhorn Foundation, 1972. HMSG/ Art © Estate of David Smith/ VAGA